THE WORLD'S MOST
INFLUENTIAL PAINTERS

AND THE ARTISTS THEY INSPIRED

THE WORLD'S MOST INFLUENTIAL PAINTERS

AND THE ARTISTS THEY INSPIRED

David Gariff

Eric Denker • Dennis P. Weller

Dedication: For my parents

A QUARTO BOOK

First edition for the United States and Canada published in 2008 by Barron's Educational Series, Inc.

Copyright © 2008 Quarto Inc.

All inquiries should be addressed to:
Barron's Educational Series, Inc.
250 Wireless Boulevard
Hauppauge, NY 11788
www.barronseduc.com

ISBN-10: 0-7641-6088-5
ISBN-13: 978-0-7641-6088-2

Library of Congress Control Number: 2007943584

QUAR.IIA

Conceived, designed, and produced by
Quarto Publishing plc
The Old Brewery
6 Blundell Street
London N7 9BH

Project editors: **Lindsay Kaubi,**
Donna Gregory
Copy editor: **Carol King**
Art director: **Caroline Guest**
Designer: **Tanya Devonshire Jones**
Picture research: **Claudia Tate,**
Veneta Bullen

Creative director: **Moira Clinch**
Publisher: **Paul Carslake**

Color separation by PICA digital, Singapore
Printed in China by 1010 Printing
International Ltd

9 8 7 6 5 4 3 2 1

CONTENTS

INTRODUCTION

The World's Most Influential Painters and The Artists They Inspired is an introduction for the student and lover of art. The organization of the text follows conventional art historical chronology, however, the book is not a traditional survey of Western art history. Instead, the book is intended to make the reader aware of the ebb and flow of artistic influences, inspirations, and ideas from the Renaissance to the present day. The directional flow of the book is not simply forward and evolutionary, but multi-directional and interdisciplinary. Painters and their works are presented as part of the larger stream of art, artists, and ideas throughout the centuries. Whenever possible, reference sources were derived not just from the visual arts of painting, sculpture, and architecture, but also from the related areas of film, literature, music, history, science, and philosophy.

Any list of the 50 most influential painters in Western art history is by definition subjective and incomplete. Unfortunately, the names of many noteworthy artists could not be included within this restrictive number. Therefore, I have endeavored to recognize the contributions of as many significant artists as possible in the sections on influence and inspiration that accompany each chapter.

The history of art is not compartmentalized as we are sometimes led to believe. It is my hope that this book will, in a small way, demonstrate the constantly evolving nature of art and creativity. "Influence" and "inspiration" as terms are themselves open to various interpretations and many shades of meaning. I have not been able to illustrate or to discuss all of the various combinations and permutations of artistic interchange that have defined the history of Western painting. However, if this book acts as a stimulus for the reader to further explore the many relationships that have shaped Western art through the years, it will have fulfilled its purpose.

Every day I have the pleasure of working with many talented educators at the National Gallery of Art in Washington, D.C. In part, I have written this book with them in mind. I hope the text stimulates teachers, students, and general readers to share their knowledge and enthusiasm for art. To open the worlds of art and art history to new audiences is an enriching and transforming experience. It is the story of all that makes us human in the best sense of the word.

David Gariff

The structure of the book

The 50 artists featured in the book have been organized into seven chapters that reflect major artistic movements, arranged chronologically. In each chapter are the artists that best reflect and describe that time period.

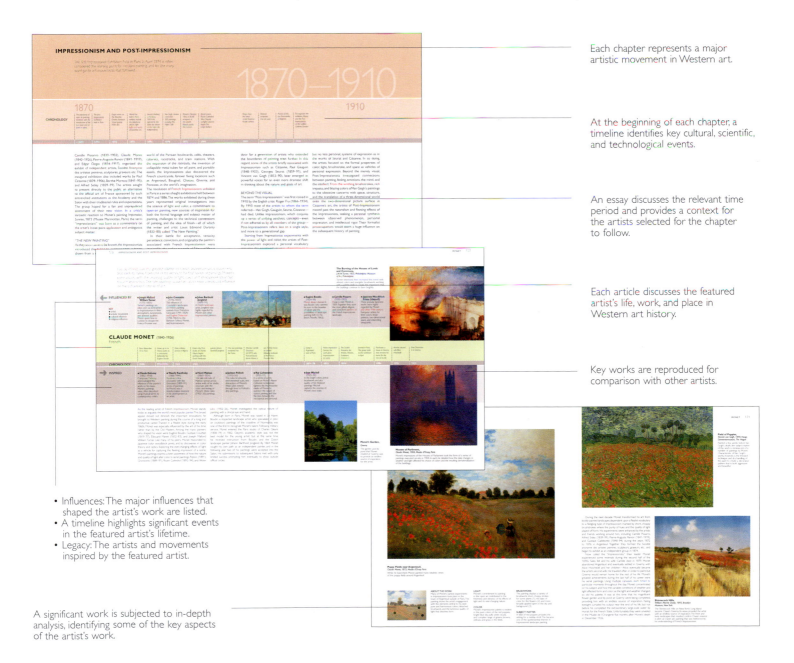

Each chapter represents a major artistic movement in Western art.

At the beginning of each chapter, a timeline identifies key cultural, scientific, and technological events.

An essay discusses the relevant time period and provides a context for the artists selected for the chapter to follow.

Each article discusses the featured artist's life, work, and place in Western art history.

Key works are reproduced for comparison with other artists.

- Influences: The major influences that shaped the artist's work are listed.
- A timeline highlights significant events in the featured artist's lifetime.
- Legacy: The artists and movements inspired by the featured artist.

A significant work is subjected to in-depth analysis, identifying some of the key aspects of the artist's work.

THE RENAISSANCE

Born in the wealthy city-states of the Italian peninsula during the 14th century, first and foremost in the city of Florence, Renaissance ideas stressing the dignity of the individual, and the desire to understand the natural world in all its varied manifestations soon spread throughout Europe.

1304

CHRONOLOGY

Petrarch born; Dante at work on the Divine Comedy	"Babylonian Captivity" begins; Pope leaves Rome to settle in Avignon	Giotto at work in the Arena Chapel in Padua	Boccaccio born	Dante dies	Giotto dies; Hundred Years' War between France and England (1337–1453)	Black Death strikes Europe	Boccaccio at work on the Decameron
1304	1305	1306	1313	1321	1337	1347–50	1348

Much of the cultural flowering that characterized European society in this period was supported, if not generated, by new economic systems of money, banking, and commerce that began to replace earlier feudal models. Religious, civic, and private patronage flourished, and competed in attempts to realize new architectural programs and artistic commissions. These were meant to rival the ancients while simultaneously acknowledging the glory of a rational God who celebrated human curiosity, ambition, achievement, and excellence.

NEW INTERPRETATIONS

In the visual arts, the Renaissance witnessed a vital interaction between artists and the world around them. Nowhere was this seen more clearly and forcefully than in Florence in the early decades of the 15th century. Blessed with an abundance of artistic talent, economic prosperity, and powerful patrons, the city became the laboratory and epicenter for the reorientation of the cultural compass away from earlier medieval examples to modern paradigms for painting, sculpture, and architecture.

At the heart of this shift were new ways of perceiving, interpreting, and translating the reality of nature into the language of art. The practical nature of artistic training and influence gave rise to the inspiration and originality of a host of creative talents, each building on their predecessors while attempting to surpass them. Artists of the 16th-century, such as Leonardo da Vinci (1452–1519), Michelangelo (1475–1564), and Raphael (1483–1520), were directly indebted to their 15th-century counterparts Filippo Brunelleschi (1377–1446), Donatello (c.1386–1466), and Masaccio (1401–28). Through apprenticeships, imitation, emulation, aesthetic debates on the nature of the visual and liberal arts, and through synthesis, Renaissance artists sought to perfect their craft and to find an original voice.

Brunelleschi born	Papacy returns to Rome; Urban VI elected Pope; Clement VII (antipope) elected	at Avignon; Great Schism begins	John Wycliffe dies	Donatello born	Chaucer's Canterbury Tales	Masaccio born	Council of Constance ends Great Schism	Jon Hus burned at the stake in Bohemia	Brunelleschi designs the dome for Florence Cathedral
1377	1378		1384	1386	1386–1400	1401	1414–17	1415	1419

INTERNATIONAL MOVEMENT

Interpretations of Renaissance principles of art varied from northern Europe to southern Europe, reflecting differing realities of history, religion, politics, economics, culture, tradition, materials, techniques, and artistic practices. However, belief in the importance of the individual, the power of an art based on humanistic ideals, the beauty to be found in nature, the Classical roots of such concepts, and the continuing relevance of a religious impulse remained constant throughout the continent, ultimately making their way across the ocean to the New World.

BIRTH OF THE MODERN

The inspiration and lasting influence of the art and ideas of the Renaissance continue to resonate today. Beyond the role that Renaissance art played in later history as a paradigm for perfection in the eyes of many, there was also the concept that elevated the status of the artist in society, and a belief in the original talents of painters, sculptors, and architects as creative individuals. Men such as Brunelleschi, Lorenzo Ghiberti (c.1378–1455), Leonardo, and Michelangelo championed a view of artists and architects that can only be called modern. Indeed, it was in the Renaissance that people first began to identify a Brunelleschi building or Raphael painting in the same way a Frank Gehry (b.1929) building or painting by Pablo Picasso (1881–1973) is today: as a specific and unique collection of characteristics that define an individual style. Therefore, the Renaissance was not only a rediscovery of the Classical past, but a vision that shaped much of the history of art thereafter.

Modern Western painting begins with Giotto. His key position in the history of art remains unchallenged. Turning away from the styles of earlier Byzantine models, Giotto's innovations represent a seismic shift in thinking about the sources and nature of art—ideas that would reach full maturity only a century later.

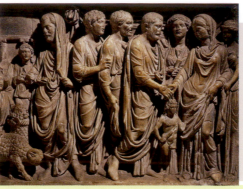

INFLUENCED BY

◆ **Classical Art**
Echoes of Roman sarcophagi, relief sculpture, and painting are present in the figures, lighting, compositional effects, and gravitas of Giotto's paintings (right: Marble sarcophagus, church of San Lorenzo Fuori le Mura, Rome).

KEY
● artist
◆ artistic movement
■ cultural influence
❖ religious influence

■ *The Golden Legend*
(c.1260)
Giotto's frescoes in the Arena Chapel, depicting scenes from the Life of the Virgin, derive from this important book by Jacobus de Voragine.

● **Cimabue**
(c.1272–1302)
Whether Giotto studied with Cimabue (as historian Giorgio Vasari [1511–74] suggests) or not, he certainly was aware of Cimabue's work.

GIOTTO DI BONDONE (c.1266–1337)
Italian

	Born in Colle di Vespignano near Florence	Begins art studies, possibly in the studio of Cimabue	First trip to Rome	Designs the Navicella, a mosaic depicting Christ Walking on	the Waters for Old St. Peter's, Rome	Travels to Padua to paint the frescoes in the Capella Scrovegni, or Arena Chapel	Paints the Ognissanti Madonna	At work on the frescoes for the Bardi and Peruzzi Chapels in the church of Santa Croce, Florence
CHRONOLOGY	c.1266	1280	c.1285	c.1300		1305	c.1310	1320s

INSPIRED

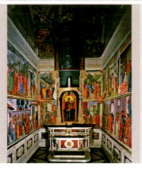

● **Masaccio**
(1401–28)
Masaccio's frescoes in the Brancacci Chapel, Florence (1425–27) (right) refined and expanded on the innovations in Italian painting begun by Giotto in the Arena Chapel.

● **Piero della Francesca**
(c.1416/17–92)
The science of painting pursued by Piero, and other 14th-century Italian artists arose from the foundation established by Giotto's art.

● **Leonardo da Vinci**
(1452–1519)
Leonardo not only appreciated the ambition of Giotto's formal language, but also his ability to probe human psychology and to create powerful psychological dramas.

● **Michelangelo**
(1475–1564)
Michelangelo's frescoes on the ceiling of the Sistine Chapel (1508–12) are the culmination of the great tradition of Italian fresco painting begun by Giotto.

Celebrated by both Dante (1265–1321) and Petrarch (Francesco Petrarca, 1304–74), Giotto emerges from the pages of Western art history as a formidable and radical voice of change. In his art are the seeds of a vision that found its fullest expression in the accomplishments of 15th-century figures such as Masaccio, Donatello (1386–1466), and Piero della Francesca. Giotto's achievement was to redirect painting away from the formulas, symbols, conventions, and repetitive patterns of Byzantine art to a world based on the direct engagement with and experience of nature. In so doing, Giotto delineated a series of formal challenges that artists would have to master in the following centuries.

Art based on nature requires the artist to confront the full scope of human materiality, activity, and emotion. It also requires an understanding of the natural and manmade arenas in which such physical forms exist and dramas unfold. Giotto's art is the first comprehensive attempt to deal with the complexity of this visual world. As no artist had before him, Giotto was able to focus his attention and skills to create a pictorial vocabulary that is among the most powerful, concentrated, and intense of any ever realized. To find parallels to the profundity of Giotto's art and his ability to shape dramatic narrative through formal devices, one must turn to creative giants such as Dante, William Shakespeare (1564–1616), Johann Sebastian Bach (1685–1750), and ultimately to Giotto's truest heir in the visual arts, Michelangelo.

Giotto's importance as a painter rests in large part on the frescoes of the Cappella Scrovegni, or Arena Chapel, in Padua, begun in 1305. The chapel is the first great step in the history of Renaissance painting that continued a little more than a century later in Masaccio's Brancacci Chapel in Florence, and culminated, almost a century after that in the ceiling frescoes



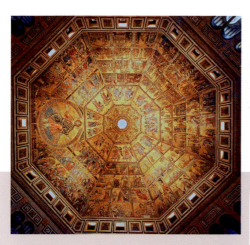

◆ Mosaics in the Florence Baptistry
These important works from the second half of the 13th century, attributed to Coppo di Marcovaldo (active 1260–79) contain a dramatic Last Judgment scene known to Dante and Giotto (above: *View of the Mosaic Ceiling, Baptistry, Florence, c.1325*).

● Pietro Cavallini
(active 1273–1308) The frescoes and mosaics of this important Roman artist were innovative in their treatment of light and three-dimensional form. Giotto would have seen Cavallini's work during his time in Rome.

■ Nature
The revolutionary quality of Giotto's art was primarily about an artist deriving his influence and inspiration from the direct observation of nature.

Madonna Enthroned with Angels and Prophets,
Cimabue, c.1280–90, Uffizi, Florence

Giotto was aware of the work of Cimabue, who may have been his teacher. Cimabue began the move from two-dimensional Byzantine forms toward paintings of greater naturalism and feeling.

In Naples in service to King Robert of Anjou	*Named capomaestro of Florence Duomo, or Cathedral. Designs the campanile*	*Dies January 8 in Florence*
1328–33	**1334**	**1337**

● Paul Cézanne
(1839–1906) The French artist's claim to be a "Primitive" relates to the importance of Giotto to his art. Like Giotto before him, Cézanne was again giving European art a new direction.

● Diego Rivera
(1886–1957) Mexican muralist Rivera was exposed to Renaissance art on a trip to Italy in 1920. He especially admired the frescoes of Giotto which inspired the scale and drama of his own murals.

● Pier Paolo Pasolini
(1922–75) In his film *The Decameron* (1971) the Italian director Pasolini assumes the character of Giotto, and recreates as a living tableau *The Last Judgment* from the Arena Chapel.

● Fernando Botero
(b.1932) Botero studied in Florence, where he made a close study of Giotto's art. The lectures and writings of Bernard Berenson (1865–1959) and Roberto Longhi (1890–1970) on Giotto also inspired Botero.

Ognissanti Madonna,
Giotto, c.1310, Uffizi, Florence

Giotto depicts a more believable world by modeling his figures with light and shadow (chiaroscuro) to create the illusion of three-dimensionality. He also employs the use of perspective and a more natural drapery style.

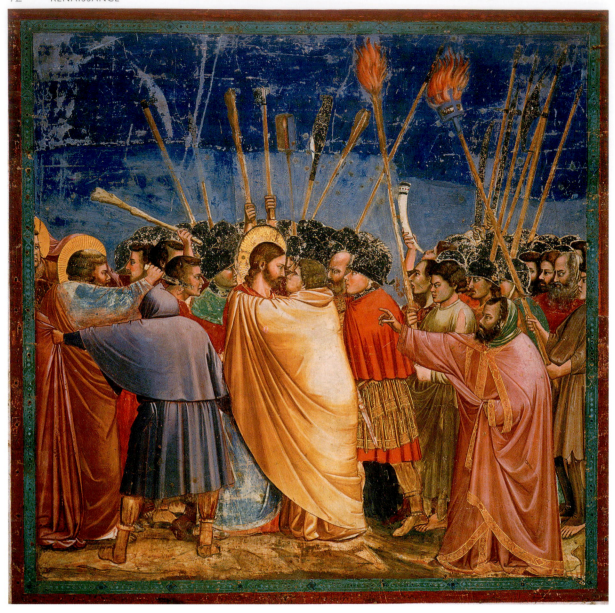

Betrayal of Christ,
Giotto, 1305–06, Arena Chapel, near Padua

Giotto was the first painter to create a narrative in a painting that depicted the unfolding drama of an event by tackling the representation of the visual world in all its complexity.

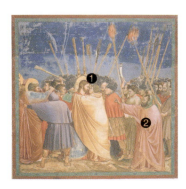

ABOUT THE WORK

In the Middle Ages, Italian art was dominated by Byzantine influences, which produced formulaic compositions and flat, stereotyped figures. With his marvelous cycle of frescoes in the Arena Chapel, Giotto began to free painting from these shackles. His solid figures and his repertoire of lifelike gestures and expressions heralded the arrival of the Renaissance. In this scene, Judas betrays Christ while, on the left, Peter cuts off the ear of the high priest's servant.

EXPRESSION

Giotto brought a new intensity to the portrayal of Biblical scenes by focusing on their human drama. Most artists depicted the actual kiss, but Giotto preferred to show the powerful, eyeball to eyeball confrontation of the two main figures (1).

MOVEMENT

In this episode, soldiers are rushing in from the right-hand side. Giotto conveys this movement by filling his foreground with three large figures, each with one arm raised, pointing to the left (2).

COMPOSITION

Giotto's figures are far more solid than those of his predecessors, but there is very little sense of depth in the composition. Instead, the picture is constructed like a frieze, with the figures in the foreground treated in precisely the same manner as those in the background.

of Michelangelo's Sistine Chapel in Rome. As with all great fresco cycles, the images in the Arena Chapel refer to each other. Giotto is careful to introduce figures, themes, or motifs in one place that can be followed through the course of the painted stories, often with a sense of tragic inevitability and pathos.

One fresco within the Arena Chapel is a summation of all that is revolutionary and remarkable about Giotto. In his portrayal of the Betrayal of Christ, things never before seen are present. Among the chaos and confusion surrounding the central group are the two protagonists of the scene, Christ and Judas, a calm focal point in the surrounding storm. Judas raises his yellow cloak of treachery up and over Christ's shoulder with his left arm. Their two heads confront each other as if emerging from a single body. By way of this motif, Giotto illustrates that there are two individuals whose separate histories have led them to this moment, and that they need each other to fulfill their respective destinies.

Christ's face is perfectly composed. Judas' face shows the corruption of the devil that has already entered his body as a result of his betrayal. Every formal device in the painting reinforces the drama and psychological intensity of the scene, including the nocturnal light, the halberds and torches that direct attention to the main scene, the poses and gestures of the figures, and the chiaroscuro and variety of the drapery folds.

In this fresco amid a chapel of notable frescoes, Giotto established a paradigm for Western painting. Creating three-dimensional forms of weight and mass, articulated by light and shadow and occupying real space, Giotto immerses his figures—and the viewer—into a dramatic narrative of moral weight and human relevance in addition to its spiritual significance. The humanity of Giotto's message, the grandeur of his vision, the conviction of his beliefs, and the confidence in his talents displayed in the Arena Chapel pointed the way to the future of Western painting.

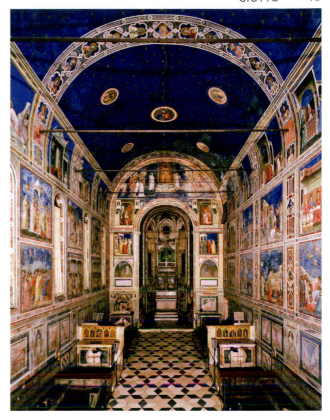

Interior view of the Arena Chapel,
Giotto, 1305–06, Arena Chapel, near Padua

Giotto's frescoes in the Arena Chapel pointed the way forward for Western painting through their sculptural portrayal of form, treatment of architecture, and use of poses and gestures to create psychological drama.

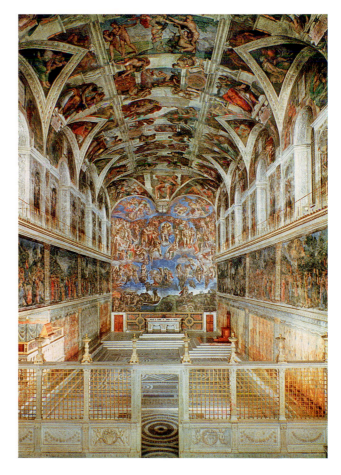

Interior view of the Sistine Chapel,
Michelangelo, 1534–41, Sistine Chapel, Rome

Michelangelo was Giotto's true heir. His paintings in the Sistine Chapel are the culmination of the tradition of large-scale frescoes begun by Giotto.

Masaccio's frescoes of the Brancacci Chapel in Florence created the bridge between the revolutionary paintings of his predecessor, Giotto di Bondone, and the later perfection of Michelangelo. Despite his death at a young age, Masaccio's remarkable achievement was to herald the dawn of the Italian Renaissance during his tragically brief career.

INFLUENCED BY	◆ Classical Art		● Giotto di Bondone	● Filippo Brunelleschi	● Nanni di Banco
KEY ● artist ◆ artistic movement ■ cultural influence ❖ religious influence	Masaccio is believed to have traveled to Rome in 1423. His art reflected the three-dimensional qualities and natural poses of Classical prototypes (right: *Statue of Doryphorus*).	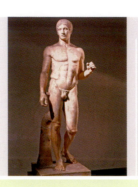	(c.1266–1337) The naturalism and grandeur of Masaccio's art was directly related to the earlier achievements of Giotto in the 14th century.	(1377–1446) Masaccio's sophisticated use of one-point linear perspective demonstrates his knowledge of Brunelleschi's accomplishments.	(c.1384–1421) The semicircular arrangement of Nanni's sculpted figures comprising the *Four Crowned Saints* (c.1413) is reflected in Masaccio's *The Tribute Money* (c.1426–27).

MASACCIO (1401–28)
Italian

	Born December 21 in Castel San Giovanni, San Giovanni Valdarno	Arrives in Florence	Enrolls in the Arte dei Medici e Speziali in Florence (the painters guild) in January	Likely visits Rome in observance of the Jubilee	At work in the Brancacci Chapel in the church of Santa Maria del Carmine in Florence	Signs contract in Pisa to create an altarpiece	Files tax declaration in Florence in July
CHRONOLOGY	**1401**	**c.1418**	**1422**	**1423**	**1425**	**1426**	**1427**

INSPIRED	● Piero della Francesca	● Michelangelo	● Raphael	● Carlo Carrà	● Mario Sironi
	(c.1416/17–92) The muscular forms, stature, and three-dimensionality of Piero's art continue the tradition of Masaccio.	(1475–1564) Not only was Michelangelo's formal language influenced by Masaccio, but also his understanding of human drama, pathos, and emotion.	(1483–1520) Raphael's ability to organize large figural compositions in a believable space harkens back to examples in Masaccio such as *The Tribute Money*.	(1881–1966) After 1914, Carrà looked to the art of Giotto, Masaccio, Paolo Uccello (c.1397–1475), and Piero for inspiration.	(1885–1961) Sironi's monumental, three-dimensional figurative style of the 1920s is directly indebted to Masaccio.

Masaccio is the direct heir to Giotto in the history of Italian painting. Separated by more than a hundred years, Masaccio was able to understand the implications of what his predecessor had achieved, particularly as a fresco painter, and to build on his legacy to advance the course of Italian art.

The frescoes Masaccio painted in the Brancacci Chapel of the church of Santa Maria del Carmine in Florence from 1425 to 1426 ushered in the Renaissance style of painting. The influence and inspiration of his paintings would resonate almost a century later when Michelangelo created his groundbreaking frescoes in Rome's Sistine Chapel.

Masaccio's creation of a new style in painting was paralleled by the advances in architecture and perspective studies of Filippo Brunelleschi, and the revolutionary sculptures of Donatello. The original ideas of this triumvirate of Florentine greats clearly informed and cross-fertilized each artist's work. It would be upon the foundation laid by Brunelleschi, Donatello, and Masaccio in the 15th century that the perfection of the 16th-century achievements of Donato Bramante (1444–1514), Michelangelo, and Raphael would rest.

Few reliable sources survive to give us a full picture of the life, training, and personal qualities of Masaccio. What is clear is that in a brief career spanning roughly seven years, he was able to bring to the art of painting the same level of sophistication and innovation that Brunelleschi and Donatello had brought to architecture and sculpture. The core of this achievement rests upon the frescoes of the Life of St. Peter, in the Brancacci Chapel, and on Masaccio's final testament to the religious, humanistic, and scientific nature of Renaissance painting: *Trinity*, c.1427 (Santa Maria Novella, Florence).

The scenes depicted on the walls of the modest-sized Brancacci Chapel include some of the most powerful and

Ognissanti Madonna,
Giotto, c.1310, Uffizi, Florence

Giotto started a revolution in Italian painting with his inclusion of lifelike figures and group scenes to create a naturalistic effect, often with a sense of pathos and drama.

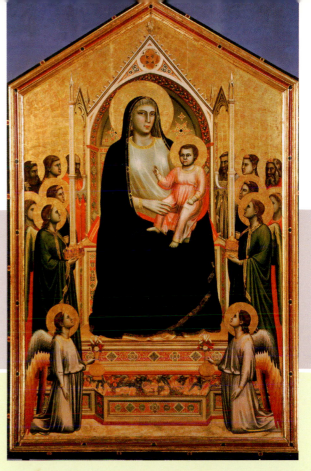

● Donatello
(c.1386–1466)
An awareness of the revolutionary nature of Donatello sculptures such as *St. Mark* (1411–13) and *St. George* (c.1415–17), (right), is evident in Masaccio's art.

Paints the Trinity in the church of Santa Maria Novella in Florence	Dies unexpectedly in Rome
c.1427/28	1428

● Renato Guttuso
(1912–87)
Guttuso believed that Italian painters should embrace the Renaissance achievement of artists such as Giotto, Masaccio, and Michelangelo (right: *Crucifixion*, 1941).

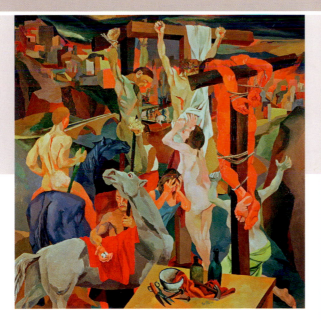

Madonna and Child Enthroned (from the Pisa polyptych),
Masaccio, c.1426, National Gallery, London

Masaccio understood the advances in Italian art made by Giotto. He built on that legacy and utilized his knowledge of 15th-century perspective studies to create a more believable sense of space and monumental form.

ABOUT THE WORK

Masaccio's cycle of frescoes at the Brancacci Chapel in Florence marks a key stage in the early development of the Renaissance. Artists working in the International Gothic style had conveyed religious scenes in a decorative or symbolic manner, with no real attempt to depict solid, three-dimensional figures in a naturalistic background. Masaccio's innovations emphasized the full tragedy of the theme and paved the way for the achievements of the great Renaissance masters.

FIGURES

The nakedness of the figures (1) shocked contemporaries. Most artists followed the Biblical account, which stated that the Lord made "coats of skins and clothed them." Masaccio's approach reflects a growing interest in portraying the human form.

PERSPECTIVE

In his frescoes, Masaccio pioneered the new technique of perspective. The modeling of the figures, the shadows that they cast (2), and the foreshortening of the angel all combine to make this scene more realistic than earlier versions of the theme.

MOOD

Masaccio's taste for Realism extends to the reactions of Adam and Eve (3). Unlike most earlier artists, he brings to life their terrible sense of grief and shame at the sin they have committed.

Expulsion of Adam and Eve,
Masaccio, c.1425, Brancacci Chapel, Santa Maria del Carmine, Florence

The scenes Masaccio depicted on the walls of the Brancacci Chapel (below) are among the most dramatic and powerful in the history of Western painting.

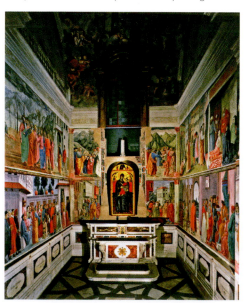

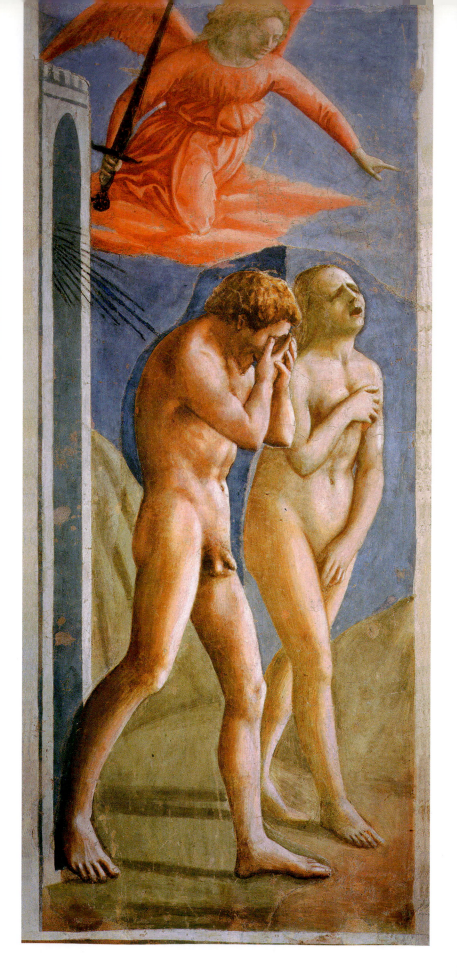

dramatic images in Western art, among them *The Tribute Money*, *Expulsion of Adam and Eve*, *St. Peter Baptizing the Neophytes*, and *St. Peter Healing with His Shadow*. Like Giotto before him, Masaccio was able to create a world that synthesized form, content, and meaning into a comprehensive statement of humanistic principles and religious faith. Perhaps the most striking difference between Masaccio and his predecessor is his depiction of the space where events take place. In Masaccio's work, location is no longer a generic and symbolic space but the recognizable landscape in and around Florence, and the Arno Valley.

The world he depicts is delineated by the clarity and precision of Brunelleschi's architecture and perspective, and is peopled with human figures that move with the ease and fluidity of Classical sculptures, similar to those of Donatello.

Masaccio's crowning statement as a painter is the remarkable fresco of the Trinity in Santa Maria Novella. Its synthesis of Renaissance art, devotion, and science aims to express the mystery of faith and God's perfection through the harmonious forms of Classical architecture, perspective, and the dignity of the human body. Under the painted altar, a skeleton serves as a *memento mori* for the viewer with its inscription: "I was once as you are and what I am you also shall be." Upon hearing the news of Masaccio's sudden death, Brunelleschi is supposed to have said, "We have suffered a great loss."

The Holy Trinity,
Masaccio, 1427–28, Santa Maria Novella, Florence

Masaccio's depiction of *The Holy Trinity* is set within one of the most sophisticated illusionistic spaces in Western painting, created by the use of one-point linear perspective and inspired by the experiments in perspective by Filippo Brunelleschi.

The Fall and Expulsion,
Michelangelo, 1510, Sistine Chapel, Rome

Michelangelo was profoundly influenced by Masaccio, and looked to him for inspiration for his religious scenes, both in terms of formal language and depicting pathos, drama, and emotion.

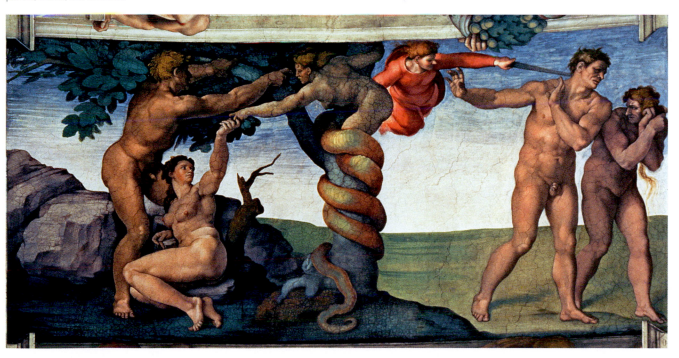

The art of Piero della Francesca embodies most of the scientific traits of Italian Renaissance painting considered "new" in the 15th century, including: modeling in light and shadow to create three-dimensional forms (chiaroscuro); a sophisticated understanding of mathematics and linear perspective; and an appreciation for the monumentality of Classical art—all translated into a meditative, timeless, and deeply moving personal style.

INFLUENCED BY

KEY
- ● artist
- ◆ artistic movement
- ■ cultural influence
- ❖ religious influence

■ *The Golden Legend*
(c.1260)
This book on the lives of saints by Jacobus de Voragine was Piero's source for his great fresco cycle in Arezzo on the *Legend of the True Cross* (c.1452).

● **Filippo Brunelleschi**
(1377–1446)
Florence's greatest architect, pioneer in the study of perspective, and founder of the new Renaissance style along with Masaccio and Donatello (right: Dome of Santa Maria del Fiore, Florence).

● **Donatello**
(c.1386–1466)
The revolutionary nature of Donatello's art made him the most influential Italian artist of the 15th century.

● **Paolo Uccello**
(c.1397–1475)
The rigor and method of Uccello's investigations into perpective influenced Piero's work in this realm.

PIERO DELLA FRANCESCA (c.1416/17–92)
Italian

	Born in the Tuscan town of Sansepolcro	First mention as a painter	Assists Domenico Veneziano in Florence	Misericordia Altarpiece in Sansepolcro first documented work	Baptism of Christ	Frescoes on the Legend of the True Cross in the choir of St. Francesco in Arezzo	Flagellation of Christ	Resurrection
CHRONOLOGY	**c.1416/17**	**1432**	**1439**	**1445**	**c.1450**	**c.1452**	**1450s**	**1460s**

INSPIRED

● **Luca Signorelli**
(1445/50–1523)
Signorelli's strongly modeled forms and understanding of light were lessons learned from Piero, with whom he studied.

● **Luca Pacioli**
(1445–1514/17)
Pacioli's writings on mathematics, proportion, and perspective were indebted to Piero's treatises on the same topics.

● **Leonardo da Vinci**
(1452–1519)
Through his study and collaboration with Luca Pacioli, Leonardo became aware of Piero's theoretical works.

● **Georges Seurat**
(1859–91)
Seurat admired the mathematics and science of Piero's art. Both painters organized their compositions according to precise mathematical relationships (right: *Circus Parade*, 1887–8).

The rise in reputation and fame of Piero della Francesca, like that of Sandro Botticelli (1446–1510) and Jan Vermeer (1632–75), results from his rediscovery by artists, historians, critics, and collectors in the 19th century. The writings of Roger Fry and Roberto Longhi in the early 20th century, coupled with a growing interest in the formalist works of Post-Impressionist painters such as Paul Cézanne (1839–1906) and Seurat, accelerated this new appreciation of Piero's remarkable talents and the originality of his work. Since then, Piero's importance in Western art history has been assured and he has become one of the best known and best loved artists of the Italian Renaissance.

In his frescoes and panel paintings—including *The Baptism of Christ* (c.1450, National Gallery, London); *Resurrection* (1460s, Pinacoteca, Sansepolcro); *Flagellation of Christ* (1460s, Galleria Nazionale delle Marche, Urbino); and his great fresco cycle from Arezzo on *the Legend of the True Cross* (c.1452)— Piero used color, light, perspective, and mathematical precision to achieve a clarity, stillness, and monumental quality that continues to affect a contemporary audience. His paintings are a mystical amalgam of the scientific and the spiritual. In this regard they are powerful examples of the seminal influences and inspirations at the heart of all Italian Renaissance art. Piero's ability to synthesize the intellectual and emotional aspects of painting into a style both personal and timeless has been remarked upon by such varied historians, writers, and critics as Fry, Longhi, Bernard Berenson, Kenneth Clark, John Pope-Hennessy, Carlo Ginzburg, Aldous Huxley, and Yves Bonnefoy. His paintings have inspired numerous works of art, poetry, music, and film, including Bohuslav Martinu's *Frescoes of Piero della Francesca, for orchestra, H. 352.*

Annunciation (from the St. Lucy Altarpiece),

Domenico Veneziano, c.1445, Fitzwilliam Museum, Cambridge

Piero learned much from his teacher, Domenico, about the latest advances in art, including the use of perspective to create the illusion of deep space.

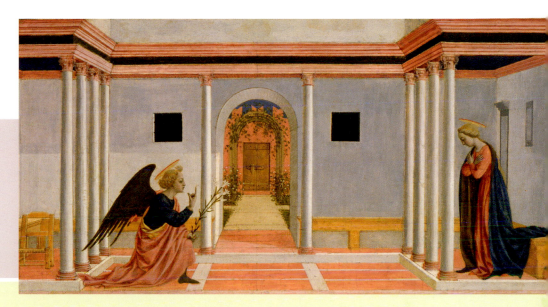

● **Masaccio**
(1401–28)
Masaccio's famous frescoes in the Brancacci Chapel in Florence were a textbook for later central Italian artists such as Piero.

● **Domenico Veneziano**
(c.1410–61)
Piero's early teacher in Florence, from whom he learned of the latest advances in Florentine art at the time.

Writes treatises on perspective and geometry	*Portraits of the Duke and Duchess of Urbino*	*Dies October 12 in Sansepolcro*
c.1474	**c.1475**	**1492**

● **Roger Fry**
(1866–1934)
Fry's appreciation for the formal qualities of Piero's paintings informed his insights into the art of Post-Impressionism.

● **Roberto Longhi**
(1890–1970)
Longhi's study, *Piero della Francesca* (1927), was a significant milestone in the rediscovery of Piero's work in the 20th century.

● **Andrei Tarkovsky**
(1932–86)
Piero's fresco *Madonna del Parto* (c.1460) plays a central role in Tarkovsky's film *Nostalghia* (1983).

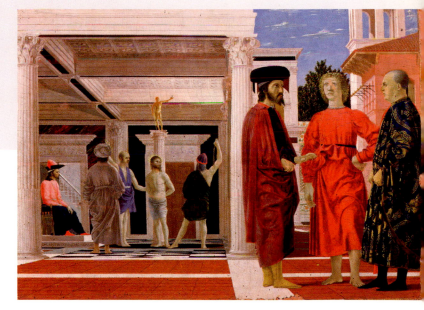

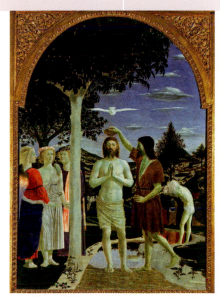

The Baptism of Christ,
Piero della Francesca, c.1450, National Gallery, London

The clarity and precision of Piero's composition creates a feeling of stillness and calm in this work.

Flagellation of Christ,
Piero della Francesca, c. late 1460s, Galleria Nazionale delle Marche, Urbino

Piero's mastery of one-point linear perspective is evident in this painting. He uses it to focus attention on the figure of Christ in the background and to create emotional tension.

Jan van Eyck was the most famous painter of his age, and a founder of the Netherlandish School. He most likely trained as a manuscript illuminator, but soon adopted oils for his meticulously detailed works on panel. His paintings combine a keen observation of nature with complex symbolism.

 INFLUENCED BY

KEY
● artist
◆ artistic movement
■ cultural influence
❖ religious influence

❖ **Manuscript Illumination**
Paintings on vellum or parchment to decorate books. "Illuminations" range from initials and simple outline drawings to elaborate full-page images with gold leaf.

◆ **Gothic Art**
Aspects of Van Eyck's formal and thematic language owed much to the continuing relevance and influence of late Gothic art in Northern Europe.

● **Robert Campin**
(Master of Flémalle) (c.1375–1444)
An influential Burgundian painter who stands alongside Van Eyck as one of the founders of the Netherlandish School.

● **Limbourg Brothers**
(Pol, Herman, and Jean) (active early 1400s)
Family of painters whose masterpiece is the *Très Riches Heures* (right, before 1416). The naturalism, detail, and colors in this book presage the work of Van Eyck.

JAN VAN EYCK (C.1385/90–1441)
Netherlandish

	Probably born in Maaseik, a town north of Maastricht in the Netherlands	Active in The Hague where he is employed as a court painter and *valet de chambre*	(personal attendant) to John of Bavaria, Count of Holland	Appointed court painter to Philip the Good, Duke of Burgundy, and served as Philip's	*valet de chambre* in Lille	Death of his brother, the artist Hubert van Eyck	Entrusted with various diplomatic missions for the Duke of Burgundy, and travels to	Spain, Portugal, and the Holy Land
CHRONOLOGY	**c.1385/90**	**1422–25**		**1425**		**1426**	**1427–29**	

 INSPIRED

● **Rogier van der Weyden**
(c.1399–1464)
An influential Netherlandish painter whose emotionally charged pictures share many similarities to works by Van Eyck.

● **Petrus Christus**
(c.1410–75/76)
The painter who most successfully imitated the style of Van Eyck. He completed unfinished works by Van Eyck after his death.

● **Antonello da Messina**
(c.1430–79)
A Sicilian artist whose Netherlandish manner and gifts as an oil painter prompted historian Giorgio Vasari (1511–74) to incorrectly identify him as a pupil of Van Eyck (right: *Portrait of a Young Man*, c.1475).

● **Johannes Vermeer**
(1632–75)
Vermeer's use of light, exquisite attention to detail, and stillness harken back to Van Eyck.

Faithful to his motto: "*Als ich kan*," meaning "As best I can," the reputation of Jan van Eyck remains as high today as during his lifetime. A founding father of the Netherlandish School of painting, Van Eyck developed a minute, painstaking style that has seen few equals. Although no longer considered the inventor of oil painting, his brilliant use of the medium enabled him to portray the natural world in infinite detail. Capturing the translucent quality of light and the brilliance of color, both his portraits and religious paintings—largely devoted to the Virgin Mary and Christ child—were seen as expressing God's magnificence and wisdom in paint. His selective naturalism replaced the stylized forms associated with late Gothic art, and paralleled ideas emerging from the Italian Renaissance. Van Eyck also possessed a keen intellect, as shown by complex symbolism woven into his images.

Like many of his colleagues, few details of Van Eyck's life are known. Documented events center largely on his activities as a court painter and *valet de chambre* to John of Bavaria, Count of Holland, and later Philip the Good, Duke of Burgundy. These appointments found him living in The Hague, Lille, and during the height of his career, Bruges. As an advisor to Philip the Good he also undertook diplomatic missions that enabled him to travel to Spain, Portugal, and the Holy Land (likely via Italy) during the late 1420s. A portrait of his wife Margaret reveals he had married, and after Van Eyck's death his widow and surviving brother, Lambert van Eyck (active 1431–42), helped dissolve the workshop.

Although a number of artists must have assisted him in his studio, none are known by name. Because of his meticulous technique, only Petrus Christus has been identified as a legitimate follower of Van Eyck. By contrast, the majority of

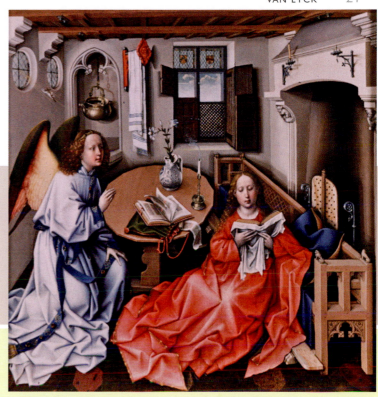

The Merode Altarpiece (central panel),
Robert Campin, c.1425, The Cloisters,
Metropolitan Museum of Art, New York

This scene of the Annunciation is set in a
contemporary Burgundian interior. The artist
combines intuitive observation of the physical
world with complex Christian symbolism
comparable to examples by Jan van Eyck.

● **Hubert van Eyck**
(d.1426)
Van Eyck's older brother,
who left the Ghent
Altarpiece (1432)
unfinished at the time
of his death. It was
completed by Jan and
dedicated in 1432.

◆ **Oil Paint**
A painting technique
in which pigments are
mixed with oil (often
linseed oil). Its advantages
over tempera paint
include brighter color
and illusionistic effects
of great richness and
luminosity.

Settles permanently in Bruges and establishes a workshop	*Dedication of the Adoration of the Lamb (the Ghent Altarpiece) in Sint Baafskathedraal, Ghent*		*Paints the portrait of Giovanni Arnolfini and his Wife*	*Paints portrait of his wife Margaret van Eyck whom he married c.1432/33*	*Dies late June in Bruges*
1431	**1432**		**1434**	**1439**	**1441**

● **Grant Wood**
(1892–1942)
Paintings by Wood,
such as *American
Gothic* (1930), are
directly indebted to the
techniques and historical
associations of paintings
by Van Eyck.

● **John Currin**
(b.1962)
Currin's meticulous
paintings echo Van Eyck's
technical craftsmanship,
and the themes and
subject matter of
Northern Renaissance
art in general.

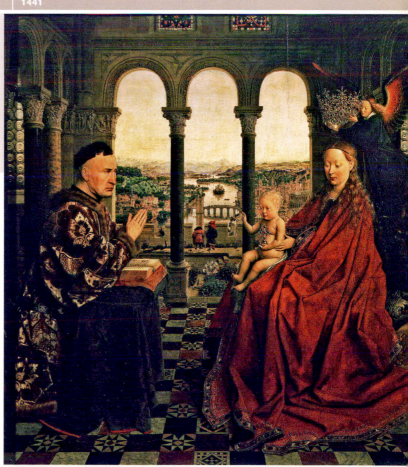

**Madonna with
Chancellor
Nicolas Rolin,**
*Jan van Eyck, c.1435,
Louvre, Paris*

The artist places the
work's donor opposite
the Madonna and Child
in an enclosed, sacred
space. The meticulous
detail in the distant
landscape reveals Van
Eyck's training as
a miniaturist.

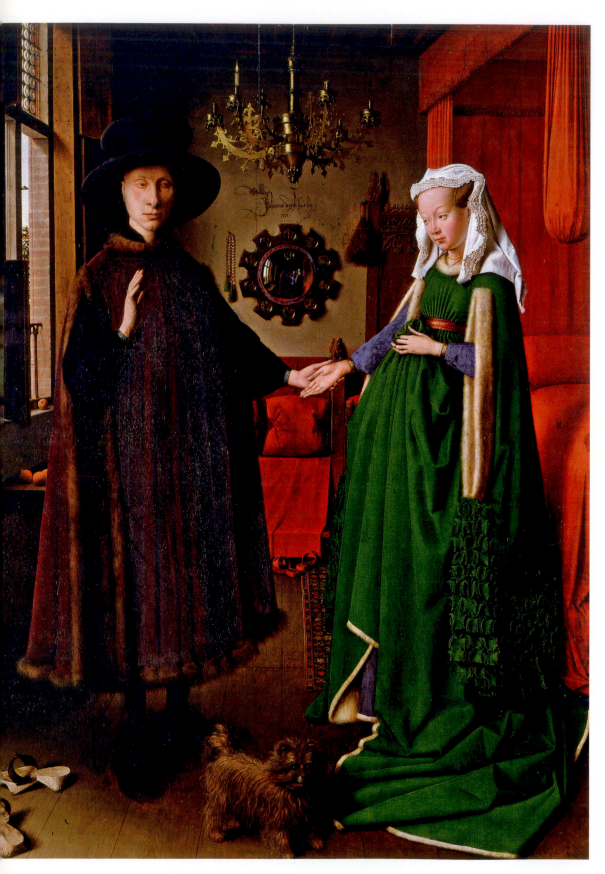

ABOUT THE WORK

This painting is one of the most important and imaginative examples of Netherlandish portraiture. Exploiting the potential of oil paint through his training as a miniaturist, Van Eyck turns his acute powers of observation from religious narrative to a secular theme in this portrait of an Italian merchant and his bride.

SPACE

Lacking a scientific knowledge of linear perspective, Van Eyck comes close to achieving the same effect through his intuitive observation of the room. Characteristic of this approach, however, the space narrows too quickly as it moves toward the background.

TECHNIQUE

Van Eyck was one of the first artists to exploit the potential of oil paint to achieve rich color, luminous effects, and exacting details. His mastery of the medium is seen in the fur trim of Arnolfini's robe and in the details of the chandelier and mirror in the background.

MEANING

Like many of Van Eyck's paintings, a complex program of disguised symbolism is present in this scene, here related to the sacrament of marriage. Noteworthy are the symbols for fidelity represented by the dog (1), and the fact that the couple have removed their shoes (2) to stand on holy ground sanctified by God. The forms of the artist and another figure are reflected in the convex mirror on the rear wall (3).

Giovanni Arnolfini and his Wife,
Jan van Eyck, 1434, National Gallery, London

Van Eyck's masterpiece *Giovanni Arnolfini and his Wife* demonstrates the artist's unparalleled mastery of rendering detail, texture, and light with oil paints for the time.

Netherlandish painters active during the next generation found inspiration in the more emotional manner displayed in the pictures of Rogier van der Weyden.

Van Eyck has long been synonymous with the use of oil paints. Although Italian biographer Giorgio Vasari mistakenly identified Van Eyck as the inventor of oils, he certainly was one of the first painters to exploit the potential of the medium, and was its most skilled practitioner. During the 15th century, oils gradually replaced egg tempera as the most important technique for painting on panel, and later on canvas. In oil painting, the artist uses powdered pigments in an oil medium such as linseed or walnut oil. This technique has many advantages, including how the paint is applied to prepared supports. Paint can be applied in thin layers like sheets of colored glass known as "glazing," as seen in Van Eyck's work, or applied more thickly as seen in the impastos of Rembrandt van Rijn (1606–69) two centuries later. Oils also provide a richness of colors, dry slowly (allowing for remixing and corrections), and allow the artist to paint translucent light.

Van Eyck's mastery of the oil technique and the iconography found in his paintings were without peer in his lifetime. He applied the same devotion to this technique in all of his masterpieces. In looking at his large *Van der Paele Madonna*, 1436 (Musée Communal des Beaux-Arts, Bruges), his portrait of *Giovanni Arnolfini and his Wife*, 1434 (National Gallery, London) or his small, jewellike *Virgin and Child with Saints*, 1437, (Alte Meister Gallerie, Dresden), viewers are witness to a flawless technique, one likely achieved using brushes consisting of merely a few ermine hairs.

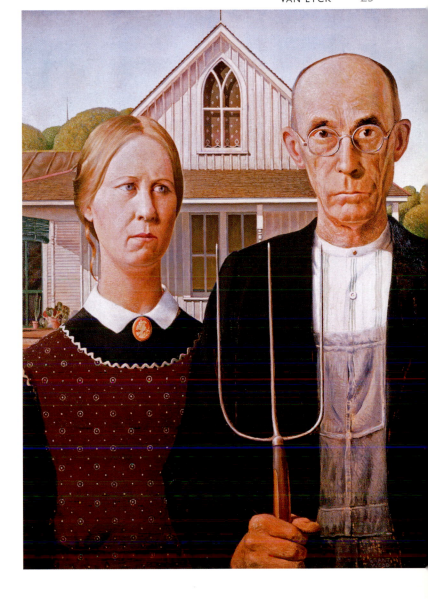

American Gothic,
Grant Wood, 1930, Art Institute of Chicago, Chicago

Influenced by Northern Renaissance painting and Van Eyck, Grant Wood created this icon of American art. The sober expression of the farmer and his wife standing in front of their simple house with its Gothic-style window has encouraged endless interpretations.

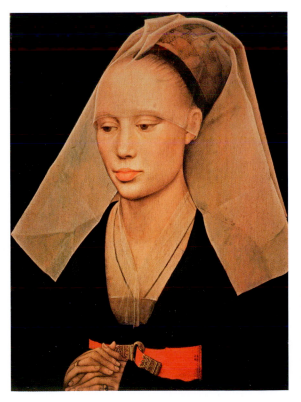

Portrait of a Lady,
Rogier van der Weyden, 1455, National Gallery of Art, Washington, D.C.

In this late portrait, Van der Weyden achieves a balance of form and pattern that creates an almost abstract elegance. His painstaking technique exemplifies the Netherlandish tradition best seen in images by Van Eyck.

Sandro Botticelli is one of the most popular and well-known artists today. During his life Botticelli's art epitomized a poetic sensibility in Italian painting that influenced his most important student, Filippino Lippi. Neglected after his death, Botticelli's formal language of expressive line, sensual beauty, and deep emotion was rediscovered in the 19th century, and continues to inspire contemporary art, design, and popular culture.

INFLUENCED BY

KEY
● artist
◆ artistic movement
■ cultural influence
❖ religious influence

◆ **International Gothic Style**
(c.1375–1425)
European style of painting and sculpture that stressed linear pattern, naturalistic detail, and courtly elegance.

● **Fra Filippo Lippi**
(c.1406–1469)
Florentine painter influential in the development of the poetic aspects of Botticelli's style.

◆ **Neo-Platonism**
The reformulation of Platonic thinking during the Renaissance attempted to reconcile Christian and Classical concepts of religion.

● **Marsilio Ficino**
(1433–99)
Most important Neo-Platonic philosopher in Florence at the court of Cosimo de'Medici.

● **Andrea del Verrocchio**
(1435–88)
Florentine painter and sculptor influential in the development of the monumental aspects of Botticelli's style (right: *Baptism of Christ* 1469–80).

SANDRO BOTTICELLI (1446–1510)
Italian

	Born in Florence	Enters the workshop of Fra Filippo Lippi	Sets up his own workshop. Patronage of the Medici begins	Pazzi Conspiracy attempts to expel the Medici from Florence	Called to Rome to paint in the Sistine Chapel	Paints the Primavera (Springtime)	Falls under the influence of Savonarola	Death of Lorenzo de' Medici, "Il Magnifico"
CHRONOLOGY	1446	1460s	1470	1478	1481	1482	1490s	1492

INSPIRED

● **Jean-Auguste-Dominque Ingres**
(1780–1867)
The artist's calligraphic line and expressive contours owe much to Botticelli's art.

● **Dante Gabriel Rossetti**
(1828–82)
Rossetti and his Pre-Raphaelite colleagues respond to the form and content of Botticelli paintings.

● **Edward Burne-Jones**
(1833–98)
Botticelli's inspiration is seen in Burne-Jones's preference for mythological subjects, undulating line, and elongated forms.

● **Edith Wharton**
(1862–1937)
Wharton's poem, *Botticelli's Madonna in the Louvre* (1891), reveals her interest in the artist.

● **Ottorino Respighi**
(1879–1936)
The Italian composer's *Botticelli Triptych* (1927) is a musical interpretation of three Botticelli paintings including the *Primavera* (1482) and the *Birth of Venus* (1485).

Sandro Botticelli is arguably the most popular Italian painter of the 15th century and one of the most familiar names to students of art history. This popularity, however, is of recent vintage. For centuries Botticelli was a neglected, if not forgotten, artist. His reputation was slowly resurrected in the second half of the 19th century, first in England, where his art was celebrated by such influential critics as Walter Pater and John Ruskin, and emulated by artists of the Pre-Raphaelite movement. Botticelli's influence carried into the Art Nouveau period, and today it is almost impossible to pick up a fashion magazine and not see an advertisement that does not owe something to the elegance, linear rhythms, hair styles, and concept of feminine beauty articulated in Botticelli's art.

Botticelli was born in Florence in 1446 where his father was a tanner. By the early 1460s he was placed in the workshop of the Florentine artist Fra Filippo Lippi to study painting. The effect of Fra Filippo's teaching is evident in Botticelli's early paintings of the Madonna and Child, because they share the same preoccupation with depicting the combination of the sensual and the spiritual. In technique both painters emphasize drawing to create elegant, almost calligraphic patterns amid a fine color palette.

By 1470 Botticelli had opened his own workshop in Florence. The same decade saw him begin his close relationship with the Medici family. It was for the Medici that Botticelli produced two of his most famous paintings: *Primavera*, 1482 (Uffizi Gallery, Florence), and the *Birth of Venus*, 1485 (Uffizi Gallery, Florence). In these two allegorical paintings, Botticelli refers to the rediscovery of Classical literary sources esteemed by Florentine humanists and Neo-Platonic philosophers of the time. Both paintings illustrate the link between the pagan and the Christian, because Venus was often associated with

Madonna and Child with Two Angels,
Fra Filippo Lippi, c.1455, Uffizi, Florence

Fra Filippo's combination of the spiritual and the sensual deeply affected the style of the young Botticelli.

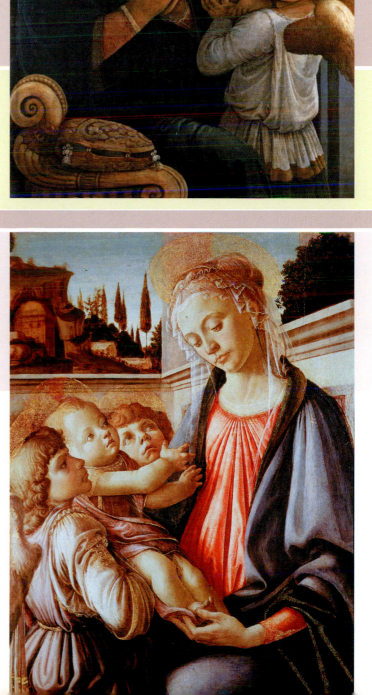

❖ Bonfire of the Vanities
(February 7, 1497)
The Dominican monk Girolamo Savonarola encouraged the citizens of Florence to burn items, such as books and works of art with pagan themes (right: *Execution of Girolamo Savonarola*).

"Bonfire of the Vanities" held in Florence	*Paints The Mystic Nativity*	*Dies May 17 in Florence*
1497	**1500**	**1510**

● Andrei Tarkovsky
(1932–86)
In the director's 1983 film *Nostalghia* (right), a Russian poet in Italy is assisted by a woman, modeled on Botticelli's depictions of Venus, who serves as his translator and guide.

Madonna and Child with Angels,
Sandro Botticelli, c.1470, Museo di Capodimonte, Naples

The effect of Fra Filippo's teaching is evidenced in Botticelli's early paintings of the Madonna and Child by his choice of a fine color palette and use of elegant patterns to create a sense of both the human and divine.

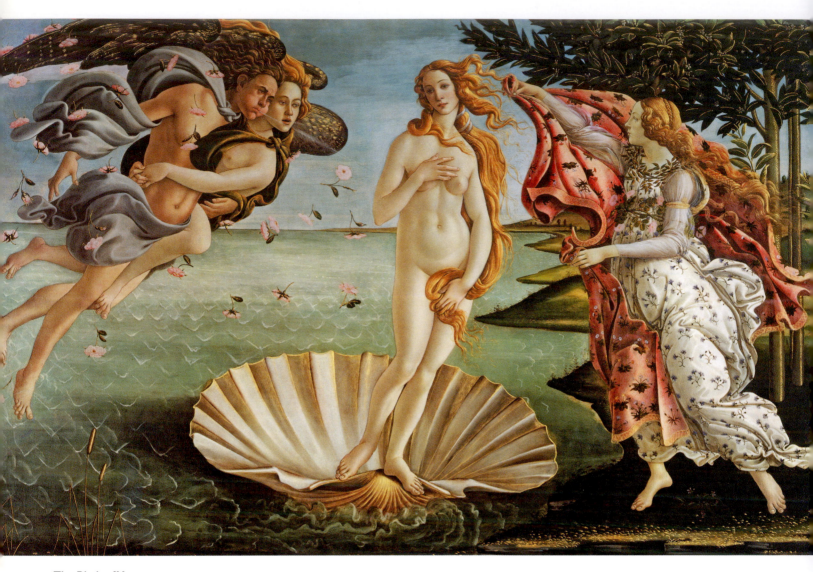

The Birth of Venus,
Sandro Botticelli, 1485, Uffizi, Florence

Botticelli's *Birth of Venus* is one of the most
well-known images in the world.

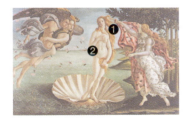

ABOUT THE WORK

In ancient myth, Venus was born
fully-grown out of the foaming sea
and was wafted ashore on a giant
scallop shell. Botticelli's picture is not a
straightforward depiction of this tale,
but an allegorical reworking of the
theme, inspired by the Renaissance
philosopher Politian. Here the goddess
represents humanitas, a complex blend
of sensual and spiritual values. These
are symbolized by the embracing
couple and, on the right, the chaste
embodiment of Spring.

LINE

By this period, Florentine artists had
developed a traditional preference
for line over color. In Botticelli's case,
this linear approach carried echoes
of the International Gothic style. His
figures are slightly elongated and are
sometimes distorted for decorative
effect. The curving lines of Venus's neck
and shoulders (1), for example, are
elegant but unnatural. This graceful
approach was greatly admired by the
Pre-Raphaelites.

POSE

Although Botticelli's theme came from
a contemporary source, his Venus
was derived from antique statuary.
Her gestures were borrowed from
the Venus pudica (Modest Venus), a
popular, classical pose (2).

LIGHT

It has been suggested that the picture
was designed to be hung near a
window, so that the daylight fell on it
from the right, aligning with the light
source in the painting.

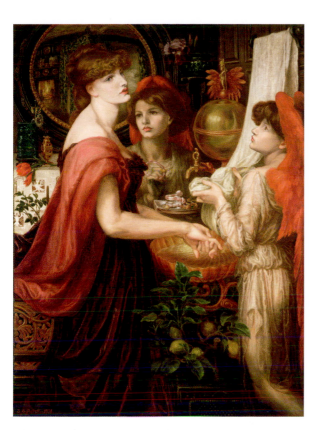

La Bella Mano,
*Dante Gabriel Rossetti,
1875, Delaware Art
Museum, Wilmington*

Rossetti and the Pre-
Raphaelites looked back to
early Renaissance masters
like Botticelli in their desire
to create an art of purity
and simplicity.

the Virgin Mary in Neo-Platonic thought. Botticelli's vision
is a synthesis between the Classical, sensual and humanist
elements of the Renaissance, and its Christian, spiritual, and
religious traditions.

The Classical and humanist basis for Botticelli's art changed
in the 1490s when the artist came under the influence of the
Dominican monk Savonarola, whose fiery sermons against the
spiritual corruption of Florence led to a wave of penitential
fervor that affected many citizens and artists. In his last, great
paintings Botticelli turned away from the pagan themes and
Classically inspired language seen in his earlier work to explore
religious subjects such as the Pietá and the Lamentation.

Bottticelli lived until 1510. By 1500, however, a new
generation of Italian artists had emerged including Leonardo da
Vinci (1452–1519), Michelangelo (1475–1564), and the young
Raphael (1483–1520). Their arrival eclipsed the achievements
of their predecessor, and consequently Botticelli's achievement
fell into obscurity for centuries.

Yet few painters demonstrated a more exciting
understanding of the power and poetry of line to organize
and activate a composition than Botticelli. Later generations
of artists rediscovered and celebrated the poetic invention,
linear brilliance, and elegant complexity of paintings such
as the *Primavera* and *Birth of Venus*. Artists including Ingres,
Rossetti, Burne-Jones, Edgar Degas (1834–1917), and Henri
Matisse (1869–1954) would later be inspired by Botticelli's use
of line. The lyricism of Botticelli's art has also inspired modern
composers, poets, novelists, and filmmakers, including Ottorino
Respighi, Edith Wharton, Vladimir Nabokov (1899–1977), and
Andrei Tarkovsky. Visual quotes based on the *Primavera* and
Birth of Venus are now part of Western popular culture.

**The Depths
of the Sea,**
*Edward Burne-Jones, 1886,
Private collection*

Botticelli's inspiration
is seen in Burne-
Jones's preference for
mythological subjects,
undulating line, and
elongated forms.

Hieronymus Bosch is one of the most enigmatic and fascinating artists to emerge from late 15th-century painting in northern Europe. Little is known of his life, and the chronology, symbolism, and meanings of his paintings are still debated. A painter with a unique sensibility active in a time of rapid artistic change, Bosch's strange visions and nightmarish scenes have become visual icons of the modern age.

INFLUENCED BY

KEY
- ● artist
- ◆ artistic movement
- ■ cultural influence
- ❖ religious influence

◆ Gothic Art
The formal and thematic content of Bosch's paintings emerged from a late Gothic tradition in northern Europe at the end of the 15th century (right: *The Crucifixion*, from church altarpiece).

● Jan van Ruysbroeck (1293–1381)
The writings and devotional literature of this Netherlandish mystic influenced a generation of religious thinkers in northern Europe.

❖ Devotio Moderna *(Modern Devotion)*
A late 14th-century movement that began in Holland and sought a renewal of the spiritual life. Its principal proponent was Gerhard Groote (1340–84), founder of the Brethren of the Common Life.

HIERONYMUS BOSCH (c.1450–1516)
Netherlandish

	Born in 's-Hertogenbosch (Bois-le-Duc) in northern Brabant	Early Period: The Cure of Folly	Bosch marries Aleyt van der Meervenne	Middle Period: Garden of Earthly Delights; The Haywain	Listed as member of the religious confraternity of the Brotherhood of Our Lady	Receives commission for altarpiece of the Last Judgment from Philip the Fair, Duke of Burgundy (now lost)	Late Period: The Road to Calvary
CHRONOLOGY	**c.1450**	**1475–85**	**c.1480**	**1486–1505**	**1486/87**	**1504**	**1506–16**

INSPIRED

● Pieter Bruegel the Elder (c.1525/30–69)
Bruegel was Bosch's immediate heir and successor in the Netherlands.

● Francisco Goya (1746–1828)
Bosch's triptych, the *Garden of Earthly Delights*, entered the Escorial in Spain in 1593 and was certainly known to Goya.

● James Ensor (1860–1949)
Ensor's many paintings on the theme of the Passion of Christ are linked both formally and thematically to the work of Bosch.

◆ Surrealism
Members of this 20th-century art movement claimed Bosch's work as an historical precedent and inspiration for their own.

■ Modern Film
Filmmakers including Pier Paolo Pasolini, David Cronenberg, David Lynch, Peter Greenaway, and Lech Majewski have all been inspired by the images and themes of Bosch's oeuvre.

The art of Hieronymus Bosch is a blend of religious piety, secular humanism, and personal imagination. Bosch's paintings reflect a variety of attitudes, fears, and beliefs in late medieval northern Europe, even if their exact symbolism then and now remains open to multiple interpretations. Debate over the precise meaning of Bosch's art has not prevented later generations of artists from claiming kinship with the visionary and fantastic aspects of his work. The modern appropriation of Bosch's art and spirit, reflected today in the very word "Boschian," is due in no small degree to the complexity and richness of Bosch's images, themes, symbols, and allegories on human nature, the exact meanings of which continue to fuel scholarly and popular debate.

In religious and secular masterpieces, including *The Ship of Fools*, c.1495 (Louvre, Paris); *The Haywain*, c.1500–05 (Prado, Madrid); and the *Garden of Earthly Delights*, c.1505–10 (Prado, Madrid) Bosch explored questions of great concern for late medieval patrons and viewers: life, death, temptation, sin, judgment, and salvation.

Few painters in Western art history can match Bosch's ability to fuse such disparate elements as medieval symbolism and Renaissance humanism, religious devotion and worldly pleasure, Biblical sources and popular literature, alchemy and natural science, imagination and observation into both personal and universal views of the world. As such, his true artistic heirs would be the visionary artists to follow, from Matthias Grünewald (1475–1528) and Bruegel, to William Blake (1757–1827), Henry Fuseli (1741–1825), Goya, and the Surrealists.

Hell (from the Hortus Deliciarum) (Garden of Delights),

Herrad of Hohenbourg, 1176–96, destroyed 1870

The afterlife was a recurrent theme in medieval art. Frequently paintings were a method of warning people of the dire consequences of leading a sinful life.

■ **Vernacular Literature**
The birth of the printed book and the rise of popular and easily disseminated images were important sources of Bosch's themes and iconography.

❖ **Anticlericalism**
Bosch's religious imagery sometimes criticized the excesses and corruption of monks and priests. His "altarpieces" were often commissions destined for secular settings, and were intended to stimulate intellectual debate.

■ **Alchemy**
Interpretations of Bosch's images and symbolism have been linked to the processes and paraphernalia of this medieval pursuit.

Dies in 's-Hertogenbosch; funeral mass

■ **Boschian**
A term often used to describe the grotesque, absurd, horrific, or fantastic.

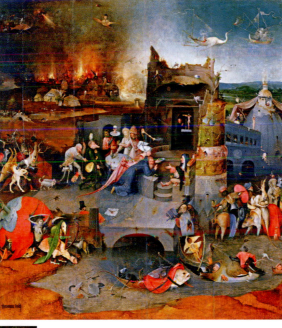

Temptation of St. Anthony (central panel),
Hieronymus Bosch, 1505–06, Museu Nacional de Arte Antiga, Lisbon

Bosch's paintings are always packed with grotesque and absurd beings. No matter what religious scene he was portraying, he was able to add a sense of the malevolent and evil.

Temptation of St. Anthony,
Max Ernst, 1945, Wilhelm Lembruck Museum, Duisburg

Surrealists such as Ernst drew inspiration from Bosch's nightmarish imagery in their attempt to depict the life of the subconscious, and explore the depths of human nature.

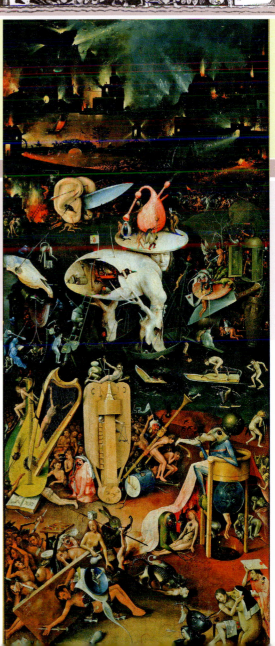

Hell (from the Garden of Earthly Delights triptych),
Hieronymus Bosch, 1505–10, Prado, Madrid

Bosch's masterpiece reflects late-medieval northern European beliefs about death. With his unique vision he created work rich in symbolism and fantasy.

Leonardo da Vinci is the epitome of the "Renaissance Man": a versatile and remarkable genius in an age of genius. He applied his natural talents, sharp eye, keen intellect, and endless curiosity not only to painting, sculpture, and architecture, but to almost every significant branch of human knowledge then known, all of which benefited from the originality of his thoughts, experiments, and accomplishments.

INFLUENCED BY

KEY
- ● artist
- ◆ artistic movement
- ■ cultural influence
- ❖ religious influence

■ Nature
Leonardo's greatest influence derived from his direct observation and study of the myriad elements, effects, and events of nature. His art was based on the primacy of the human eye and sight.

■ Science
Leonardo's intellect, powers of observation, scientific experiments, and curiosity about the nature of reality informed his ideas about art and beauty.

◆ Oil Paint
Leonardo was one of the most accomplished oil painters. His understanding of the full potential of the medium for blending colors and creating subtle effects of light, or *sfumato*, is unsurpassed.

● Andrea del Verrocchio
(1435–88)
Leonardo emerged from the workshop of the most important Florentine sculptor of the second half of the 15th century. Much of Leonardo's craftsmanship and technique derived from Verrocchio.

◆ Netherlandish Painting
It is likely that Leonardo knew the work of Jan van Eyck (c.1385/90–1441), and that of other Netherlandish painters. His refined oil technique and love of detail are similar to the art of 15th-century northern Europe.

LEONARDO DA VINCI (1452–1519)
Italian

	Born April 15 in Vinci; the illegitimate son of a notary	Apprenticed in the workshop of Andrea del Verrocchio in Florence	Enters the Guild of St. Luke for painters	Paints portrait of Ginevra de'Benci for Bernardo Bembo; paints the Annunciation;	begins the Adoration of the Magi (left unfinished)	Moves to Milan; offers his services as a military engineer to Ludovico Sforza	Paints the Virgin of the Rocks	At work on the Last Supper in the refectory of the Dominican monastery at the
CHRONOLOGY	**1452**	**c.1470**	**1472**	**c.1475–81**		**1482**	**1483–86**	**1495–98**

INSPIRED

● Albrecht Dürer
(1471–1528)
Dürer shared Leonardo's belief in the relationship between art, science, and beauty. His treatises on measurement and proportion (1525 and 1528) are reflections of Leonardo's inspiration.

● Raphael
(1483–1520)
Raphael inherited the perfection of Leonardo's perspective space, his figural groupings, and innovations in portraiture.

● Andrea del Sarto
(1486–1530)
The aura of mystery and tonal qualities in many paintings by Andrea are evidence of Leonardo's impact in Florence.

● Antonio Allegri da Correggio
(c.1489/94–1534)
The softness of Correggio's forms, the *sfumato* effects of his light, and his delicate modeling are indebted to Leonardo's example.

● Marcel Duchamp
(1887–1968)
When searching for an icon of Western culture and "high art" to defile, Duchamp chose Leonardo's *Mona Lisa*.

Leonardo's accomplishments as an artist are inextricably woven into the fabric of a life devoted to the pursuit of knowledge, beauty, and perfection. His name is synonymous with the spirit of the Italian Renaissance and the desire to reconcile humanistic learning with religious faith. Unlike many of his contemporaries, however, Leonardo's inspiration as an artist and scientist was neither Christian teaching nor Classical philosophy. Above all else, Leonardo trusted the ability of the human eye (to observe nature) and the intellect (to understand what was witnessed) to unlock not only the secrets of art, but of the universe. In this regard, Leonardo's demonstration of the power of human perception and reason is among his greatest attributes and gifts to later generations of artists and thinkers.

Leonardo was born the illegitimate son of a notary, west of Florence in the town of Vinci. As a young, precocious student, he matured in the rich environment of late 15th-century Florence. Leonardo emerged from the workshop of the sculptor Verrocchio in the decade of the 1470s as a fully-formed and independent artist. A generation before Michelangelo (1475–1564) and Raphael (1483–1520), it is Leonardo's art that marks the first achievements of the High Renaissance in Florence.

In early paintings such as the *Annunciation*, c.1475–79 (Uffizi, Florence), and the unfinished *Adoration of the Magi*, 1481 (Uffizi, Florence), viewers encounter the full range of Leonardo's interests as a painter, including his detailed observation of nature, his ability to render atmospheric perspective, the sophisticated treatment of drapery based on a clear understanding of chiaroscuro, the ease with which his figures move in space, the subtle use of light to model faces, and, in the *Adoration of the Magi* (along with its related

Portrait of a Woman (Ginevra de 'Benci),
Andrea del Verrocchio, c.1475–80, Bargello, Florence

Verrocchio instilled a sense of craftsmanship and refinement in the young Leonardo's developing style.

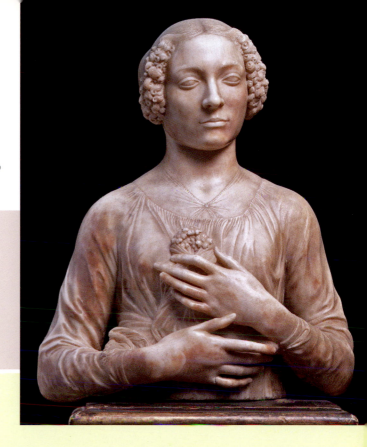

■ Anatomical Dissection

Leonardo was a diligent anatomist and dissector of human and animal cadavers. His quest to understand the human body for his science and art was unparalleled (left: Human musculature anatomical drawings).

church of Santa Maria delle Grazie in Milan	Returns to Florence	Begins portrait of Lisa di Antonio Maria Gherardini, wife of the prominent	Florentine citizen Francesco del Giocondo. Painting now known as the Mona Lisa	Works almost exclusively in Milan	Accepts invitation from King Francis I to come to France; settles in Cloux near Amboise	Dies May 2 in Cloux
	1500	**1503**		**1508–13**	**1516**	**1519**

● Andy Warhol
(1928–87)

Warhol's final series of paintings *The Last Supper* (1986) was based on Leonardo's version and exhibited across the street from the original in Milan.

● Jeff Koons
(b.1955)

Koons's *St. John the Baptist* (1988) is a Postmodern riff in porcelain on Leonardo's enigmatic painting from c.1513–16 in the Louvre.

Ginevra de'Benci (?),
Leonardo da Vinci, c.1474/78, National Gallery of Art, Washington, D.C.

Leonardo's training in Verrocchio's workshop contributed to the inventiveness and elegance of his early style.

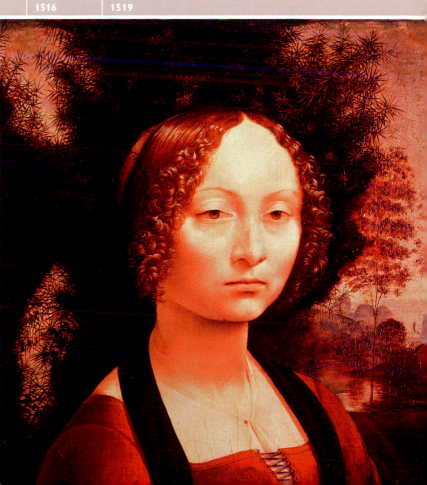

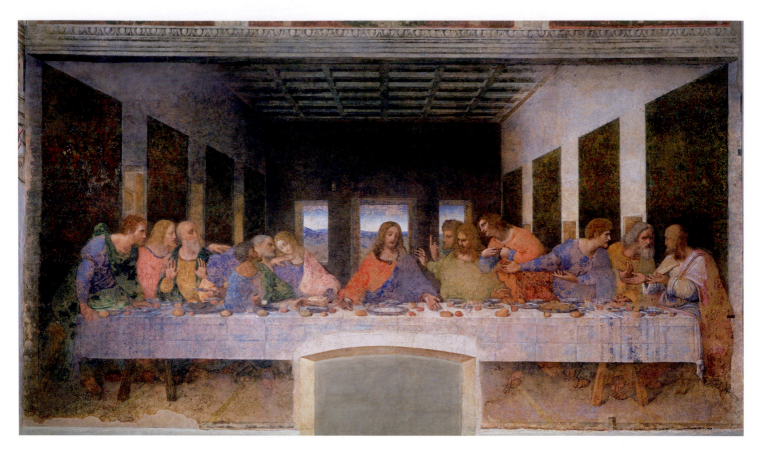

The Last Supper
Leonardo da Vinci, 1495–98, Convent of Santa Maria delle Grazie, Milan

The Last Supper is the epitome of Renaissance one-point linear perspective with the vanishing point focusing the viewer's attention on the head of Christ. Leonardo's painting is the direct heir of Masaccio's earlier fresco of *The Holy Trinity*.

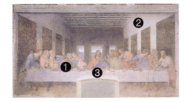

ABOUT THE WORK

Traditionally, painters used *The Last Supper* to illustrate the inauguration of the Eucharist, the central rite of the Christian Church. Leonardo combined this message with a moment of intense human drama. Unlike his predecessors, he focused on the instant when Christ revealed to his disciples that one of them would betray him. Leonardo used his studies of human psychology to capture their expressions of horror and disbelief with unerring accuracy.

COMPOSITION

Conventionally, artists had placed Judas on the near side of the table, to isolate him from the other apostles and make him easy to identify. This did not suit Leonardo's carefully balanced composition where, in spite of their shock, the disciples separate neatly into four groups of three. Instead, Judas is identified by his reaction. He shows no sign of surprise and recoils guiltily away from Jesus (1).

LIGHT

The light falls on the right-hand wall (2) and illuminates most of the figures. Only Judas is left in shadow.

GESTURES

The gestures of the apostles show surprise and alarm, but Christ barely seems to notice them. His expansive gesture (3), indicating the bread and the wine—the holy sacrament—is not meant for them, but for the monks who are dining in the refectory below.

drawing), one of the most rigorous examinations of one–point linear perspective in all of Italian art.

It is Leonardo's portrayal of *The Last Supper,* 1495–97/98 in the refectory of the church of Santa Maria delle Grazie, however, that is considered to be the first work of the High Renaissance. It is a comprehensive statement of most of the important principles of Renaissance painting in Italy. *The Last Supper* acknowledges the importance of the art and thought of 15th-century predecessors Filippo Brunelleschi (1377–1446), Donatello (c.1386–1466), Masaccio (1401–28), and Leon Battista Alberti (1404–72), but in its mathematical symbolism, use of perspective, psychological complexity, dramatic focus, and idealization it speaks an original language that inspired the works of both Michelangelo and Raphael.

The innovations of Leonardo's portrait style—from the detailed effects in early works such as *Ginevra de 'Benci,* c.1474/78 (National Gallery of Art, Washington, D.C.); to the rhythms and movement of *Lady with an Ermine* (Portrait of Cecilia Gallerani?), c.1490 (Czartorychi Muzeum, Cracow); and his use of oils to create the *sfumato* effects of the *Mona Lisa,* 1503 (Louvre, Paris)—would dramatically alter the subsequent history of portraiture in Western art.

For all his secretiveness, detachment, and personal complexity, Leonardo's art is an eloquent testament to imagination, creativity, knowledge, and the dignity of the human being.

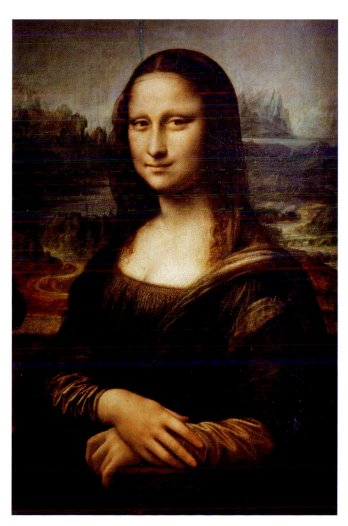

Mona Lisa,
Leonardo da Vinci, 1503, Louvre, Paris

The Mona Lisa's pose, sfumato effects, and atmospheric perspective would forever change portraiture and came to define High Renaissance art in Italy.

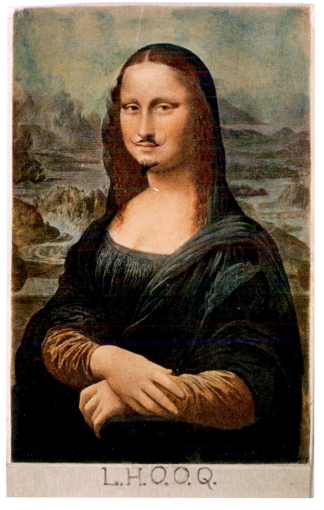

L.H.O.O.Q.,
Marcel Duchamp, 1919, Private collection, Paris

Duchamp chose Leonardo's *Mona Lisa* as an icon of Western culture and high art when searching for an iconic image to defile.

Albrecht Dürer was the most significant German artist of the Renaissance. His art was influential throughout Europe both during and after his lifetime. Dürer was a renowned painter and one of the greatest printmakers in Western art. He elevated the woodcut and engraving to new heights of artistic expression, and was the first major artist to experiment with etching. His painted and graphic images have inspired European artists for centuries.

← INFLUENCED BY

KEY
- ● artist
- ◆ artistic movement
- ■ cultural influence
- ❖ religious influence

◆ **Classical Sculpture**
Dürer's *Adam and Eve* (1504) engraving is based on his knowledge of Vitruvian proportion, and his familiarity with works such as the *Apollo Belvedere* (c.350–25 BCE) and the *Medici Venus* (c.100 BCE).

● **Giovanni Bellini**
(c.1430–1516)
Dürer's esteem for the Venetian painter is well documented in his letters, in which he says Bellini treated him with respect and admiration (right: *The Madonna of the Trees*, 1487).

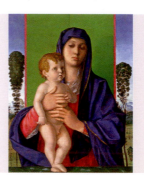

● **Michael Wolgemut**
(1434–1519)
Dürer learned the rudiments of painting and printmaking in Nuremberg's leading workshop run by this printmaker and painter at a time when it was producing

woodcuts for major publications, including the *Schatzkammer der wahren Reichthumer des Heils* (1491).

ALBRECHT DÜRER (1471–1528)
German

	Born May 21 in Nuremberg	Serves as apprentice in Nuremberg to leading printmaker Michael Wolgemut	Spends four years traveling through central and northwestern Europe	Visits Colmar to meet engraver Martin Schongauer, but arrives after	Schongauer's death. Publishes first woodcut, St. Jerome in his Study	Returns to Nuremberg and marries Agnes Frey. First trip to Italy.	Meets Frederick III, Elector of Saxony (1463–1525), who becomes patron	Publishes the 15 woodcuts of The Apocalypse; their powerful imagery and technical
CHRONOLOGY	**1471**	**1486–89**	**1490**	**1492**		**1494**	**1496**	**1497–98**

→ INSPIRED

◆ **Pupils and Followers**
Dürer's art influenced his pupils Hans Schäuffelein (c.1483–1539/40) and Hans Baldung Grien (1484/5–1545), as well as contemporaries including Lucas Cranach the Elder (1472–1553) and Hans Holbein the Younger (1497/8–1543).

● **Hendrik Goltzius**
(1558–1617)
Dutch printmaker who was a part of the Dürer revival in the late 16th century, imitating Dürer in works such as the engraving of the *Pietà* (*The Sorrowing Virgin with the Dead Christ in Her Lap*) (1596).

● **Rembrandt van Rijn**
(1606–69)
Rembrandt owned engravings and woodcuts by Dürer, and his influence is evident in numerous compositional and figurative borrowings, as seen in the two masters' graphic images of *The Death of the Virgin*.

● **Caspar David Friedrich**
(1774–1840)
By the 19th century, Dürer was a German cultural icon. Friedrich's woodcut, *The Woman with the Spider's Web* (c.1803) was inspired by Dürer's *Melencolia I* (1514).

◆ **The Nazarenes**
Founded in 1809, this group of German Romantic painters was inspired by Dürer's realism, emulating his direct and powerful use of the engraved line. Among those influenced by Dürer was Julius Schnorr von Carolsfeld (1794–1872).

Albrecht Dürer was the preeminent painter and printmaker of his era in Germany. He was among the first international artists of the Renaissance and traveled widely, disseminating his style and imagery through engravings and woodcuts. His trips to Italy helped establish the tradition of travel to Rome and Florence as an integral part of northern European artistic education. His appreciation of Italian art fused with his predilection for detailed realism to produce a High Renaissance ideal for northern European artists to emulate.

Dürer's early training was in his father's shop as a goldsmith. His talent and skill as a draftsman are displayed in a rare surviving silverpoint, *Self-Portrait at Age 13*, 1484 (Albertina, Vienna). In 1486 Dürer was an apprentice in the workshop of Michael Wolgemut, the leading painter and printmaker in Nuremberg at the end of the 15th century. His training placed him firmly in the realist traditions of Northern Renaissance

art. In 1490 Dürer departed Nuremberg for his *Wanderjahre* (a year of traveling or "wandering" meant to expand a young person's knowledge and perspective), the earliest of the many travels that infused his art with an international character. Crucial to his development was his visit to Colmar in 1492, in hopes of meeting—and possibly working with—the engraver Martin Schongauer. Unfortunately, Schongauer had died the previous year. Nevertheless, Dürer learned a lot from studying the older master's surviving work.

In 1494 Dürer returned to Nuremberg where he married Agnes Frey, the daughter of an affluent merchant, in an arranged marriage. More significantly for his art, later in 1494, the 23-year-old Dürer traveled to Venice, where he remained until the following spring. In Venice, Dürer had his first engagement with contemporary Italian art, coming into contact not only with Giovanni Bellini and Venetian painting,

The Frari Altarpiece,
Giovanni Bellini, 1488, Santa Maria Gloriosa dei Frari, Venice

In Bellini's altarpiece, the carefully modeled saints interacting with each other and the Madonna and Child occupy a precisely constructed fictive space that extends from the illusionistic chapel interior to the decoration of the surrounding frame.

● Martin Schongauer
(c.1450–91)
German engraver and painter Schongauer was the seminal influence on Dürer's desire to elevate the art of engraving to a significance rivaling that of painting and sculpture.

● Master of the Housebook
(c.1465–1500)
A number of Dürer's early prints derive their subjects and designs from an early master of dry-point engraving who worked in southern Germany known as the "Master of the Housebook."

● Leonardo da Vinci
(1452–1519)
Dürer's *Christ Among the Doctors* (1506) is the clearest indication of his regard and appreciation for Leonardo's painting.

	1505–07	1512	1513–14		1518		1520		1528
virtuosity make him famous throughout Europe	Second trip to Italy. Paints the Feast of the Rose Garlands for the church of San Bartolomeo.	Meets Holy Roman Emperor Maximilian I of Habsburg	Dürer executes his three engraved masterpieces: Knight, Death, and the Devil (1513);	St. Jerome in his Study (1514); and Melencolia I (1514)	Attends Diet of Worms as part of Nuremberg delegation, and meets Maximilian	I. Executes studies of the emperor for later portraits; the emperor dies January 12, 1519	Attends the coronation of Holy Roman Emperor Charles V (1500–58) in	Aachen, who renews Dürer's annuity	Dies on April 6 in Nuremberg

● Käthe Kollwitz
(1867–1945)
Kollwitz's personification of death as a skeletal form, stalking, measuring the passing of time, and waiting to seize its victims, owes much to Dürer's graphic imagery.

◆ German Expressionism
German artists, including Emil Nolde (1867–1956), Käthe Kollwitz, and the younger artists of *Die Brücke*, looked back to Dürer's art with pride, and were responsible for a 20th-century revival of the graphic arts—especially the woodcut—in Germany.

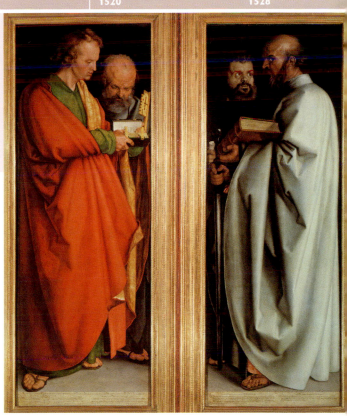

Madonna and Child,
Albrecht Dürer, c.1496–99, National Gallery of Art, Washington, D.C.

The youthful Dürer greatly admired the Renaissance art of Italy during his first trip there in 1494. He particularly revered the paintings of Bellini, as evidenced by this Bellini-inspired image of the Virgin and Child.

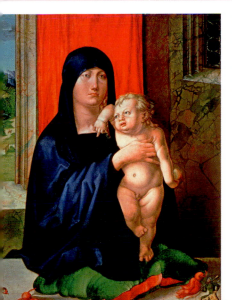

The Four Holy Men,
Albrecht Dürer, 1526, Alte Pinakothek, Munich

Toward the end of his career, Dürer adopted the poses and the naturalism of Bellini's saints for the depiction of these four sacred figures.

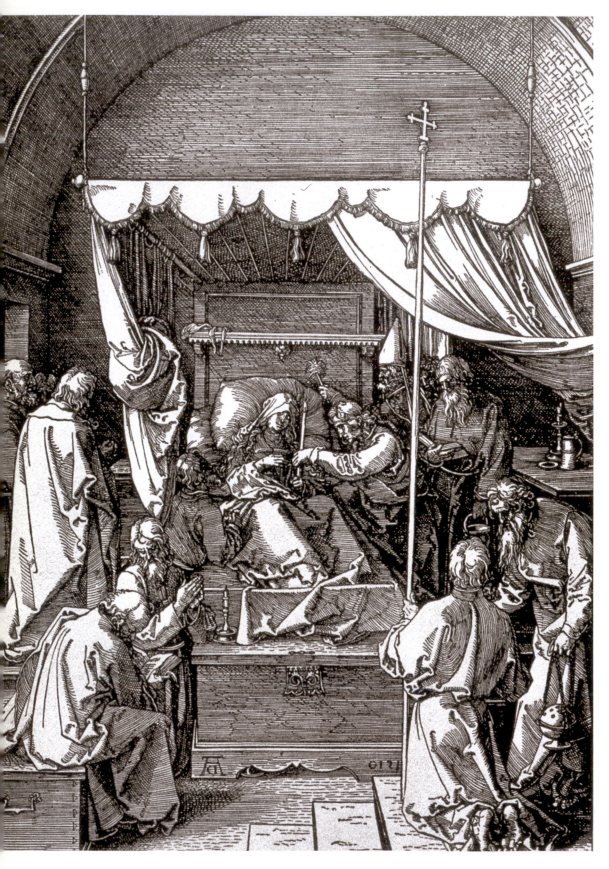

ABOUT THE WORK

From the outset of his career as a printmaker Dürer often conceived of his graphic work in series. In 1511, he published his woodcuts of *The Life of the Virgin* in book form, comprising 19 illustrations and a title page. Although most of the images were cut between 1502 and 1505, the *Death of the Virgin* is stylistically more advanced, dating to 1510 after the artist's second trip to Italy. In the earlier prints in the series, Dürer's use of perspective and illusionistic space is fully realized but the compositions lack a unified sense of light.

LIGHT

In Italy, the artist honed his understanding of chiaroscuro; using light and shadow more expressively to unify his images. Here, the areas of bright light and deeper shadow on the apostles in the foreground (1), and the subtle variations in crosshatching used to distinguish the arched vault from the back wall illustrate this refined understanding.

CONTRAST

Equally striking is the contrast Dürer established between the light playing across the bed hangings above the Virgin (2) and the darker areas below in shadow (3).

SIGNATURE

Dürer was the first artist to sign his woodcuts (4), a tribute to his unique accomplishment in the relief printmaking technique.

Death of the Virgin,
Albrecht Dürer, 1510, National Gallery of Art, Washington, D.C.

Dürer was one of the first German artists to seek training in Italy and was directly inspired by the artists of the Italian Renaissance.

but also with the prints of Andrea Mantegna and Antonio del Pollaiuolo (c.1429/33–98). On his return to Nuremberg his painting was tempered by his exposure to Venetian color, and to the figurative and perspectival innovations of Italian art.

He returned to Italy a decade later as a well-known printmaker and painter. In Venice he received major commissions from both German and Italian patrons, including the *Feast of the Rose Garlands* (1506), painted for the church of San Bartolomeo. Dürer also visited Bologna, Florence, and Rome, where he was influenced by the works of Leonardo and Raphael (1483–1520).

Dürer's travel was limited between 1507 and 1519. His greatest patron during this period was the Holy Roman Emperor Maximilian I, who visited Nuremberg in 1512, and went on to regularly commission the artist for the next six years. Following the death of his patron in 1519, Dürer traveled to the Netherlands, and then to Aachen to have his pension confirmed by the new Holy Roman Emperor Charles V. Dürer's visit left a lasting influence on painting and printmaking in the Low Countries. Conversely, his own art was influenced by the work of Lucas van Leyden (1489/94–1533), one of many artists whom he met on the trip.

Dürer's wide-ranging interest in perspective, measurement, and proportion, augmented by his desire to understand all aspects of the natural world, bestowed upon him a reputation parallel to that of Leonardo's in Italy. Dürer's later years were devoted to writing and publishing the theoretical and practical ideas that occupied him throughout his life. From 1525 to 1528 he published the *Teaching of Measurements, Various Instructions of the Fortifications of Towns, Castles and Large Villages*, and his *Four Books on Human Proportion*. Dürer's learning and accomplishments elevated the status of the artist in northern Europe, much as Leonardo, Michelangelo (1475–1564), and Titian (1485–1576) had done in Italy. In defining the artist not merely as a craftsman but as a creative genius, Dürer received the recognition and admiration of two Holy Roman Emperors and numerous rulers of the era.

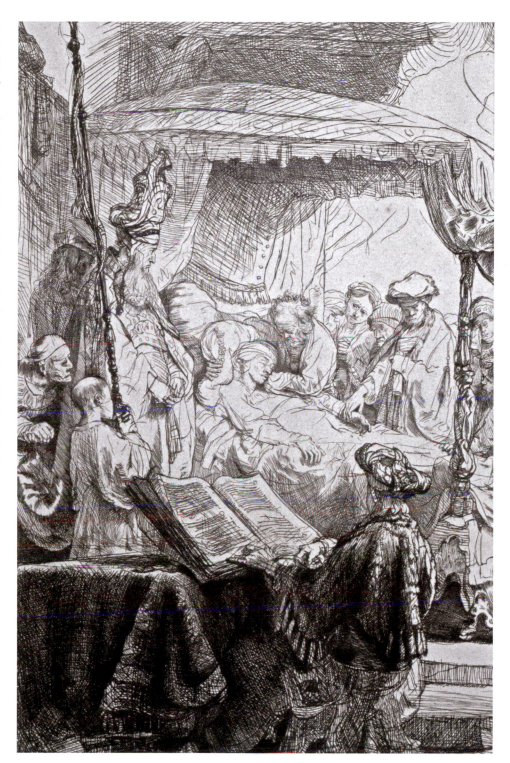

Death of the Virgin,
Rembrandt van Rijn, 1639, National Gallery of Art, Washington, D.C.

More than one hundred years after Dürer's death, Rembrandt turned to Dürer for inspiration in his portrayal of the *Death of the Virgin* through its composition, sensitive interaction of figures, and strong chiaroscuro.

Matthias Grünewald is one of the greatest German artists of the 16th century. Despite his limited production and the fact that he did not leave behind a school of followers, Grünewald's fame and influence were assured by the creation of one of the most important paintings in the history of Renaissance art: the *Isenheim Altarpiece*.

INFLUENCED BY

KEY
- ● artist
- ◆ artistic movement
- ■ cultural influence
- ❖ religious influence

◆ Gothic Art
Grünewald's vision was directly shaped by late Gothic religious art in Germany that stressed images of pain, suffering, and sorrow.

■ The Plague
The meaning, function, formal language, and placement of the Isenheim Altarpiece underline its significance as a healing image for plague victims.

● Martin Schongauer
(c.1450–91)
The imaginative engravings of religious subjects by Schongauer, a German artist from Colmar, influenced both Grünewald and Albrecht Dürer.

● Hieronymous Bosch
(c.1450–1516)
The power of Bosch's expressive and personal style is echoed in Grünewald's interpretations of religious scenes.

❖ Revelations of St. Bridget
(1492)
Graphic descriptions of Christ's suffering in devotional literature such as this were echoed in Grünewald's depictions of the Passion.

MATTHIAS GRÜNEWALD (c.1475/80–1528)
German

	Born in Würzburg	Mocking of Christ, first dated painting (1503)	Enters service of Uriel von Gemmingen, archbishop of Mainz	Called to Bingen as a hydraulic engineer	At work on the Isenheim Altarpiece for the high altar of the church of the	monastery of Saint Anthony, near Isenheim, in Alsace	Enters service of Cardinal Albrecht von Brandenburg, archbishop of Mainz	Peasants' War in Germany, in which Grünewald may have participated
CHRONOLOGY	**c.1475/80**	**c.1503/06**	**1509**	**1510**	**c.1512–16**		**c.1516**	**1525**

INSPIRED

● Emil Nolde
(1867–1956)
Nolde first saw the *Isenheim Altarpiece* in 1927 but certainly knew it before then through reproductions. His *Crucifixion* from the *Life of Christ* polyptych is indebted to Grünewald.

● Ludwig Gies
(1887–1966)
Gies' great wooden *Crucifixion* (1921) for the Lubeck cathedral, destroyed by the Nazis in 1938, was another descendant of Grünewald's crucified Christ in the *Isenheim Altarpiece*.

● Max Ernst
(1891–1976)
The visionary *Resurrection* from the *Isenheim Altarpiece* inspired similar scenes in Ernst's art and that of fellow Surrealists.

● Paul Hindemith
(1895–1963)
The art and life of Grünewald inspired Hindemith's opera *Mathis der Maler* (1934) and a symphony by the same name (1934).

◆ Die Brücke
All members of this early 20th-century German Expressionist movement were inspired by Grünewald's art, especially the *Isenheim Altarpiece*.

The paintings that comprise the *Isenheim Altarpiece* are among the most influential in the history of Western art. The man who created them, Matthias Grünewald, is one of Germany's greatest 16th-century artists, along with his contemporary Albrecht Dürer (1471–1528). They are, however, a study in contrasts. Dürer's art was based in large part on Classical sources from the Italian Renaissance, whereas Grünewald remained closer to his northern European roots and Gothic traditions. Both artists were rediscovered and celebrated by later German artists, but it was the images produced in the *Isenheim Altarpiece* by Grünewald that resonated far beyond their time to inspire German Expressionism in the 20th century.

Little is known of Grünewald's life. Yet his art is one of the most personal and expressive bodies of work in Western painting. It is a powerful synthesis and intense exploration of suffering, faith, redemption, and salvation, conveyed through a formal language of dramatic light, tortured drawing, arresting color, and exaggerated compositional effects. At the center of Grünewald's small body of work is the *Isenheim Altarpiece*, c.1512–16 (Musée d'Unterlinden, Colmar), and at the heart of the altarpiece are the depictions of the *Crucifixion* and *Resurrection*—images that can be described as the alpha and omega of suffering and transcendence. Few artists before or since have been able to achieve a more complex and heartfelt examination of the story of Christ than Grünewald in the *Isenheim Altarpiece*. As such, it stands as one of a select group of creative achievements in the arts, the impact and inspiration of which elevate it to a special level of distinction.

Virgin with the Dead Christ (Röettgen Pieta),
Gothic sculpture, c.1300–25, Rheinisches Landesmuseum, Bonn

Grünewald was influenced by Gothic religious art that was infused with a sense of pain and sorrow, as depicted in this statue of Mary holding the dead body of Christ on her lap.

❖ Protestant Reformation
Both Grünewald and Dürer were affected by the teachings of Martin Luther (1483–1546) and the turmoil of the Protestant Reformation (left: *Martin Luther*).

Moves to Frankfurt	Works in Halle as a hydraulic engineer	Dies of plague in late August in Halle
1526	1527	1528

● Jasper Johns
(b.1930)
Johns has embedded motifs drawn from the *Isenheim Altarpiece* in many of his later paintings.

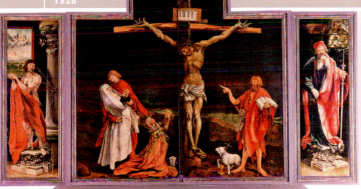

Isenheim Altarpiece,
Matthias Grünewald, c.1512–15, Musée d'Unterlinden, Colmar

The dramatic lighting, vibrant use of color, and exaggerated composition contribute to Grünewald's tour-de-force interpretation of Christ's suffering on the cross.

Crucifixion from the Life of Christ polyptych,
Emil Nolde, 1911–12, Ada und Emil Nolde Stiftung, Seebüll

Grünewald's expressive style, spiritual themes, and brilliant color palette influenced members of the German Expressionist movement of the early 20th century such as Nolde.

Christ Carrying the Cross,
Matthias Grünewald, 1515–17, Staatliche Kunsthalle, Karlsruhe

The dramatic lighting, dissonant colors, and expressive distortions in Grünewald's painting reinforce the tragedy and pain of Christ's suffering on the cross.

Michelangelo is a towering figure in the history of Western art and culture. He has few rivals as sculptor, painter, and architect, and even fewer who match his dedication to the expression of beauty through the creative processes of art—a theme at the heart of much of his poetry. Difficult, conflicted, uncompromising, and utterly consumed by and devoted to his calling as an artist, he was the paradigm of the creative genius.

INFLUENCED BY

KEY
- ● artist
- ◆ artistic movement
- ■ cultural influence
- ❖ religious influence

◆ Classical Art
Michelangelo had first-hand knowledge of some of the greatest examples of Classical sculpture housed in the Vatican collections.

● Giotto di Bondone (c.1266–1337)
Among Michelangelo's earliest drawings are studies after Giotto's frescoes in the church of Santa Croce.

● Filippo Brunelleschi (1377–1446)
Michelangelo grew up in the shadow of Brunelleschi's dome of the Florence Cathedral. Its engineering would later influence his design for the dome of St. Peter's in Rome.

● Donatello (c.1386–1466)
Donatello was Florence's greatest sculptor of the 15th century. His work was crucial to the development of Michelangelo as a sculptor.

● Masaccio (1401–28)
Copying Masaccio's frescoes in the Brancacci Chapel was an important part of Michelangelo's early training.

MICHELANGELO (1475–1564)
Italian

	Born March 6 in Caprese, near Arezzo	Enters the workshop of Domenico Ghirlandaio in Florence	Resides in the Medici household and works in the Medici sculpture garden under the	supervision of the sculptor Bertoldo di Giovanni	In Rome at work on the Pietà	Receives the commission for the David in Florence	Receives commission in Rome for tomb of Pope Julius II	Begins work on the Sistine Chapel ceiling in Rome
CHRONOLOGY	**1475**	**1488**	**1490–92**		**1496–98**	**1501**	**1505**	**1508**

INSPIRED

● Raphael (1483–1520)
Michelangelo's figures in the Sistine Chapel were a revelation to Raphael. The impact of their powerful movements was immediately transferred to his own frescoes in the papal apartments.

● Andrea Palladio (1508–80)
Palladio's sculptural spaces, use of colossal orders, and willingness to violate Classical norms for expressive purposes reflect the inspiration of Michelangelo's architectural ingenuity.

● Annibale Carracci (1560–1609)
Carracci's illusionistic ceiling in the Palazzo Farnese (1597–1601), while different in aspects of its form and content, is nonetheless indebted to the scheme and ambition of Michelangelo's Sistine Chapel ceiling.

● Caravaggio (1571–1610)
Numerous works by Caravaggio were directly inspired by Michelangelo, while all of his paintings owe something to the sculptural forms of his predecessor (right: The Flagellation of Christ, 1607).

The art of Michelangelo is a supreme achievement in the history of Western culture. The paintings in the Sistine Chapel embody the scope of Michelangelo's ambition, the mastery of his craft, and the power of his wish to speak directly to humanity. Like the plays of William Shakespeare (c.1564–1616), the passions of Johann Sebastian Bach (1685–1750), or the symphonies of Ludwig van Beethoven (1770–1827), his is an art of dedication and conviction that prompts the viewer to marvel at the single-minded genius capable of creating it.

Michelangelo's talents and originality were displayed equally in painting, sculpture, and architecture. Born in the small village of Caprese in the Florentine territory near Arezzo, he was still a newborn when his family returned to Florence to live in the neighborhood near the church of Santa Croce. At the age of 13 Michelangelo entered the workshop of the painter Domenico Ghirlandaio where he learned the technique of fresco painting, and may well have assisted his teacher in his series of frescoes in the choir of the church of Santa Maria Novella in Florence. As a young artist he made drawings copying frescoes by Giotto in Santa Croce and by Masaccio in the Brancacci Chapel in Santa Maria del Carmine. He soon entered the circle of the Medici court and household, where he came into contact with some of the greatest humanists of the day.

With the death of Lorenzo de Medici (1449–92), political upheaval in Florence, and the end of his apprenticeship, Michelangelo traveled to Rome in 1496, where he completed one of his earliest masterpieces, the Pietà 1498–1500 (St. Peter's, Rome). This remarkable carving from Carrara marble—in its detail, finish, understanding of human anatomy, compositional unity, and strong sentiment—immediately established Michelangelo's reputation.

Belvedere Torso,
Unknown, c.100 BCE, Vatican Museum, Rome

Michelangelo had access to Classical works held in the Vatican collection that, together with contemporary discoveries of Classical sites, inspired interest in capturing the human form.

● **Bertoldo di Giovanni**
(c.1430/40–91)
Bertoldo had been an assistant to Donatello and oversaw the sculptures in the Medici Garden where Michelangelo studied as a boy.

● **Domenico Ghirlandaio**
(1449–94)
During Michelangelo's brief apprenticeship with Ghirlandaio, he most likely learned the technique of fresco painting.

● **Leonardo da Vinci**
(1452–1519)
Leonardo returned to Florence in 1500. His cartoon for an altarpiece of the *Madonna and Child with St. Anne* (1507–08) was publicly exhibited in the city and admired by Michelangelo.

■ **Neo-Platonism**
Michelangelo's interest in Neo-Platonic thought was instilled during his time at the Medici court, which was frequented by leading Neo-Platonic philosophers of the day.

Commission for the Medici tombs in Florence. Death of Leonardo da Vinci in France	*Death of Raphael*	*Begins work on the Last Judgment in the Sistine Chapel*	*Rondanini Pietà, left unfinished*	*Dies February 18 in Rome at age of 89; buried in Florence*
1519	**1520**	**1534**	**1555**	**1564**

● **Peter Paul Rubens**
(1577–1640)
Rubens' love of Italian art centered in large part around his fascination with the forms of Michelangelo and the color of Titian.

● **Gian Lorenzo Bernini**
(1598–1680)
Bernini was the true heir to Michelangelo as a pure carver of marble. He was inspired by the Medici tombs in his own tomb sculptures, and indebted to Michelangelo as an architect.

● **Auguste Rodin**
(1840–1917)
The power, classicism, musculature, tension, and pathos found in many Rodin sculptures are directly attributable to the inspiration of Michelangelo.

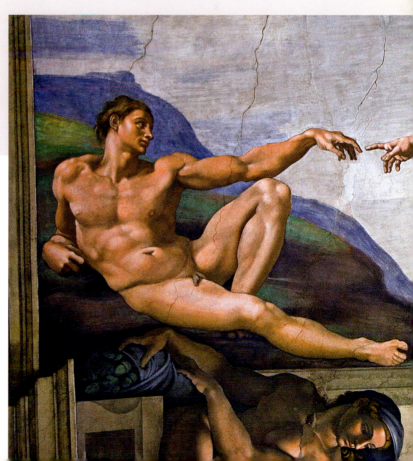

The Creation of Adam (detail),
Michelangelo, 1511, Sistine Chapel, Vatican, Rome

Perhaps the most iconic image in Western art, the electrifying moment when God invests Adam with life displays Michelangelo's Classically inspired idealization of the nude male body.

The Entombment (unfinished),
Michelangelo, 1500–01, National Gallery, London

The young Michelangelo's unified sense of composition focuses attention on the limp body of Christ being carried to the sepulcher and adds to its pathos.

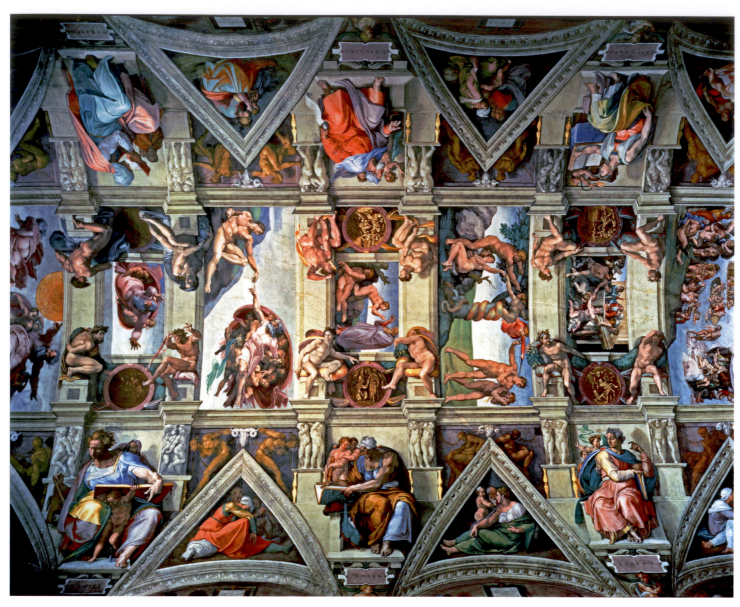

Sistine Chapel Ceiling,
Michelangelo, 1508–12, Sistine Chapel, Rome

For many, the Sistine Chapel ceiling is the crowning achievement of the Renaissance and one of the pinnacles of Western art.

ABOUT THE WORK

Commissioned by Pope Julius II, Michelangelo completed the monumental task of painting the Sistine Chapel ceiling in just four years, working virtually unaided. It proved to be a considerable feat of endurance, as well as an artistic triumph. Michelangelo painted standing up, with his head bent backward, and it took him months to recover from laboring so long in this awkward position.

MEANING

The symbolic program of the Sistine Chapel is dauntingly complex. Michelangelo may have had theological advice on some of the details, but the overall concept is entirely his own. At the heart of the composition are nine scenes from the *Book of Genesis*. The most famous of these is *The Creation of Adam* (1).

FIGURES

Michelangelo considered himself a sculptor first and foremost, so it is hardly surprising that his figures are the highlight of the ceiling. They exude a heroic sense of grandeur that has rarely been equaled.

COMPOSITION

The entire composition is bound together by a network of illusionistic architectural details, with "marble" columns and playful putti. From the ground, these appear convincingly real.

If Leonardo da Vinci's art was based on nature and the powers of observation, the key to understanding Michelangelo's art resided from the start in his relentless investigation of the human form and its potential to convey ideas. This is true both for his work as a sculptor and painter.

As a painter Michelangelo's achievement rests almost entirely on the frescoes of the Sistine Chapel. Nowhere in the history of painting does the human body fulfill as grand and powerful a role as a vessel for the transmission of human and spiritual drama of profound and universal significance combining Christian theology and Classical prototypes.

The frescoes in the Sistine Chapel include both the perfection of form and divine order represented in the *Creation of Adam* (1511), one of the major scenes of the ceiling, and the tormented images of damned souls dragged to their eternal punishments in the cataclysmic scene of the *Last Judgment* (1534–41) above the altar wall. In this cycle, Michelangelo both created and destroyed: The ceiling representing the apotheosis of High Renaissance achievement in painting, and the *Last Judgment* looming as a frightening negation of that earlier vision. Few artists have been able to convey the range of spiritual ecstasies and physical torments, the hope of salvation and the remorse of sin, the promise of creation and the tragic forfeiture of that promise. Only an artist believing in his own divine spark and yet conscious of his human limitations could even conceive of such a journey.

The Thinker,
Auguste Rodin, c.1902–04, Musée Rodin, Paris
Rodin focused on a study of the paintings and sculptures of Michelangelo during his first trip to Italy in 1875. The Renaissance master's influence remained with him throughout his long career.

Jeremiah (detail from Sistine Chapel ceiling),
Michelangelo, 1511, Sistine Chapel, Rome

Michelangelo's portrayal of human and spiritual drama, ecstasy, and torment in the Sistine Chapel is a work of genius that has never been equaled and is a continuing source of inspiration for artists.

Few artists in the history of Western painting can boast the influence that Raphael has had throughout the ages. For centuries his art was considered the paradigm to which artists should aspire. In academies and classes throughout Europe and the United States it was Raphael's art, not that of Michelangelo or Leonardo da Vinci, that was considered the epitome of purity, taste, refinement, and excellence.

INFLUENCED BY

KEY
● artist
◆ artistic movement
■ cultural influence
❖ religious influence

● **Giovanni Santi**
(c.1435–94)
Raphael's father, a minor painter at the Montefeltro court in Urbino, gave his son his first lessons in art.

◆ **Northern Renaissance Painting**
Raphael was exposed to Netherlandish painting at the court of Urbino. The color and light of Northern Renaissance art influenced the oil technique and illusionism in his paintings.

● **Perugino**
(c.1450–1523)
The young Raphael absorbed the essence of his teacher's poetic and lyrical style into his own.

● **Leonardo da Vinci**
(1452–1519)
Leonardo's art showed Raphael the power of light and shadow to create three-dimensional form, and the psychology of painting.

● **Michelangelo**
(1475–1564)
The power and movement of Michelangelo's figures on the Sistine Chapel ceiling were directly translated into Raphael's frescoes in the Vatican apartments. Raphael first viewed the still-unfinished project in August, 1511.

RAPHAEL (1483–1520)
Italian

	Born April 6, Good Friday, in Urbino	Studies with Perugino (c.1450–1523), in Perugia	Completes the Colonna Altarpiece for the church of San Antonio in Perugia	Moves to Florence where he meets Leonardo and Michelangelo, and sees their work	At work in Florence, but continues to visit Urbino, Perugia, and Rome	Paints portraits of Angelo Doni and his wife, as well as La Belle Jardinière	Travels to Rome	Begins frescoes in the apartments of Pope Julius II; appointed writer for the pope
CHRONOLOGY	**1483**	**c.1495–1500**	**1501–02**	**1504**	**1504–07**		**1508**	**1509**

INSPIRED

● **Pupils and Followers**
Students, collaborators, and assistants disseminated aspects of Raphael's style throughout the 16th century, among them his most gifted pupil and chief assistant, Giulio Romano (c.1492/99–1546).

● **Annibale Carracci**
(1560–1609)
Members of the Carracci family and their "academy" in Bologna based their reforms of the antinaturalist Mannerist style on the techniques and formal language of Raphael.

● **Jacques-Louis David**
(1748–1825)
David was inspired by the balance, purity, and clarity of form in Raphael's art, and encouraged in this regard by the writings of Johann Joachim Winckelmann (1717–68).

● **Jean-Auguste-Dominique Ingres**
(1780–1867)
Ingres venerated Raphael. This admiration is best seen in his painting for the Cathedral of Montauban, The Vow of Louis XIII (1824) based on Raphael's Sistine Madonna (1513).

❖ **Édouard Manet**
(1832–83)
Manet borrowed the river gods in Raphael's Judgment of Paris (1517–20) for his poses and composition in Le Déjeuner sur l'Herbe (1863) (Luncheon on the Grass).

Raphael's greatest achievements as an artist were his understanding and total assimilation of most, if not all, of the advances made in Italian painting since the time of Giotto di Bondone (c.1266–1337). It would be upon his example, using his art as a model, that artists and academies over the next five centuries would establish themselves. If Michelangelo's art was considered *terribilità*, meaning too powerful and intense, and Leonardo's overly intellectual and personal, Raphael's art was valued for its ability to reconcile both these aspects, and to recast them into an idealized style that became the touchstone for Western culture.

Raphael was born in Urbino, and was fortunate in having access—perhaps through his father, who was a minor painter—to one of the most important and enlightened courts in Italy, that of Federico da Montefeltro, Duke of Urbino (1422–82). Sometime after his father's death in 1494, Raphael entered the studio of the leading painter of Perugia, Pietro Vannucci, known as Perugino, who had already completed his great frescoes in the Sistine Chapel. He had a pleasing and graceful style that left an impression on the young Raphael. Yet before long the apprentice surpassed his master in his ability to create rich and complex relationships within the poses and attitudes of his figures.

By 1505 Raphael was in Florence, where he came into contact with the latest trends in art represented by Leonardo and Michelangelo. Raphael found a willing market for his talents, and soon produced a body of work that reflected his uncanny abilities to synthesize ideas and motifs from these two great masters. Among his most popular paintings from this period were the many representations of the Madonna and Child, including the Leonardo-inspired *Madonna of the Meadows*, 1505 (Art History Museum, Vienna).

Giving of the Keys to St. Peter,
Perugino, 1481, Sistine Chapel, Vatican, Rome

Perugino's fresco in the Sistine Chapel is among the most important examples of a harmonious space based on the laws of one-point linear perspective and reflects knowledge of all the major advances in 15th-century Florentine art and architecture.

◆ Classical Art
Raphael embraced Classical art from his early twenties. His mature work reflects the range of these interests, from the Classical sculptures of the Vatican collections, to the monuments of ancient Rome, to coins, medals, and ancient gems.

1510–11	1513	1514		1515–16	1516–20		1520		
Completes the frescoes in the pope's apartments	*Pope Julius II dies. Completes fresco of the Liberation of St. Peter in the Stanza d'Eliodoro*	*Death of architect Donato Bramante (1444–1514), and Raphael*	*succeeds Bramante as architect of St. Peter's*	*Plans and executes sketches for the Sistine Chapel tapestries*	*Commissioned to paint the Transfiguration, his last major altarpiece, for*	*Cardinal Giulio de'Medici, later Pope Clement VII. Begins work on the frescoes in the*	*Villa Farnesina for Agostino Chigi (1465–1520)*	*Dies April 6, Good Friday, in Rome on his 37th birthday;*	*buried in the Pantheon*

● Cindy Sherman
(b.1954)
American Sherman based one of her photographs in the *History Portraits* (1989–90) on Raphael's portrait *Donna Velata* (La Fornarina) (c.1513).

◆ Raphael and the United States
Raphael's importance for American artists was significant. Artists inspired by Raphael's reputation and works include John Smibert (1688–1751), Benjamin West (1738–1820), John Singleton Copley (1738–1815), John Vanderlyn (1775–1852), Washington Allston (1779–1843), and Thomas Crawford (1813–57) (below, left: *The Artist's Wife, Elizabeth, and their son Raphael, Benjamin West, c.1773*).

Marriage of the Virgin,
Raphael, 1504, Brera Gallery, Milan

Raphael's interpretation of this scene is indebted to Perugino's *Giving of the Keys to St. Peter* in its figures, architecture, space, and color harmonies. In the unity of its conception and realization, however, the young student has surpassed his teacher.

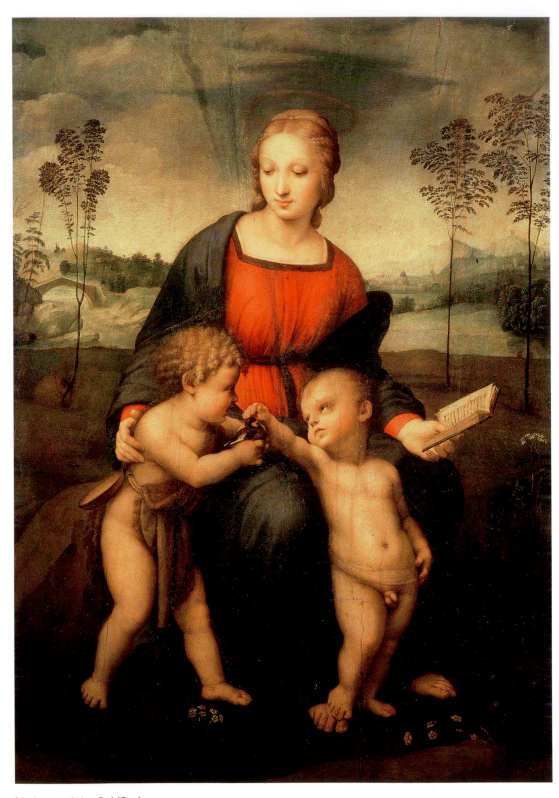

Madonna of the Goldfinch,
Raphael, c.1505/6, Uffizi, Florence

Raphael's paintings of the Madonna and Child were
among his most important and influential works
emulated by later artists.

ABOUT THE WORK

The Madonna of the Goldfinch was
painted for Raphael's friend Lorenzo
di Bartolomeo Nasi on the occasion
of his wedding to Sandra di Matteo
Canigiani. According to Vasari, the
painting was severely damaged in 1548
and restored shortly thereafter. It was
created sometime after Raphael's
arrival in Florence (c.1505) and
reflects his awareness of works by the
Florentine masters Leonardo da Vinci
and Michelangelo. *The Madonna of the
Goldfinch* is one of several important
depictions of the Madonna and Child
theme painted by Raphael before his
departure for Rome (c.1508).

MEANING

Raphael's depiction of the Virgin
Mary, the young St. John the
Baptist, and the young Christ Child,
identifies and speaks to the complex
interrelationships and destinies of
each protagonist. The Virgin's book
symbolizes her wisdom (1), the
goldfinch the Passion of Christ, and
the Baptist's presentation of the
bird his awareness and warning of
that death (2).

COLOR

The simplicity and clarity of Raphael's
colors, especially his use of the
primary colors red and blue (3),
reinforce the purity and harmony
of the overall painting.

COMPOSITION

The composition of the painting
is based upon a pyramid, inspired
by similar formats in the works of
Leonardo, and reinforced by the
unifying interaction of the figures'
gestures and gazes. The space
recedes slowly and logically into
the background, enhanced by the
use of atmospheric perspective
to imply the distant horizon.

Self-Portrait at the Age of Twenty-Four,
Jean-Auguste-Dominique Ingres, 1804, Musée Condé, Chantilly

Ingres's abiding admiration for the art of Raphael is reflected in this youthful self-portrait, which may very well have been inspired by Raphael's *Portrait of Bindo Altoviti.*

Portrait of Bindo Altoviti,
Raphael, c.1515, National Gallery of Art, Washington, D.C.

Once believed to be a self-portrait, Raphael's *Portrait of Bindo Altoviti* is now recognized as the image of the wealthy banker and friend of the artist.

It was when Raphael arrived in Rome in 1508 that he found his own vision and moved beyond the imitation of his earlier Florentine period. In his frescoes for the Vatican stanze, or apartments, Raphael achieved a comprehensive statement of artistic principles, articulated through the array of frescoes that comprised the commission, that would later be viewed as the summation of Renaissance painting.

From the *Disputa* (1509) and *School of Athens* (1510–11) in the Stanza della Segnatura, to the *Expulsion of Heliodorus* (1512) and *Liberation of St. Peter* (1513) in the Stanza d'Eliodoro, Raphael created a lexicon of figure types, body language, spatial and compositional arrangements, movement, effects of light, color harmonies, and dramatic narrative that would be referred to, copied, emulated—and even at times, debased—by future generations of artists.

This legacy of Raphael, the "Prince of Painters" as he came to be known, conferred upon the artist a status and aura that endured for centuries to come. Even artists who later rejected his achievement, such as the Pre-Raphaelites in England, in so doing acknowledged the long shadow of his influence and inspiration.

Titian initiated the High Renaissance in Venice. His career began in the workshop of Giovanni Bellini, the dominant Venetian artist of the 15th century. Titian synthesized the visual language of Bellini with the style and thematic innovations of Giorgione. Titian's virtuoso technique combined brilliant Venetian color, expressive applications of oil, and an atmospheric approach to form that would be adopted by artists for the next 500 years.

INFLUENCED BY

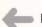

KEY
● artist
◆ artistic movement
■ cultural influence
❖ religious influence

■ Nature
Titian's appreciation and study of natural light is evident in many of his early works, including the *Gypsy Madonna* (c.1511) and the paintings for the *camerino d'alabastro*, or alabaster room, in Ferrara (1517–18; c.1523/24).

■ Venice
The city's light, atmosphere, color, effects of water, and reflection affected Titian.

● Giovanni Bellini
(c.1435–1516)
The young Titian learned his craft in Bellini's workshop, as did most of the significant artists working in Venice at the end of the 15th century.

● Michelangelo
(1475–1564)
Michelangelo's Moses (c.1515) provided the inspiration for the robust figure and powerful hand in Titian's *Portrait of Doge Andrea Gritti* (c.1546/48).

● Giorgione
(c.1477–1510)
Titian worked alongside Giorgione during the first decade of the 16th century, absorbing the older artist's use of atmospheric light and his interest in secular and poetic subjects (right: *The Tempest*, c.1508).

TITIAN (c.1490–1576)
Italian

	Born in Pieve di Cadore in the foothills of the Dolomites north of Venice	Enters the workshop of Gentile Bellini, followed by the workshop of his	more celebrated brother Giovanni	Works with Giorgione on the frescoes of the Fondaco dei Tedeschi in Venice	Death of Giorgione	Paints the Assumption of the Virgin for the high altar in the church of Santa	Maria Gloriosa dei Frari in Venice; Giovanni Bellini dies	Paints the Madonna of the Pesaro Altarpiece for the Church of the Frari in Venice
CHRONOLOGY	c.1490	c.1500		c.1508	1510	1516		1519

INSPIRED

● El Greco
(1541–1614)
Born in Crete when it was a Venetian possession, El Greco traveled to Venice where he was influenced by the painting methods, light, and color of both Titian and Tintoretto (Jacopo Robusti, c.1518–94).

● Peter Paul Rubens
(1577–1640)
Rubens' full-bodied figures, understanding of movement, and use of thick impasto derive from his direct study of Titian's paintings in Italy.

● Diego Velázquez
(1599–1660)
A major collection of Titian paintings was at the Spanish court by the end of the 16th century. Velázquez's art begins with his appreciation of Titian's bold compositions, color, and expressive brushwork.

● Rembrandt van Rijn
(1606–69)
Rembrandt knew and adapted motifs from Titian's works seen in both the Amsterdam auction market, and in engravings and woodcuts.

● Eugène Delacroix
(1798–1863)
While Delacroix praised the work of Titian's contemporary, Raphael (1483–1520); his own paintings reveal the inspiration of Titian's rich color and thick paint application.

Titian was the most important painter in 16th-century northern Italy, and the first artist to achieve international fame. At the height of his career he was in demand by the Venetian state, the papacy, and major rulers from Spain to France, Italy, and central Europe. From humble origins, he strove to elevate the status of the artist from that of mere craftsman to unique creative genius. An early biographer relates the story of this change by describing how Holy Roman Emperor Charles V, while having his portrait painted by Titian, stooped to hand a fallen brush back to the artist.

Titian's artistic development occurred in a late 15th-century Venice dominated by the paintings of Giovanni Bellini and his circle. Bellini's work was defined by its clarity, pure tones, sharp delineation of form revealed through a bright Venetian light, and brilliant, enamellike finish. Titian is the pivotal figure in the artistic evolution of Renaissance painting from the precise brushwork and crisp contours of 15th-century art to the looser brushwork, richer colors, softer focus, and greater atmospherics of 16th-century painting. His use of color to model forms is the basis of the painterly school of European art later codified in 17th-century France in the distinction between the "Rubenistes" and the "Poussinistes." Titian's influence can be seen in artists as diverse as Tintoretto (Jacopo Robusti, c.1518–94), El Greco, Caravaggio (1571–1610), Peter Paul Rubens, Rembrandt van Rijn, Antoine Watteau (1684–1721), Eugène Delacroix, Édouard Manet, and the Impressionists.

Titian applied his loaded-brush technique to the array of subjects available to artists of his era, including religious altarpieces, mythological and historical scenes, allegories, portraits, and self-portraits. His early work is closely identified with Giorgione, with whom he shared a studio in the first

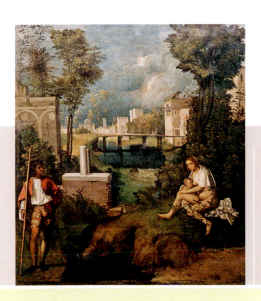

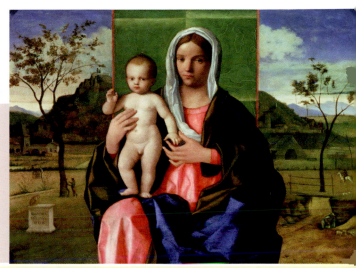

Madonna and Child,
Giovanni Bellini, 1510, Pinacoteca di Brera, Milan

Titian studied with Bellini, the most influential 15th-century Venetian artist. In this late work, Bellini set the Madonna and Child in an unusual horizontal format against rich landscape.

■ Classical Literature

Venice was the publishing center of Europe in the early 16th century. Titian adapted many of his subjects from Classical history, mythology, and pastoral literature.

1527		1533	1545–46		1548	1576
The writer Pietro Aretino and the architect Jacopo Sansovino arrive in Venice after the	*sack of Rome and befriend Titian; Michelangelo in Venice*	*Paints the portrait of Holy Roman Emperor Charles V*	*Welcomed to Rome by Pope Paul III; visits Michelangelo's*	*studio; granted Roman citizenship*	*In Augsburg to paint for Holy Roman Emperor Charles V*	*Dies August 27 in Venice of the plague*

● Édouard Manet
(1832–83)

Manet based his two controversial masterpieces on paintings by Titian: the *Déjeuner sur l'Herbe* (1863) on Titian's *Concert Champêtre* in the Louvre; and the *Olympia* (1863) on Titian's *Venus of Urbino* in the Uffizi.

● Willem de Kooning
(1904–97)

De Kooning's fleshy and energized depictions of the female nude descend directly from Titian (below: *Marilyn Monroe*, 1954).

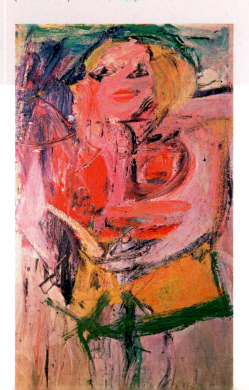

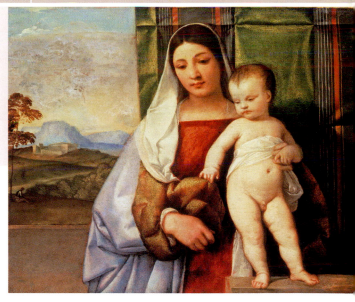

Madonna with Child, ("Gypsy Madonna"),
Titian, 1512, Kunsthistorisches Museum, Vienna

Titian's youthful panel of the Virgin and Child adopted Bellini's horizontal format and interest in landscape. Titian, however, rendered the figures as more relaxed and robust, and the landscape as freer and in a more natural state.

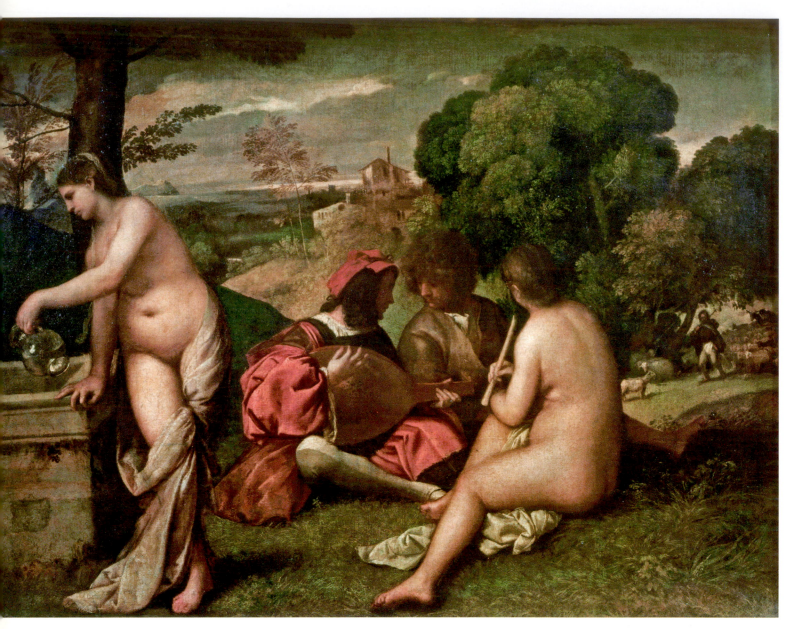

The Pastoral Concert,
Titian, 1510, Louvre, Paris
Recently attributed to Titian, *The Pastoral Concert* is thought
to be an illustration of an ancient poem or story.

ABOUT THE WORK

The Pastoral Concert is one of the most famous and controversial paintings of the Renaissance. Its attribution has flowed back and forth from Giorgione to Titian over the past two centuries. Recently it has been firmly, but not universally, accepted as a youthful work of Titian based on stylistic comparison with other early paintings and on careful scientific examination.

MEANING

The specific meaning of the work is unclear. Two youths in a landscape in the Veneto; one is a well-dressed urban male, the other a barefoot rustic (1). The men are oblivious to the flanking nudes (2). The nudes may be personifications of the muses and therefore invisible to the seated men. With these identifications, the painting is interpreted as an illustration of a pastoral poem or story from antiquity or the Renaissance.

FORM

Whatever its meaning, the attraction of the painting is in its figures' graceful poses, the lush landscape setting, subtle modeling in light and shadow, and atmospheric perspective.

MOOD

The mood of the work is meditative and sensual—a celebration of life, love, nature, poetry, music, and painting.

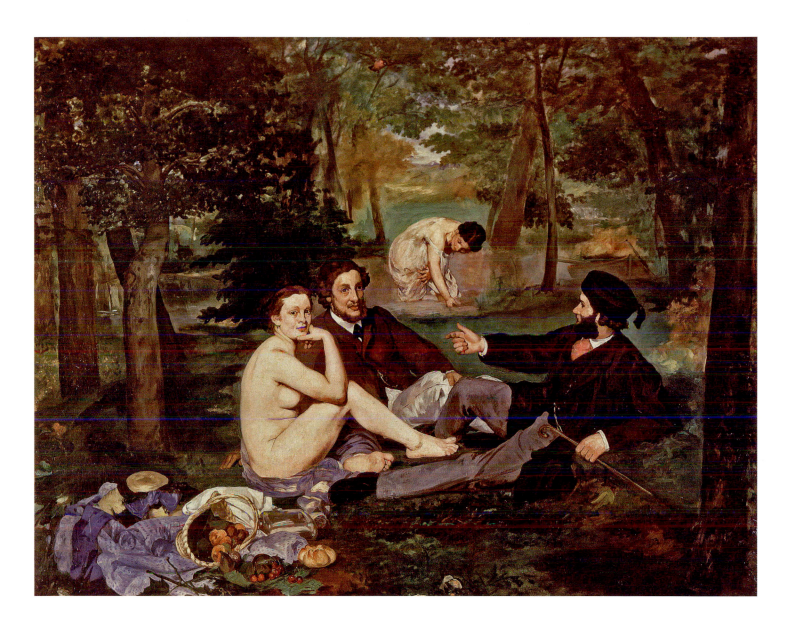

decade of the 16th century. Their styles were so similar that their work is often difficult to identify, leading to confusion in the attributions of several key paintings, including the *Concert Champêtre*, c.1510 (Louvre, Paris). Titian is known to have altered or completed several of Giorgione's late works including the *Sleeping Venus*, 1509–10 (Alte Meister Gallerie, Dresden). The Dresden Venus initiates the line of mythological nudes explored by Titian over the next 50 years, most notably in his *Venus of Urbino,* 1538 (Uffizi, Florence), variations of which continue in the works of later artists such as Diego Velázquez, Francisco Goya (1746–1828), Jean-Auguste-Dominique Ingres (1780–1867), Pierre-Auguste Renoir (1841–1919), Paul Gauguin (1848–1903), Henri Matisse (1869–1954), and Pablo Picasso (1881–1973).

Titian emerged from Giorgione's shadow after the latter's sudden death from the plague in 1510. Masterpieces from

this period include the portrait, *Man with a Quilted Sleeve*, c.1512 (National Gallery, London); a private devotional image, the *Noli Me Tangere,* c.1514 (National Gallery, London); as well as an allegorical figure of *Flora*, c.1520 (Uffizi, Florence). In its monumentality of form, gracefulness of gesture, and rich intensity of color, Titian's *Assumption of the Virgin*, 1517 (Santa Maria Gloriosa dei Frari, Venice), marks the beginning of the High Renaissance in Venice. His *Pesaro Madonna,* 1519–26 (Santa Maria Gloriosa dei Frari, Venice) for the same church was also revolutionary. It reoriented the traditional compositional scheme of the religious altarpiece away from a horizontal grouping to a receding diagonal that penetrates the fictive space of the composition.

Déjeuner sur l'Herbe,
*Edouard Manet, 1863,
Musée d'Orsay, Paris*

Titian's *The Pastoral Concert* entered the Royal Collections in France in the 17th century and had a considerable influence on French painting. Manet's direct quotation of the Titian work is an updated, contemporary luncheon in the grass.

BAROQUE

The word "Baroque," is the term used to describe Western art and architecture in the 17th century. The exact origins of the word are unclear. It may derive from the Portuguese word *barrocco* referring to a rough or irregularly shaped pearl. The word's appearance as a stylistic term dates back to the late 18th century when critics who disliked what they considered to be the excessive and free inventions of the 17th century, especially in comparison with the earlier Renaissance style, used the word in a disparaging manner.

1492

CHRONOLOGY

1492	1541	1545	1576	1599	1605	1607	1621
Christopher Columbus discovers the Americas	St. Ignatius Loyola writes Spiritual Exercises	Roman Catholic Church convenes Council of Trent	Titian dies	Caravaggio in Rome working on Calling of St. Matthew	Publication of The Ingenious Hidalgo Don Quixote of La Mancha by Cervantes	Monteverdi's opera L'Orfeo premieres in Mantua	Van Dyck travels to Italy and begins his Italian Sketchbook

As with Renaissance art, the Baroque style traces its origins to Italy and was influenced by the Roman Catholic Church's response to the Protestant Reformation during this period (the Counter-Reformation). Rome was the major center for the Italian Baroque style that took on Classical aspects, seen in the works of Gianlorenzo Bernini (1598–1680) and Annibale Carracci (1560–1609). A more realistic strain of the Baroque style is found in the paintings of Caravaggio (1571–1610), and his many followers including Orazio (1563–1639) and Artemisia Gentileschi (c.1593–c.1652). Baroque art in Spain, France, and Holland followed much the same dichotomy seen in the Classically inspired works of the Flemish painter Peter Paul Rubens (1577–1640), and his younger French contemporary Nicolas Poussin (1594–1665); and the lively realism of Rembrandt van Rijn (1606–69) in Holland, and Diego Velázquez (1599–1660) in Spain.

By the 17th century, Europe's conflicts between Catholics and Protestants had evolved into the reality of a continent destined to be divided along religious lines, and defined by the political, economic, and military ambitions of powerful nation-states such as Spain, France, and England. Baroque art and culture reflected this amalgam of cultural, spiritual, and secular forces.

The 17th century, as the century before it, witnessed great accomplishments by remarkable individuals, not only in the visual arts of painting, sculpture, and architecture, but in literature, theater, music, science, philosophy, and religion. Miguel de Cervantes (1547–1616), William Shakespeare (1564–1616), Claudio Monteverdi (1567–1643), Galileo Galilei (1564–1642), Johannes Kepler (1571–1630), Sir Isaac Newton (1643–1727), Blaise Pascal (1623–62), René Descartes (1596–1650), Baruch Spinoza (1632–77), and Saint Ignatius Loyola (1491–1556) expanded the boundaries of human inquiry, achievement, empirical knowledge, and spiritual fulfillment.

RELIGIOUS THEMES

For Italian painters such as Caravaggio, the Baroque spirit manifested itself through religious subjects stressing the sacrifice and martyrdom

1492–1661

1661

1625	1628	1633	1635	1637	1641	1656	1658	1660–61
Rubens completes the Marie de Medici allegorical cycle in Paris	Velázquez and Rubens meet in Madrid	Galileo convicted for heresy by the Inquisition for his book Dialogue Concerning the Two Chief World Systems (1632)	Rembrandt paints Belshazzar's Feast	Descartes posits "I think, therefore I am" in his Discourse on the Method	Poussin appointed First Painter to King Louis XIII of France	Velázquez paints Las Meninas (The Maids of Honor)	Bernini begins work on Rome's Sant'Andrea al Quirinale church	Vermeer paints View of Delft

of the **Roman Catholic Church's** many saints: paintings meant to appeal directly to the human emotions of believers in a post-Reformation world. Through powerfully muscled forms, theatrical effects of light, dynamic rhythms, and an emphasis on the most dramatic moment in a story, viewers became active participants in Caravaggio's revolutionary interpretations of traditional religious themes.

Northern Baroque painters, such as Rembrandt, emphasized a direct relationship between God and the faithful in opposition to the hierarchical and magisterial language of Italian painters. Through images of quiet introspection bathed in a soft light that seems to emanate from the deepest recesses of his compositions, Rembrandt probed the personal side of spiritual crisis and suffering, thereby equating it with all human pain and affliction.

THE BAROQUE LEGACY
Despite variations in style and goals between Italian and northern Baroque painters, and artists committed to Classicism and Realism,

Baroque painters throughout Europe explored an impressive array of illusionistic effects based on a return to nature and an engagement with the expressive power of light, color, and movement. By so doing, Baroque artists reestablished the Renaissance principles of Classicism, proportion, and harmony that had recently been challenged by the style known as Mannerism (c.1520–80).

The implications of the formal language of Baroque painting resonated throughout subsequent centuries becoming crystalized in the 19th-century debate between the followers of Rubens (Rubenistes) and Poussin (Poussinistes)—a debate between the relative importance of color versus drawing and design. This Baroque legacy of influence would continue into the 20th century, shaping the Modernist visions of both Henri Matisse and Pablo Picasso.

Rubens (Rubenistes)
Poussin (Poussinistes)
Color vs. drawing design

Caravaggio brought a realism to painting in his fervent portrayals of both sacred and secular subjects. Painting directly on his canvas, using exaggerated effects of light and dark, he interpreted both revered saints and humble sinners through the lens of human suffering and emotion. Caravaggio's art was revolutionary, his life tragic, and his followers many.

INFLUENCED BY

KEY
- ● artist
- ◆ artistic movement
- ■ cultural influence
- ❖ religious influence

◆ **Classical Art**
Caravaggio's important patrons in Rome allowed him access to many of the greatest public and private collections of Classical and High Renaissance art in the city.

● **Michelangelo**
(1475–1564)
Caravaggio owed much to the expressive body language in Michelangelo's art. But Caravaggio's paintings reflected a new spirit of realism, and the power of light and dark, known as "tenebrism."

● **Titian**
(c.1490–1576)
Whether Caravaggio traveled to Venice is much debated. His teacher, Peterzano, was known as a "student of Titian," and at least one Titian painting was in Milan during Caravaggio's lifetime (right: *The Crowning with Thorns*, 1542).

● **Sofonisba Anguisciola**
(c.1532/5–1625)
Caravaggio may well have known works by this artist from Cremona. Her drawing *Child Bitten by a Crayfish* (c.1554) relates to Caravaggio's early painting *Boy Bitten by a Lizard* (c.1595).

CARAVAGGIO (1571–1610)
Italian

	Born September 29 in Caravaggio, a small town in the region of Bergamo	Enters the studio of Simone Peterzano, known as a "student of Titian," in Milan	Departs for Rome. Does early paintings on secular themes, Boy Bitten by a	Lizard, and The Musicians	Executes paintings on the Life of St. Matthew for the church of San	Luigi dei Francesi. Paints the Crucifixion of St. Peter and Conversion of St.	Paul for the church of Santa Maria del Popolo	Paints the Madonna of Loreto
CHRONOLOGY	**1571**	**1584**	**1595–98**		**1600–04**			**1605**

INSPIRED

● **Artemisia Gentileschi**
(c.1593–c.1652)
Gentileschi inherited the bold effects of light and shadow, powerful forms, and dramatic narratives of Caravaggio from her father, the painter Orazio Gentileschi (1563–1639).

◆ **Utrecht Caravaggisti**
These Dutch followers of Caravaggio included Dirck van Baburen (c.1590–1624), Gerrit van Honthorst (1590–1656), and Hendrick ter Brugghen (1588–1629). All had worked in Rome, and were deeply affected by Caravaggio's style.

● **Georges de La Tour**
(1593–1652)
La Tour's dark, backlit paintings owe a debt to Caravaggio by way of Utrecht painters such as Honthorst.

● **Rembrandt van Rijn**
(1606–69)
Rembrandt's use of light as a narrative and spiritual device, and the drama of his early religious paintings such as the *Blinding of Samson* (1636), reveal the impact of Caravaggio.

● **Théodore Géricault**
(1791–1824)
Géricault copied one of Caravaggio's most influential works, the *Entombment* (c.1603), just before beginning his painting *Raft of the Medusa* (1818–19).

In a modern world where the idea of the artist as outsider has become a cliché, the art and life of Caravaggio remain moving testaments to a bona-fide revolutionary painter and rebellious spirit. The artistic achievements of few painters would be able to withstand the drama, scandals, mysteries, legends, and tragedy of Caravaggio's personal life. The fact that his place as one of the most significant figures in Western art remains secure is proof of the substance of his legacy as a painter.

The revolution of Caravaggio's art embodied the rejection of both the idealized beauty of Renaissance art and the formal artifice of Mannerism to usher in a painting style based on realism, truth to nature, and emotional honesty. From his early mythological fantasies, to the brooding still-lifes, and anecdotal genre paintings of musicians and card sharps, Caravaggio sought to bring painting in line with an innovative vision of the unvarnished truth of life.

It is in his religious paintings, however, that Caravaggio made his greatest contribution to the history of art: Finding the truth of his subjects, and revealing the human dimension of suffering and revelation to link his paintings directly to the faith of his viewers. In the *Calling of St. Matthew*, 1599–1600 (Contarelli Chapel, San Luigi dei Francesi, Rome), the *Crucifixion of St. Peter*, 1600–01 (Cerasi Chapel, Santa Maria del Popolo, Rome), and the *Conversion of St. Paul*, 1600–01 (Cerasi Chapel, Santa Maria del Popolo, Rome), Caravaggio created a potent mix of the spiritual and earthly, the mystical and the real, coalesced into moments of supreme drama and meaning. In the exaggerated effects of light and shadow, powerfully foreshortened figures, diagonal movements, and bold touches of color used as contrapuntal points of emphasis, Caravaggio conveys the surprise of St. Matthew's recognition, the torment of St. Peter's sacrifice, and the mystery of St. Paul's transformation.

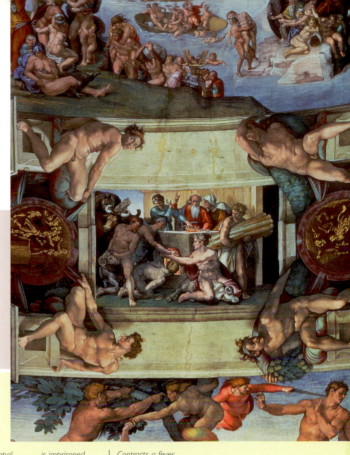

The Sacrifice of Noah,
Michelangelo, 1508–10, Sistine Chapel Ceiling, Rome

Michelangelo's depiction of the human body on the ceiling of the Sistine Chapel served as a textbook for Caravaggio and countless artists to follow.

❖ **Spiritual Exercises**
(1541)
Caravaggio's art was a visual counterpart to many ideas expressed in this text that encouraged prayer and devotional exercises written by St. Ignatius Loyola (1491–1556), founder of the Society of Jesus (1534).

❖ **Council of Trent**
(1545–63)
The Protestant Reformation prompted the Roman Catholic Church to convene this council to debate issues of reform. Baroque art was a part of the religious revival of the Roman Catholic Church.

● **Claudio Monteverdi**
(1567–1643)
Music played an important role in Caravaggio's art. Composer Monteverdi was Caravaggio's great contemporary and the father of modern opera. His opera *L'Orfeo* (1607) premiered in Mantua, and ushered in the era of the musical drama.

Kills a man, and is wanted for murder; he escapes to Naples. Paints the	Seven Works of Mercy.	Departs for Malta	Flees Malta for Sicily; paints the Resurrection of Lazarus. Returns to Naples, and is	seriously wounded in a fight	Seeks a papal pardon, so sets out for Rome. Disembarks at Porto Ercole, and	is imprisoned by mistake	Contracts a fever, possibly malaria. Dies July 18 in Porto Ercole
1606		**1607**	**1607–09**		**1609**		**1610**

● **Derek Jarman**
(1942–94)
Jarman's film, *Caravaggio* (1986), is a lavish and appropriately "baroque" visual exploration of the artist's life, art, and times.

● **John Tilbury**
(b.1936)
The Hands of Caravaggio (2001), a concerto created by Keith Rowe (b.1940), and inspired by Caravaggio's painting *The Taking of Christ* (1602), was recorded by this British pianist and the ensemble M.I.M.E.O.

❖ **Popular Art and Culture**
Caravaggio's art, and his chaotic and troubled life—filled with intrigue, duels, and escapes from the law—have been the subject of films, historical novels, plays, and contemporary music.

St. John the Baptist,
Caravaggio, 1602, Galleria Doria Pamphilj, Rome

The expressive body language of Michelangelo's male nudes (*ignudi*) from the ceiling of the Sistine Chapel influenced Caravaggio. However, Caravaggio's work heralded a new spirit of realism and a more dramatic use of light and shadow.

Judith Beheading Holofernes,
Caravaggio, c.1595–1600, Palazzo Barberini, Rome

In *Judith Beheading Holofernes* the violence, dramatic light, and unflinching realism of Caravaggio's style are apparent.

ABOUT THE WORK

Caravaggio often chose to portray violent scenes. Here, he tackles a theme from the Apocrypha showing Judith, a patriotic Jewish heroine, saving her people by killing an Assyrian warlord. Most artists depicted the moment after the head had been severed, but Caravaggio preferred to illustrate the brutal process of decapitation, lingering over the details with obvious relish.

LIGHT

Caravaggio increased the dramatic impact of his paintings with striking light effects. Most of his scenes are set in darkness, with a little background detail. By contrast, his figures are brightly lit, compelling the viewer to concentrate on them and their actions.

MOOD

Caravaggio shocked contemporaries with his unflinching realism. Here,

Judith's troubled frown and Holofernes's despairing grip on the bedsheet (1) help bring the horror of the situation to life.

EXPRESSION

The grotesque expression on the maid's face (2) adds to the air of tension. Caravaggio may have been inspired by caricatures produced by Leonardo da Vinci and other Renaissance masters.

Many patrons attacked Caravaggio's paintings for their lack of idealized forms and insensitivity to religious tradition. It was Caravaggio's ability to make the spiritual appear real, the transcendental human, and the unexplainable comprehensible that links him to such contemporaries as St. Ignatius Loyola, St. Philip Neri (1515–95), scientist Galileo Galilei (1564–1642), and composer Claudio Monteverdi. Ultimately, Caravaggio's art played a major role in the Roman Catholic Church's desire to reclaim its faithful and win converts.

The critical fortunes of Caravaggio and his art would rise and fall through subsequent centuries. Nicolas Poussin (1594–1665), claimed that he "came to destroy painting." Johann Joachim Winckelmann (1717–68), Sir Joshua Reynolds (1723–92), and Stendhal (1783–1842), took little notice of him. Swiss painter Henry Fuseli (1741–1825) admired Caravaggio's courage in stressing the power of expression over ideal beauty. For English critic John Ruskin (1819–1900), he was simply vulgar and sinful. The stark realism of Caravaggio's style and his direct engagement with the truth of nature would nonetheless have a profound impact on the later history of Western painting, from the 17th-century art of Rembrandt van Rijn, Jusepe de Ribera (1591–1652), Diego Velázquez (1599–1660), and Georges de La Tour, to the Neoclassical works of Jacques-Louis David (1748–1825), and the 19th-century paintings of Théodore Géricault, Eugène Delacroix (1798–1863), Gustave Courbet (1819–77), and Édouard Manet (1832–83). Caravaggio's life and art continue to inspire contemporary literature, film, theater, dance, music, and design.

Judith Slaying Holfernes,
Artemisia Gentileschi, c.1614–20, Uffizi, Florence
Both Artemisia and her father Orazio were followers of Caravaggio and employed his exaggerated effects of light and shadow (tenebrism) and powerful forms to create dramatic effects.

Peter Paul Rubens is one of the Baroque era's most innovative and versatile artists. A man of vast energy and numerous interests, he supervised a large and successful studio that enabled him to fulfill commissions from patrons across Europe. His paintings are characterized by bold colors, dynamic compositions, and vigorous brushwork. Respect and admiration for Rubens and his art have diminished little in the centuries since his death.

INFLUENCED BY

KEY
- ● artist
- ◆ artistic movement
- ■ cultural influence
- ❖ religious influence

◆ Antique Art
Rubens wrote: "In order to attain the highest perfection in painting, it is necessary to understand ancient art" (right: *The Medici Venus*).

● Titian
(c.1490–1576)
Titian's innate understanding of the properties of oil paint, his sensuous color, and atmospheric effects of light all influenced Rubens.

■ Justus Lipsius
(1547–1606)
The Belgian scholar and humanist most responsible for attempting to resurrect Stoic philosophy. Rubens' brother studied with Lipsius, and conveyed his ideas to the painter.

● Caravaggio
(1571–1610)
Caravaggio's realism, powerfully modeled figures, and dramatic effects of light found followers throughout Europe, including Rubens.

PETER PAUL RUBENS (1577–1640)
Flemish

	Born June 28 in Seigen, Westphalia	Apprenticed with the Antwerp artist Otto van Veen (1556–1629)	Becomes a master in the Painters' Guild of St. Luke in Antwerp	Begins eight-year-long stay in Italy, and is appointed court painter to Vincenzo	Gonzaga (1562–1612), Duke of Mantua	Appointed court painter to Archdukes Albert and Isabella. Marries Isabella	Brandt (d.1626)	Anthony van Dyck joins Rubens' growing workshop
CHRONOLOGY	**1577**	**1594**	**1598**	**1600**		**1609**		**1618**

INSPIRED

● Anthony van Dyck
(1599–1641)
Rubens identified Van Dyck as his most gifted assistant. It was the example of Rubens' art that contributed to Van Dyck's distinguished career (right: *James Stuart*, c.1633–34).

◆ Rubenistes
Artists in the French Academy who, as Rubens, believed in the importance of color and brushwork over design and drawing as advocated by the "Poussinistes" followers of Nicolas Poussin (1594–1665).

● Jean-Antoine Watteau
(1684–1721)
Watteau's concept of the *fête galante* (fashionable outdoor gatherings) was inspired by similar stylish alfresco scenes in Rubens' art.

● Eugène Delacroix
(1798–1863)
Delacroix strongly identified with Rubens. He wrote: "[Rubens] dominates, he overwhelms you with so much liberty and audacity."

Peter Paul Rubens has had few equals among artists over the centuries. His vast artistic production identifies him as one of the innovators of the Baroque, and his keen intellect informed his work as a Classical scholar, book illustrator, renowned collector of art and antiquities, and diplomat. A staunch supporter of the Roman Catholic faith, Rubens was knighted by the kings of both England and Spain. Perhaps unduly associated with his large, fleshy, female figures that set the standard of beauty during his lifetime, it was his vigorous brushwork and brilliance as a colorist that are central to his genius as a painter.

Rubens was born in 1577 in Seigen, Westphalia. Following his father's death, the family returned to Antwerp in 1589. He then attended Latin school, and became a court page. Two years later his formal artistic training began in the studio of Tobias Verhaeght (1561–1631), and continued with Adam van Noort (1562–1641). Rubens then entered the workshop of Otto van Veen (1556–1629), whose keen intellect was not lost on the fast-maturing artist. Rubens joined the Antwerp Painters' Guild of St. Luke in 1598.

Yet perhaps Rubens' real education came during an eight-year-long stay in Italy; he also visited Spain as a representative of his employer Vincenzo Gonzaga, Duke of Mantua. In addition to acquiring firsthand knowledge of antique art and the Italian Renaissance, he witnessed the development of the Italian Baroque. His subsequent paintings betray influences as diverse as Classical sculpture, Titian, and Caravaggio.

His return to Antwerp in late 1608 came just before the beginning of a 12-year-long truce between the Spanish-controlled southern Netherlands and its northern provinces, soon to be the Dutch Republic. Conversant with a modern Baroque style, and in a city in need of artistic renovation,

Venus of Urbino,
Titian, 1538, Uffizi, Florence

Titian drew upon a work by his Venetian predecessor Giorgione for this image of a reclining female nude. More like a mortal than a goddess, Titian's painting is both sensual and provocative as well as elegant and reserved.

■ Neo-Stoicism
The attempt in the 16th and 17th centuries to revive ancient Stoic philosophy and reconcile it with Christian beliefs. Rubens followed Neo-Stoic doctrine stressing reason, self-discipline, and obedience to nature's laws.

❖ Counter-Reformation
The Roman Catholic Church's response to the effects of the Protestant Reformation. Among the initiatives was a call to artists to create dramatic images of the suffering of Christ, and the lives of saints and martyrs.

Commissioned to decorate the new Jesuit church in Antwerp	Completes the Marie de Medici allegorical cycle in Paris	Involved in diplomatic activities taking him to Spain, England, and the northern Netherlands	Knighted by King Charles I in England; marries 16-year-old Helena Fourment	Dies May 30 in Antwerp
1620	**1625**	**Late 1620s**	**1630**	**1640**

●Pierre Auguste Renoir
(1841–1919)
The inspiration of Rubens is seen in Renoir's move toward more full-bodied nude forms and mythological subjects late in his career (left: *Diana*, 1867).

● Jenny Saville
(b. 1970)
Saville's monumental images of male and female bodies echo the tactile properties of Rubens.

The Three Graces,
Peter Paul Rubens, mid-1630s, Prado, Madrid

Handmaidens of Venus, the Three Graces personified Chastity, Beauty, and Love in ancient mythology. This painting reflects Rubens' admiration for Titian's art, his palette, and technique.

The Garden of Love,
Peter Paul Rubens, mid-1630s, Prado, Madrid

Rubens anticipated the Rococo in this large, colorful masterpiece from the last decade of his life.

ABOUT THE WORK

This painting's genesis can be traced to the love gardens found in medieval manuscript illumination. Here Rubens applies his Baroque vocabulary of dynamic forms to combine the real with the mythical. Interpretations of the work have varied, from a biographical reading to wider themes related to contemporary fashion, social refinement, and courtship.

BRUSHWORK

As in many of his late works, Rubens takes a more painterly approach to enhance the dynamic character of the subject. The painting reveals his renewed interest in Titian and anticipates the language of Watteau in the 18th century.

COLOR

Rubens juxtaposed bright areas of red, blue, white, and rust with darker colors (1) to lead the viewer through the composition. Flesh tones are used extensively, providing a balance and structure to the frieze of figures across the foreground.

MOOD

The motifs within the composition create a moment that is both private and public. The picture's colorful palette, lively brushwork, and use of light combine to convey a lighthearted mood that encourages the viewer to join in the festivities.

Departure from the Island of Cythera,
Jean-Antoine Watteau, 1717, Louvre, Paris

This painting identified Watteau as a painter of *fêtes galantes* (outdoor party). Its pastel colors, feathery brushwork, and lyrical subject matter are among the elements associated with this type of theme.

Death of Sardanapalus,
Eugene Delacroix, 1828, Louvre, Paris

With this scene, Delacroix demonstrated his leadership among French Romantic painters. The subject was inspired by Lord Byron but the hot palette, active brushwork, and dynamic composition are indebted to Rubens.

Rubens became an instant triumph, and was much in demand. His dynamic, colorful style proved sympathetic to the prevailing Counter-Reformation mood in the city, as well as to the interests of friends and colleagues who shared his Neo-Stoic philosophy.

Rubens became a court painter, married, organized his large workshop, accumulated wealth, and enjoyed all the benefits that accompany such success. Commissions came from the Roman Catholic Church, various European royal houses, and powerful patrons and friends. Never content to limit his artistic vision, his style evolved over time. His early naturalistic and dramatic manner gave way to a Classical repose, only to be followed by his grand decorative schemes, and then a more personal and atmospheric style seen in his landscapes and portraits. In his later works Rubens also revealed a renewed interest in the art of Titian.

Rubens' popularity demanded a large workshop in which many of Antwerp's most important artists participated, among them Anthony van Dyck, Jacob Jordaens (1593–1678), and Frans Snyders (1579–1657). As a Neo-Stoic, Rubens seems to have been highly disciplined and actively engaged in a variety of endeavors. His resolve briefly waned after the death of his first wife in 1626, and during this period his diplomatic activities abroad intensified, possibly as a diversion from his loss. Renewed energy and focus came with his second marriage, although illness eventually curtailed his activity during the last years of his life.

Nicolas Poussin was the leading proponent of Classicism in European Baroque painting. Born in France but mostly active in Rome, the restraint and intellect he applied to his compositions were matched only by the order he brought to his personal life. His paintings exerted enormous influence on the French Academy for more than a century, where his followers became known as the "Poussinistes."

INFLUENCED BY

KEY
● artist
◆ artistic movement
■ cultural influence
❖ religious influence

◆ **Classical Art**
Poussin was deeply affected by the formal and moral strength of ancient Greek and Roman art (right: *The Laocoon Group*, first century).

● **Titian**
(c. 1490–1576)
The power and vibrant color of Titian's work were important influences on the development of Poussin's palette (right: *The Holy Family and a shepherd*, c.1510).

NICOLAS POUSSIN (1594–1665)
French

	Born in Les Andelys, a village in Normandy	Moves to Paris, remaining there for more than a decade	Arrives in Rome, via Venice	Marries Anne-Marie Dughe	Becomes a member of the Academy of St. Luke in Rome	Urged by Cardinal Richelieu, goes to Paris and is presented to King Louis XIII	Appointed First Painter to the King of France	After an unhappy stay in Paris, returns to Rome where he stays for the rest of his life
CHRONOLOGY	**1594**	**1612**	**1624**	**1630**	**1631**	**1640**	**1641**	**1642**

INSPIRED

● **Charles Lebrun**
(1619–90)
Lebrun directed the reorganized French Academy, creating a system of artistic orthodoxy based on the Classicism of Poussin.

● **Jacques-Louis David**
(1748–1825)
The great Neoclassical paintings of David drew upon thematic and formal precedents in the art of Poussin (right: *The Death of Socrates*, 1787).

● **Jean-Auguste-Dominique Ingres**
(1780–1867)
Ingres upheld the Classical tradition of Poussin in direct confrontation with Delacroix and his Rubenistes followers in the 19th century.

Born in the Norman village of Les Andelys, Nicolas Poussin was one of the most important and influential painters of his age. Limited by the training received in his hometown, the young artist soon moved to Paris. There he was drawn to Classical art and Renaissance masters, including Raphael and Titian. Poussin's passion for the Classical intensified during his stay in Rome beginning in 1624, and his Neo-Stoic philosophy found its equal in his paintings of religious and Classical subjects. Basing his creativity on the intellect rather than the eye, Poussin's pictures express an antiquarian spirit. In his figures contours are hardened, movement frozen, gestures articulated, and emotion drained.

Poussin's severe form of Classicism separated his art from the works of his Baroque contemporaries. As a consequence, he was not fully embraced by the Church and important patrons in Rome. By contrast, the French at the court of King Louis XIII were more sympathetic to his goals. After much urging, Poussin returned to Paris in 1640 and briefly worked as First Painter to the King. Two years later he returned to Italy, but his popularity among the French bourgeoisie never waned. Back in Rome, his painting style continued to evolve, with his compositions reflecting increasingly stringent "rules" for clarity of conception, and intellectual and moral solemnity.

The qualities found in Poussin's mature works were ones that members of the French Academy enthusiastically embraced. Identified as "Poussinistes," they emphasized Classical design and the primacy of line. They were opposed by the followers of Rubens, the "Rubenistes," who stressed the importance of color and emotion. It was a debate that continued for almost two centuries, culminating with the battle between Jean-Auguste-Dominique Ingres and Eugène Delacroix (1798–1863) in the 19th century.

Madonna of the Fish,
Raphael, c.1514, Prado, Madrid

Raphael controls the emotion in his painting and weds a balanced composition to a subtle color scheme reflecting High Renaissance goals of perfection and harmony.

● **Raphael**
(1483–1520)
Raphael's Classically-inspired subject matter and formal logic influenced Poussin. One contemporary described Poussin as "the Raphael of our century."

● **Annibale Carracci**
(1560–1609)
Carracci's exploration of Classical and Renaissance prototypes reinforced both the formal and thematic aspects of Poussin's art.

■ **Neo-Stoicism**
Like Peter Paul Rubens (1573–1640), Poussin shared this philosophy of restraint and endurance that Renaissance scholars had revived from antiquity.

Finally elected head of Rome's Academy of St. Luke, but rejects the honor

In failing health and no longer able to work, dies on November 19;

buried in the church of San Lorenzo in Lucina, Rome

1657 **1665**

● **Paul Cézanne**
(1839–1906)
Cézanne wanted "to do Poussin again, from Nature."

● **Pablo Picasso**
(1881–1973)
Seeking an art based less on personal expression and more on an intellectual investigation of form and space, Picasso looked back to Poussin.

● **George Braque**
(1882–1963)
After a brief flirtation with the expressive tenets of Fauvism, Braque reevaluated Poussin's art in search of greater structure.

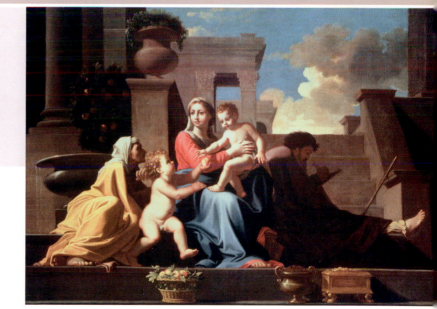

The Holy Family on the Steps,
Nicolas Poussin, 1648, Cleveland Museum of Art, Cleveland, Ohio

In the *Holy Family*, Poussin reveals his Classical interests through the triangular composition, (somewhat energized by the low vantage point), controlled brushwork, and balanced local colors. The frozen expressions and strongly modeled bodies of the figures display a cool abstraction.

Diego Velázquez is considered by many to be the greatest European painter ever. His unrivaled talent as an oil painter is often viewed as the zenith of achievement in the medium, especially by fellow painters. Given the list of remarkable artists who have worked in oils, including such perfectionists as Jan van Eyck and Leonardo da Vinci, such recognition of Velázquez' place in the history of painting is high praise.

INFLUENCED BY

KEY
● artist
◆ artistic movement
■ cultural influence
❖ religious influence

● **Titian**
(c.1490–1576)
A collection of Titian's paintings was at the Spanish court by the end of the 16th century. Velázquez was indebted to the bold compositions, colors, atmospheric light, and expressive brushwork of Titian.

● **Tintoretto**
(1518–94)
During his first Italian sojourn, Velázquez made copies of Tintoretto's *Crucifixion* (1566) and *Last Supper* (1594) in Venice. He presented his copy of the *Last Supper* to the king.

● **El Greco**
(1541–1614)
Velázquez' teacher, Francisco Pacheco, visited El Greco in Toledo in 1611, soon after Velázquez entered Pacheco's studio. Velázquez admired El Greco's portrait style.

● **Miguel de Cervantes**
(1547–1616)
Velázquez and Spanish writer Cervantes shared a belief in the importance of truth in art. They were sympathetic to the poor and infirm, and stressed the dignity and worth of everyone, regardless of social standing.

● **Francisco Pacheco**
(1564–1654)
The teacher of Velázquez, Pacheco wrote an important treatise on painting, and was Censor of Paintings to the Spanish Inquisition at the time. Velázquez married Pacheco's daughter in 1618.

DIEGO VELÁZQUEZ (1599–1660)
Spanish

	Born in Seville; son of a lawyer of Portuguese origin	Publication of The Ingenious Hidalgo Don Quixote of La Mancha by Miguel de	Cervantes (1547–1616)	Enters the studio of Francisco Pacheco in Seville	Marries Juana Pacheco (1602–60), daughter of his teacher	Paints The Water Carrier of Seville	Summoned to Madrid to paint a portrait of the king (now lost);	named official court painter
CHRONOLOGY	**1599**	**1605**		**1611**	**1618**	**1619**	**1623**	

INSPIRED

● **Francisco Goya**
(1746–1828)
Goya was Velázquez' true heir in the history of Spanish painting, reflecting the influence of the Baroque master in almost every aspect of his art.

◆ **Spanish Revival in France**
By the 1860s the French taste for Spanish art and culture reached a pinnacle affecting painters such as Gustave Courbet (1819–77) and Édouard Manet, and composers such as Georges Bizet (1838–75).

● **Édouard Manet**
(1832–83)
Manet's trip to Spain in 1865 was a seminal moment in his career. His "Spanish" style of the 1860s was directly related to his admiration for, and study of, Velázquez' art.

● **James Abbott McNeill Whistler**
(1834–1903)
Whistler's full-length portraits of isolated figures seen against blank backgrounds, restricted color schemes, and brushwork are all indebted to Velázquez.

● **Thomas Eakins**
(1844–1916)
Eakins discovered Velázquez on a trip to Spain in 1869. The psychological quality of his portraits, and rich effects of light and shadow relate to Velázquez.

Few painters in the history of Western art have been as influential and as admired as Diego Velázquez. The list of those who have acknowledged a debt to Velázquez includes some of the most gifted painters in art history who, themselves, were original and remarkable artists. Velázquez' originality was so complete, his technique so breathtaking, his vision so unique, that his true heirs would not be found among his younger Spanish contemporaries such as Bartolomé Esteban Murillo (1617–82), but among the more revolutionary artists of the 19th century including Gustave Courbet, Édouard Manet, James Abbott McNeill Whistler, Thomas Eakins, and John Singer Sargent. Velázquez is, however, a Spanish painter occupying a position of primacy in one of the greatest art-historical lineages that any single national school can boast: the lineage from El Greco to Velázquez, to Francisco Goya, and Pablo Picasso.

Velázquez was born in Seville in 1599 during the Golden Age of Spanish art and culture that began with the voyages of Christopher Columbus in 1492 and ended with the Treaty of the Pyrenees in 1659. In this period Spain produced some of the greatest names in the visual, musical, and literary arts including the Greek expatriate El Greco, José Ribera (1591–1652), Francisco Zurbarán (1598–1664), Tomás Luis de Victoria (1548–1611), Lope de Vega (1562–1635), and Miguel de Cervantes.

Velázquez' training as an artist began late in 1610 when he was apprenticed to the well-known but not very original painter Francisco Pacheco in Seville. Although not the most gifted artist, Pacheco was a theorist and humanist, and through his circle of friends and scholars the young Velázquez was introduced to the sophisticated intellectual ideas of the Renaissance.

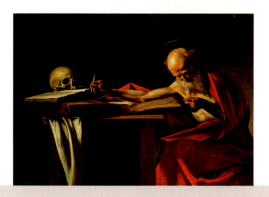

● Caravaggio
(1571–1610)

The realism, dramatic light, common subject, and earthy characters in Velázquez' *Water Carrier of Seville* (1619) owe much to the example of Caravaggio and his followers (above: *Saint Jerome writing*, c.1604).

● Peter Paul Rubens
(1577–1640)

Velázquez met Rubens in 1628 when the Flemish painter was on a diplomatic mission in Madrid. Their encounter stimulated Velázquez to travel to Italy the next year.

Portrait of Pope Paul III,
Titian, 1543, Museo Nazionale di Capodimonte, Naples

Velázquez was familiar with Titian's work, and was influenced by his bold compositions, expressive brushwork, vivid color, and atmospheric lighting.

Meets the Flemish painter Peter Paul Rubens at the Madrid court	Travels in Italy; paints The Forge of Vulcan	Paints The Surrender at Breda	Second trip to Italy, and paints Portrait of Pope Innocent X while in Rome	Paints Las Meninas (The Maids of Honor)	Receives the Order of the Knights of Santiago	Dies August 6 in Madrid
1628	**1629–31**	**1634–35**	**1649–51**	**1656**	**1658**	**1660**

● John Singer Sargent
(1856–1925)

The spatial complexity in Sargent's *Daughters of Edward Darley Boit* (1882) owes much to the example of Velázquez' *Las Meninas.*

● Pablo Picasso
(1881–1973)

The effect of Velázquez' work on Picasso runs like a thread throughout his career, from his Blue Period portraits, to his numerous variations and reinterpretations of *Las Meninas.*

● Francis Bacon
(1909–92)

Bacon's tortured and visceral paintings based on Velázquez' *Portrait of Pope Innocent X* (c.1650) have become icons of modern angst.

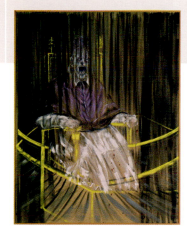

Study after a Portrait of Pope Innocent X,
Francis Bacon, 1953, Private Collection

With their nightmarish visions and contorted images, Bacon's paintings based on Velázquez' *Portrait of Pope Innocent the X* have become iconic.

Portrait of Pope Innocent X,
Diego Velázquez, c.1650, Galleria Doria Pamphilj, Rome

Velázquez' sense of coloration is indebted to Titian, and helps define form and space in this realistic and psychologically penetrating portrait that reveals the pope's humanity.

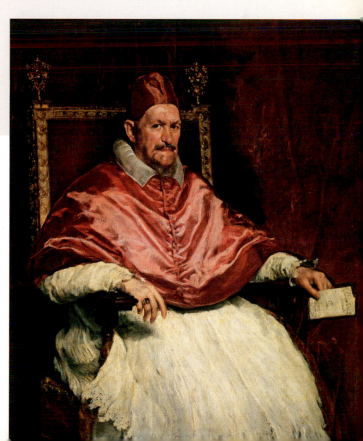

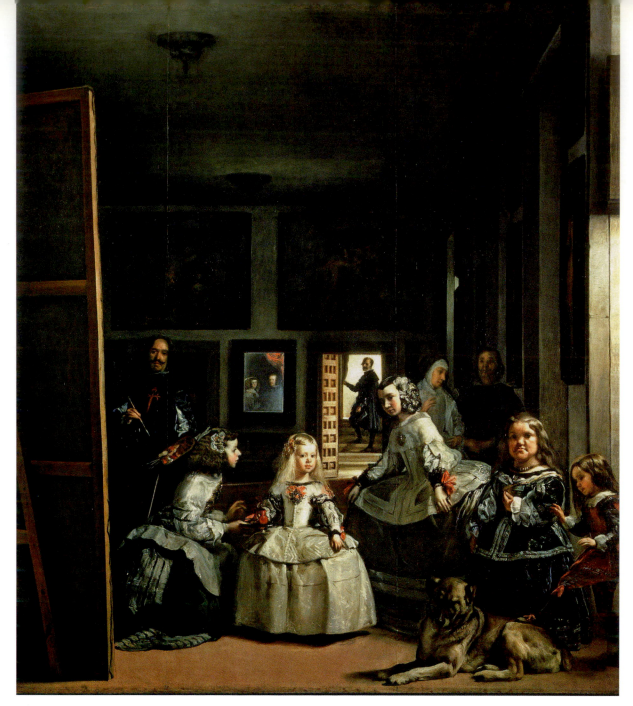

Las Meninas (family of King Philip IV of Spain),
Diego Velazquez, 1656, Prado, Madrid
Velázquez' masterpiece was created at the height of his powers, and its subject matter has caused debate across the centuries regarding the role of the artist in society.

ABOUT THE WORK

Widely acknowledged as Velázquez' masterpiece, *Las Meninas* is also an ingenious, artistic puzzle. Is the artist creating a portrait of the royal couple, their daughter, or an allegory of painting itself? Either way, it is a dazzling example of his virtuoso skills.

LIGHT

Velázquez admired the dramatic light contrasts of Caravaggio and his followers, employing them to good effect here. The light from the right-hand window (1) and the open doorway is just sufficient to illuminate this scene.

COMPOSITION

The artist uses a series of half-obscured rectangles to weave his mystery. At the back, there are two identifiable paintings. Beneath them is a framed image, which resembles a picture but is actually a reflection of the royal couple (or a picture of them) (2). Most teasing of all is the back of the canvas, prominently positioned on the left, with its subject hidden from us.

MOOD

Velázquez' forms appear strikingly realistic, but they were often composed of a flurry of rapid, spontaneous brushstrokes. Viewed close up, for example, the painter's hand consists of nothing more than a few deft streaks of color (3).

The Jester Pablo de Valladolid,
Diego Velázquez, c.1632–35, Prado, Madrid
Velázquez' sense of composition, loose brushwork, strong use of black, and pale coloration of the skin set off against dark colors was to influence artists such as Manet.

The Tragic Actor (Rouvière as Hamlet),
Édouard Manet, 1865–66, National Gallery of Art, Washington, D.C.
Manet visited Spain in 1865, where he studied Velázquez' work. Such was his admiration for his predecessor that he adopted a Spanish style, and this portrait was his homage to the artist.

Velázquez' real education as an artist started with his first trip to Italy in 1629. He had been encouraged to make the trip the year before by Peter Paul Rubens, with whom he became friends during one of the Flemish painter's diplomatic missions to Madrid. Already influenced by Rubens' own painting technique and Venetian-inspired colors, the trip to Italy would reinforce these traits, and Velázquez studied and copied the great works of Titian and Tintoretto in Venice. *The Forge of Vulcan,* 1630, (Prado, Madrid) was a result of the sway of both Rubens and Italian painting on Velázquez. Color and light define forms and space, and Velázquez was less reliant on the detailed realism of his earlier genre paintings such as *The Water Carrier of Seville,* 1619 (Wellington Museum, London), in the tradition of Michelangelo.

The decades of the 1630s and 1640s saw Velázquez' reputation increase. He continued to be supported and appreciated by King Philip IV, who had recognized the talents of the painter as early as 1623 when Velázquez was first summoned to the Spanish court. The combination of King Philip IV's patronage, along with Velázquez' desire to increase his own social status and that of the artist in society, led to the creation of one of the most important paintings in the history of art, *Las Meninas* (The Maids of Honor), 1656 (Prado, Madrid). It depicts the young Infanta Margarita with her maids-in-waiting in the artist's studio. Reflected in the mirror are the images of King Philip IV and Queen Mariana, whose full-length, double portrait Velázquez may be painting. However, it is Velázquez himself who stares out confidently as if to study his subjects, but in reality looks to the future of Spanish painting and the later achievements of Western art.

Anthony van Dyck was one of Europe's most sought-after portrait painters during his brief lifetime. A prodigy, he was painting portraits at the age of 14, and was an assistant to Rubens by the time he was 18 years old. Van Dyck's elegant portrait style inspired many followers, particularly at the English court, where he painted for much of the last decade of his life.

INFLUENCED BY

KEY
● artist
◆ artistic movement
■ cultural influence
❖ religious influence

● **Raphael**
(1483–1520)
Raphael's mastery of both the anatomy and movement of the human body was an important source for Van Dyck's art.

● **Titian**
(c.1490–1576)
Titian's religious paintings and portraits influenced the formal language of Van Dyck's work as they had Rubens'. Van Dyck was an avid collector of paintings by Titian.

● **Peter Paul Rubens**
(1577–1640)
Van Dyck was among Rubens' most gifted assistants. He admired the dramatic compositions, light, color, and brushwork in Rubens' paintings, as well as his intellect.

● **Guido Reni**
(1575–1642)
The elegance and grace of Reni's style appealed to Van Dyck. The two artists may even have met in Bologna (right: *Greek princess Deianira, wife of Hercules*, 1620–21).

ANTHONY VAN DYCK (1599–1641)
Flemish

	Born March 22 in Antwerp	Recorded as a pupil of Hendrik van Balen (1575–1632)	Becomes a master in the Antwerp Painters' Guild on February 11; employed by	Rubens in his workshop	Makes the first of many trips to England	Departs from Antwerp for Italy; arrives in Genoa on November 20	Returns to Antwerp and establishes a studio	Moves to London and is knighted by King Charles I
CHRONOLOGY	**1599**	**1609**	**1618**		**1620**	**1621**	**1627**	**1632**

INSPIRED

● **Peter Lely**
(1618–80)
Trained in the Dutch portrait tradition but a follower of Van Dyck, Lely was described as "the best artist in England" by the middle of the 17th century.

● **Joshua Reynolds**
(1723–92)
Reynolds developed the Grand Manner for his portraits often quoting from the Classical, Old Masters, and Van Dyck (right: *Miss Susanna Gale*, c.1763–64).

● **Thomas Gainsborough**
(1727–88)
This British portrait painter's fresh, spontaneous, and lively portrait style derives in part from Van Dyck.

● **John Singleton Copley**
(1738–1815)
The American painter who settled in London learned much from the naturalistic style of Van Dyck and his many English followers.

Anthony van Dyck was second only to Peter Paul Rubens as the most important Flemish painter of the 17th century. The son of a wealthy silk merchant, his genius as a painter was quickly recognized. By the time he joined Antwerp's Painters' Guild of St. Luke in 1618 his portraits were already in demand, and Rubens considered him to be his most talented assistant. According to one early admirer, Van Dyck's work "is almost as highly appreciated as Rubens." Comparisons with Rubens were not rare, but in spite of his accomplishments as a portraitist and history painter, Van Dyck was never able to escape from the elder artist's shadow.

Van Dyck's career can be divided into four phases. During his first Antwerp period he developed his elegant portrait style, and painted moving religious and mythological scenes that owe much to Rubens' example. A five-year Italian period followed, where—like Rubens before him—he was commissioned to paint fashionable portraits that seamlessly combined the real and the ideal. Returning home in 1627, Van Dyck began his second Antwerp period. During this era he produced many of his greatest masterpieces: portraits of princely patrons and Antwerp burghers (prosperous citizens) alongside important altarpieces.

The final phase of Van Dyck's career was mostly spent in England, arriving there in April 1632. Named a court painter to King Charles I and Queen Henrietta Maria, Van Dyck's output in England was primarily limited to court portraits. The elegant and sophisticated portraits Van Dyck painted in England would influence British painting for centuries—the later work of Peter Lely, Thomas Gainsborough, and Sir Joshua Reynolds are unthinkable without Van Dyck's example.

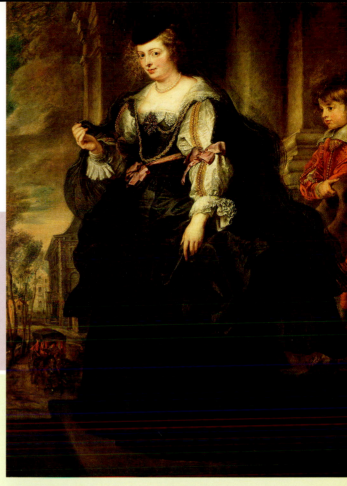

Helene Fourment,
Peter Paul Rubens, c.1639, Louvre, Paris

Although painted late in his life, this picture is a return to an earlier compositional format. His young wife Helene and one of their sons emerge from a stately building. His affection for his wife is complemented by his painting technique and bold palette.

◆ **Van Dyck's** *Italian Sketchbook*

While in Italy between 1621 and 1627, Van Dyck created numerous drawings from life and free copies of famous works of art, especially the paintings of Titian. The sketchbook was a source for his paintings.

◆ *The Iconography*
(c. 1632–44)

A collection of prints, some etched by Van Dyck, others engraved from his drawings, depicting famous artists, princes, and aristocrats of his day.

Elected an honorary dean of the St. Luke's Guild in Antwerp	Marries Mary Ruthven, a noble lady-in-waiting to the English queen	Dies December 9 at Blackfriars, London; buried two days later in	the choir of St. Paul's Cathedral	His tomb and remains destroyed in London's Great Fire
1633	**1639**	**1641**		**1666**

● **Edouard Manet**
(1832–83)

Manet's *Christ Scourged* (1865) is likely to have been based on Van Dyck's painting *Christ Crowned with Thorns* (1620), and an engraving from the painting.

● **John Singer Sargent**
(1856–1925)

Sargent's English portraits portray a Van Dyck-inspired elegance and liveliness (left: *Lady Warwick and her Son*, 1905).

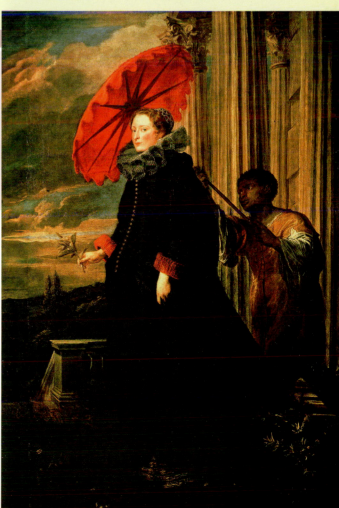

Marchesa Elena Grimaldi Cattaneo,
Anthony van Dyck, 1623, National Gallery of Art, Washington, D.C.

Van Dyck was directly influenced by Rubens' portraits. In this image of a member of a wealthy family, the creamy flesh tones of this aristocratic woman are accented by the red parasol.

Rembrandt van Rijn was the greatest artist of the Dutch Golden age in the 17th century. His sensitivity to the human condition—and talents as a draftsman and painter—allowed him to create compelling portraits, as well as religious and mythological paintings. In a long and industrious career, Rembrandt produced one of the most substantial and important bodies of work in European art. His influence on Dutch art was widespread through his legion of pupils and followers.

INFLUENCED BY

KEY
- ● artist
- ◆ artistic movement
- ■ cultural influence
- ❖ religious influence

■ Nature
At a time when idealization in painting was the accepted mode, Rembrandt carefully studied the true appearance and behavior of people around him.

◆ Italian Renaissance
Rembrandt regularly quoted passages from engravings by or after the works of Andrea Mantegna (1431–1506), Leonardo da Vinci (1452–1519), Raphael (1483–1520) and Michelangelo (1475–1564).

● Titian
(c.1490–1576)
Served as the inspiration for a number of Rembrandt's works, including his *Self-Portrait* (1640).

● Caravaggio
(1571–1610)
Rembrandt derived his dramatic use of light from the powerful chiaroscuro and tenebrism of Caravaggio and his followers in the north, the Utrecht Caravaggisti.

● Peter Paul Rubens
(1577–1640)
Echoes of Rubens' dramatic narratives survived into Rembrandt's later biblical imagery (right: *Samson and Delilah*, c.1609).

REMBRANDT VAN RIJN (1606–69)
Dutch

	Born July 15 in Leiden	Apprenticed to Leiden figure painter Jacob Isaacsz van Swanenburgh	(1571–1631). Studies in Amsterdam with Pieter Lastman	Moves to Amsterdam. Partnership with art dealer, Hendrick Uylenburgh	Paints the Anatomy Lesson of Dr. Nicolaes Tulp	Marries Saskia van Uylenburgh (1612–42), niece of his partner. She poses for many of	his paintings and prints. Becomes a member of the Guild of St. Luke	His son Titus is born. His wife, already in poor health, dies the following year
CHRONOLOGY	**1606**	**c.1620–24**		**c.1630**	**1632**	**1634**		**1641**

INSPIRED

◆ Rembrandt School
Rembrandt had an enormous influence on contemporary Dutch painting through his numerous students and followers.

● Sir Joshua Reynolds
(1723–92)
Reynolds' *Self-Portrait* (1780), with its intended homage to Michelangelo is, in fact, a clear reference in form and content to Rembrandt's *Aristotle with the Bust of Homer*, 1653.

● James Abbott McNeill Whistler
(1834–1903)
Rembrandt was an artistic model for Whistler, from the early etched self-portraits to references to the Dutch master in his "Ten O'Clock" lecture.

● Thomas Eakins
(1844–1916)
The United States' greatest native-born portraitist was inspired by Rembrandt in both his individual portraits and his monumental medical group portraits *The Gross Clinic*, 1875, and *The Agnew Clinic*, 1889.

Rembrandt rose above modest beginnings to become one of the most important painters of his age, and one of the most significant artists in Western art history. His early training, most importantly with Pieter Lastman in Amsterdam, gave him the ability to compose groups of figures drawn from passages in the Bible or derived from Classical literature. His early religious paintings, such as *Belshazzar's Feast*, 1635 (National Gallery, London) and the *Blinding of Samson*, 1636 (Städelsches Kunstinstitut mit Städtischer Galeria, Frankfurt am Main), are Baroque creations rivaling Rubens in their theatricality. These works, as well as his portraits of the time, reveal Rembrandt's understanding of the dramatic contrast of light and shadow in the art of Caravaggio. Rembrandt's later portraits and narrative scenes, including the *Denial of Peter*, 1660 (Rijksmuseum, Amsterdam) and the *Conspiracy of the Batavians under Claudius Civilus*, 1661 (Nationalmuseum,

Stockholm), while superficially calmer, are nonetheless invested with emotion simmering beneath their surfaces.

Rembrandt sketched constantly throughout his life, recording everyday life and the places around him. From the start he was interested in understanding physiognomy—the myriad ways that the human face, posture, and gesture express character and inner emotional states. His many self-portraits explore the power of his own face to communicate through subtle changes in countenance. Rembrandt's study of physiognomy allowed him to invest his art with a vividness and truth that both define and transcend the individual sitter or story depicted. His best portraits, including many of the self-portraits, portraits of his wife Saskia van Uylenburgh and lover Hendrickje Stoffels, Jan Six (1618–1700), and the Syndics of the Draper's Guild, give emotional and intellectual insight into subtle and poignant aspects of the human condition.

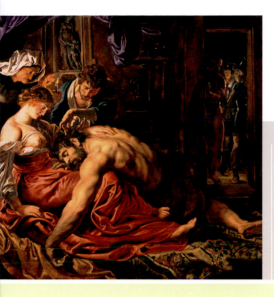

A Man with a Quilted Sleeve,
Titian, c.1510, National Gallery, London

Rembrandt never left the Netherlands, yet, he would have known Titian's striking portrait either from seeing the painting in the collection of the Spaniard Alfonzo Lopez in Amsterdam, or from an engraving.

● **Pieter Lastman**
(1583–1633)
Rembrandt learned to compose groups of figures from this most prominent history painter of the time.

Completes the group portrait of The Company of Captain Frans Banning Cocq,	better known as The Night Watch	Hendrickje Stoffels (c.1625–63) enters Rembrandt's household. The	couple never marry, but she gives birth to his daughter Cornelia in 1654	Declares bankruptcy. His house, paintings, and possessions are sold at auction	Paints the Syndics of the Draper's Guild	Stoffels dies during an epidemic of the plague	Son Titus dies six months after his marriage and several months before the birth	of his daughter, Titia, Rembrandt's grandchild	Dies October 4 in Amsterdam
1642		**c.1649**		**1656**	**1662**	**1663**	**1668**		**1669**

● **Vincent van Gogh**
(1853–90)
Van Gogh's early paintings before his arrival in Paris are directly related to the palette, light, and brushwork found in Rembrandt's art. Like Rembrandt, Van Gogh also documented the course of his life through self-portraits (below: *Raising of Lazarus [after Rembrandt]*, 1890).

■ **Popular Culture**
Rembrandt's name and art have become a part of contemporary life from names of cigars and hotels, to charms, toothpaste and beauty products, to men's suits and venture capitalists.

Self-Portrait at the Age of 34,
Rembrandt van Rijn, 1640, National Gallery, London

Rembrandt's self-portrait of 1640 was inspired by two early 16th-century Italian Renaissance paintings in Amsterdam at that time: Raphael's portrait of Baldassare Castiglione and Titian's *Man with a Quilted Sleeve*.

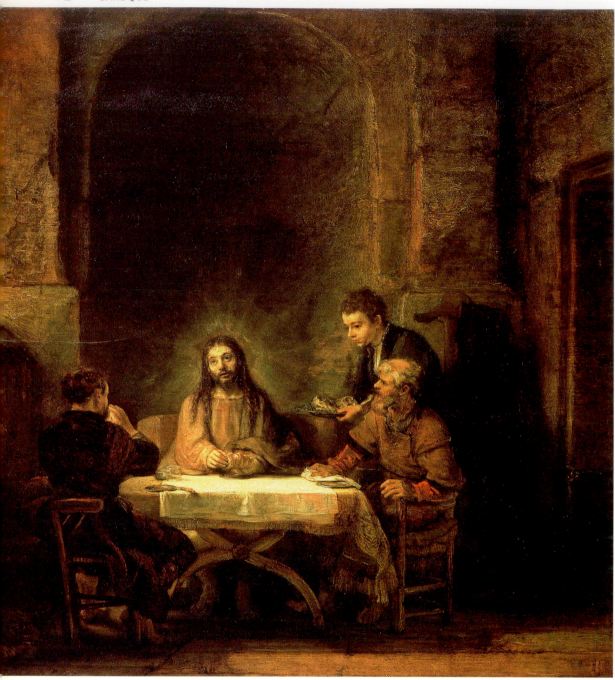

The Supper at Emmaus,
Rembrandt van Rijn, 1648, Louvre, Paris

Rembrandt's *The Supper at Emmaus* is a personal and deeply moving interpretation of this well-known Biblical subject.

ABOUT THE WORK

The story of the journey and of the *Supper at Emmaus* is related in the Gospel of Saint Luke. Shortly after the Resurrection, two disciples on their way to Emmaus were joined by Christ, whose identity was disguised. The disciples related the recent events to the stranger, and invited the unrecognized Christ to dine with them. At dinner Christ blessed and then broke the bread, revealing his identity to his followers. Rembrandt first represented the theme in a youthful painting full of strong emotion, the biblical action highlighted by a dramatic use of light and shadow.

MOOD

In this mature work of 1648, the artist imbued the theme of the Supper at Emmaus with the gentle light of divine revelation. As a servant looks on, (1) Christ sits calmly at the table, breaking bread for the pilgrims seated to either side. Rembrandt chose the most dramatic moment in the story, the moment when the disciples draw back in awe as they recognize the divinity of their guest.

LIGHT

Light emanates from Christ (2), brightly illuminating the tablecloth and softly defining the expressions of the witnesses and the monumental architecture of the background.

COMPOSITION

Rembrandt employs the apse above both (3) to emphasize the figure of Christ and as an allusion to the altar setting where religious rites occurred. He may have derived the architectural details from prints of Italian Renaissance paintings.

The Potato Eaters,
Vincent van Gogh, 1885, Van Gogh Museum, Amsterdam

The spiritual quality of Rembrandt's late religious paintings found a parallel in the humble yet reverent atmosphere of Van Gogh's *The Potato Eaters*. Van Gogh admired Rembrandt's work from his earliest years in art. In 1885 he wrote that he would gladly have sacrificed 10 years of his life to have been able to sit for 14 days in front of Rembrandt's *The Jewish Bride*.

An exceptional painter, draftsman, and printmaker, Rembrandt was not exemplary of his age. In Holland in the early part of the 17th century, the demise of the church as a major patron of the arts and the lack of significant royal patronage forced Dutch artists to diversify. Landscape, still-life, and genre scenes were added to history, religion, mythology, and portrait painting as important subjects. In one of the first "open" markets in the history of patronage, most Dutch artists became specialists in a particular subject. Rembrandt is the great exception, investigating religious narrative, portraiture, landscape, genre, and occasionally still-life. Despite this impressive array of subjects, through most of his career Rembrandt made his living with commissioned portraits. He is also regarded as one of the most important printmakers in the history of art, employing a supple etched line to many of the same subjects found in his paintings.

From the beginning of his career in Amsterdam, Rembrandt had many pupils, some passing quickly through his studio, others spending more time under the master's guidance. A pupil's early work was heavily influenced by Rembrandt's choice of subjects, as well as his paint application and chiaroscuro. Many students' works, reflecting the vision of their mentor, have been attributed to Rembrandt over the years, and are only now beginning to be recognized as works by artists in his circle. A short list of Rembrandt's most important pupils would include such well-known artists as Gerrit Dou (1613–75), Govert Flinck (1615–60), Ferdinand Bol (1616–80), Gerbrand van den Eeckhout (1621–74), Carel Fabritius (1622–54), Willem Drost (c.1630–c.1680), Nicholaes Maes (1634–93), and Arent de Gelder (1645–1727).

Johannes Vermeer's status as one of the great masters of Dutch 17th-century art was first recognized in the middle years of the 19th century. Despite a brief career and a life spent almost entirely in the city of Delft, Vermeer produced a small but significant number of paintings unique in their formal rigor and psychological complexity.

← INFLUENCED BY

KEY
- ● artist
- ◆ artistic movement
- ■ cultural influence
- ❖ religious influence

● **Carel Fabritius**
(1622–54)
Dutch painter with whom Vermeer may have studied. It is Fabritius who perhaps introduced Vermeer to the relationship between the science of optics and its applications to painting.

● **Pieter de Hooch**
(1629–84)
Dutch painter. de Hooch's subjects of domestic interiors and his formal investigations of light, color, and composition influenced Vermeer in the 1650s.

■ **Camera Obscura**
A box device (right) or room used to collect light through an aperture. Vermeer probably experimented with such a device to better understand light, color, and perspective.

◆ **Utrecht Caravaggisti**
Dutch artists from the city of Utrecht, who were followers of the Italian painter Caravaggio and brought the realism and dramatic lighting of his style into Dutch art.

JOHANNES VERMEER (1632–75)
Dutch

	Baptized in Delft on October 31	Marries Catharina Bolnes	Signs one of his first known paintings, The Procuress	Borrows money from patron, Pieter van Ruijven	Paints View of Delft	Paints Woman in Blue Reading a Letter	Pieter van Ruijven leaves him money in will	Paints The Girl with a Pearl Earring
CHRONOLOGY	**1632**	**1653**	**1656**	**1657**	**1660–61**	**1663–64**	**1665**	**1665–66**

→ INSPIRED

● **Etienne Joseph Théophile Thoré**
(1807–69)
Also known as Thoré-Bürger, he was the critic and scholar most responsible for the rediscovery of Vermeer's art.

● **Marcel Proust**
(1871–1922)
Vermeer and his painting *View of Delft* figure prominently in the *Captive*, part six of *À la Recherche du Temps Perdu*.

● **Edward Hopper**
(1882–1967)
The American painter's preference for isolated figures in quiet interior spaces owes much to Vermeer's art (right: *Morning in a City*, 1944).

● **Salvador Dali**
(1904–89)
The Spanish painter had a lifelong fascination with both Vermeer's subject matter and meticulous paint handling.

Since his rediscovery in the mid-19th century, Johannes Vermeer has held a privileged position among artists and the public alike. Few painters have been as lavishly praised and written about and few museum exhibitions have attracted the crowds that Vermeer's art did in 1996, when a major presentation of his paintings was held at the National Gallery of Art in Washington, D.C., and at the Mauritshuis in The Hague.

From the early critical reassessments of Vermeer's art written by the French critic Thoré-Bürger in 1855, to the most recent fascination that Vermeer's life and art have exerted—not only on modern painters, but on writers, poets, essayists, filmmakers, and composers—the artist and his accomplishments continue to engage and inspire.

Born in the Dutch city of Delft in 1632, Vermeer's career was a brief one. Today the catalogue of his paintings consists of a modest 35 known works. While the number of paintings Vermeer produced is small, the impact that these works have had on artists, past and present, is hard to overestimate. Jean-Francois Millet (1814–75), Gustave Courbet (1819–77), Vincent van Gogh (1853–90), Georges-Pierre Seurat (1859–91), Paul Cézanne (1839–1906), Edward Hopper, Piet Mondrian (1872–1944), René Magritte (1898–1967), Salvador Dali, Roy Lichtenstein (1923–97), Claes Oldenburg (b.1929), David Hockney (b.1937), Damien Hirst (b.1965), and Tom Hunter (b.1965) are just a few of the artists indebted to the legacy of Vermeer.

Why has Vermeer's art held such power over so many artists? What is it about a Vermeer painting that continues to captivate and so enthrall us today? The answers to these questions vary from artist to artist. First and foremost is simply Vermeer's ability to see, to observe things. The clarity and

Courtyard of House in Delft,
Pieter de Hooch, 1658, National Gallery, London,

The treatment of the formal elements of space, texture, color, and light found in de Hooch's intimate street scenes of Delft directly inspired Vermeer.

■ **Dutch optics**

Vermeer's life and career coincided with a golden age of Dutch innovation in the realm of optics, especially in Delft. New discoveries about the property of lenses and their manufacture led to advances in the designs of spectacles, magnifying glasses, telescopes, microscopes, and optical devices like the camera obscura.

Paints two of his last known works	*French invade; Vermeer's finances deteriorate*	*Buried in Delft on July 20, leaving enormous debts*
1670	**1672**	**1675**

◆ **Contemporary writers, filmmakers, composers**

Vermeer's art and life continue to inspire contemporary artists: *Girl with a Pearl Earring* written by Tracy Chevalier in 1999, and made into a film in 2003; and the opera *Writing to Vermeer* (1999) with a libretto by Peter Greenaway.

The Little Street,
Johannes Vermeer, c.1658–60, Rijksmuseum, Amsterdam

Vermeer's ability to wed the truth of observation with the intellectual reordering of formal elements combines to create a scene that is both immediate and timeless.

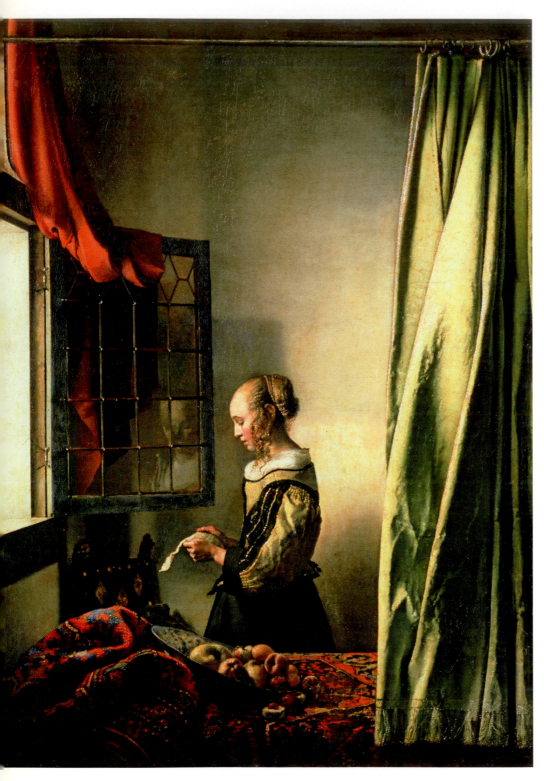

A Girl Reading a Letter by an Open Window, *c.1657–9, Staatliche Kunstsammlungen, Gemäldegalerie, Dresden*

Compositional elements like the curtains (2), table, chair, and still-life resting on a Turkish carpet enhance both the structure and meaning of the painting.

MOOD

The formal traits of this painting work together to create a mood of silence, stillness, and introspection. The young girl, engaged in the simple act of reading, is immersed in her own thoughts (3). We are invited to share a private moment and to contemplate the meaning of the scene before us.

ABOUT THE WORK

This painting from the late 1650s marks the end of Vermeer's early training and the beginning of his mature period. Lessons from earlier Dutch masters like Carel Fabritius and Pieter de Hooch have been absorbed and Vermeer begins to develop his own personal formal language and painting technique. Experiments with the camera obscura may have begun by this time.

LIGHT

The motif of light entering a room from a window on the left (1) is established here. Light is used by Vermeer to define forms and space, to create mood, and to reflect interior thoughts and states of mind.

COMPOSITION

As with many Vermeer paintings from the 1650s, the influence of Pieter de Hooch is felt in this composition: a figure placed in the corner of a room illuminated by a window to the left.

Woman Reading a Possession Order,
Tom Hunter, 1997, White Cube, London

Changing the subject, time, place, and medium, but adopting many of the formal structures of Vermeer, Tom Hunter transforms *A Girl Reading A Letter By An Open Window* into a contemporary image.

strength of his vision is one of his most potent gifts. Vermeer's powers of observation, however, much like Cézanne's, also relate to his powers of distillation: the ability to see something with his eye and then to distill it in his mind. Only this dual process of observation and distillation can account for the subtle adjustments, methodical placements, and intriguing dialogues that exist in every Vermeer painting. Formalist painters like Cézanne, Seurat, and Vermeer's countryman, Piet Mondrian, understood this rigorous system of formal relationships that give a Vermeer painting both its logic and emotion.

Surrealist painters like Salvador Dali and René Magritte admired Vermeer for his precise paint handling, atmospheric clarity, and the stillness of his interiors. This last trait—Vermeer's stillness—is one of the most frequently remarked upon characteristics of his paintings. Artists like the American Edward Hopper, among others, were especially attuned to this aspect of Vermeer's talent. Vermeer's understanding of light, color (especially his use of yellow and blue), overall design, and spatial logic has been celebrated and emulated, but rarely equaled.

Amid the formal structures of a Vermeer painting, however, exists a world of themes and symbolic meanings that has also been inspirational to artists. Through a restricted vocabulary consisting of one or two figures placed in intimate interiors and engaged in simple acts drawn from daily life, Vermeer succeeds in exploring a rich and varied tapestry of human emotions and meaning. This aspect of Vermeer's art, and the myriad interpretations and subjective responses that his paintings elicit, has become a crucial feature of the modern Vermeer so admired and appreciated today.

Contemporary artists and viewers are as likely to find in Vermeer a visual discourse on the nature of contemplation, stillness, absence, self-sufficiency, centeredness, solitude, peace, and serenity as on any more conventional iconographic and symbolic themes. In this regard, Vermeer's paintings are the ultimate expression of artistic inspiration in their ability to be reinvented, reshaped, reinterpreted, recontextualized, and redefined for each succeeding generation of artists and admirers.

Morning in a City,
Edward Hopper, 1944, Williams College Museum of Art, Williamstown

Indebted to Vermeer, Edward Hopper's *Morning in a City* adds a modern psychology and cinematic quality to the formal language and mood of the Dutch master.

ROCOCO TO NEOCLASSICISM

The term "Baroque" can be used expansively to describe European art throughout the first half of the 18th century. However, with the dawn of that century, and with the death of the French King Louis XIV in 1715, new forces emerged to challenge long-accepted traditions of European social, political, and cultural life. In the art of the early 18th century, the Rococo style represents this significant change in taste from the Grand Manner of 17th-century painting, sculpture, and architecture.

1682

CHRONOLOGY	King Louis XIV of France establishes his royal court at Versailles	Watteau enters Departure from the Island of Cythera to the French Academy under painter of the féte galante	Paris Salon first held at the Palais du Louvre	Chardin admitted to the French Academy as a painter of animals and fruit	Excavation of Herculaneum	Outbreak of the War of the Austrian Succession	Pompeii rediscovered	Gainsborough working on the portrait Mr. and Mrs. Andrews
	1682	1717	1725	1728	1738	1740	1748	1748

Baroque art was first formed in Italy, while the defining characteristics of Rococo art first emerged in France. In architecture the Rococo stressed a delicacy and intimacy, especially in interiors where light, mirrors, undulating walls, and refined ornamentation inspired by shells and other natural forms—referred to as rocaille—gave the style its name. In painting there was an emphasis on a pastel palette, delicate figures, and amorous, often frivolous, themes. Rococo sculpture witnessed a diminution in scale, and similar playful themes as those found in painting.

INFLUENTIAL WOMEN

Many of the trends associated with Rococo art in France involved a shift in taste from the style advanced under Louis XIV (1638–1715) to that of his successor King Louis XV (1710–74). The French court returned to Paris from the palace at Versailles after the death of Louis XIV, and the Rococo style reflected the smaller private residences, hotels, parks, and urban life of the city. The phenomenon was shaped in no small way by the rise of Parisian salon culture, and the importance of women as both trendsetters and patronesses of the arts. Among the most important of these influential women were Madame de Pompadour (1721–64), Madame du Deffand (1697–1780), and Julie de Lespinasse (1732–76). Many leading thinkers of the day could be found at their salons, including such notables as Voltaire (1694–1778), Denis Diderot (1713–84), and other French philosophers.

Major painters of the Rococo style in France include Antoine Watteau (1684–1721), François Boucher (1703–70), and Jean-Honoré Fragonard (1732–1806). In England, the paintings of Sir Joshua Reynolds (1723–92) and Thomas Gainsborough (1727–88) display many Rococo traits, but with less affectation.

TREMOR OF CHANGE

With the discovery and excavations of the ancient Roman cities of Herculaneum in 1738, and

1682–1824

1824

Seven Years' War begins, it spreads across Europe and its colonies	Voltaire's novel Candide published	Winckelmann's The History of Ancient Art published	Diderot writes Essay on Painting	Reynolds made first president of London's Royal Academy of Arts	The Storming of the Bastille heralds the French Revolution	King Louis XVI of France executed; David paints The Death of Marat	Napoléon Bonaparte crowned Emperor of the French	Ingres submits Vow of Louis XIII to the Paris Salon
1756	**1759**	**1764**	**1765**	**1768**	**1789**	**1793**	**1804**	**1824**

Pompeii in 1748, yet another tremor of change began to resonate throughout European art. The playful and superficial nature of the Rococo style was found wanting in the seriousness and requisite virtues expected of great art. Fueled by the rationalism of Enlightenment thought, and the growing desire for an art based upon moral principles and didactic purpose, a revived interest in Classicism emerged in European culture. This "Neoclassicism" was further strengthened by the writings of the German art historian Johann Joachim Winckelmann (1717–68) and by a general renewal of interest in Classical history, literature, and scholarship.

In the art of French painters such as Jean-Baptiste-Siméon Chardin (1699–1779) and Jean-Baptiste Greuze (1725–1805) something new had been seen and felt. The straightforward honesty of Chardin's still lifes and genre scenes, and Greuze's paintings of moral and didactic dramas, had sown the seeds of a more serious art. Their paintings lacked only the suitable forms and themes necessary to galvanize them into a call to arms for a new aesthetic. These final elements were provided by Greek and Roman sources, prototypes, and inspiration. The most powerful visual manifestation of the Neoclassical ideal in painting was the art of Jacques-Louis David (1748–1825). The long-term implications of this Classical point of view, and its quest for truth, beauty, and perfection would have a lasting influence on the history of Western art.

Antoine Watteau was an artist of extraordinary invention and sensitivity, and during his brief career he established a genre, the "fête galante." Inspired by Peter Paul Rubens and Venetian art, his paintings were liberated from the constraints of French Academic style. While his Rococo themes of fashionable people at play sparkle with charm and frivolity, they often express a deeper note of melancholy and human emotion.

← INFLUENCED BY

KEY
● artist
◆ artistic movement
■ cultural influence
❖ religious influence

● **Peter Paul Rubens**
(1577–1640)
In late paintings by this Flemish Baroque master such as The Garden of Love (mid-1630s), Rubens seems to anticipate the *fête galante* developed by Watteau.

● **David Teniers the Younger**
(1610–90)
Flemish genre painter who specialized in peasant imagery. The naturalism of his style appealed to Watteau.

● **Pierre Crozat**
(1665–1740)
A French financier and art connoisseur who befriended Watteau and granted him access to his vast collection of paintings by Old Masters.

JEAN-ANTOINE WATTEAU (1684–1721)
French

	Baptized on October 10 in Valenciennes	Receives artistic training with local artists in Valenciennes	Arrives in Paris	Active in the workshop of the decorative painter Claude Gillot	Joins the studio of Claude Audran III (1658–1734), an ornamental artist and decorator,	and keeper of the Palais du Luxembourg collection	Awarded first runner-up for the Prix de Rome. Returns to Valenciennes	Returned to Paris
CHRONOLOGY	**1684**	**c.1793–94**	**1702**	**1705–08**	**1708**		**1709**	**1710**

→ INSPIRED

◆ **Fête Galante**
A specific type of Rococo painting emphasizing elegant outdoor settings and fashionable young people; this style gained Watteau admission to the French Academy in 1717.

◆ **The Rococo**
A decorative style in the arts that emerged in France under King Louis XV (1710–74). Watteau's art, along with that of his younger contemporaries, François Boucher (1703–70), and Jean-Honoré Fragonard, defined the French Rococo style.

● **Jean-Baptiste Pater**
(1695–1736)
French painter born in the same town as Watteau. He was the artist's closest imitator, but lacked Watteau's originality and expressive gifts.

● **Jean Honoré Fragonard**
(1732–1806)
Painter who continued in the Rococo style until the advent of the French Revolution (1789–99) and Neoclassicism. His palette, brushwork, figure types, and settings were indebted to Watteau.

● **Edgar Degas**
(1834–1917)
Degas was a worthy heir to Watteau in his mastery of pose, gesture, and movement.

During his brief life and activity as a painter and draftsman, Jean-Antoine Watteau is credited with creating a genre, the *fête galante*. These small, colorful paintings represent the leisure class at play, and are marked by decorative and fashionable elements that contributed to the development of the French Rococo style. His works freed French painting from the Classical constraints of Academic art. In spite of their playfulness, many of his pictures are infused with a sense of human frailty, and the fleeting nature of pleasures. Paintings by Watteau were avidly collected during his life. In the decades following his early death he had many followers and imitators, especially in France and England.

Watteau was born in Valenciennes, a town previously in Flemish territory. During his lifetime the artist was often described as "le peintre Flamand," or "the Flemish painter," and a number of his early works owe a debt to 17th-century Flemish genre painters.

Few events in Watteau's life are documented; after receiving his initial training in Valenciennes, he relocated to Paris and worked in the studios of the decorative painters Claude Gillot and Claude Audran III. The examples of Gillot and Audran were not lost on the young artist. Watteau's mature style reflects a theatricality linked to the Italian *commedia dell'arte*, the vibrant palette of Peter Paul Rubens, and the *fêtes champêtres* (rural feasts) of Venetian art. Many of these elements appear in his diploma picture submitted to the French Academy in 1717, *Departure from the Island of Cythera*, 1717 (Louvre, Paris). Because of its subject matter and formal qualities, Watteau entered the academy under a new category, painter of the *fête galante*.

Fête Champêtre,
Titian, c.1510, Louvre, Paris

Watteau's invention of the *fête galante* was not without precedent. Titian's mesmerizing picture reveals a similar theme. The parklike setting, musical performance, and emotional ambiguity are elements often reappearing in pictures by Watteau.

● **Claude Gillot**
(1673–1722)
French painter and decorative artist. The dealer Gersaint wrote: "Gillot was the only teacher who can truly be assigned to Watteau." (Left: *The tomb of Master André*, c. 1716–17).

■ **Commedia dell'arte**
Form of Italian comedy based on improvisation, humor, and amorous themes. It included a number of stock characters often depicted by Watteau and his Rococo contemporaries.

■ **Fête Champêtre**
An outdoor picnic or pastoral celebration, this predecessor of Watteau's *fête galante* had its roots in medieval gardens of love and was revived in 16th-century Venetian art.

1711			1717		1719	1720		1721
Introduced to the important French art collector, banker Pierre Crozat, whose	vast collection included works by Peter Paul Rubens, Anthony van Dyck (1599–1641),	and Venetian painters	Received into the French Academy as painter of "fêtes galantes," a new category of	painting; executes Departure from the Island of Cythera	Develops tuberculosis, and travels to London for a medical consultation	In Paris living with the most famous art dealer of early 18th-century Paris, Edmé-	François Gersaint (1694–1750)	Completes Gersaint's Shopsign. Dies in Nogent-sur-Marne, near Paris, on July 18

● **Pierre-Auguste Renoir**
(1841–1919)
Renoir's pastel palette, feathery brushwork, playful themes, and pastoral settings were inspired by Watteau and French Rococo.

Gilles,
Jean-Antoine Watteau, 1717–18, Louvre, Paris

The bittersweet image of Pierrot (called Gilles) is unequaled in Watteau's oeuvre for inspiring artists, writers, photographers, and filmmakers.

Seated Pierrot,
Pablo Picasso, 1918, Museum of Modern Art, New York

Picasso's interpretation of Gilles explores many of the same emotional subtleties found in the painting by Watteau.

The Music Party,
Jean-Antoine Watteau, c.1718, Uffizi, Florence

Musical parties are central to Watteau's imagery. In them, he expresses the frivolous pastimes of the Parisian upper classes. Though the mood is upbeat, these images are filled with longing and unfulfilled love.

Chardin is arguably the greatest still-life painter in European art, and one of the most popular artists in the Western tradition. His paintings of simple objects interpreted with insight and dignity elevated the status of still-life painting to new heights. Virtually all subsequent still-life artists have acknowledged Chardin's importance, and benefited from his achievement.

INFLUENCED BY

KEY
● artist
◆ artistic movement
■ cultural influence
❖ religious influence

■ **Nature**
In both still-life and figurative painting, Chardin always worked directly from the motif before him, and not from his imagination.

● **Rembrandt van Rijn** (1606–69)
Chardin adapted the Dutch master's rich impasto and sensuous manipulation of paint to describe the soft atmospheric light surrounding his figures and still-life objects.

● **David Teniers the Younger** (1610–90)
This Flemish painter inspired French 18th-century painters from Antoine Watteau (1684–1721) to Jean-Baptiste Greuze (1725–1805). Chardin was sometimes referred to as the "French Teniers."

● **Willem Kalf** (1619–93)
Chardin's subjects were influenced by Kalf's 17th-century still-lifes employing kitchen utensils.

● **Johannes Vermeer** (1632–75)
The quiet, contemplative nature of individuals in Vermeer's genre scenes finds its parallel in the cooks, maids, and children of Chardin's figurative paintings.

JEAN BAPTISTE-SIMÉON CHARDIN (1699–1779)
French

	Born November 2 in Paris	Accepted as a master painter by the Academy of St. Luke, the traditional painters' guild	Exhibits 12 paintings including, The Ray (The Skate), at the Place	Dauphine; admitted to the Royal Academy of Painting and Sculpture	Marries Marguerite Saintard in February; his first son, Jean-Pierre, born in November	Executes his earliest figurative paintings	Death of his wife and daughter	Exhibits eight figurative paintings at the Salon du Louvre; shows a total of
CHRONOLOGY	**1699**	**1724**	**1728**		**1731**	**1733**	**1735**	**1737**

INSPIRED

● **Gustave Courbet** (1819–77)
Courbet derived much of his formal language from Chardin's painting. Chardin was also responsible for bestowing seriousness on subjects of everyday life that Courbet exploited in his commitment to Realism.

● **Édouard Manet** (1832–1883)
As Courbet, Manet's still-lifes and genre scenes often depended directly upon his knowledge of and variations after Chardin's paintings in the Louvre.

● **Henri Fantin-Latour** (1836–1904)
France's greatest 19th-century still-life painter was indebted not only to Chardin's style but also to the calmness and dignity Chardin invested in his paintings.

● **Paul Cézanne** (1839–1906)
Cézanne appreciated the structural elements of Chardin still-lifes with their sense of solidity and interaction of elements.

● **Henri Matisse** (1869–1954)
Matisse closely studied Chardin paintings in the Louvre, making copies of both The Ray (1728) and The Pyramid of Peaches (1730).

Jean-Baptiste-Siméon Chardin's career spanned more than half a century during the age of the Rococo in France. His still-life and genre paintings stand apart from much of the "official" art of the period, characterized by the works of François Boucher (1703–70) and Chardin's pupil, Jean-Honoré Fragonard (1732–1806). Chardin's subject matter and formal approach to painting departed from traditional Rococo celebrations of aristocratic life and playful themes conveyed with pastel colors and feathery brushwork.

Chardin began as a still-life painter, a genre occupying a low order in the French Academy's hierarchy of subjects for artists. His art descended from the great Dutch and Flemish still-life tradition of the 17th century that included artists such as Pieter Claesz (c.1597–1660) and Willem Kalf, but Chardin's intentions differed from his northern European predecessors. Dutch still-life placed a high value on the illusionistic reproduction of light across specific textures.

Chardin's approach was not to define each texture but to suggest each surface through a combination of subdued light and active brushwork. Chardin also differed from Dutch still-life painters by avoiding their moralizing and symbolic allusions. Chardin's art is characterized by a directness of vision in assembling humble objects in simple settings to achieve a balance of color, light, object, and overall composition.

Chardin was admitted to the French Academy in 1728 as a painter of animals and fruit; however, he soon turned to figure paintings with scenes of everyday life—modest pictures depicting people in humble surroundings. Chardin avoids the affectation and sentimentality of earlier genre and still-life painting to create art that is truthful, direct, and honest. In this regard his paintings captured the imaginations of later artists as varied as Gustave Courbet, Édouard Manet, Henri Matisse, Georges Braque (1882–1963), Giorgio Morandi, and Lucien Freud.

Woman Holding a Balance,
Johannes Vermeer, c.1664, National Gallery of Art, Washington, D. C.
A carefully orchestrated image, this painting shows a woman engaged in an everyday activity, lost in quiet contemplation. The light pouring in through the window and onto the still-life elements is balanced with the young woman silhouetted against the dark background.

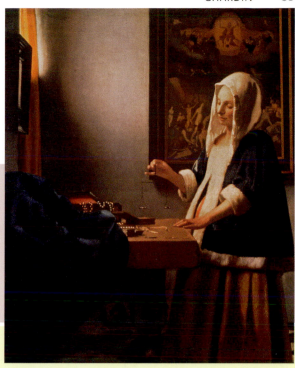

● **Pierre-Jacques Cazes** (1676–1754) and
● **Noël-Nicolas Coypel** (1690–1734)
Late French Baroque history painters who were Chardin's earliest teachers.

■ **French Enlightenment**
Chardin's paintings were celebrated by French philosophes Denis Diderot (1713–84) and Jean-Jacques Rousseau (1712–78) for their moral seriousness, and sympathetic portrayals of the virtues and honesty of ordinary people.

30 paintings in the Salons of 1737 to 1741	Elected councilor to the Royal Academy of Painting and Sculpture	Marries Françoise Marguerite Pouget	Receives a pension from the king	Provided with living quarters in the Louvre	His son Jean-Pierre drowns in Venice	Dies December 6 in Paris
	1743	**1744**	**1752**	**1757**	**1772**	**1779**

● **Giorgio Morandi** (1890–1964)
The solidity, quietness, introspection, and rich paint handling in Morandi still-lifes reflect his appreciation of Chardin.

● **Lucien Freud** (b.1922)
Freud executed two painted versions and an etched interpretation (all 1999–2000) based upon Chardin's *The Young Schoolmistress* (c.1735–36) in the National Gallery, London.

Soap Bubbles,
Jean-Baptiste-Siméon Chardin, c.1733/34, National Gallery of Art, Washington, D. C.

Chardin's image of a young man blowing bubbles would have been understood by the artist's contemporary audience as an allusion to the transience of human life.

Boy Blowing Bubbles,
Édouard Manet, 1867–9, Calouste Gulbenkian Museum, Lisbon

Manet's Realist image is derived from Chardin's renderings of the same subject, but without the veneer of timelessness in the old master's work.

The House of Cards,
Jean-Baptiste-Siméon Chardin 1736–37, National Gallery, London

In Chardin's restrained composition, a young man sits concentrating on the pleasures of constructing a house of cards. Chardin was the true heir to Vermeer's subdued color harmonies and sense of quiet meditation.

Jacques-Louis David is one of the greatest painters and most complex personalities in Western art history. David was witness, chronicler, and active participant in the upheaval and bloodshed of the French Revolution and its aftermath. His art is a testament both to the highest aspirations of painting, and to its less exalted status as political propaganda.

 INFLUENCED BY

KEY
● artist
◆ artistic movement
■ cultural influence
❖ religious influence

◆ **Classical Art**
During his time in Rome, David made numerous copies of Classical sculptures including *The Dying Gaul* (c.230–220 BCE), and the reliefs of the *Column of Trajan* (113).

● **Raphael**
(1483–1520)
David slowly came to appreciate the purity, balance, and sophisticated learning of Raphael's art.

● **Caravaggio**
(1571–1610)
Upon his arrival in Rome, David was initially attracted to the realism and strong chiaroscuro in the paintings of Caravaggio.

● **Nicolas Poussin**
(1594–1665)
David repeatedly referred to figures and motifs from Poussin paintings, especially Poussin's *Abduction of the Sabine Women* (1633–34).

● **Joseph-Marie Vien**
(1716–1809)
David studied with Vien, both at the Académie Royale in Paris and at the French Academy in Rome. Vien encouraged David to look to Classical sources from Italian art instead of following French taste.

JACQUES-LOUIS DAVID (1748-1825)
French

	Born August 30 in Paris	Meets painter François Boucher (1703–70) who suggests he study with the painter	Joseph-Marie Vien	Studies with Vien at the Académie Royale	Awarded the Prix de Rome, and remains in Rome until 1780	Exhibits The Oath of the Horatii at the Paris Salon	Exhibits The Death of Socrates at the Paris Salon	Exhibits Brutus Receiving the Bodies of his Sons at the Paris Salon
CHRONOLOGY	**1748**	**1764**		**1766**	**1774**	**1785**	**1787**	**1789**

 INSPIRED

● **Anne-Louis Girodet de Roucy-Trioson**
(1767–1824)
Along with Ingres, one of David's most talented pupils but one who was criticized by David for the Romantic and poetic aspects in his paintings.

● **Marie-Guillemine Benoist**
(1768–1826)
David's pupil whose paintings benefited from her female perspective. Her *Portrait of a Negress* (1799–1800) was an image of emancipation following the abolition of slavery in France in 1794.

● **Baron François Gérard**
(1770–1837)
Like David, his teacher Gérard became caught up in revolutionary politics and equivocal allegiances, and saw his art suffer as a result.

● **Baron Antoine Jean Gros**
(1771–1835)
Another David student and his true successor as the painter of the Napoleonic myth. Gros was the student closest to David, and yet, unable to maintain the purity of David's Neoclassicism.

● **Jean-Auguste-Dominique Ingres**
(1780–1867)
Ingres was the most gifted student to emerge from David's studio.

The paintings of Jacques-Louis David are vivid examples of the complex intermingling of art and politics. During the tumultuous years from the start of the French Revolution to the fall of Napoléon I of France, David produced a series of remarkable paintings that began as a call to arms for revolution, and ended as the artistic legitimization for an emperor. In *The Oath of the Horatii*, 1784 (Louvre, Paris); *The Death of Socrates*, 1787 (The Metropolitan Museum of Art, New York); *Brutus Receiving the Bodies of his Sons*, 1789 (Louvre, Paris); *The Death of Marat*, 1793 (Musées Royaux des Beaux-Arts, Brussels); *Napoléon Crossing the Great Saint-Bernard*, 1801 (Musée National du Château, Malmaison); and *The Coronation of Josephine (Le Sacre)*, 1805–08 (Louvre, Paris), David presented a visual chronicle of the ideas, events, and personalities of this transformative period in European history that he helped to shape both as an artist and politician.

David's great triumvirate of masterpieces—*The Oath of the Horatii*, *The Death of Socrates*, and *Brutus Receiving the Bodies of his Sons*—were a perfect synthesis of individual artistic genius, and contemporary political sentiment. The trio of paintings signaled an end to the Rococo era of excess and triviality in art and society in their taut, muscular, and austere Classical language, and in the dignity, grandeur, and high moral tone of the narratives they depicted.

If *The Oath of the Horatii* was the initial salvo of this revolution, and *Brutus Receiving the Bodies of his Sons* its stern and inexorable conclusion, then *The Death of Socrates* was perhaps the most perfect expression of David's aesthetic and political idealism.

Drawing on sources as varied as Classical sculpture, Michelangelo (1475–1564), Raphael, Caravaggio, and Nicolas Poussin, David presented a Classical drama of sacrifice, pathos,

Dying Gaul,
Unknown, c.230–220BCE, Capitoline Museum, Rome

David was inspired by Classical art, and during his time in Rome he made sketches of statues and reliefs that were to influence his work.

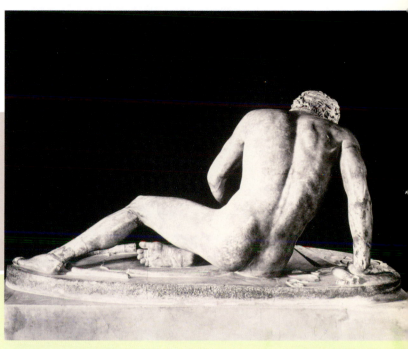

■ **Excavations at Herculaneum**
(1738) and
■ **Pompeii**
(1748)
The archeological rediscoveries of these lost Roman cities contributed to the birth of the European movement of Neoclassicism.

■ **Napoléon Bonaparte**
(1769–1821)
David's career as painter for Napoléon I of France forever altered his life and art, turning him away from the power and conviction of his great Neoclassical masterpieces.

■ **French Revolution**
(1789–99)
David's life, art, and politics were inextricably linked, for better and for worse, to the events of the French Revolution and its aftermath.

Elected Deputy for Paris to the National Convention	*Votes for the death of the king; appointed to the Committee of General Security.*	*Paints The Death of Marat*	*Named President of the National Convention. Jacobins defeated in Convention, and*	*David was arrested and imprisoned. Released in general amnesty in 1795*	*Paints Napoléon Crossing the Great Saint-Bernard*	*Named First Painter to Napoléon I of France*	*Exhibits The Coronation of Josephine (Le Sacre) at the Paris Salon*	*Exiled to Brussels following the fall of Napoléon I, and never returns to France*	*Dies December 29 in Brussels*
1792	**1793**		**1794**		**1801**	**1803**	**1808**	**1815**	**1825**

◆ **The Barbus**
A young, rebellious group of David pupils who emerged in 1800 advocating a return to purity in art. Among the members were Maurice Quay (c.1779–1802/03), Lucile Franque (1780–1803), and Jean Broc (1771–c.1850).

● **Edvard Munch**
(1863–1944)
Munch's two paintings on the theme of the *"Death of Marat"* (1906–07), translated David's icon of political martyrdom into personal and highly charged images based on an event in his own life.

● **Carlo Maria Mariani**
(b.1931)
Born in Rome, Mariani's paintings recall the Neoclassical world of David's idealized forms. In 1980 he recreated the lost painting by David depicting Lepelletier de Saint-Fargeau on his deathbed.

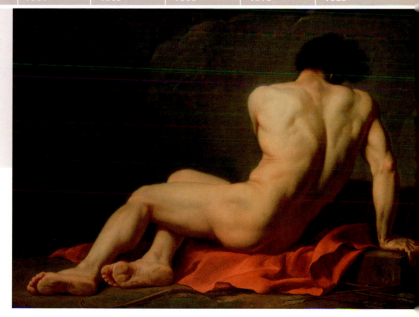

Patroclus,
Jacques-Louis David, 1780, Musée Thomas-Henry, Cherbourg

The dramatic light, bold color, and austerity of this painting are typical of David's sense of the aesthetic, drawing on the formal composition, and taut, muscular forms of Classical art.

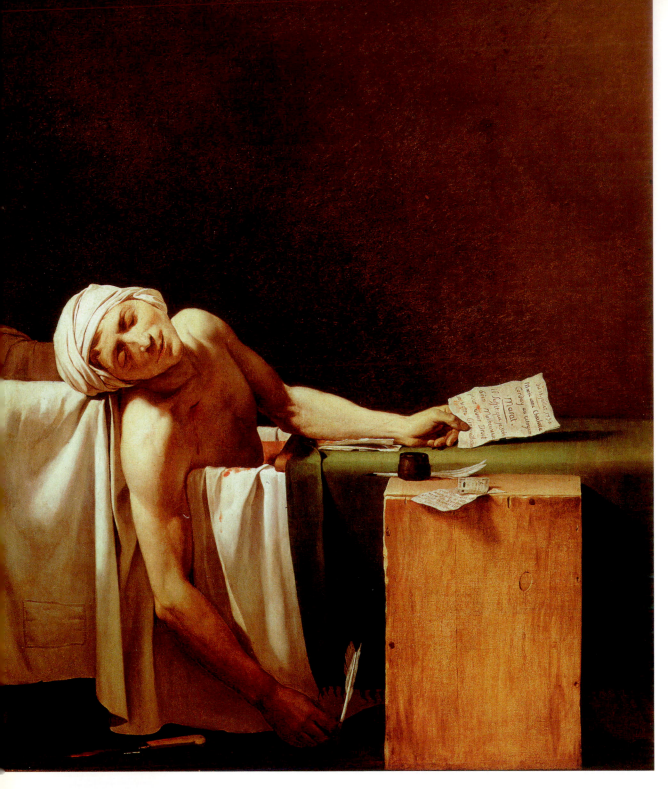

ABOUT THE WORK

Marat suffered from a skin disease which was only soothed by spending long hours in the bath, so he took to using the place as a makeshift office. It was here that he was stabbed to death by the royalist Charlotte Corday on July 13, 1793. In his hand, Marat is still holding the fateful letter of introduction, which enabled her to gain access to him.

LIGHT

Like Caravaggio, David used a dramatic spotlight to focus on the key elements: his martyred friend's face (1) and the shabby crate, which emphasized his spartan lifestyle.

COMPOSITION

In true Classical fashion, David borrowed from the old masters to lend weight to his theme. Here, Marat's pose (2) is deliberately reminiscent of devotional paintings of the Dead Christ.

MOOD

The mood is somber but idealized. David has removed Marat's skin blemishes and toned down the gore. The victim's wound and blood are scarcely noticeable amidst the deathly pallor of the scene. The letter on the crate (3), offering money to a soldier's widow, underlines his charitable nature.

and tragedy so focused and rigorous in its formal composition, dramatic light, bold colors, and sculpted forms that Sir Joshua Reynolds (1723–92) declared it "the greatest effort of art since the Sistine Chapel and the Stanze of Raphael in the Vatican."

David was an artist at his best when drawing energy and inspiration from the political events of the French Revolution. While the extent to which his own political actions affected the changes swirling around him is questionable, and even the degree to which he understood the full implications of his own rhetoric, what is clear is that his paintings were the visualization of ideas in action—a rare and important portrait of political change at a crucial moment in Western civilization.

The culmination of David's political convictions and genius as a painter is *The Death of Marat:* the greatest painting of political martyrdom in the history of Western art. Here in a painting where every element, effect, and detail has been carefully calculated, David presents an image of Spartan economy so densely packed with symbolic meaning as to strangle any possibility of visual, intellectual, or political apathy on the part of the viewer. It is a riveting and searing conflation of form and content that is unforgettable in its power and resonance.

As the French Revolution moved through its bloodiest phase, and one by one David's friends and compatriots such as Jean-Paul Marat (1743–93) met violent ends, so, too were his own personal, political, and artistic fortunes threatened. But unlike Marat and the others, David soon found himself under the direct influence (if not supervision) of the man responsible for France's return to order, Napoléon Bonaparte—a leader in need of a political legitimacy that could be gained by David's powerful visual images.

David's art and life complete a circle during one of the most important periods of French history. From his coming of age under King Louis XV amid the painters of the Rococo such as François Boucher, to his studies with Joseph-Marie Vien, his seminal trip to Rome in 1774 and creation of the Neoclassical style in France, to the revolutionary paintings and his vote for the death of King Louis XVI, to his own fall from grace and subsequent rehabilitation by Napoléon, to his final exile to Brussels after Napoléon's fall, David was a witness to his age. He leaves behind one of the most powerful and influential visual records of that history. Between 1785 and 1814, David's studio was the most important in Europe, producing a line of painters, including Ingres, who were a testament to their master's best qualities as they themselves began to alter his canon.

Marat with the Fishes
Alison Watt, 1990, Gallery of Modern Art, Glasgow

Watt is aware of the mood and composition of David's painting as she too depicts the dead Marat pale and idealized, his corpse slumped with his body and face toward the viewer to enhance the dramatic effect.

Jean-Auguste-Dominique Ingres dominated "official" French painting for the first half of the 19th century. A pupil of the Neoclassical master Jacques-Louis David, Ingres defended the Classical tradition against the spirited Romanticism championed by his rival Eugène Delacroix. Praised for his history paintings during his lifetime, today it is Ingres' portraits that are admired for their formal qualities, especially their mastery of line.

INFLUENCED BY

KEY
● artist
◆ artistic movement
■ cultural influence
❖ religious influence

● **Raphael**
(1483–1520)
Ingres was profoundly affected by the art of Raphael, admiring the clarity and perfection of his compositions and the brilliance of his drawing.

● **Nicolas Poussin**
(1594–1665)
Ingres championed the importance of Poussin's drawing and design placing him in opposition to Eugène Delacroix's (1798–1863) followers who championed the color of Peter Paul Rubens (1577–1640).

◆ **The Salon**
The name for the exhibitions held by members of the Royal French Academy of Painting beginning in the 17th century. The name comes from the hall in the Louvre (Salon d'Apollon) where the exhibitions were held.

● **Johann Joachim Winckelmann**
(1717–68)
The writings of Winckelmann on the nature of ancient Greek art had a significant impact on Ingres and all Neoclassical artists.

● **Jacques-Louis David**
(1748–1825)
Ingres embraced the strict Neoclassical canon created by his teacher David, although ultimately contributing to its demise.

JEAN-AUGUSTE-DOMINIQUE INGRES (1780–1867)
French

	Born August 29 at Montauban. His father is a sculptor, painter, and musician	Enters the Toulouse Academy under Guillaume-Joseph Roques (1757–1847)	Moves to Paris to study with the painter Jacques-Louis David	Wins the Prix de Rome but his trip to Italy is delayed until 1806	Begins his four-year scholarship in Rome; extends his stay until 1820	Returns to Paris, exhibits in the Salon; receives the Legion of Honor early next year	Named professor at the École des Beaux-Arts in Paris	Appointed director of the French School in Rome
CHRONOLOGY	**1780**	**1791**	**1796**	**1801**	**1806**	**1824**	**1826**	**1834**

INSPIRED

● **Edgar Degas**
(1834–1917)
Degas is arguably the artistic heir to Ingres who best understood the originality and expressive potential of his line.

● **Henri Matisse**
(1869–1954)
The compositional rhythms, calligraphic line, color relationships, and sensuality of themes in Matisse paintings relate to Ingres' inspiration (right: *Reclining Nude, Back*, 1927).

● **Pablo Picasso**
(1881–1973)
Picasso's art was engaged in a continuous dialogue with the formal language and subject matter of Ingres.

Jean-Auguste-Dominique Ingres was the last champion of the French Classical style that had begun with Nicolas Poussin two centuries earlier. Although precocious as an artist, his early career met with limited success. At one point he was forced to paint portraits as a source of income. Ironically, Ingres' portraits are now more admired than his history paintings. Only in 1824, after a long stay in Italy, was Ingres embraced by the French establishment. As someone who sought perfection in his works, Ingres was a procrastinator who constantly reworked his canvases, fussed over details, and became increasingly obsessive as the years passed. Reserved and calculating, his stoic character is evident in his art.

Born in Montauban, Ingres received early training from his father, an amateur painter, sculptor, and musician. Before he was 12 years old, however, he was enrolled in the Academy of Toulouse where he studied with the history painter Guillaume-

Joseph Roques. Talented and showing considerable promise, he moved to Paris in 1796 to study with Jacques-Louis David, the founding father of Neoclassicism. In addition to working with many of the most influential artists of his generation, Ingres read Johann Joachim Winckelmann's writings on Greek art, studied the paintings of the Italian Renaissance, especially works by Raphael, and developed his own intellectual style. Winning the Prix de Rome in 1801, Ingres arrived in the Eternal City in 1806, remaining there until 1820 before relocating to Florence for another four years.

Prior to his return to Paris in 1824, Ingres' history paintings had often been criticized, as were his Greek-inspired nude odalisques. Yet as a portraitist, his pencil drawings and paintings, characterized by their cool sensuality, were highly prized. Everything changed with his return to Paris and the submission of the Vow of Louis XIII, 1824, (Montauban Cathedral,

The Sistine Madonna
Raphael, 1513, Gemäldegalerie, Dresden

One of Raphael's supreme creations, this work allegorizes Pope Julius II's entry to Paradise and vision of the Madonna and Child. Ingres exploited this harmony of balanced forms and rich tones in his history paintings.

● John Flaxman
(1755–1826)
Flaxman's gift for linear design, and the purity and simplicity of his drawings and book illustrations deeply influenced Ingres (left: *A Seated Female Figure in Long Drapery, Mourning*).

Returns to Paris	Retrospective exhibition at the Exposition Universelle	Dies January 14 in Paris
1842	**1855**	**1867**

● Man Ray
(1890–1977)
Man Ray repeatedly mined the imagery in Ingres' paintings as source material for his work. His altered photograph *Le Violon d'Ingres* (1924) is an iconic image in Modernist art.

● Cindy Sherman
(b.1954)
In her History Portraits (1989–90) Sherman uses Ingres' portraits of women as inspiration for exploring concepts of female beauty, sexuality, and tensions between the real and the ideal.

● The Guerrilla Girls
(1985–)
The Guerrilla Girls appropriated Ingres' Grande Odalisque (1814) in one of their poster/billboards to ask the question: Do women have to be naked to get into the Met. Museum? (1989).

Vow of Louis XIII,
Jean-Auguste-Dominique Ingres, 1824, Montauban Cathedral, Montauban

Ingres' painting draws liberally from *The Sistine Madonna* and other works by his avowed "God" Raphael. By replacing the figure of the pope with that of Louis XIII, the painting moves from a religious to a political arena. Ingres' enormous debt to Raphael is displayed in stylistic terms as well, but reflective of his own genius, he never resorts to mere copying.

ABOUT THE WORK

Painted over a number of years, this work reflects Ingres' unmatched skills as a portraitist. While the hard contours and subtle modeling of the sitter's face and arms reflect his Neoclassical style, her colorful dress provides a decorative element that runs counter to Classical restraint and balance. The compressed space of the composition is also offset by the provocative reflection in the mirror behind the sitter.

LINE

The master of line and tight brushwork, Ingres expresses these elements in the hard contours and timeless quality of Madame Moitessier's idealized features (1).

PATTERN

Competing for attention in the work is the decorative flower pattern in the fashionable dress (2). The colorful bouquets and garlands reveal a freedom of execution that contrasts with the sitter's classical features and other elements in the compressed space of the composition.

MOOD

The mood generated by Ingres' portrait is one of cool detachment, perhaps accompanied by a hint of mild bemusement. Madame Moitessier scrutinizes us (3) as much as we do her, but Ingres provides few clues concerning her state of mind.

The Valpinçon Bather,
Jean-Auguste-Dominique Ingres, 1808, Louvre, Paris

Ingres' Neoclassicism displayed an interest in the exotic more commonly associated with Romanticism. In this provocative but modest image of a bather, the painter teases the viewer by providing few revealing details. Instead, the long expanse of the figure's back is exaggerated and abstracted by means of Ingres' love of linear design and pattern.

The Violin of Ingres,
Man Ray, 1924, J. Paul Getty Museum, Los Angeles

In this black and white photograph, Man Ray creates a new image based upon Ingres' *Valpinçon Bather*. His modern interpretation is indebted to ideas derived from both the Dada and Surrealist movements.

Montauban) to the Salon in November 1824. Favorably received, it elevated Ingres to the position of protector of French Classicism in the struggle against the Romanticism of Eugène Delacroix. It was a battle Ingres would fight for the rest of his life. Although he eventually lost the war, his career saw him receive wide acclaim, numerous commissions for history paintings (many of which were never completed), and his share of academic appointments, honors, and wealth.

Until recently, art historians have tended to see Neoclassicism and Romanticism as opposed styles. Today, the former has been folded into a broader definition of Romanticism, for it too reflected the spirit of the age. Certainly Ingres' interest in subjects drawn from contemporary literature and scenes of harem women attest to his fascination with the exotic, however contradictory it may seem to the goals of upholding the Classical tradition. Nevertheless, the conflict between Ingres and Delacroix was both real and personal. A contemporary cartoon shows the two artists jousting before the Institute of France. Ingres holds a pen and Delacroix a brush; the draftsman confronts the painter, the "Poussiniste" competes against the "Rubeniste." Ingres would later describe Delacroix as "the apostle of the ugly." While such a libelous statement seems out of character for an artist with such a controlled intellect, it suggests the seriousness with which Ingres took his role as defender of the French Classical style.

ROMANTICISM TO REALISM

The term "Romanticism" encapsulates many and varied aspects. For Jean-Jacques Rousseau (1712–78) Romanticism meant a return to nature; for Johann Wolfgang von Goethe (1749–1832) it was disease; for Heinrich Heine (1797–1856) it was the infinite; for Victor Hugo (1802–85) the truth of life; for George Sand (1804–76) the art of the emotions and of the heart; and for Charles Baudelaire (1821–67) the modern.

1827

CHRONOLOGY

Delacroix exhibits Death of Sardanapalus and is recognized as leader of the Romantic school of art.	Goya dies	Constable works on Salisbury Cathedral from the Meadows	Turner named Deputy President of the Royal Academy	Courbet writes his Manifesto of Realism	Baudelaire's Les Fleurs du Mal (The Flowers of Evil) published	Courbet exhibits Burial at Ornans and The Stone Breakers at the Salon; Wordsworth's The Prelude published	Champfleury provides the theoretical framework for the Realist aesthetic in Le Réalisme (The Realism)
1827	1828	1831	1845	1855	1857	1850	1857

In painting, a Romantic spirit unites artists as diverse as Henry Fuseli (1741–1825), Francisco Goya (1746–1828), William Blake (1757–1827), Caspar David Friedrich (1774–1840), Joseph Mallord William Turner (1775–1851), John Constable (1776–1837), Jean-Auguste-Dominique Ingres (1780–1867), Théodore Géricault (1791–1824), Francesco Hayez (1791–1882), and Eugène Delacroix (1798–1863). Romanticism in art, music, and literature is often contrasted to the Classic impulse or point of view. The concepts of Classicism—and in the 18th century Neoclassicism—and Romanticism are inextricably linked, and hard to separate. Nowhere is this better seen than in the art of Ingres, whose paintings might aptly be referred to as "Romantic Classicism" or "Classical Romanticism." Among the defining characteristics that shape a Romantic vision in art are an approach to subject matter that is subjective and emotional; a love of the exotic; a world view that stresses the vastness and chaotic nature of the universe; an interest in science and empirical knowledge; and an overriding concern with the rights of the individual in society—a reflection of the impulses and ideas generated by the U.S. and French Revolutions.

IN THE ROMANTIC TRADITION

Romantic art emerged in the late 18th century in Germany, England, and Italy with the literature and poetry of Goethe, William Wordsworth (1770–1850), John Keats (1795–1821), Ugo Foscolo (1778–1832), and Giacomo Leopardi (1798–1837), and the paintings of Fuseli, Blake, Turner, and Constable. By the year 1830, with the triumph of Hugo's drama *Hernani,* the painters Ingres and Delacroix had established themselves as major protagonists in the battle between Classic and Romantic forces in France.

The ideas and attitudes generated by the Romantic movement anticipated a host of modern concepts that affected the subsequent history of Western art and culture. The legacy of a Romantic spirit continued to influence later artistic struggles against academic formulae, constraining rules, and entrenched traditions.

Las Meninas (The Maids of Honor),
Diego Velázquez, 1656, Prado, Madrid

Goya was the true heir to Velázquez, and made studies and copies of his work. Both artists worked as court painters, and on occasion had to paint group portraits of the royal family.

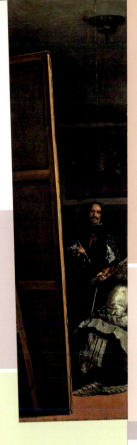

■ The Peninsular War
(1808–14)
Goya's fervent nationalism led to the production of some of his greatest works of art during this "people's" war (a guerrilla war of the pueblo) against the invasion, occupation, and oppression of the French.

■ Witchcraft
Witches and related characters of cats, bats, owls, and goblins were popular motifs in Goya's art. They allowed him to juxtapose the world of reason against the fears, folktales, and superstitions of his fellow Spaniards.

■ Spanish Nationalism
Goya was intimately involved in the struggle of the Spanish people to free Spain from the oppression of Napoleonic France. His art is influenced by the events, suffering, and aspirations of this specific historical moment.

Publication of Los Caprichos	Paints portrait of Charles IV and his family	French invasion of Spain	The Disasters of War (published complete in 1863)	French expelled from Spain. Paints The Second of May, 1808 and The Third of May, 1808	Summoned before the Spanish Inquisition because of his works, The Naked	Maja, and The Clothed Maja
1799	1800	1808	1810–13	1814	1815	

● Gian Carlo Menotti
(1911–2007)
Menotti's opera *Goya* (1986) is based on the life of the artist.

● Robert Motherwell
(1915–91)
In his monumental *Spanish Elegy* series of paintings on the theme of the Spanish Civil War, Motherwell drew inspiration from both Goya and Picasso.

● Susan Sontag
(1933–2004)
In her final book of essays, *Regarding the Pain of Others* (2004), the critic Sontag addresses Goya's *The Disaster of War* series in a discussion of images of war, and how they affect people and culture.

● Dinos Chapman
(b.1962) and
● Jake Chapman
(b.1966)
The British Chapman brothers' *Disas...* is a small-scale, three-dimensional re... images from Goya's print series. In a... work, they purchased a rare edition... *Disasters of War* series, and drew on... perhaps implying that art is powerle...

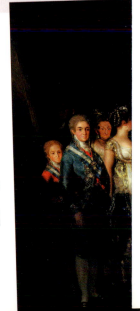

Charles IV and his Family,
Francisco Goya, 1800, Prado, Madrid

Goya included a self-portrait of himself with his patrons (before the canvas on the left) as Velázquez had done many years before when he painted the family of King Philip IV in Las Meninas.

1827–1871

1871

The American Civil War breaks out	Homer paints Sharpshooter on Picket Duty	Marx's Das Kapital (Capital) published; Manet works on The Execution of the Emperor Maximilian of Mexico	Franco-Prussian War breaks out	Defeat of the short-lived Paris Commune; Whistler paints Arrangement in Gray and Black	#1: Portrait of the Artist's Mother
1861	1863	1867	1870	1871	

MODERN LIFE AND EVERYDAY PEOPLE

Like Romanticism, the term "Realism" has many definitions and applications in Western art history. With the invention of photography in 1839 new challenges and discussions arose about the nature and purpose of painting, and its relationship to truth and reality. The traditions of both Classicism and Romanticism appeared exhausted, outdated, and irrelevant in an industrialized world. In France during the middle years of the century, the art of Gustave Courbet (1819–77) was seminal in creating a Realist program that stressed a commitment to representing the heroic aspects of modern life and everyday people. The directness of his subject matter, the boldness of his technique, his radical politics, and fiery personality all contributed to a sensibility in European art that can only be described as modern. In this regard, Courbet's influence on the art of Édouard Manet (1832–83), and through Manet on the development of French Impressionism, was profound. In England, artists of the Pre-Raphaelite Brotherhood founded in 1848, such as John Everett Millais (1829–96), despite a predilection for religious, historical, and literary themes, displayed a commitment to truth, factual accuracy, open-air nature studies, and meticulous detail that was adopted by later artists less interested in Pre-Raphaelite subject matter. Other 19th-century Realist painters of note include Honoré Daumier (1808–79), Jean-François Millet (1814–75), Wilhelm Leibl (1844–1900), Winslow Homer (1836–1910), and Thomas Eakins (1844–1916). A Realist impulse has continued to manifest itself in various ways throughout modern painting from Pop Art to Photo-Realism, and to the diverse contemporary styles of Andrew Wyeth (b.1917), Lucien Freud (b.1922), Gerhard Richter (b.1932), John Currin (b.1962), and Jenny Saville (b.1970).

The paintings and graphic works of Francisco Goya confront mankind's cap[...]
brutality and suffering. Goya's art is a powerful, and original premonition o[...]
good and evil impulses inherent in humanity.

← INFLUENCED BY

KEY
- ● artist
- ◆ artistic movement
- ■ cultural influence
- ❖ religious influence

● **Diego Velázquez**
(1599–1660)
Goya was the true successor to Velázquez. Goya's portrait of *Charles IV and his Family* (1800) is indebted to *Las Meninas* (The Maids of Honor), (1656) by Velázquez.

● **Giambattista Tiepolo**
(1696–1770)
Goya was influenced both by the paintings of Tiepolo and by his imaginative prints of scherzi and capricci. Tiepolo's *Scherzi di Fantasia* (c.1743–57) directly affected the fantasy elements of Goya's *Los Caprichos* (1799).

❖ **Emblem Books**
The iconography of Goya's imagery can often be traced to the visual motifs, mottos, and moral lessons found in these popular 16th-and 17th-century books.

FRANCISCO GOYA (1746–1828)
Spanish

	Born March 30 in Fuendetodos, near Saragossa, Aragon	Studies under the painter José Luzán (1710–85) in Saragossa	Travels to Italy	Marries the sister of the painter Francisco Bayeu (1734–95)	Elected member of the Royal Academy of San Fernando
CHRONOLOGY	**1746**	**1760**	**1770**	**1773–74**	**1780**

→ INSPIRED

● **Édouard Manet**
(1832–83)
Manet repeatedly turned to Goya for inspiration, and found in his Spanish predecessor the beginnings of modern painting techniques and subject matter.

● **Pablo Picasso**
(1881–1973)
Picasso's life, art, and Spanish nationalism are everywhere touched by the inspiration of Goya. The example of Goya is palpable in Picasso's graphic work, especially his etching *The Minotauromachy* (1935), and in the imagery of his epic painting depicting the Nazi bombing of a town in the Basque country, *Guernica* (1937).

● **Ernest Heming[...]**
(1899–1961)
Art and artists p[...]
role in Hemingw[...]
resonated with [...]
of Spain, sympat[...]
during the Span[...]
and graphic des[...]
committed by b[...]
are found in his [...]
Tolls* (1940).

The art of Francisco Goya represents a tangible break with the past, just as that notable in the music of Goya's contemporary, composer Ludwig van Beethoven (1770–1827). In both cases an innovative form of artistic expression emerges that marks a shift from earlier models and traditions. Such achievements represent watershed moments in the history of art, when there is an almost palpable leap forward into a new creative realm.

The lives of Goya and Beethoven straddle in almost equal measure the end of the 18th and beginning of the 19th centuries. Their artistic development has much in common, too. Both artists were educated and formed in an 18th-century cultural tradition: Beethoven reflecting the influences of Franz Joseph Haydn (1732–1809) and Wolfgang Amadeus Mozart (1756–91); Goya the traditions of the Rococo painter Giambattista Tiepolo. As the turn of the

century appro[...]
stage, affecte[...]
profound cha[...]
solely to the [...]
to their grow[...]
order and re[...]
insight is ann[...]
paths their [...]
Caprichos (pu[...]
(Eroica) (180[...]

Goya's a[...]
potential of [...]
forces in 19[...]
of the indiv[...]
Images from [...]
(1796–98), [...]

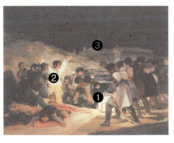

The Third of May 1808,
Francisco Goya, 1814, Prado, Madrid
Goya painted the social and political problems of his day, and in particular the excesses of violence and war. A patriot, he was keen to depict the suffering of his people at the hands of the French.

ABOUT THE WORK
Goya's painting commemorates an atrocity from the Peninsular War (1808–14), when Napoleon's troops occupied Spain. On May 2, 1808, there was a violent uprising in Madrid, which the French suppressed. Then, on the following day, reprisals took place and about a hundred Spaniards were executed on a hill outside the city. Goya recorded both events in a pair of paintings after the war was over.

LIGHT
The eerie lighting comes from a single, huge lantern (1), which highlights the suffering of the most prominent victim. His memorable pose epitomizes the plight of his fellow countrymen.

COMPOSITION
Goya contrasts the well-ordered, anonymous efficiency of the firing squad with the individualized suffering of the victims. Their martyrdom is emphasized by the kneeling figure in white, who adopts a crucifixion pose (2). He is enormous. If he stood up, he would dwarf all of the others.

MOOD
The actual killings took place during the day, but Goya has created a nightmarish atmosphere by setting the episode at night. The silhouette of the city (3) is reminiscent of El Greco's city views.

(1816–23), his indictment of the French occupation of Spain, and execution of Spanish citizens in *The Third of May, 1808, 1814* (Prado, Madrid), are among the most memorable, searing, poignant, and profound examinations of the disguises under which inhumanity and its attendant foibles, arrogance, and slogans hide. His *Black Paintings*, 1820–24 (Prado, Madrid), are the pictures he surrounded himself with in his house, the Quinta del Sordo, and were meant for his eyes only. They are constant reminders of the war he fought with the direct assaults of his brush against the rough walls.

The continuing relevance of Goya's art resides in its ability to probe beneath the surface of things, and to connect the specific impulse to the universal truth. Few artists working in any realm of creative expression, past or present, can rival Goya's awareness, intelligence, and the inherent perceptiveness of his instincts and vision. For this reason his art has been much admired, studied, imitated, and written about. At a time when traditional structures, beliefs, and expectations in society were being questioned and dismantled, Goya threw people back onto themselves to confront the prejudices, superstitions, and evils that made them weak, destructive, and hateful in the hopes of opening their eyes to the potential for an enlightened but nonetheless human redemption. His art was of its time— but as all great art, it is also of today.

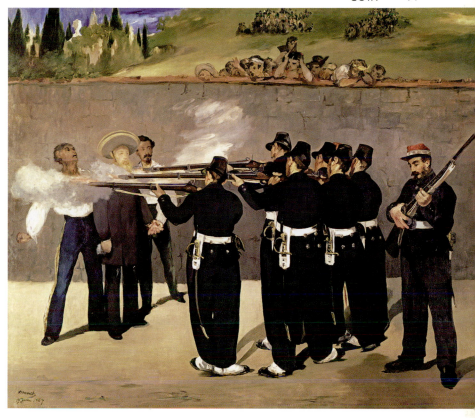

The Execution of the Emperor Maximilian of Mexico, 1867–68,
Édouard Manet, Städtische Kunsthalle, Mannheim
Manet rarely painted reconstructions of historical events, but was shocked by the emperor's execution. He is likely to have seen Goya's work when he visited Madrid in 1865, and drawn on it for inspiration.

Massacre in Korea,
Pablo Picasso, 1951, Musée Picasso, Paris
Picasso was inspired by Goya's nationalism, and his abhorrence of brutality; this work, based on a massacre of Korean civilians by American forces, explores a similar theme to *The Third of May 1808*.

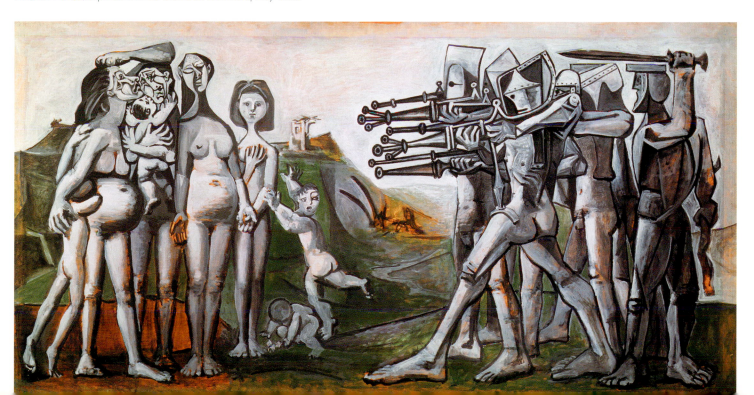

John Constable's approach to landscape painting had important implications for the subsequent development of the genre. His direct engagement with open-air painting; interest in the science of light, color, and atmospheric effects; innovative technical procedures; and practice of making full-scale oil sketches in preparation for finished works mark him as one of the 19th-century's most influential landscape artists.

INFLUENCED BY

KEY
- ● artist
- ◆ artistic movement
- ■ cultural influence
- ❖ religious influence

- **● Peter Paul Rubens**
 (1577–1640)
 The large scale and freely brushed surfaces of Constable's "six-foot" sketches are indebted to his study of this Baroque master (right: *Peasants Returning from the Fields*, c.1635).

- **● Claude Lorrain**
 (1600–82)
 Lorrain's paintings encouraged Constable to explore aspects of the Classical and picturesque in his early landscapes.

- **● Jacob van Ruisdael**
 (c.1628/29–82)
 The scientific accuracy, close observation, and monumentality of Van Ruisdael's landscapes left a lasting impression on Constable.

JOHN CONSTABLE (1776–1837)
English

Born June 11 in East Bergholt, Suffolk County, England	Enters Royal Academy Schools, London	First exhibition at Royal Academy Schools	Begins painting in the open air	Paints Wivenhoe Park, Essex	Marries Maria Bicknell. Settles in London	Paints The White Horse, first "six-footer"; elected member of Royal Academy	The Hay Wain is awarded a Gold Medal at the Paris Salon
CHRONOLOGY							
1776	1799	1802	1814	1816	1817	1819	1824

INSPIRED

- **● Eugène Delacroix**
 (1798–1863)
 Both Delacroix and Théodore Géricault (1791–1824) praised Constable's art and contributed to the spread of his influence in France.

- **● Richard Parkes Bonnington**
 (1802–28)
 The freshness and open-air quality of Bonnington's watercolors owed much to the example of Constable.

- **◆ Barbizon School**
 Exposure to Constable's art in France directly affected the development of this school of landscape painting (right: *The Harvest*, Charles Daubigny, 1851).

John Constable and Joseph Mallord William Turner (1775–1851) are the two great names in the history of 19th-century English landscape painting. Constable was born and raised in the small village of East Bergholt nestled in the Stour River valley of Suffolk County. Like the influence of Provence on Paul Cézanne (1839–1906), the countryside in and around the Stour River in the southeast of England provided Constable with an endless supply of subjects, as seen in some of his greatest landscape paintings.

Constable entered the school of the Royal Academy in London at the late age of 22. He also studied past landscape masters including Peter Paul Rubens, Jacob van Ruisdael, and Thomas Gainsborough. Their art exposed him to conventions of landscape painting encompassing traditions of the Classical and the picturesque. Constable's true education and inspiration, however, came from his love of the English countryside in his native Suffolk. His breakthrough in his work as a landscape painter came with his realization that to understand and capture the fleeting and variable qualities of a landscape, an artist must work in the open air, directly from nature. As such, Constable was to become a seminal figure in the subsequent development of landscape painting, especially in France, where his art influenced Romantic painters such as Théodore Géricault (1791–1824), Delacroix, the members of the Barbizon School, and ultimately the French Impressionists.

Two Mills,
Jacob van Ruisdael, c.1655, Detroit Institute of Arts, Detroit

The monumental nature of landscape master Van Ruisdael's works, with their scientific accuracy and keen sense of observation, made a long-lasting impression on Constable.

● **Thomas Gainsborough**
(1727–88)
The large scale of Constable's paintings, tonal quality of his drawings, and picturesque compositions of his early watercolors are all influenced by Gainsborough.

● **William Wordsworth**
(1770–1850)
Poets Wordsworth and Samuel Taylor Coleridge (1772–1834) parallel Constable's move away from 17th-century models in favor of more modern forms of expression.

■ **Modern Science**
Constable's awareness of current scientific developments dealing with natural phenomena and meteorology is most visible in his cloud studies and painted skies.

Death of Constable's wife	*Paints Hadleigh Castle; elected full member of the Royal Academy*	*Dies March 31 in Hampstead, London*
1828	**1829**	**1837**

◆ **French Impressionism**
The French Impressionists inherited an interest in Constable's paintings extending back to Géricault, Delacroix, and the Barbizon School.

■ **British Pastoral Style in Music**
Celebrations of the English countryside, fueled by a resurgence of interest in Constable were evoked by composers Ralph Vaughan Williams (1872–1958), Gerald Finzi (1901–56), and Peter Warlock (1894–1930).

● **Frank Auerbach**
(b.1931)
Auerbach has repeatedly cited the inspiration of the Constable paintings in the National Gallery, London, for his work.

The White Horse,
John Constable, 1819, National Gallery of Art, Washington, D.C.

Constable's biggest inspiration was the English countryside itself, which he endowed with a sense of prestige and status hitherto only afforded to historic, religious, and mythological paintings.

Among Constable's greatest achievements as a landscape painter was his practice of making full-scale oil sketches on canvas in preparation for his "six-foot" paintings.

Constable's finished paintings based on these large-scale studio sketches and his smaller, open-air studies, bestowed upon landscape painting a prestige and status usually reserved for the subjects of history, religion, and mythology.

Constable's innovations extended beyond the scale of painting to include his working methods. His use of heavy impasto, palette knife, scumbling of paint, flecked dabs of

The Hay Wain,
John Constable, c.1821, National Gallery, London
Probably Constable's most famous work, *The Hay Wain*
depicts a millstream in rural Suffolk, England.

ABOUT THE WORK

Constable revolutionized the practice of landscape-painting, abandoning artificial, picturesque conventions, in favor of a more realistic approach, based on a close study of nature. Significantly, he exhibited this picture under the title of *Landscape: Noon*. It met with a lukewarm reception in England, where the critics disliked its emphasis on the working countryside, but won a gold medal at the Salon in France and was admired by Delacroix.

LIGHT

Constable enjoyed portraying patchy sunlight filtering through clouds and trees. This is most brilliantly conveyed in the distant fields (1), some of which are in shadow, while the remainder are brightly lit.

COLOR

The most distinctive feature of Constable's palette was his use of white flecks of paint, to indicate not only the fall of light, but also the texture of wet surfaces, such as damp timbers and rain-soaked foliage. Hostile critics dubbed this "Constable's snow" (2).

NATURE

Constable's landscapes are remarkably atmospheric, capturing minute variations in the weather conditions. He achieved this through his close observation of nature and, more specifically, his detailed sketches of cloud formations (3).

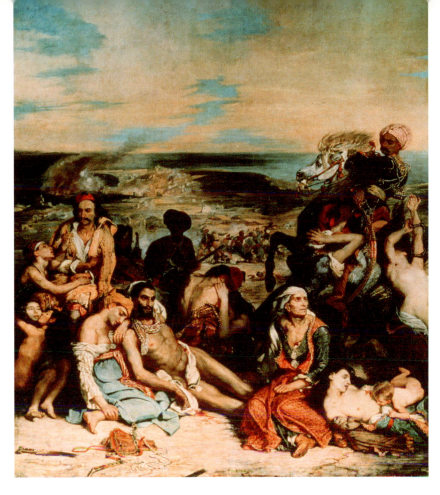

white for highlights, and red for accents, all contribute to the freshness and vibrancy found in his best landscapes.

It is in Constable's depictions of the sky that not only his acute skills of observation are best appreciated, but also his interest in the latest scientific studies dealing with natural phenomena and the emerging science of meteorology. Constable's ability to render the effects of color, light, shadow, moisture, cloud formations, and the variable atmospheric conditions of weather mark him as one of the first modern painters of landscape in Western art.

Constable's six-foot paintings and related six-foot sketches were based on extensive open-air, on-site studies, but were completed in the controlled conditions of his studio. Unlike his great contemporary and rival Turner, Constable's view of the landscape remained closely tied to observation, the specificity of conditions, and the inspiration of place. Only at the end of his career did Constable cautiously explore the more sublime aspects of nature that were so much a part of Turner's vocabulary. One contemporary critic attempting to characterize the differences between the two artists described Turner as having the "poetry of nature" and Constable "more of her portraiture."

The Massacre at Chios,
Eugène Delacroix, 1821–22, Louvre, Paris

Delacroix saw Constable's *Hay Wain* at the Paris Salon of 1824. Its light, color, and technique inspired him to make last minute changes to his own submission to that same Salon: *The Massacre at Chios.*

The Lake at Argenteuil,
Claude Monet c.1872, Musée d'Orsay, Paris

Impressionist painters such as Monet were influenced by Constable's direct observation of nature *plein air*, and depiction of natural phenomena such as clouds in the sky.

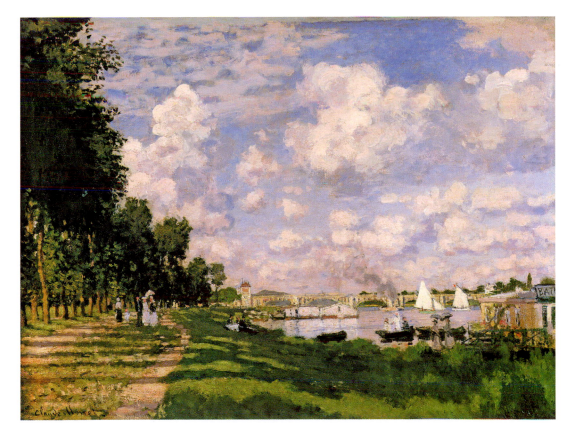

Joseph Mallord William Turner became one of the most important landscape painters of the 19th century spanning a 60-year-long career. His canvases reveal a world of light and color, atmosphere, and emotion. Anticipating the Impressionists and later Abstract painting, Turner's canvases and watercolors attracted many followers, and received high praise from contemporaries such as English critic John Ruskin.

 INFLUENCED BY

KEY
- ● artist
- ◆ artistic movement
- ■ cultural influence
- ❖ religious influence

◆ The Picturesque
Turner's art emerged from this topographical landscape tradition that stressed the curious, charming, and visually pleasing aspects of nature.

● Claude Lorrain
(1600–82)
Turner admired the compositional devices, lighting effects, and poetic moods of the Classical landscapes of the French master.

● Richard Wilson
(1714–82)
One of England's most important landscape painters, his Neo-Classical style did not preclude him from representing mood alongside the picturesque.

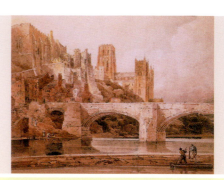

JOSEPH MALLORD WILLIAM TURNER (1775–1851)
English

	Born in Covent Garden, London	Works with the artist Thomas Malton. Admitted to the Royal	Academy of Arts Schools in London	Exhibits his first watercolor at the Royal Academy	Exhibits his first oil painting at the Royal Academy (Fishermen at Sea)	Elected an Associate Member of the Royal Academy	Elected full Member of the Royal Academy; undertakes the first of many	trips to the European continent.
CHRONOLOGY	**1775**	**1789**		**1790**	**1796**	**1799**	**1802**	

 INSPIRED

◆ Impressionism
Turner's exploration of the variable nature of color, light, and the abstract quality of sky and water presage many of the formal interests of French Impressionism.

● James Abbott McNeill Whistler
(1834–1903)
The atmospheric effects and abstract qualities of Whistler's Thames Nocturnes (1870s) are indebted to Turner's example.

● Thomas Moran
(1837–1926)
This American landscape painter, born in England, was called the "American Turner." His panoramic views of the American West capture the sublime qualities of light, color, and atmosphere found in Turner's art.

● Claude Monet
(1840–1926)
Monet's views of the River Thames, Venice, seascapes and landscapes often reflect the inspiration and study of Turner.

● Louise Bourgeois
(b.1911)
Bourgeois says of Turner: "Though my art is different from Turner, I am able to identify with his work and to fully appreciate him."

Joseph Mallord William Turner rose above his modest beginnings to become England's most important and celebrated landscape painter of the 19th century. Only John Constable (1776–1837) comes close in comparison. Turner's originality set him apart from his contemporaries. By the end of his career Turner's colorful and expressive pictures displayed an abstract artistic quality that was unmatched in European art of the period. Influenced by the concept of the "sublime" as articulated in the writings of Irish politician and philosopher Edmund Burke (1729–97), Turner gave visual form to the frightening and destructive power of nature. The art critic John Ruskin (1819–1900) became a passionate defender of his art, suggesting that in his landscapes Turner saw the world in a new way.

Turner was not a precocious talent. After learning some of the rudiments of art as a young man, the aspiring artist produced his first drawings in 1787. Shortly after, he was briefly employed by architectural draftsman Thomas Malton (1748–1804), who concluded Turner would never be of any worth as an artist. Other false starts followed, but in 1789 Turner entered the Schools of the Royal Academy of Arts. Within a few years he gained the respect of his contemporaries with his watercolors, drawings, and paintings. Steeped in the tradition of the Old Masters, many of Turner's early works were uninspiring. At this time he also began his life-long practice of sketching from nature, filling many sketchbooks during his numerous travels at home and abroad.

During the early 19th century Turner found his true voice. His paintings and watercolors of shipwrecks, mountain passes, the city, and the countryside reveal a fresh approach to landscape. Light and atmosphere, color and dramatic movement combine to announce Turner's own brand of

Seaport: The Embarkation of St. Ursula,
Claude Lorrain, 1641, National Gallery, London

Claude's mastery of the classical landscape is shown by this scene depicting an episode in the life of St. Ursula. The massive architecture is bathed in a glowing light that defines rather than dissolves form. Turner's early work was strongly influenced by Claude.

● **Thomas Girtin**
(1775–1802)
Girtin's landscape watercolors used strong colors applied in broad washes. Turner remarked on Girtin's short life: "If Tom Girtin had lived, I should have starved" (left: *Durham Cathedral and Bridge*, 1799).

◆ **The Sublime**
An aesthetic concept with roots in ancient Greece presented in Edmund Burke's treatise *A Philosophical Enquiry into the Origin of our Ideas of the Sublime and Beautiful* (1757). The most dramatic effects of nature were sublime.

Becomes a Professor of Perspective at the Royal Academy	Resigns lecturer post at the Royal Academy	Named Deputy President of the Royal Academy	Final exhibition at the Royal Academy	Dies December 19 in Chelsea; buried in St. Paul's Cathedral
1807	**1837**	**1845**	**1850**	**1851**

● **Cy Twombly**
(b.1928)
Twombly's series of three canvases, *Three Studies from the Temeraire* (1998–99), painted for his house in Italy, was inspired by the Turner painting on the same theme.

Thames: Nocturne in Blue and Silver,
James Abbot McNeill Whistler, c.1872–78, Yale Center for British Art, Paul Mellon Fund

Whistler's series of *Nocturne* paintings are indebted to Turner's ability to abstract and to create atmosphere.

Dido Building Carthage,
J.M.W. Turner, 1815, National Gallery, London

Turner's debt to Claude Lorrain is obvious in this early painting. Turner, however, infuses the light with moisture, allowing the forms to dissolve naturally and emotionally.

Yacht approaching the Coast,
J.M.W. Turner, c.1835–40, Tate Britain, London

Turner's paintings from the last years of his career display the innovative approach to light, atmosphere, color, dramatic movement, and emotion that were the precursor to so many artistic movements.

ABOUT THE WORK

Near the end of his career, through technical innovations and experiments with color and paint application, Turner created pictures that were unique—presaging later modernist concerns with abstraction. His quest for the sublime culminates in these late works of imagination and artistic vision.

LIGHT

The bright vortex generated by the sun at the center of the composition (1) threatens to consume everything in its path, including the sailboats escaping toward the coastline.

COLOR

The golden brilliance of the sun invades the entire composition, affecting all the other hues. The deep blue waters are bisected by the yellow-oranges reflected off the waves (2). The sky explodes into a subtle rainbow of white, yellow, orange, blue, and gray.

TECHNIQUE

The most experimental element in this painting is Turner's bold paint handling and working of the surface. The canvas is treated aggressively, reinforcing the visual image of the wrath of nature (3).

Romanticism. His scenes approach the sublime in mood and spirit. He infused a power and presence into his works that referenced the Old Masters, as well as diverse literary and historical subjects. In spite of some strong criticism, his vision found many supporters who acknowledged his skill and vision, among them the writer Ruskin, and the painter Sir Thomas Lawrence (1769–1830.)

By the 1830s Turner was enjoying enormous success, although becoming increasingly isolated in his personal life. During the decade his style evolved as he experimented with color and luminosity to the point of abstraction. In his later works, topographical references dissolve before the viewer's eye. His intention was to express the feeling of experiencing nature rather than the look of nature. Capturing the sublime in perhaps its rawest form, the power of nature became the primary subject in his paintings. Ruskin saw these works as genius, but some viewers were critical of what they saw as his paintings' "indistinctiveness."

Turner's legacy was profound. His example found followers from the Impressionists to the Abstract Expressionists—freeing artists to seek new possibilities of vision, and providing a vehicle to experience nature in its most frightening and destructive forms. Turner extended his generosity to his country, and much of his large body of work was given to the nation. The Clore Gallery, opened in 1987 at Tate Britain in London, is devoted to his work.

Untitled,
Mark Rothko, 1963, National Gallery of Art, Washington, D.C.

Compared to Turner's art, the abstract expressionist painter Mark Rothko (1903–70) achieved the sublime in a different but equally powerful manner. Rothko donated his Seagram Murals to the Tate Gallery, hoping to see them exhibited next to the paintings of Turner.

Eugène Delacroix was the leader of the French Romantic School, and one of the last great European history painters. His style employed dazzling color and bold brushwork. Delacroix's art drew upon many literary and artistic influences, including William Shakespeare, Dante, Peter Paul Rubens, and Théodore Géricault. His paintings inspired all the great colorists of later Modernist art, including Vincent van Gogh and Henri Matisse.

INFLUENCED BY

KEY
● artist
◆ artistic movement
■ cultural influence
❖ religious influence

● **Titian**
(c. 1490–1576)
Titian's ability to integrate light, color, and expressive brushwork, especially in his late paintings, was a model for Delacroix.

■ **William Shakespeare**
(1564–1616)
Delacroix's love of Shakespeare was deep and long-lasting. Paintings based on Shakespearean themes number among his most significant works.

● **Peter Paul Rubens**
(1577–1640)
Delacroix's style was often seen as a Neo-Baroque interpretation of the works by this innovative Flemish master (right: *The Flight from Blois (Marie de Medici Series)*, c.1622).

■ **Morocco**
As with Henri Matisse years later, the people, landscape, customs, light, and colors of North Africa stimulated Delacroix's imagination and artistic vision.

EUGÈNE DELACROIX (1798–1863)
French

	Born April 26 in Charenton-Saint-Maurice near Paris	Attends the Lycée Imperial in Paris. Wins prizes in Classics and drawing	Studies alongside Théodore Géricault in the Paris studio of	Pierre Guérin (1774–1833)	Enrolls in the École des Beaux-Arts in Paris; begins copying Old Master	paintings in the Louvre	Makes his Salon debut exhibiting Dante and Virgil in Hell (The Barque of Dante)	Sees John Constable's (1776–1837) The Hay Wain at the Paris Salon
CHRONOLOGY	**1798**	**1806–15**	**1815**		**1816**		**1822**	**1824**

INSPIRED

● **Pierre Auguste Renoir**
(1841–1919)
Renoir's color, exoticism, and commitment to the human form were all indebted to Delacroix. He considered Delacroix the link between him, Rubens, and Titian.

● **Paul Gauguin**
(1848–1903)
Gauguin's masterpiece *The Vision after the Sermon (Jacob Wrestling with the Angel)* (1888) is indebted to Delacroix's earlier painting on the same theme.

● **Vincent van Gogh**
(1853–90)
Van Gogh's dramatic use of color, loose brushwork, and strong emotional approach to painting were inspired by Delacroix. Van Gogh made direct copies of Delacroix paintings.

● **Paul Cézanne**
(1839–1906)
Cézanne considered Delacroix's palette to be one of the most beautiful in all of French painting

● **Auguste Rodin**
(1840–1917)
As a sculptor, Rodin saw Delacroix as a painter of movement.

For half a century Eugène Delacroix occupied a central position in European Romanticism in the visual arts. The recognized leader of the revolt that displaced the Classicism of Jacques-Louis David (1748–1825) and that of his greatest pupil Jean-Auguste-Dominique Ingres (1780–1867), Delacroix's paintings expressed a Romantic spirit through their subject matter, bold color, active brushwork, dynamic compositions, and above all, through their strong emotions that reflected the artist's temperament. Yet Delacroix did not abandon all the tenents of Classicism, and he attained a "Classical" simplicity and grandeur in many of his major works.

Delacroix grew up in a privileged household, with art, music, and literature part of his upbringing. His schooling encouraged many of these interests, and during his stay at the Lycée Imperial in Paris he won prizes in Classics and drawing. Pursuing the Fine Arts, he entered the studio of Pierre Guérin

in 1815, and the next year enrolled at the École des Beaux-Arts. Coming of age during a vibrant time in French art and literature, and energized by lessons learned in copying Old Masters at the Louvre, the young painter emerged from his training inspired with a Romantic fervor.

A series of dramatic Delacroix paintings—*Dante and Virgil in Hell*, 1822, (Louvre, Paris), the *Massacre at Chios*, 1824, (Louvre, Paris), and the *Death of Sardanapalus*, 1827, (Louvre, Paris)—created a sensation, and elevated the artist to the leadership of the French Romantic School. These works reveal many of Delacroix's life-long interests and influences, and emphasize the diversity of the literary, historical, and exotic sources entering his repertoire. Among the notables who fired his artistic imagination were the writers Dante (1265–1321), William Shakespeare, Johann Wolfgang von Goethe (1749–1832), and Lord George Byron; and the artists Peter

The Raft of Medusa,
Théodore Géricault, 1819, Louvre, Paris

As one of the seminal works of French Romanticism, Géricault's painting influenced a generation of artists, among them Delacroix. Many of its formal traits speak a classical language, but its controversial subject matter and life-and-death drama—pitting man against nature—generated a visceral response from the public.

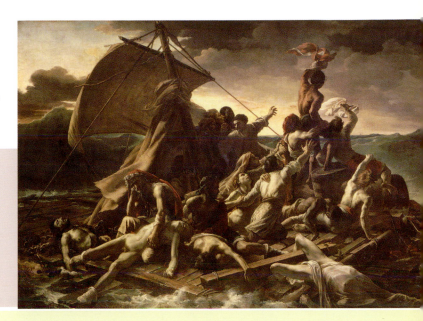

■English Romantic Poets
The works of John Keats (1795–1821), William Wordsworth (1770–1850), Samuel Taylor Coleridge (1772–1834), Percy Bysshe Shelley (1792–1822), and Lord George Byron (1788–1824) influenced the themes and sentiments in Delacroix's paintings.

● Théodore Géricault
(1791–1824)
Founder of the Romantic School in France and a mentor to the young Delacroix. It was Géricault who introduced Delacroix to the English school of painters.

■ Romantic Music
Delacroix's circle of friends included many of the leading composers of the day: Chopin (1810–49), Liszt (1811–86), and Paganini (1782–1840), among them. Delacroix's paintings were influenced by—and helped to define—the spirit of Romantic music.

Exhibits Death of Sardanapalus at the Salon; Delacroix recognized as the	*leader of the Romantic school in France*	*Travels to Morocco, Algeria, and Spain*	*Exhibits 55 paintings at the Exposition Universelle in Paris; made a*	*commander of the Légion d'Honneur*	*Elected to the Institut de France; eligible to teach at the École des Beaux-Arts*	*Dies August 13 in Paris*
1827	**1832**	**1855**	**1857**	**1863**		

● Georges Seurat
(1859–91)
The science and color theories explored by Delacroix paved the way for Neo-Impressionism and Seurat's pointillist technique.

● Wassily Kandinsky
(1866-1944)
Kandinsky was particularly interested in Delacroix's ability to use color to evoke emotion.

● Henri Matisse
(1869–1954)
Matisse responded strongly to Delacroix's use of bright color and his Moroccan imagery.

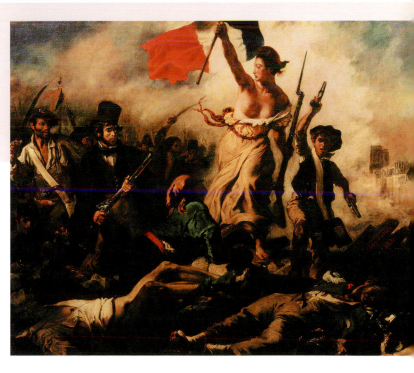

Liberty Leading the People,
Eugène Delacroix, 1830, Louvre, Paris

Delacroix's engagement with Romanticism took to the streets of Paris in this dynamic and colorful composition. Responding to events he witnessed during the July Monarchy, the artist was influenced by Géricault in his composition and imaginative combination of fact and allegory.

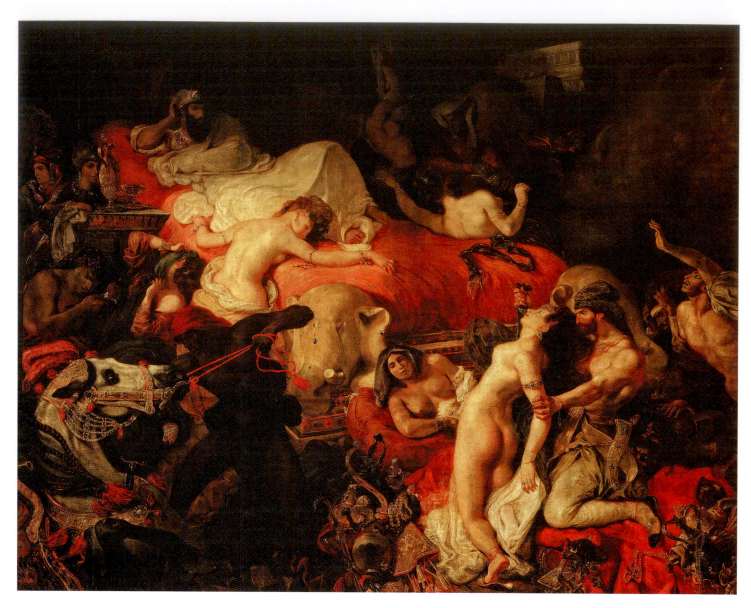

The Death of Sardanapalus,
Eugène Delacroix, 1827, Louvre, Paris

The strong Baroque diagonal in Delacoix's masterpiece moves us quickly from the foreground carnage to the figure of Sardanapalus witnessing the destruction of all his most beloved possessions.

ABOUT THE WORK

The drama of a Lord Byron narrative poem inspired this visual orgy of death. Delacroix's dazzling brushwork, hot colors, sensuality, and exoticism are all harnessed in this work that was his entry to the Salon of 1827.

MOOD

The alarming story of the Assyrian King Sardanapalus ordering the destruction of all his possessions after his armies' defeat is transformed by Delacroix into a romantic inferno of death, destruction, exoticism, and eroticism. The brushwork and bold palette combine with the work's dynamic composition and dramatic lighting to enhance the terror of the moment.

COLOR

Delacroix's colorful and dynamic palette, with its contrast of deep reds and flesh tones, points to his reliance on the work of the Flemish painter Rubens. During his lifetime Delacroix aligned himself with the followers of Rubens, aptly named the Rubenistes.

COMPOSITION

To heighten the effect of the savagery, Delacroix adopts a claustrophobic, chaotic composition that provides no means of escape. The king's crimson bed (1), soon to become his funeral pyre, serves as a diagonal focal point contrasting the passive ruler to the mayhem in the foreground.

Paul Rubens, Titian, Rembrandt van Rijn (1606–69), Théodore Géricault, and Antoine-Jean Gros (1771–1835).

Delacroix developed a style and technique that marked a break from traditional artistic practices. His brushwork became increasingly loose and expressive, and his use of color sparked a revolution still felt today. Responding to developments in color theory, Delacroix placed complementary colors adjacent to each other to intensify their effect. Some of the best examples of this technique are found in his scenes of wild animals and other subjects based on his travels to Morocco.

He was an accomplished writer who kept journals during extended periods of his career. Much of the information known about his working methods can be gleaned from his journal entries. In addition, the artist was often praised by contemporary writers, including the critic Charles Baudelaire (1821–67), who, in a Romantic vein, described Delacroix as "a lake of blood haunted by wicked angels." Other insights about Delacroix and his art emerge from the long-running battle that pitted his paintings against those of Ingres. For years Ingres prevented Delacroix's election to the Institut de France, but in 1857 he was finally admitted. This honor allowed him to fulfill his wish to teach at the École des Beaux-Arts, and in so doing remove the last barrier blocking his unrivalled position as France's most important painter. By then, however, a new spirit of painting was emerging in the visual arts: Realism.

Women of Algiers in their Harem,
Eugène Delacroix, 1834, Louvre, Paris
The exotic theme of the harem inspired Delacroix on many occasions. Here his colorful palette matches the sensuality of the subject. Delacroix's experiments with color influenced French painting from the Impressionists to Matisse and beyond.

Women of Algiers (after Delacroix),
Pablo Picasso, 1955, Prado, Madrid
Picasso constantly found inspiration in the art of others, in this case Delacroix. His interpretation of the *Women of Algiers* focuses on the sexuality of the women. Picasso began this series shortly after the death of Matisse, Picasso's friend, rival, and fellow admirer of the art of Delacroix.

Gustave Courbet began one of the great reforms in 19th-century art. Profoundly anti-academic, he sought to overturn the tenets of both Neoclassical and Romantic art. Courbet depicted scenes of peasant life and labor that were not idealized, insisting on the democratic nature of art and asserting that the only appropriate subject matter derived from the real world. All subsequent art movements would be affected by his example.

INFLUENCED BY

KEY
● artist
◆ artistic movement
■ cultural influence
❖ religious influence

■ **Nature**
Courbet turned his back on the idealizing qualities of Neo-Classicism and Romanticism to stress the tangible and real world of nature.

■ **Ornans**
Courbet's home town provided the inspiration for many of his subjects, including his signature works *Burial at Ornans* (1850) and *The Stone Breakers* (1849).

◆ **Old Masters**
Courbet's early work, especially his portraits and self-portraits, reflect his interest in Dutch, Flemish, Venetian, and Spanish Old Masters in the Louvre.

● **Caravaggio**
(1571–1610)
All 19th-century Realist painters owed a debt to the dramatic light and naturalism of Caravaggio's art, and that of his followers.

● **Diego Velázquez**
(1599–1660)
The sophistication of Velázquez' oil technique, his rich, tactile surfaces, and use of light all resonated with Courbet.

GUSTAVE COURBET (1819–77)
French

Born June 10 in Ornans, in the Franche-Comté region	Studies at the Royal College in Besançon with Fajoulet, pupil of David	Studies in Paris with the painter Steuben. Spends next four years copying in the	Louvre. Rejected at the Salons of 1841 to 1843	First painting accepted at the Salon: Self-Portrait with Black Dog	Meets Baudelaire, and Jules-François-Félix Husson Champfleury. Exhibits 10	paintings at the Salon, and receives first serious critical attention	Artist-juried Salon selects 11 of Courbet's paintings. Government
CHRONOLOGY	**1819**	**1837–39**	**1839**	**1844**	**1848**		**1849**

INSPIRED

◆ **The Impressionists**
The Impressionist concern with optical truth and preference for scenes drawn from everyday life refer back to Courbet's Realist imagery.

● **Édouard Manet**
(1832–83)
Manet was perhaps Courbet's truest acolyte, translating Courbet's exploration of rural life into scenes of urban Paris portrayed in a contemporary fashion.

● **James Abbott McNeill Whistler**
(1834–1903)
Whistler's early Realist paintings rely on the palette, brushwork, and vision of Courbet.

● **Paul Cézanne**
(1839–1906)
Cézanne's early work reflects Courbet's restrained color and use of the palette knife, while his later work displays Courbet's understanding of landscapes seen as planes of color.

● **Paul Gauguin**
(1848–1903)
Gauguin's bohemian persona was largely inspired by the anarchic behavior of Courbet (right: *Self Portrait*, 1893).

Gustave Courbet is a pivotal artist in the 19th-century's evolution from history and religious painting to subjects of everyday life. Neo-Classical painters, led by Jacques-Louis David (1748–1825), and Romantic artists, including Eugène Delacroix (1798–1863), had adhered to a hierarchy with large-scale narrative paintings on historical, religious, and mythological themes at its apex. Parisian critics and patrons celebrated these subjects that sought to engage and instruct on the great moral questions of human experience. The conservative French Academy continued to emphasize the importance of didactic history painting. Courbet, the self-styled bohemian artist from Ornans, arrived in Paris, and challenged the mystique of moralizing history painting by concentrating on large-scale episodes of everyday life, most often peasant and provincial village life. Jean-François Millet (1814–75) and others in his circle, such as Charles-Emile Jacques (1813–94),

depicted the harsh realities of rural existence in a golden glow that mythologized the industry, virtues, and nobility of peasant life. Their small-scale, idealized representations of peasant life attracted positive attention at the annual Salons.

In contrast, Courbet's large-scale paintings of daily life were deliberately unromantic. Throughout the 1840s and 1850s he set out to depict the truth of life in the provinces. In the harsh light of day, common villagers enact the rituals of everyday life, from shepherds in their fields to local funeral services. Courbet's greatest early painting, *The Stone Breakers*, 1849 (formerly at Gemälde-galerie, Dresden; destroyed in 1945), was a manifesto of the impoverishment and misery of peasant life. Two male figures, one young and one old, are subjected to an endless cycle of mundane, physical labor: breaking larger stones into smaller ones for a road. It is not a sentimental portrayal, but a stark, raw depiction of physical work.

The Silver Goblet,
Jean-Baptiste Siméon Chardin, 1728, Louvre, Paris

The directness of Chardin's vision, simplicity of his subjects, and physicality of his paint handling are all echoed in Courbet's still-lifes.

● **Pierre-Joseph Proudhon**
(1809–65)
Courbet and the anarchist philosopher were friends. They shared a suspicion and hatred of the French government, a belief in pacifism, and a preference for the countryside over the city.

■ **Karl Marx**
(1818–83)
Marx extolled the dignity of labor and expressed his concerns about the treatment of the working class, as did Courbet.

● **Jules-François-Félix Husson Champfleury**
(1821–89)
This prominent writer and critic provided the theoretical framework for the Realist aesthetic in art.

purchases After Dinner at Ornans, which wins a Salon medal	Exhibits eight paintings at the Salon, including the controversial	Burial at Ornans and The Stone Breakers	Eleven Courbet paintings exhibited at the Exposition Universelle	Courbet sets up his own exhibition across from the fair, the "Pavilion of Realism"	Courbet declines the French Légion d'Honneur. Franco-Prussian war breaks out	The Paris Commune is organized. After the defeat of the Commune Courbet	is arrested, and sentenced to six months in prison for his role in the revolt	Courbet goes into exile in La Tour de Peilz, Switzerland	Dies December 31 in La Tour de Peilz, Switzerland
	1850		**1855**		**1870**	**1871**		**1873**	**1877**

● **Lucien Freud**
(b.1922)
Freud's depictions of the body, his desire to paint the truth of what he sees, and his fleshy application of paint echo the goals and practice of Courbet.

Still Life with Apples and a Pomegranate,
Gustave Courbet, 1871–72, National Gallery, London

The importance of Chardin's still-lifes for artists like Courbet, Manet, Cézanne, and other French painters of the 19th century is evident throughout their work.

Woman with Parrot,
Gustave Courbet, 1866, Metropolitan Museum of Art, New York

Courbet's *Woman with Parrot* is presented frankly and directly without the cloak of an acceptable allegory or myth to justify her nudity.

ABOUT THE WORK

Courbet's frank portrayal of the female nude was attacked for its lack of taste, refinement, and decorum when it was exhibited in the Salon of 1866.

It was exactly its provocative qualities, however, that attracted the attention of artists like Édouard Manet and Paul Cézanne who greatly admired the picture. Manet's painting *Young Lady* in 1866 (Metropolitan Museum of Art, New York) exhibited two years later at the Salon of 1868 was directly indebted to the Courbet work, a similarity that was remarked upon by critics of the Manet picture.

COLOR

Courbet's juxtaposition of dark earth colors and creamy flesh tones—notably where the woman's hair flows next to her throat and shoulders (1)—contributes to the painting's overall sensuality.

LIGHT

Courbet's dramatic light and shadow emphasize the sculptural qualities of the woman.

TECHNIQUE

Courbet's handling of paint stresses its tactile and material nature and gives all his paintings a physical presence.

In these early masterpieces, Courbet deliberately chose a limited and subdued palette as a parallel to his choice of country themes. His narrow range of blacks, browns, and grays emphasized the earthiness of his subjects and the reportage nature of his scenes. He employed a thick, heavy impasto to draw attention to the physicality and humbleness of his own working materials and labors.

Courbet was also politically engaged and volatile. He disliked the strong central power of the French government in Paris. He spoke up for greater freedom and democracy, bordering on a form of anarchy. His disdain for artistic authority led him to the revolutionary idea of creating his own rival exhibition across from the Exposition Universelle of 1855, the "Pavilion of Realism." The exhibition was the first significant crack in the foundation of the French Academy's dictatorial rule of French painting, suggesting that critics and the public could judge works of art for themselves, without the intervention of Salon juries. His challenge expanded with the Salon des Refusés of 1863, leading eventually to the independent exhibitions put on by Impressionists in the 1870s and 1880s.

Leigh Bowery (Seated),
Lucien Freud, 1990, Private Collection

Inspired by Courbet's fleshy paint application, confrontational poses, and provocative subject matter, Lucien Freud is a modern heir to the realist tradition of his 19th-century French predecessor.

James Abbott McNeill Whistler was an innovative painter and printmaker, and an astute theoretician. Although his work is recognized as an important achievement in 19th-century art, his importance as a precursor of Modernism is underappreciated today. Whistler deserves recognition as a radical reformer of the pictorial arts, and a pioneer in the development of nonrepresentational painting.

 INFLUENCED BY

KEY
- ● artist
- ◆ artistic movement
- ■ cultural influence
- ❖ religious influence

● **Rembrandt van Rijn** (1606–69)
The Dutch painter and printmaker figured prominently in Whistler's art, from the style and subjects of his early Realist etchings, to the economy of the Venice etchings, to the late lithographs.

● **Diego Velázquez** (1599–1660) and
● **Francisco Goya** (1746–1828)
Whistler was one of many 19th-century artists, such as Édouard Manet (1832–83) and John Singer Sargent, to be influenced by these Spanish artists.

● **Gustave Courbet** (1819–77)
Whistler's early paintings were indebted to Courbet's Realism, including his subjects drawn from everyday life, his limited tonal range, and his thick application of paint.

◆ **Japanese Prints**
The appearance of Japanese woodcuts in Paris in the 1850s started a fascination with their essential features: exotic subject matter, flattened areas of bright color, striking cropping of elements, and distinctively Oriental perspective.

◆ **Photography**
The development of photography in the 1860s and 1870s created a revolution in aesthetic design, the representation of movement, and in the deliberate cropping of forms that suggests a limited view derived from a broader vista.

JAMES ABBOTT MCNEILL WHISTLER (1834–1903)
American

Born July 11 in Lowell, Massachusetts	Leaves United States. Goes to Paris to study, and never returns to the United States	Two etchings accepted for the Paris Salon. Leaves Paris and moves to London	The White Girl (later retitled Symphony in White #1), arouses	controversy in the famous Salon des Refusés in Paris	Paints Arrangement in Gray and Black #1: Portrait of the Artist's Mother	Whistler's libel action against the critic John Ruskin (1819–1900) comes to trial.	Despite a verdict in his favor, Whistler is forced to pay court costs
CHRONOLOGY							
1834	**1855**	**1859**	**1863**		**1871**	**1878**	

→ INSPIRED

● **W. S. Gilbert** (1836–1911) and
● **Arthur Sullivan** (1842–1900)
Their comic opera Patience (1881) satirized the Aesthetic Movement with parodies of Whistler, Algernon Swinburne (1837–1909), and Oscar Wilde (1854–1900).

◆ **Camera Work**
Turn-of-the-century photographers such as Alfred Stieglitz (1864–1946) revered Whistler's abstracted images and soft-focus nocturnes.

● **Édouard Vuillard** (1868–1940) and
● **Pierre Bonnard** (1867–1947)
Whistler's aesthetic vocabulary provided the theoretical underpinning of the Nabi group.

● **John Singer Sargent** (1856–1925)
The American expatriate painter who lived in Paris and London was inspired by Whistler's novel approach to Venice, and his controversial portraits of London celebrities.

◆ **Anglo-American Printmakers**
Generations of etchers, from Joseph Pennell to Francis Seymour Haden; Walter Sickert to Muirhead Bone; and from James McBey to David Y. Cameron; were inspired by Whistler.

Whistler's early work is rooted in the Realism of Courbet. His 1863 submission to the Salon des Refusés in Paris, *Symphony in White No. 1: The White Girl*, 1862 (National Gallery of Art, Washington, D.C.), first brought him critical attention. In the late 1860s he abandoned Realism for an aesthetic inspired by Classical art, Spanish painting, and Japanese prints. He rejected the Victorian notion that a painting needed to illustrate a story. Whistler titled his paintings with musical terms, such as "symphonies," and "nocturnes," saying, "As music is the poetry of sound, so is painting the poetry of sight, and the subject matter has nothing to do with harmony of sound or color."

In the 1870s his work achieved a new maturity. In portraiture, his strong sense of design was evident in the *Arrangement in Gray and Black, No. 1: Portrait of the Artist's Mother*, 1871 (Musée d'Orsay, Paris), while his landscapes minimized detail in favor of a simplified tonal harmony. These paintings, including the *Nocturne in Blue and Gold: Old Battersea Bridge, 1872–77* (Tate Britain, London) and *Nocturne in Black and Gold: the Falling Rocket,* 1875 (Detroit Institute of Arts), approach abstraction. The latter was the painting that John Ruskin found so reprehensible, leading to the libel suit of 1878. Despite his victory, the suit led to Whistler's bankruptcy and acceptance of a commission to etch in Venice. For 14 months, he executed more than 50 prints and approximately 100 pastels that are at the core of his artistic achievement. Whistler's economical approach to representing Venice distinguished his work from the anecdotal sentimentality of Victorian imagery.

On February 20, 1885, Whistler delivered his "Ten O'Clock" lecture on his aesthetic views at Prince's Hall in London. His defense of artistic individuality and the importance of formal elements provided the intellectual justification for Abstract art from the Nabis to the Abstract Expressionists.

Pablo de Valladolid,
Diego Velázquez, 1637, Prado, Madrid

Whistler appreciated Velázquez for the subtlety of his brushwork and his ability to convey a tangible sense of atmosphere around his figures.

■ Venice

The city inspired some of Whistler's most innovative work, including his etchings of alleys, canals, and deserted squares, as well as mosaiclike pastels of courtyards and facades.

Whistler declared bankrupt, and leaves for Venice. Returns in 1880 with 53 etchings	*and more than 100 pastels that reestablish his artistic reputation*	*Delivers the "Ten O'Clock" lecture in London; repeats it several times that year*	*Marries Beatrice Godwin (1857–96), widow of E. W. Godwin (1833–86)*	*Publishes The Gentle Art of Making Enemies, a compendium of his earlier writings*	*Arrangement in Gray and Black #1: Portrait of the Artist's Mother, is the first American*	*painting purchased for the French state collections*	*Made an Officier of the French Légion d'Honneur*	*Dies July 17 in London*
1879		**1885**	**1888**	**1890**	**1891**		**1892**	**1903**

◆ 20th-Century Abstraction

Whistler asserted through his paintings and writings that before a painting was a picture of something, it was an arrangement of colors on a flat surface.

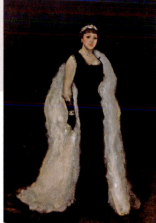

Brown and Gold, (Self-Portrait),
James Abbott McNeill Whistler, 1895–1900, Hunterian Art Gallery, University of Glasgow

Whistler's admiration for the Spanish Baroque painter is evident in this late full-length self-portrait, a clear homage to Velázquez.

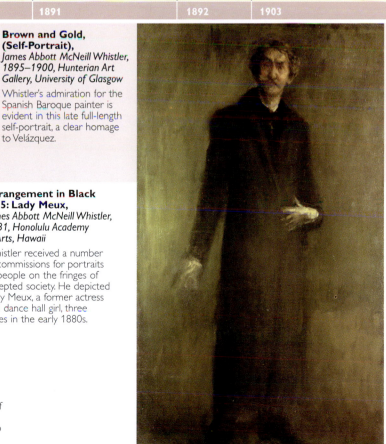

Arrangement in Black no.5: Lady Meux,
James Abbott McNeill Whistler, 1881, Honolulu Academy of Arts, Hawaii

Whistler received a number of commissions for portraits of people on the fringes of accepted society. He depicted Lady Meux, a former actress and dance hall girl, three times in the early 1880s.

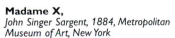

Madame X,
John Singer Sargent, 1884, Metropolitan Museum of Art, New York

Sargent would have seen Whistler's daring portraits of Lady Meux. His own portrait of the American expatriate Virginie Gautreau, Madame X, adopted Whistler's approach to a similar subject.

Édouard Manet is one of the geniuses of French 19th-century painting. His intellectual curiosity and talent led him to apply a sophisticated interpretation of Gustave Courbet's Realism to Parisian scenes of everyday life. He is among Courbet's truest followers, a recorder of contemporary life who exerted an enormous influence on the young Impressionists and on the subsequent history of art.

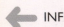 **INFLUENCED BY**

KEY
● artist
◆ artistic movement
■ cultural influence
❖ religious influence

● Honoré Daumier
(1808–79)
Daumier's lithographs, watercolors, drawings, and sculptures explored many of the social and political issues of concern to Manet and other painters of contemporary urban life.

● Thomas Couture
(1815–79)
Couture's *Romans of the Decadence* (1847) attracted much critical and popular attention. His innovative teaching practices drew many students to his studio, including a young Manet.

● Gustave Courbet
(1819–77)
Manet's everyday subject matter, thick application of paint, loose brushwork, and restrained palette were inspired by the Realism of Courbet.

◆ Italian Renaissance
Manet used images by Titian and Raphael as compositional inspiration for his bold paintings of *Olympia* (1863) and *Le Déjeuner sur l'Herbe* (1863).

◆ Spanish Art
Spanish art and culture fascinated Manet. He was deeply influenced by the paintings and prints of Diego Velázquez and Goya seen during his 1865 trip to Spain.

ÉDOUARD MANET (1832–83)
French

	Born January 23 in Paris	Studies with Thomas Couture, a successful Salon painter, and innovative teacher	Meets writer Charles Baudelaire (1821–67)	Exhibits at the Salon for the first time with Portrait of M. and Mme. Manet, and The	Spanish Singer which receives an honorable mention	Exhibits Le Déjeuner sur l'Herbe (Luncheon on the Grass) in the Salon des Refusés	Olympia causes a scandal when Manet exhibits the overtly contemporary	nude in the annual Paris Salon
CHRONOLOGY	**1832**	**1850–56**	**1858**	**1861**		**1863**	**1865**	

INSPIRED

◆ Impressionism
Manet's central role in advocating the painting of contemporary urban life and his avant-garde techniques inspired the younger generation of Impressionists, including Monet, Renoir, and Pissarro.

◆ Post-Impressionism
Paul Cézanne and Paul Gauguin both made copies of works by Manet. Other artists of the 1870s and 1880s were inspired by Manet's independence, work ethic, and commitment to his art despite rejection and criticism.

● Berthe Morisot
(1841–95)
Manet's student, friend, colleague, and sister-in-law, Morisot learned much from Manet, including approaches to subject matter from daily life. Morisot, in turn, inspired Manet's brighter palette in the 1870s.

● Mary Cassatt
(1844–1926)
Cassatt was inspired by the Spanish themes in Manet, his radical formal language, and the essential Realism of his art.

● Eva Gonzalès
(1849–83)
Gonzalès met Manet in 1869, and became his model and student. Her paintings were most inspired by the Spanish style of Manet's works from the 1860s.

Édouard Manet was one of the leaders of the French avant-garde in the second half of the 19th century. He is a pivotal figure in the transition from the traditional Neoclassic and Romantic narratives of the French Academy to the Realism of the second half of the century. He is the last great painter firmly rooted in art history, and the first of the great Modernists. Manet sought to capture aspects of the new urban experience in one of Europe's most exciting capitals, Paris. Following in the footsteps of Gustave Courbet's Realist subject matter of the countryside, Manet recorded the diverse urban life of Second Empire Paris. His paintings reflect the changing quality of this urban world: the increase in the city's size and population, and the subsequent displacement of the poor and disenfranchised during the renovations undertaken by Baron Haussman (1809–91) and Napoleon III (1808–73), as seen in *Music in the Tuileries*, 1862 (National Gallery,

London) and *The Old Musician*, 1862 (National Gallery of Art, Washington, D.C.). His two most controversial paintings of the 1860s, *Le Déjeuner sur l'Herbe*, 1863 (Musée d'Orsay, Paris), and *Olympia*, 1863 (Musée d'Orsay, Paris) shocked the artistic establishment in their brazen reflection of modern urban society. By 1870, Manet began to explore the contemporary scene in portrayals of writers and critics, and in his Parisian genre scenes, including portraits of Berthe Morisot and Émile Zola, and his *Masked Ball at the Opera*, 1873 (National Gallery of Art, Washington, D.C.).

Beginning in the 1860s, Manet systematically transformed the formal language of painting, emphasizing flatness, bold contrasts of light, solid colors, shape, line, and the material nature of the paint itself. His keen intellect synthesized the expressive potential of these elements from diverse sources, including Baroque painting, the newly developed art and

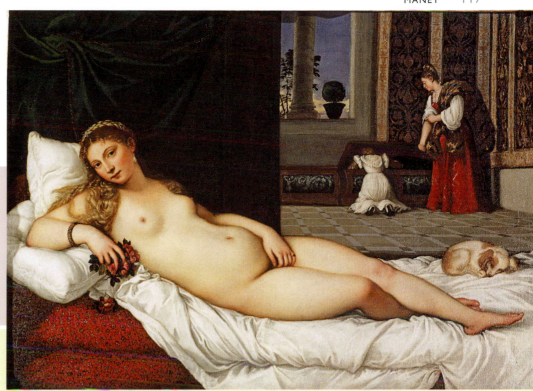

Venus of Urbino,
Titian, 1538, Uffizi, Florence

Manet first saw Titian's great nude as a student on a trip to Italy in 1853. It was one of three paintings by Titian that the artist copied.

◆ Japanese Prints
Manet adopted many of the design elements of Japanese woodcuts in his paintings of the 1860s, including bold contrasts, flat shapes, cropped forms, and two-dimensional perspective.

◆ Photography
Manet adapted the qualities of the photographic image to his own aesthetic needs: the flatness and stark black-and-white contrasts, the moment-frozen-in time, and the arbitrary cropping at the margins of a scene.

Writer Émile Zola (1840–1902) publishes the first serious consideration of Manet's art; retrospective exhibition at the Exposition Universelle	Enlists in the National Guard during the Franco-Prussian War	Exhibits The Railway at the annual Salon; declines to show with the Impressionists in their first group exhibition	Is elected a Chevalier of the French Légion d'Honneur	Exhibits A Bar at the Folies-Bergère at the Salon	Left leg amputated April 19; dies April 30 in Paris	Olympia is finally accepted at the Louvre
1867	**1870–71**	**1874**	**1881**	**1882**	**1883**	**1893**

◆ Modernism
Manet's assertion that a painting is an investigation of formal elements on a flat surface and his challenge to conventions of subject matter inspired the Abstract language and broad array of themes open to artists in the 20th century.

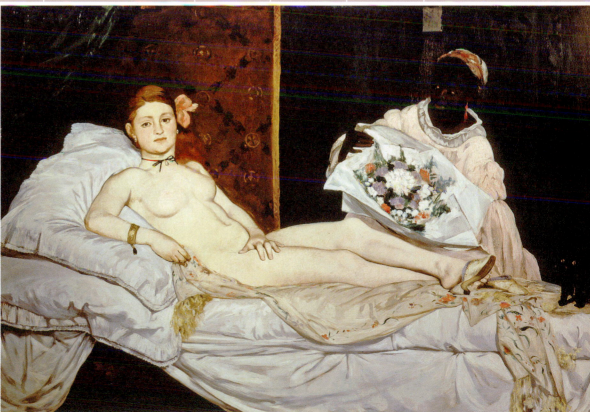

Olympia,
Édouard Manet, 1863, Musée d'Orsay, Paris

The artist derived the subject and format of his controversial Salon submission from Titian's model, but with significant changes to modernize the subject. Manet's figure is not idealized, more naked than nude, and directly engages the viewer with her gaze.

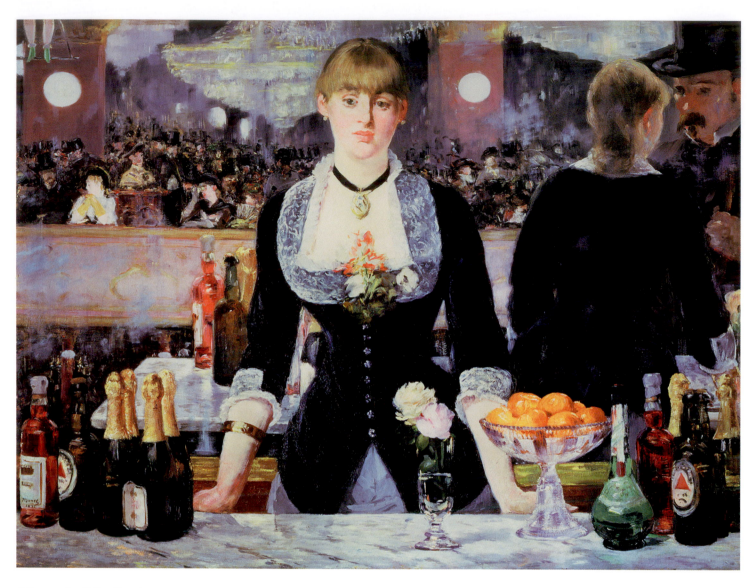

A Bar at the Folies-Bergère,
Édouard Manet, 1881–2, Courtauld Institute Galleries, London

Manet's masterpiece, *A Bar at the Folies-Bergère* is a comment on the anonymity and feeling of isolation found in urban spaces.

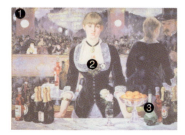

ABOUT THE WORK

A Bar at the Folies-Bergère was one of Manet's last great works and his final submission to the Paris Salon, the arena where he had championed avant-garde painting throughout his career.

CONTEXT

The artist set the painting in one of the most fashionable nightspots in Paris, a café and theatrical venue that offered entertainments in a chic atmosphere.

COMPOSITION

Manet placed the viewer on a balcony inwardly lined with loges facing the performance and with mirrors on the outer walls of the adjacent promenades. We face a barmaid and the reflection of the horseshoe shaped theater behind us, where an acrobat performs (1). The model for the barmaid was Suzon, a waitress from the Folies-Bergère, although she posed for the painting in his studio (2).

MOOD

Her explicit lack of emotion is a device Manet regularly employed throughout his career to indicate the anonymity and loneliness that characterized the typical arbitrary meetings of a modern metropolis. He reinforced this sense of displacement and isolation through his deliberate flaunting of traditional perspective in the mirror reflections on the right side. In the left and right foreground he creates one of the richest still-life passages (3) in the history of Western painting.

science of photography, and the discovery of Japanese prints. His original application of these principles led to fresh possibilities in the understanding of the purpose and meaning of paintings.

As a leader of the avant-garde in France in the late 1860s, Manet is often grouped with the Impressionists. He is distinguished from Monet and his circle, however, by a number of crucial issues, including his greater emphasis on the formal elements of painting, his continued use of black in his palette; his indifference to capturing the transitory effects of light; and his ongoing commitment to exhibit his work at the annual Salon, the traditional forum for artistic recognition, rather than choosing to participate in the revolutionary Impressionist exhibitions. By the mid-1870s, under the influence of Morisot, Manet displayed a brighter palette, and greater interest in the ephemeral effects of outdoor light, but these interests were short-lived.

Manet's greatest achievement was the creation of a modern vocabulary of painting. In his art and life are revealed a basic set of truths regarding the nature of painting and the roles of artist, critic, and public in determining meaning: This debate began with Manet.

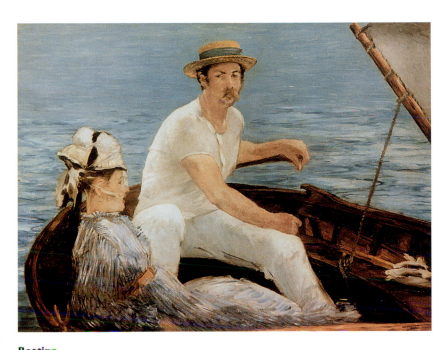

Boating,
Édouard Manet, 1874, Metropolitan Museum of Art, New York

Manet's image of recreational sailing, executed during his most Impressionist period, focused attention on the central figure of the boatman, and on the surrounding light and atmosphere.

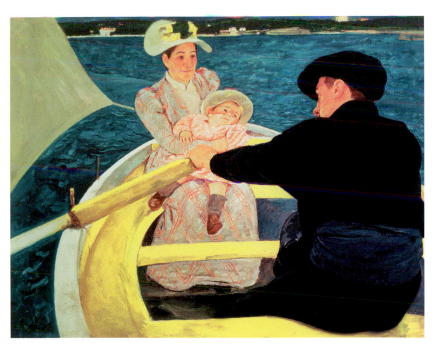

The Boating Party,
Mary Cassatt, 1893–94, National Gallery of Art, Washington, D.C.

Cassatt derived her image of boating in Antibes from Manet but altered crucial formal elements. Attention is focused on the woman holding the child. The broad areas of flat color and the two-dimensional design of the surface reflect the later concerns of Post-Impressionism.

Winslow Homer was the preeminent artist working in the United States during the second half of the 19th century. His early work represented the complexities of life during and after the traumatic bloodshed of the American Civil War. Departing from contemporary subjects, Homer's later paintings became increasingly complex, depicting transcendent themes of man's struggle against the vast and powerful elements of the natural world.

 INFLUENCED BY

KEY
● artist
◆ artistic movement
■ cultural influence
❖ religious influence

■ **Nature and the Sea**
From early in his career, Homer was inspired by the majesty and power of nature and the sea.

● **Matthew Brady**
(c.1823/24–96)
Homer based a number of his early American Civil War engravings on the photographs of this preeminent American war photographer.

■ **Elgin Marbles**
These Classical sculptures in London's British Museum inspired Homer to create figures with greater monumentality and solidity than he had previously achieved.

● **John James Audubon**
(1785–1851)
Homer based the composition of his late masterpiece *Right and Left* (1909) on Audubon's lithograph of the *Golden-eye Duck* (1836).

◆ **Victorian British Watercolors**
Homer's watercolors painted during his time in Cullercoats and after his return to the United States reflect his appreciation of large-scale watercolors of the Victorian era.

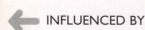

WINSLOW HOMER (1836–1910)
American

	Born February 24 in Boston	Serves apprenticeship in the lithographic workshop of John H. Bufford	Begins his career as an illustrator for Ballou's Pictorial	Arrives in New York City where he begins freelance work for Harper's Weekly	Harper's Weekly sends Homer to cover the American Civil War at the front lines with	General George McClellan's Army of the Potomac	Executes his first oil painting, Sharpshooter on Picket Duty	Elected an associate of the National Academy of Design; elected a
CHRONOLOGY	**1836**	**1854–55**	**1857**	**1859**	**1861**		**1863**	**1864**

INSPIRED

● **John Marin**
(1870–1953) and
● **Marsden Hartley**
(1877–1943)
As with every American painter of the sea, these two Modernists absorbed and reflected Homer's accomplishments in their portrayals of the power of the natural world.

● **Edward Hopper**
(1882–1967)
Hopper was attracted to many of the same themes (boating) and locales (Maine) explored by Homer. The naturalism and light in Hopper's paintings and watercolors were inspired by Homer.

● **Rockwell Kent**
(1882–1971)
Among the most popular American illustrators of the 20th century, the dramatic mood found in prints by Kent echoes the feeling in Homer's wood engravings of the 1870s.

● **Andrew Wyeth**
(b.1917)
America's leading contemporary Realist painter based his early watercolors directly on Homer's style.

● **Eric Fischl**
(b.1948)
Fischl's painting *The Old Man's Boat and the Old Man's Dog* (1982) appropriates the seascape from Homer's *The Gulf Stream* (1899) for its setting.

Winslow Homer's training in John H. Bufford's lithographic workshop, along with his time as an illustrator, deeply influenced his early paintings. Largely self-taught, his American Civil War (1861–65) subjects are essentially reportorial in character. Homer eschewed traditional battle scenes to capture in detail, conditions of life at the front in paintings such as *Sharpshooter on Picket Duty*, 1863 (Portland Art Museum, Portland, Maine). After the war, Homer continued his explorations in genre paintings representing a society's desire to return to normal life. From this period came his depictions of children in school, playing, or working, among the most famous *Snap the Whip*, 1872 (Butler Institute of American Art, Youngstown, Ohio).

In the 1870s, Homer regularly visited the New England fishing village of Gloucester on Cape Ann in Massachusetts. There he began his first paintings of marine subjects in *Breezing Up*, 1876 (National Gallery of Art, Washington, D.C.).

The subject of the sea would fascinate Homer for the rest of his life. His stay in England from 1881 to 1882 in the North Sea fishing village of Cullercoats profoundly affected his work. The harsh conditions of life there, for both the fishermen and their families, inspired a renewed *gravitas* in Homer's work.

In 1883, Homer moved to Prout's Neck on the coast of Maine, where he could study the sea under changing conditions. During this period Homer portrayed scenes of seamen struggling with the power of nature as in *The Life Line*, 1884 (Philadelphia Museum of Art). He also spent parts of each winter in the tropics exploring the bright color and sharp light of Florida, Bermuda, and the Caribbean in watercolors.

Homer began to focus his attention on the sea alone in 1890. His late paintings of the turbulent sea along the rocky coast of Maine are among his greatest works, displaying an emotional and aesthetic power that has never been equaled

Golden-eye Duck after John James Audubon,
Robert Havell, 1836, National Gallery of Art, Washington, D. C.

In a beautifully composed design, the great American naturalist illustrator John James Audubon observed and depicted these two Golden-eye Ducks in an awkward moment of flight.

● **Gustave Courbet**
(1819–77)
● **Édouard Manet**
(1832–83) and
● **Claude Monet**
(1840–1926)
Homer's stay in Paris exposed him to the work of Courbet and Manet, and to the light and shadow of Monet's early paintings.

◆ **Japanese Prints**
As with many Western artists of his time, Homer was intrigued by the asymmetry, cropping, flatness, and colors of Japanese prints by Hokusai and Hiroshige.

full academician of the Academy the following year	*Paints Prisoners from the Front. Sails for France, spends a year studying in Paris*	*Makes his first trip to the Adirondack Mountains in upstate New York;*	*he returns there approximately 20 times over the next 40 years*	*Breezing Up (A Fair Wind) shown at the Philadelphia*	*Centennial exhibition*	*Sails for England, and settles in Cullercoats near Tynemouth on the North Sea*	*Returns to the United States and moves to Prout's Neck on the coast of Maine*	*Paints The Fox Hunt*	*Dies September 29 in his studio at Prout's Neck*
	1866	**1870**		**1876**		**1881**	**1882–84**	**1893**	**1910**

■ **Outdoor Sport and Field Magazines**
Homer's scenes of fish rising out of rivers and deer hunting in the Adirondack Mountains are the ancestors of numerous hunting and fishing magazine front covers and advertisements in the United States today.

Right and Left,
Winslow Homer, 1909, National Gallery of Art, Washington, D. C.

In his last great canvas, Homer clearly adapted Audubon's Golden-Eye Duck to his own image, literally a bird's-eye point of view of duck hunting on the coast of Maine.

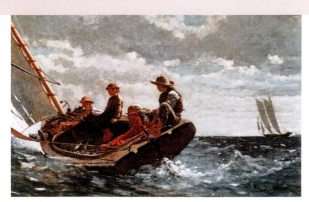

Breezing Up (A Fair Wind),
Winslow Homer, 1873–76, National Gallery of Art, Washington, D. C

In *Breezing Up*, Homer captured the freshness of salt air, the sea-spray, and the exuberance of the boys sailing their catboat off Gloucester Harbor at the end of a day's fishing.

Ground Swell,
Edward Hopper, 1939, Corcoran Gallery of Art, Washington, D. C.

John Marin, Edward Hopper and other American artists of the early 20th century followed Homer's lead in depicting the New England coast and man's engagement with the sea.

IMPRESSIONISM AND POST-IMPRESSIONISM

The First Impressionist Exhibition held in Paris in April 1874 is often considered the starting point for modern painting, and for the many avant-garde art movements that followed.

1870

CHRONOLOGY	The popularity of open-air painting increases with the introduction of the box easel and oil paint in tubes	The First Impressionist Exhibition held in Paris	Degas works on The Absinthe Drinker; Barbizon School painter Millet dies	World Fair held in Paris, exhibits include the telephone, electric light bulbs, and works of Japanese art	Seurat's Bathing at Asnières, 1883–84, rejected by the Salon but shown at the Salon des Indépendants	Van Gogh creates more than 200 paintings, including The Night Café	Manet's Olympia, 1863, is finally accepted at the Louvre; Munch paints The Scream	Monet paints Rouen Cathedral, West Façade, Sunlight; Cézanne begins The Large Bathers
	c.1870	1874	1875	1878	1884	1888	1893	1894

Camille Pissarro (1830–1903), Claude Monet (1840–1926), Pierre-Auguste Renoir (1841–1919), and Edgar Degas (1834–1917), organized the exhibit of independent artists, Société Anonyme des artistes peintres, sculptures, graveurs etc. The inaugural exhibition also included works by Paul Cézanne (1839–1906), Berthe Morisot (1841–95), and Alfred Sisley (1839–99). The artists sought to present directly to the public an alternative to the official art of France sponsored by such entrenched institutions as the Academy and the Salon with their traditional rules and expectations. The group hoped for a fair and unprejudiced assessment of their new vision. In a critic's sarcastic reaction to Monet's painting *Impression, Sunrise*, 1873 (Musée Marmottan, Paris) the term "Impressionism" was born as a commentary on the artist's loose paint application and ambiguous subject matter.

"THE NEW PAINTING"

As they soon came to be known, the Impressionists introduced the public to contemporary subjects drawn from a direct engagement with the urban world of the Parisian boulevards, cafés, theaters, cabarets, racetracks, and train stations. With the expansion of the railroads, the invention of collapsible metal tubes for oil paint, and portable easels, the Impressionists also discovered the French countryside, forever fixing locations such as Argenteuil, Bougival, Chatou, Giverny, and Pontoise, in the world's imagination.

The revolution of French Impressionism unfolded in Paris in a series of eight exhibitions held between 1874 and 1886. The works exhibited during these years represented original investigations into the science of light and color, a commitment to open-air painting, new sources of inspiration for both the formal language and subject matter of painting, challenges to the technical conventions of painting, and the idea of finish—all of which the writer and critic Louis Edmond Duranty (1833–80) called "The New Painting."

In their battle for acceptance, tenacity, persistence, conviction, and originality the painters associated with French Impressionism were inspired by the earlier example of Édouard Manet

*Degas buys
the latest
model Eastman
Kodak camera*

*Debussy
composes
Clair de Lune*

*Picasso paints
Les Demoiselles
D'Avignons*

*Fry organizes the
exhibition Manet
and the Post-
Impressionists
at the Grafton
Galleries, London*

1895 1903 1907 1910

(1832–83). In turn, the Impressionists opened the door for a generation of artists who extended the boundaries of painting even further. In this regard, some of the artists briefly associated with Impressionism such as Cézanne, Paul Gauguin (1848–1903), Georges Seurat (1859–91), and Vincent van Gogh (1853–90), later emerged as powerful voices for an even more dramatic shift in thinking about the nature and goals of art.

BEYOND THE VISUAL

The term "Post-Impressionism" was first coined in 1910 by the English critic Roger Fry (1866–1934). By 1910 most of the artists to whom the term referred—Van Gogh, Gauguin, Seurat, Cézanne—had died. Unlike Impressionism, which conjures up a series of unifying aesthetic concepts—even if not adhered to by all members of the group—Post-Impressionism refers less to a single style, and more to a generational gap.

Starting from Impressionist experiments with the power of light and color, the artists of Post-Impressionism explored a personal vocabulary stressing the emotional sources of painting, as in the works of Van Gogh and Gauguin; or intellectual, but no less personal, systems of expression as in the works of Seurat and Cézanne. In so doing, the artists focused on the formal properties of color, light, brushstroke, and space as vehicles of personal expression. Beyond the merely visual, Post-Impressionists investigated connections between painting, feeling, emotions, the mind, and the intellect. From the writhing brushstrokes, rich impasto, and blazing colors of Van Gogh's paintings to the obsessive concerns with space, structure, and the translation of a three-dimensional world onto the two-dimensional picture surface in Cézanne's art, the artists of Post-Impressionism moved past the naturalism and fleeting effects of the Impressionists, seeking a personal synthesis between observed phenomenon, personal expression, and intellectual rigor. Their formalist preoccupations would exert a huge influence on the subsequent history of painting.

Edgar Degas was a seminal painter in the development of French Impressionism. Important aspects of his training, interests, talent, and beliefs, however, separate him from the more orthodox adherents and ideas of the movement. In his study of the Old Masters, concern with drawing, exploration of movement, and technical experimentation, Degas expanded the options and possibilities for late 19th-century French artists.

 INFLUENCED BY

KEY
● artist
◆ artistic movement
■ cultural influence
❖ religious influence

◆ **Italian Mannerism**
Degas admired the linear qualities, elegance, and proportions of works by Pontormo (1494–1556) and Agnolo Bronzino (1503–72).

● **Jean-Auguste-Dominique Ingres** (1780–1867)
Ingres' advocacy of drawing as the foundation of art and his mastery of line made an impression on the young Degas and remained so thoughout his career.

● **Gustave Courbet** (1819–77)
Courbet influenced Degas' choice of subjects with his depictions of people and events drawn from real life.

● **Eadweard Muybridge** (1830–1904)
Muybridge's stop-action photographs of human and animal locomotion were studied and copied by Degas.

● **Édouard Manet** (1832–83)
Degas shared much in common with Manet personally and professionally. Both artists explored contemporary concerns to construct an innovative formal vocabulary of painting.

EDGAR DEGAS (1834–1917)
French

	Born July 19 in Paris	Meets Jean-Auguste-Dominique Ingres. Admitted to the École des Beaux-Arts	Embarks on a three-year trip to Italy	Exhibits at the Paris Salon for the first time	Becomes part of the avant-garde circle of artists, writers, and composers in Paris	Helps to organize and exhibits at the first Impressionist exhibition	Exhibits his wax sculpture Little Dancer, Aged Fourteen at the	sixth Impressionist exhibition
CHRONOLOGY	**1834**	**1855**	**1856**	**1865**	**1868**	**1874**	**1881**	

INSPIRED

● **Mary Cassatt** (1844–1926)
Degas was Cassatt's most important mentor, friend, and supporter after her arrival in Paris.

● **Walter Sickert** (1860–1942)
Sickert learned much from Degas while working with him in Paris. Degas' use of photographs as sources for paintings was especially important to him.

● **Henri de Toulouse-Lautrec** (1864–1901)
Lautrec was directly indebted to Degas' subjects, formal language, and working methods (right: La toilette, 1896).

Edgar Degas is among the most important artists of the 19th century. His name is associated with innovations and change in the realms of painting, sculpture, drawing, printmaking, and photography. Degas' use of vibrant color, focus on the boudoir and the female nude, and increasingly freeform linework paved the way for the next generation of artists. His impact as an artist resonated beyond his career, and encouraged Modernist titans Pablo Picasso and Henri Matisse to constantly innovate in style, subject matter, and medium.

Degas drew upon the rich heritage of art history and was scrupulous in his study and preparation for a career as an artist. He was influenced by such important past masters as Raphael (1483–1520), Titian (c.1490–1576), Diego Velázquez (1599–1660), Eugène Delacroix (1798–1863) and most especially Jean-Auguste-Dominique Ingres, at the same time that he was indebted to and inspired contemporaries

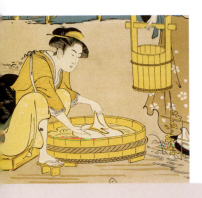

Nude Woman Displaying her Back,
Jean-Auguste-Dominique Ingres, 1807, Musée Bonnat, Bayonne

As a young man Degas met Ingres and formed a lifelong admiration for his mastery of drawing and the line.

◆ **Japanese Art**
Degas' art incorporates the flatness, cropped forms, unusual viewpoints, and asymmetry of Japanese prints (above: *Woman Washing at the River*, September 1888, magazine cover for *Le Japon*).

● **Émile Zola**
(1840–1902)
The naturalist writings of Zola, with their contemporary themes, stark realism, and urban settings, find parallels in Degas' art.

■ **Photography**
Degas practiced photography and the photographic image affected the formal qualities, studio practices, and working methods of his art.

Exhibits pastels of women bathing at the eighth and final Impressionist exhibition	Experiments with photography	One-man exhibition at the Fogg Art Museum in Cambridge, Massachusetts	Dies September 27; buried in Montmartre Cemetery
1886	**1895–96**	**1911**	**1917**

● **Pierre Bonnard**
(1867–1947)
Bonnard's great series of paintings of the female nude from the 1920s and 1930s recalled the subjects, innovations, and vision of Degas.

● **Henri Matisse**
(1869–1954)
Matisse was inspired both by Degas' expressive use of line and his free technique but also by the vivid colors of the late pastels.

● **Pablo Picasso**
(1881–1973)
Picasso owned a large number of Degas prints and returned frequently to Degas' art as a source of inspiration and dialogue.

like Édouard Manet, Camille Pissarro (1830–1903), Claude Monet (1840–1926), Pierre-Auguste Renoir (1841–1919), and Auguste Rodin (1840–1917).

Degas explored a variety of media and sources for his art. His imagination and interests extended to Japanese art, photography, modern literature, science, and human psychology. He was a rigorous, probing, and complicated artist whose originality and powers of invention redefined concepts of both the academic and the avant-garde. An important member of the Impressionist circle in France, Degas' achievement far outstripped the specific and limited goals of that movement to create an innovative vocabulary for art. In his formal investigations of light, movement, and space, and in his experimentation with materials and the processes of art, Degas anticipated many of the major interests of the 20th century.

The Tub,
Edgar Degas, 1885–86, Hill-Stead Museum, Farmington, California

In later life Degas began to focus on the intimate domestic scenes of women bathing and at their toilette, often using pastels. His nudes were drawn from real life, rather than idealized Classic beauties.

Claude Monet was the greatest painter of French Impressionism, a movement that took its name from one of his works. In his final series of paintings Monet's experiments with the changing quality of light, color, and atmosphere advanced toward abstraction. The late paintings would go on to have a profound influence on the subsequent course of art.

INFLUENCED BY

KEY
- ● artist
- ◆ artistic movement
- ■ cultural influence
- ❖ religious influence

● **Joseph Mallord William Turner**
(1775–1851)
Turner's paintings are often seen as forerunners to Impressionism in their atmospheric, luminescent, and abstract qualities. Monet spent time in London to escape the Franco-Prussian war.

● **John Constable**
(1776–1837)
The influence of Constable's landscapes on French painting extends from Théodore Géricault (1791–1824) and Eugène Delacroix (1798–1863) to the Barbizon School, Monet, and Impressionism.

● **Johan Barthold Jongkind**
(1819–91)
A Dutch landscape artist, Jongkind was highly regarded by Monet and other Impressionist painters.

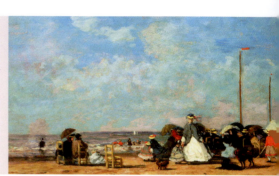

CLAUDE MONET (1840–1926)
French

	Born November 14 in Paris	Grows up in Le Havre; works as a caricaturist; befriended by Eugène Boudin	Does military service in Algeria	Enters the Paris studio of Charles Gleyre; begins working with the Dutch landscape	painter Johann Barthold Jongkind	Has two paintings accepted into the Salon	Marries Camille Doncieux (d.1879) who had previously borne Monet a	son. Family moves to London following outbreak of the Franco-Prussian War
CHRONOLOGY	**1840**	**Mid-1850s**	**1861**	**1862**		**1865**	**1870**	

INSPIRED

● **Claude Debussy**
(1862–1918)
Composer Debussy acknowledged the influence of the painter's work on his music. Monet's paintings were often described using musical terms by contemporary critics.

● **Wassily Kandinsky**
(1866–1944)
Kandinsky's first encounter with the *Grainstack* (1889–91) series of paintings by Monet was a transformative moment in his development as an artist.

● **Henri Matisse**
(1869–1954)
The late cut-outs of Matisse spread across entire walls of his studio resonate with the color and feeling of Monet's *Water Lilies* (1902–26) paintings.

● **Jackson Pollock**
(1912–56)
The color, brushwork, environmental scale, and abstraction of Monet's *Water Lilies* extend through time to Pollock's drip paintings.

● **Roy Lichtenstein**
(1923–97)
In a series of prints based on Monet's *Rouen Cathedral*, Lichtenstein tightens the Impressionist daubs of Monet to question the nature of optical painting, and blur the lines between the mechanical and personal.

As the leading artist of French Impressionism, Monet stands today as arguably the world's most popular painter. This broad appeal should not diminish the important innovations he brought to Western painting during the course of a long and productive career. Trained in a Realist style during the early 1860s, Monet was especially influenced by the art of his time rather than by the Old Masters. Among the many painters who shaped his vision were Eugène Boudin, Gustave Courbet (1819–77), Édouard Manet (1832–83), and Joseph Mallord William Turner. Like many of his peers, Monet responded to Japanese color woodblock prints, and to discoveries in color theory and optics. Exploring the ever-changing effects of light as a vehicle for capturing the fleeting impression of a scene, Monet's paintings express a keen awareness of how the nature and quality of light alter color. In serial paintings *Poplars* (1891), *Grainstacks* (1889–91), *Rouen Cathedral* (1892–94), and *Water*

Lilies (1902–26), Monet investigated the optical nature of painting with a clinical eye and hand.

Although born in Paris, Monet was raised in Le Havre. Boudin, a respected landscape artist who specialized in *plein air* (outdoor) paintings of the coastline of Normandy, was one of the first to recognize Monet's talent. Following military service, Monet entered the Paris studio of Charles Gleyre (1808–74) in 1862. Gleyre's academic style was not the best model for the young artist, but at the same time he received instruction from Boudin, and the Dutch landscape painter Johann Barthold Jongkind. By 1864 Monet sought his own path as an independent painter, and in the following year two of his paintings were accepted into the Salon. His submissions to subsequent Salons met with only limited success, prompting him eventually to show outside official circles.

The Burning of the Houses of Lords and Commons,
J.M.W. Turner, 1835, Philadelphia Museum of Art, Philadelphia

Turner witnessed, then recreated this event with vibrant colors and energetic brushwork, working with a palette knife to create the impression that the buildings continue to burn brightly.

● Eugène Boudin
(1824–98)
Monet always claimed it was Boudin who opened his eyes to the beauties of nature and the possibilities of landscape painting (left: *On The Beach, Trouville*, 1863).

● Camille Pissarro
(1830–1903)
Pissarro met Monet in 1859. Together they were the most gifted, diligent, and consistent painters of the French Impressionist landscape.

◆ Japanese Woodblock Prints (Ukiyo-E)
These popular Japanese works were highly regarded by Monet and other 19th-century European artists for their colors, linear patterns, two-dimensional space, and interesting viewpoints.

Living in Argenteuil, west of Paris	*Paints Impression: Sunrise, the work gives Impressionism its name*	*The Société Anonyme des Artistes, Peintres, Sculpteurs, Graveurs is*	*formed in Paris. The group holds its first exhibition in April*	*Purchases a house in Giverny that remains his home for the rest of his life*	*Marries second wife Alice Hoschedé*	*Dies December 6 in Giverny*
1871–78	**1873**	**1874**		**1890**	**1892**	**1926**

● Joan Mitchell
(1925–92)
In the bright colors, lyrical brushwork, and airy quality of her Abstract paintings Mitchell captures the essence of Monet's best traits.

Monet's Garden,
Giverny

The garden and lily pond that Monet created at Giverny was to provide an endless source of inspiration for the artist.

Houses of Parliment,
Claude Monet, 1904, Musée d'Orsay, Paris

Monet's impressions of the Houses of Parliament took the form of a series of paintings executed on-site in 1904. In each, he detailed how the daily changes in weather and light affected his choice of colors and the resulting dematerialization of the buildings.

Poppy Fields near Argenteuil,
Claude Monet, 1873, Musée d'Orsay Paris

While he lived there Monet painted many idealistic views
of the poppy fields around Argenteuil.

ABOUT THE WORK

Many of Monet's earliest experiments
in Impressionism took place in the
town of Argenteuil outside of Paris. This
painting shows the artist's engagement
with the elements central to his style:
pure and harmonious colors, detached
brushwork, and the luminous quality of
light that dissolves form.

LIGHT

Monet's commitment to painting
in the open air contributed to the
freshness and vibrancy of his effects of
light and its ever-changing nature.

COLOR

Monet's Impressionist palette is evident
in the pure colors of the red poppies,
bright blue sky, puffy white clouds,
and complex range of greens, browns,
yellows, and grays in the fields.

BRUSHWORK

The painting displays a variety of
brushwork: short, choppy strokes
for some plants (1), red dabs of
color for the flowers (2), and more
broadly-applied layers in the sky and
background (3).

SUBJECT MATTER

A field of red poppies provides the
setting for a midday stroll. This became
one of the quintessential themes in
Impressionist landscape painting.

Field of Poppies,
Vincent van Gogh, 1890, Haags Gemeentemuseum, The Hague

Painted a few weeks before Van Gogh's death, the subject matter of this work is reminiscent of a number of paintings by Monet. Characteristic of Van Gogh's works, however, is the frenzied technique and dry handling of the paint to create a decorative pattern that is both aggressive and beautiful.

During the next decade Monet transformed his art from boldly-painted landscapes dependent upon a Realist vocabulary to a fledgling type of Impressionism marked by short, choppy brushstrokes where the purity of hues and the quality of light played off form. His experiments were enhanced by the artists and friends working around him, including Camille Pissarro, Alfred Sisley (1839–99), Pierre-Auguste Renoir (1841–1919), and Gustave Caillebotte (1848–94) during the years 1872 to 1876 in Argenteuil. Together they formed the Société anonyme des artistes peintres, sculpteurs, graveurs, etc., and began to exhibit as an independent group in 1874.

Now called the "Impressionists," their leader Monet experienced some reversals during the second half of the 1870s. Sales fell and his wife Camille died in 1879. Monet abandoned Argenteuil, and eventually settled in Giverny with Alice Hoschedé and her children—Alice eventually became the artist's second wife. He traveled often in order to paint, but Giverny would remain home for the rest of his life. Monet's greatest achievements during the last half of his career were his serial paintings. Using multiple canvases, each timed to particular moments throughout the day, Monet concentrated on his subject, and how the variable conditions of weather and light affected form and color; as the light and weather changed, so did his palette. It was at this time that his magnificent flower garden and lily pond at Giverny were being completed, providing him with an endless source of inspiration. Failing eyesight curtailed his output near the end of his life, but not before he completed the extraordinary large-scale water lily murals for the French State. Unfortunately, they were unveiled in the Musée de l'Orangerie five months after Monet's death in December 1926.

Shinnecock Hills,
William Merritt Chase, 1895, Brooklyn Museum, New York

The Shinnecock Hills on New York's Long Island became Chase's Giverny. Its views provided the artist with an endless source of inspiration. The fresh and lively landscapes that resulted confirm Chase's interest in *plein air* (open air) painting that was reinforced by his understanding of French Impressionism.

Few artists can claim the position of importance that Paul Cézanne occupies in any discussion of artistic influence. The lessons and legacy of Cézanne's art are fundamental to an understanding of the development of modern painting. His experiments with space and color affected artists such as Pablo Picasso and Henri Matisse. His accomplishments mark a turning point in the history of Western painting.

INFLUENCED BY

KEY
● artist
◆ artistic movement
■ cultural influence
❖ religious influence

● **Nicolas Poussin** (1594–1665)
Cézanne hoped to revive and redo Poussin's Classical landscapes from nature.

● **Jean-Baptiste-Siméon Chardin** (1699–1779)
The close observation and seriousness found in Chardin's still-life paintings deeply affected Cézanne.

● **Gustave Courbet** (1819–77)
Especially in his early portraits, Cézanne echoed the rich impasto, encrusted surfaces, and bold palette knife work of the French Realist.

● **Camille Pissarro** (1830–1903)
The one artist who can perhaps be referred to as Cézanne's teacher. The two artists worked closely together in the 1870s (right: *View of Pointoise*, late 19th century).

PAUL CÉZANNE (1839–1906)
French

	Born January 19 in Aix-en-Provence	Befriends Émile Zola in Aix	Travels to Paris. Meets Camille Pissarro.	Meets Hortense Fiquet	Birth of son Paul	Participates in First Impressionist Exhibition	Marries Hortense. Friendship with Zola ends.	Paints The Peppermint Bottle (National Gallery, Washington, D.C.)
CHRONOLOGY	1839	1852	1861	1869	1872	1874	1886	1893–95

INSPIRED

● **Émile Zola** (1840–1902)
Cézanne's boyhood friend and champion who used the artist's life and career struggles as the basis for his novel *L'Oeuvre* (1886).

● **Henri Matisse** (1869–1954)
Like Picasso, Matisse constantly returned to the spirit of risk-taking, commitment and experimentation found in Cézanne's art.

● **Hans Hofmann** (1880–1966)
Hofmann's concept of "push and pull" owes much to the spatial tensions and effects of color in Cézanne's paintings.

● **Pablo Picasso** (1881–1973)
It is hard to imagine Picasso's *Les Demoiselles d'Avignon* (1907) without the earlier inspiration of Cézanne's bather paintings.

● **Lucian Freud** (b.1922)
Freud's painting, *After Cézanne* (1999–2000), is a paraphrase and commentary on Cézanne's *Afternoon in Naples* (c.1875).

Paul Cézanne epitomizes the concept of a painter's painter. His art is a disciplined, focused, and intense exploration of the problems that are fundamental to painting. The nature of art as we know it today is hard to imagine without his contribution. Cézanne created an art that is challenging, sometimes difficult, and fraught with implications for the later history of Modernism. Henri Matisse and the Fauves; Pablo Picasso and the Cubists; non-objective painters such as Piet Mondrian (1872–1944) and Kazimir Malevich (1879–1935); and contemporary artists ranging from Lucian Freud to Jasper Johns to Anselm Kiefer (b.1945) are all indebted to Cézanne.

Cézanne's painting represents a move away from the purely visual and sensory to a more cerebral and intellectual art. His example takes us beyond the optical paintings of Impressionism to explore a new relationship between the eye and the mind. Few artists have worked as intensely to understand and to question the problems of the painter, his materials, and processes. The struggle to understand and to reconcile the three-dimensional reality of nature with the two-dimensional space of the painted surface—the struggle to distinguish between what is objective and subjective became a titanic battle for Cézanne.

Despite the originality and importance of his achievement, Cézanne is, nonetheless, indebted to a host of earlier painters extending back to the pastoral traditions of Titian (c.1490–1576) and Giorgione (c.1477–1510), the Classical landscapes of Nicolas Poussin, the still-lifes of Jean-Siméon-Baptiste Chardin and, closer to his own day, the art of Gustave Courbet, Édouard Manet (1832–83) and, most especially, Camille Pissarro. Cézanne would later be described by Picasso as "the father to us all," and by Matisse as "a benevolent God of painting."

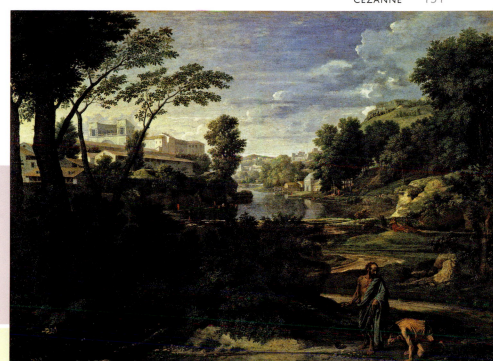

Diogène breaking his drinking bowl,

Nicolas Poussin, c.1648, Louvre, Paris

Cézanne worked in the pastoral tradition, and hoped to revive Poussin's Classical landscapes by redoing them from direct observation in nature.

■ **Provence**
Few artists have derived more influence from or been more inspired by a place than Cézanne and his native Provence.

■ **Montagne Sainte-Victoire**
Cézanne returned to paint this landmark near Aix-en-Provence throughout his career. It is the subject of some of his best and most radical paintings.

Paints The Large Bathers (National Gallery, London)	Paints Montagne Sainte-Victoire (Philadelphia Museum of Art)	Dies October 23 in Aix	Memorial exhibition of 56 paintings in Paris
1894–1905	**1902–06**	**1906**	**1907**

● **Jasper Johns**
(b.1930)
Like Cézanne, a painter whose art is about the nature of painting and not the personality of the artist.

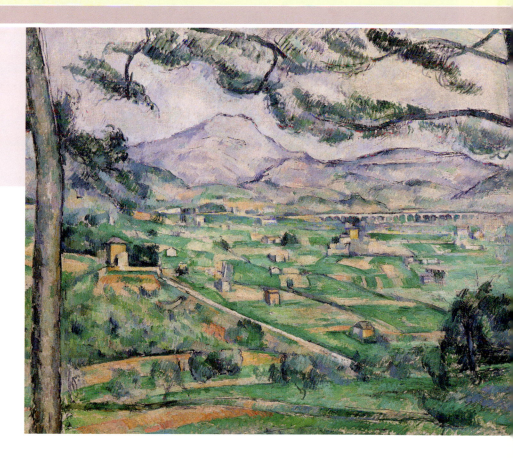

Montagne Sainte-Victoire,
Paul Cézanne, 1886–87, The Phillips Collection, Washington, D.C.

The Saint-Victoire mountain in Cézanne's native Aix-en-Provence was a constant source of inspiration to the artist, and he is known to have painted it more than 60 times from various different angles.

Vincent van Gogh is arguably the best known artist in the world today. His life and work have inspired both serious art-historical scholarship and a popular culture industry. Despite the appropriation—and at times trivialization—of Van Gogh's name and legacy, his paintings remain one of the most moving personal testaments to an individual's belief in art, and one of the most profound statements of collective humanity.

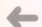 **INFLUENCED BY**

KEY
● artist
◆ artistic movement
■ cultural influence
❖ religious influence

❖ **Religion**
Van Gogh was a deeply religious individual and initially hoped to have a career as a minister; however, he slowly began to replace conventional concepts of God and religion with more personal ones centered on art and nature.

■ **Color**
Van Gogh wrote in 1888: "I want to paint men and women with that something of the eternal which the halo used to symbolize, and which we seek to convey by the actual radiance and vibration of our coloring."

● **Rembrandt van Rijn** (1606–69)
Van Gogh revered the achievements of his great Dutch predecessor. Rembrandt's truth, passion, rich impasto, sensitivity to light, love of both portraiture and self-portraiture all find echoes in Van Gogh's art.

● **Eugène Delacroix** (1798–1863)
Through Delacroix Van Gogh came to understand the potential of color. Ironically, much of Van Gogh's knowledge of Delacroix came not from direct contact with his paintings but through reproductions and texts.

● **Jean-François Millet** (1814–75)
Millet's Realist art was an important part of Van Gogh's self-education as a painter. Van Gogh's images of peasants are indebted to Millet. *The Sower* (1850) by Millet is among the most quoted images by Van Gogh.

VINCENT VAN GOGH (1853–90)
Dutch

Born March 30 in Zundert in the southern province of North Brabant, in the Netherlands	Birth of Van Gogh's brother, Theo	Begins working as a junior clerk at The Hague gallery of the French art dealer Goupil & Cie	Writes first letters to Theo	Transfers to the London branch of Goupil & Cie. First visit to Paris	Transfers to Paris. Moves to England to become a teacher, then an assistant preacher	Studies theology in Amsterdam. Does evangelical work in the Borinage region of Belgium	Decides to become an artist, and studies briefly at the Brussels Academy
CHRONOLOGY							
1853	**1857**	**1869**	**1872**	**1873**	**1875–76**	**1877–78**	**1880**

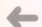 **INSPIRED**

● **Paul Gauguin** (1848–1903)
Gauguin was inspired by Van Gogh, and also influenced him. Gauguin was impressed by Van Gogh's commitment to art. Ultimately, however, the differences in their personalities caused each man to follow his own path.

● **Henri Matisse** (1869–1954)
The final liberation of color from the mere description of nature advanced by Matisse and the Fauves was the completion and fulfillment of the late 19th-century legacy of Van Gogh.

● **Maurice Vlaminck** (1876–1958)
Vlaminck's first encounter with Van Gogh's paintings at a 1901 retrospective in Paris was a life-altering moment for the artist. He intensified all the expressive aspects of his paintings as a result.

● **Paula Modersohn-Becker** (1876–1907)
The German Expressionist most receptive to French ideas of painting, having made numerous trips to Paris, was impressed by the paintings of Van Gogh, Gauguin, and the Fauves.

● **Francis Bacon** (1909–92)
Bacon's series of paintings from the 1950s based on Van Gogh's *The Artist on the Road to Tarascon* (1888; destroyed in World War II) explores the theme of the artist as a solitary traveler.

The paintings of Vincent van Gogh are among the most inspirational works in the history of modern art. Van Gogh's uncompromising, almost religious dedication to his life as an artist, and the paintings he produced during a brief 10-year-long career, represent one of the richest creative legacies born from self-education, an obsessive work ethic, personal hardship, and, most importantly, original talent. Speaking about the artist, the Impressionist painter Camille Pissarro, who was among Van Gogh's early mentors, said: "This man will either go mad or outpace us all. That he would do both, I did not foresee." Inherent in Pissarro's statement is the triumph and tragedy of Van Gogh's life and art. The difficulty is in separating the concrete nature of Van Gogh's artistic achievements from the surrounding mythology about the man and the artist that arose after he died. Few artists working in any realm of art have left a legacy as distorted as that of Van Gogh.

Van Gogh's life as an artist was one marked by the intensity and dedication of his work ethic. He came to painting late in life, after a series of aborted careers as clerk in an art firm, school teacher, preacher, and even evangelical missionary. In some ways all of his early endeavors were preparation for his life in art. He brought the same religious fervor and knowledge gained from these diverse experiences to his rigorous self-education as an artist. Van Gogh benefited from occasional and informal art training at various schools with various teachers, but learned most by looking, doing, reading, and conversing with other artists. He was diligent, organized, and focused on his new path.

The artists from whom Van Gogh learned included Peter Paul Rubens (1573–1640), Rembrandt van Rijn, Jacob van Ruisdael (1628–82), Eugène Delacroix, Honoré Daumier (1808–79), Adolphe Monticelli (1824–86), Jean-François Millet,

Weeping Cherry and Bullfinch,
Katsushika Hokusai, c.1832, Honolulu Academy of Arts, Hawaii

Like many artists of the time, Van Gogh was a keen collector of Japanese woodblock prints, which he copied. He admired their simplicity of form, and often referenced them in his own works.

● Camille Pissarro
(1830–1903)
Through his brother Theo, Van Gogh was introduced to Pissarro, who encouraged Van Gogh to brighten his palette, and to explore the juxtaposition of complementary colors for greater luminosity.

● Paul Gauguin
(1848–1903)
The relationship between Van Gogh and Gauguin was complex. They first met in 1887, and later lived and worked together in Arles. Van Gogh admired Gauguin, and saw him as an innovative painter.

■ Theo van Gogh
(1857–91)
Theo was the most important person in the artist's life. He was Van Gogh's brother, confidant, dealer, critic, and financial supporter. Without Theo it is difficult to imagine Van Gogh creating the body of work that he did.

◆ Japanese Art
Van Gogh's appreciation for Japanese art is a leitmotif throughout all his work and writings. He admired the formal language of Japanese woodblock prints, collected them avidly, and referred to them in his paintings.

Various stays and art studies in Etten, The Hague, Nuenen, and Antwerp	*Moves to Paris where he lives with his brother; meets Henri de Toulouse-Lautrec*	*Organizes an exhibition of Japanese woodcuts; meets Paul Gauguin and Georges Seurat*	*Moves to Arles in February, and Gauguin visits in October. Van Gogh cuts off his left*	*earlobe during a seizure; his paintings are exhibited in Paris*	*Enters the asylum of Saint-Rémy as a voluntary patient*	*Sells his first painting in January, and the first published article devoted*	*to his work is enthusiastic. Moves to Auvers-sur-Oise near Paris in May*	*Shoots himself in the chest on July 27; dies July 29*	*Theo van Gogh dies on January 21 in Utrecht*	
1881–85	**1886**	**1887**	**1888**		**1889**	**1890**			**1891**	

◆ Modern Expressionism
Whether through his formal language, subject matter, or philosophy of art, Van Gogh inspired generations of Expressionist painters, including the artists of Fauvism, Northern European Expressionism, *Die Brücke* (The Bridge), *Der Blaue Reiter* (The Blue Rider), Abstract Expressionism, and the Neo-Expressionists of the 1980s *(below: Pentecost, Emil Nolde, 1909).*

■ Cinema
Many important film directors have been drawn to Van Gogh's story, including Vincente Minelli, *Lust for Life* (1956); Akira Kurosawa, *Dreams* (1990); Robert Altman, *Vincent and Theo* (1990); and Maurice Pialat, *Van Gogh* (1991).

■ Popular Culture
Van Gogh's art and life have been celebrated, commemorated, and exploited by everything from rock groups, popular songs, and fiction, to countless commercial products including T-shirts, coffee mugs, tote bags, and even an action figure.

Branches of an Almond Tree in Blossom,
Vincent van Gogh, 1890, Van Gogh Museum, Amsterdam

The influence of Japonisme is obvious in Van Gogh's work in paintings such as this both in terms of its subject matter and the clarity of its composition.

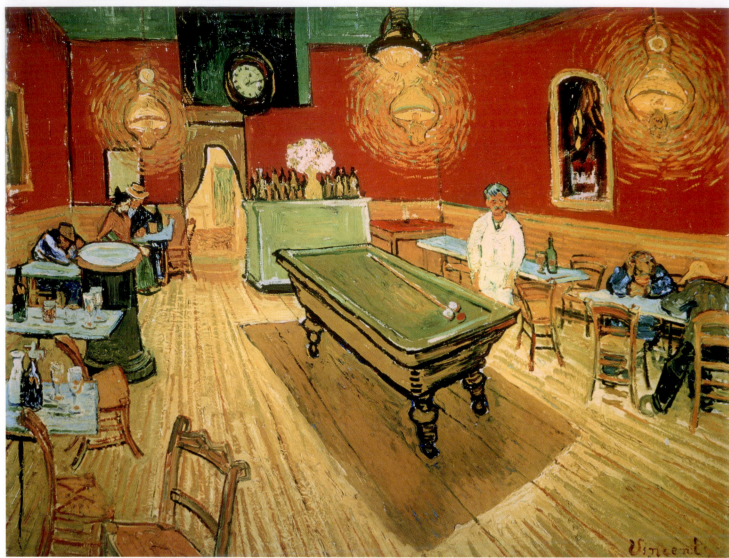

The Night Café, on Place Lamartine in Arles,
Vincent van Gogh, 1888, Yale University Art Gallery,
New Haven
When painting this picture, Van Gogh used simplified
color to express a feeling of seediness and desperation
about the café and its nighttime patrons.

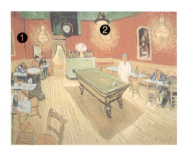

ABOUT THE WORK

Van Gogh produced this remarkable
picture a month before Gauguin's
fateful arrival in Arles. Inspired by the
heat of his new southern home and
his growing love of Japanese prints, the
artist lightened his palette, adopting a
range of bright, intense colors. He also
felt incredibly lonely, and a sense of
isolation permeates his work. He used
to sleep during the day, so that
he could create his vision of this
seedy, all-night dive, which is, in many
respects, the spiritual ancestor of
Edward Hopper's *Nighthawks*.

COLOR

Van Gogh used blocks of pure,
unmixed colors (1) to express the
intensity of his emotions. Referring to
this painting he commented: "I have
tried to portray with red and green
this terrible human suffering."

LIGHT

Light sources seem almost to take on
a life of their own in Van Gogh's later
paintings. Here, the café's huge lamps
(2) appear to throb and vibrate,
rather like the swollen stars in his
nocturnal scenes.

SPACE

Under the influence of Japanese
prints, Van Gogh often employed an
exaggerated form of perspective.
As a result, the room appears to tilt
alarmingly toward the viewer.

Jules Breton (1827–1906), Pissarro, Georges Seurat (1859–91), Henri de Toulouse-Lautrec (1864–1901), Emile Bernard (1868–1941), and most especially Paul Gauguin. He was often limited to making copies of works from magazine illustrations and prints, and was constantly seeking models willing to pose for him in his desire to hone his drawing skills. He also cultivated a lifelong interest in Japanese art early in his career.

Van Gogh's numerous studies of peasants, farmers, and miners, in which he sought to portray their lives and labors with honesty and feeling, culminated in the work where he first felt himself to be a painter, *The Potato Eaters*, 1885 (Van Gogh Museum, Amsterdam). Indebted to the light and palette of Rembrandt, and to the peasant themes of Millet, Van Gogh nonetheless created something original in this intense, somber, stark, and perhaps severe portrayal of peasant life.

It was with Van Gogh's arrival in Paris in 1886 that a profound change took place in his art. Living with his art dealer brother, Theo van Gogh, he slowly confronted the latest advances and ideas in French painting, and met most of the important artists of Impressionism and Post-Impressionism, including Edgar Degas (1834–1917), Paul Cézanne (1839–1906), Claude Monet (1840–1926), Paul Signac (1863–1935), Pissarro, Toulouse-Lautrec, Seurat, Bernard, and Gauguin. Pissarro encouraged Van Gogh to brighten his color palette, and to explore the luminous effects created by the juxtaposition of complementary colors.

The urban intensity of Paris, however, eventually affected Van Gogh's health, as well as his ability to concentrate on his work. In 1888 he left Paris for Arles in the south of France, a region Van Gogh referred to as the "Japan of the south." Here began his most productive period during which he produced more than 200 paintings in 15 months, including some of his most famous works: *The Sower*, 1888; *The Yellow House*, 1888; *The Artist's Bedroom*, 1888 (all at the Van Gogh Museum, Amsterdam); and *The Night Café*, 1888 (Yale University Art Gallery).

By this time Van Gogh's mature Expressionist style was in place with its strong spatial distortions, bold colors, writhing brushstrokes in a thick impasto, and intense emotional responses to his subjects. Describing his painting *The Night Café* Van Gogh articulated an Expressionist manifesto for subsequent generations: "In my picture *The Night Café*, I have tried to express the idea that the café is a place where one can ruin oneself, go mad or commit a crime…It is color not true from the point of view of the delusive Realist, but color suggesting some emotion of an ardent temperament." From Edvard Munch to Wassily Kandinsky (1866–1944), and from Henri Matisse to Francis Bacon and beyond, Van Gogh's belief that "Real painters do not paint things as they are…They paint them as they themselves feel them to be" remains his greatest legacy and inspiration.

Old Peasant Woman,
Paula Modersohn-Becker, c.1905, Detroit Institute of Arts, Detroit
The German Expressionist Modersohn-Becker made several trips to Paris in the early 1900s, and was impressed by the paintings of Van Gogh and Gauguin.

Portrait of Madame Roulin (La Berceuse),
Vincent van Gogh, 1888–90, Kröller-Müller State Museum, Otterlo
Color was a vital inspiration for Van Gogh. The orange hair and vermilion floor contrast the olive-green clothes, and are typical of his use of complementary colors.

MODERNISM

"Modernism," like so many terms in the history of Western art, is subject to a wide variety of definitions and nuanced meanings. It transcends the visual arts to refer to music, literature, poetry, and theater. Brilliant early 20th-century voices including Igor Stravinsky (1882–1971), Arnold Schoenberg (1874–1951), Marcel Proust (1871–1922), James Joyce (1882–1941), Virginia Woolf (1882–1941), Ezra Pound (1885–1972), and T. S. Eliot (1888–1965), showed the world new ways of thinking about concepts of time, space, and reality.

1910

CHRONOLOGY

1910		1911–12	1913		1914	1915	
Kandinsky writes Concerning the Spiritual in Art, outlining his theories on the spiritual value of art; Schoenberg	writes the book on music theory, Harmonielehre; the Mexican Revolution begins	Picasso's Woman with a Guitar ushers in Cubism	Duchamp's Nude Descending a Staircase, No. 2, 1912, causes controversy at the Armory Show in New York;	the premiere of Stravinsky's Le Sacre du Printemps (The Rite of Spring) incites a riot	Outbreak of World War I; Matisse paints Window Swung Open at Collioure	Malevich shows his iconic Black Square; Einstein publishes his general theory of relativity;	Charles Chaplin (1889–1977) directs The Tramp

The roots of Modernist thinking extend back to the closing decades of the 19th century when challenges to accepted conventions and definitions of life and art emerged with a ferocious power and originality. The period of 1890 to 1914 is one of the richest, most seminal, and revolutionary in Western cultural history. During these years, changes in art reflected similar advances that were taking place, or had taken place, in science and philosophy. The disruptive—and at times threatening—theories of scientists and philosophers Charles Darwin (1809–82), Karl Marx (1818–83), Sigmund Freud (1856–1939), Søren Kierkegaard (1813–55), Friedrich Nietzsche (1844–1900), Henri Bergson (1859–1941), and Albert Einstein (1879–1955) shook the long-accepted principles supporting many of life's deeply held beliefs. In the arts, conventional strategies of linear narrative, temporal sequence, melodic line, poetic meter, visual perspective, or illusionism gave way to an awareness that no single interpretation of what one sees, hears, reads, or experiences is ever sufficient.

SPACE, LIGHT, COLOR, LINE, AND SHAPE

In painting, such thinking began at the end of the 19th century in the works of the Post-Impressionist artists. An important component of their language was formalist thinking: ascribing significance first and foremost to the formal elements of art such as space, light, color, line, and shape. When the painter Maurice Denis (1870–1943) declared in 1890: "that a picture, before being a horse, a nude, or some kind of anecdote, is essentially a flat surface covered with colors assembled in a certain order" he expressed in words what many artists had already begun to explore in paint. Beginning with Édouard Manet's revolutionary art in the 1860s, and continuing with the Impressionists and Post-Impressionists, Western painting experimented with alternative modes of visual thought and expression: Exploring the new vocabulary of Abstraction in search of an art that, as critic Walter Pater (1839–94) remarked, "aspires towards the condition of music."

1910–1945

1917	1918	1922	1929	1930	1932	1936	1937	1940	1945
Duchamp's Fountain, causes a scandal at its unveiling; Bolsheviks seize power in Russia	Armistice heralds end of World War I	Joyce's Ulysses and Eliot's The Wasteland published	Dalí makes the controversial film Un Chien Andalou (An Andalusian Dog) with filmmaker Luis Buñuel	O'Keeffe works on Ranchos Church, New Mexico; Freud's Civilization and Its Discontents published	Kahlo paints Henry Ford Hospital	Spanish Civil War breaks out	Picasso paints the anti-Fascist mural Guernica	Outbreak of World War II, Charles Chaplin's The Great Dictator released	Allied victory ends World War II; United Nations created

NEW SPIRIT OF EXPERIMENTATION

Instrumental painters in the revolution of Modernism in 20th-century Europe were Henri Matisse (1869–1954), Pablo Picasso (1881–1973), Georges Braque (1882–1963), Wassily Kandinsky, Piet Mondrian (1872–1944), and Kazimir Malevich (1878–1935). In the U.S., Georgia O'Keeffe (1887–1986), and the many talented painters associated with Alfred Stieglitz's (1864–1946) Gallery 291 in New York, shaped early Modernism. All these artists discovered a new spirit of experimentation, an awareness of the interdisciplinary language of the arts, and a fundamental reexamination of the nature of reality and its relationship to art, life, science, and traditional systems of belief. The legacy of this first generation of Modernists in both Europe and the U.S. continued to resonate through subsequent generations, fueling advances and manifestations in European art between the two world wars, and ultimately crossing the Atlantic to inspire the painters of U.S. Abstract Expressionism.

The later writings of the U.S. critic Clement Greenberg (1909–94), expanding upon the ideas of the early 20th-century English critics Roger Fry (1866–1934) and Clive Bell (1881–1964), reinforced the dominance of Modernist theory for a new generation of artists and viewers. Greenberg's often dogmatic pronouncements on formal purity, artistic quality, and the autonomy of painting, however, would ultimately prompt a fresh assault from those seeking to return art to the broader arenas of society, politics, culture, and human experience.

Edvard Munch declared: "I do not paint what I see, but what I saw." Few artists have been as committed to the idea of painting as the exploration of personal biography as Munch. In bold, expressionist paintings devoted to the people, places, events, and traumas of his life, Munch dissected the hidden emotions, fears, and anxieties of the human soul.

INFLUENCED BY	● **Caspar David Friedrich** (1774–1840) Northern Romantic art in general—and Friedrich's paintings specifically—greatly influenced Munch. Friedrich's isolated figures seen from the back became an often-used device in Munch's art.	● **Henrik Ibsen** (1828–1906) The great Norwegian playwright explored many of the same themes found in Munch's paintings. Munch created set designs for productions of Ibsen's plays *Ghosts* (1881) and *Hedda Gabler* (1890).	● **August Strindberg** (1849–1912) Along with Ibsen, one of the most important figures in Scandinavian literature and theater. Munch met Strindberg late in 1892. Strindberg affected many of Munch's attitudes about love, death, women, and the conflict of the sexes.	● **Christian Krohg** (1852–1925) Krohg was an important early mentor to Munch. Munch greatly admired Krohg's painting *The Sick Child* (1880–81) that had a direct influence on his own painting *The Sick Child* (1885–86).	● **Hans Jaeger** (1854–1910) Jaeger was leader of the literary and artistic bohemians in Kristiania. The group advocated artistic, political, religious, and sexual freedom. Munch's involvement with the group spurred innovations in his painting.

KEY
● artist
◆ artistic movement
■ cultural influence
❖ religious influence

EDVARD MUNCH (1863–1944)
Norwegian

	Born December 12 in Løten, Norway	Family moves to Kristiania (Oslo)	Mother dies of tuberculosis at age 30	Sister Sophie dies of tuberculosis at age 15	Enrolls at the Kristiania Technical College to study engineering; quits after a year to study	painting; at the Royal School of Design, and the Royal School of Drawing in Kristiania	Meets Hans Jaeger; becomes part of the Kristiania Bohème	First trip to Paris; exhibits The Sick Child in Kristiania
CHRONOLOGY	**1863**	**1864**	**1868**	**1877**	**1879–81**		**1884**	**1885–86**

INSPIRED	● **Käthe Kollwitz** (1867–1945) The autobiographical nature of Kollwitz's graphic works, and her concerns with death and personal loss find clear echoes in Munch's art.	● **Emil Nolde** (1867–1956) Nolde and all the German Expressionists owe a debt to Munch, especially to his importance as a graphic artist, and the confrontational and powerful nature of his imagery.	● **Ernst Ludwig Kirchner** (1880–1938) Kirchner's paintings of Berlin streets with their visual distortions, threatening environments, and claustrophobic space were inspired by similar street scenes by Munch.	● **Egon Schiele** (1890–1918) The frank, often graphic nature of Schiele's psychically-charged images of men, women, human sexuality, and eroticism find precedents in Munch's paintings and graphic work.	● **Francis Bacon** (1909–92) No artist has better utilized and expanded upon Munch's motif of the scream as a visual metaphor for personal fear, horror, alienation, anxiety, panic, and human isolation.

Edvard Munch's art was a personal testament or, as he referred to it, a "confession" that expressed the deepest emotions and visceral anxieties of his often-troubled nature. In the obsessive exploration, interpretation, and reinterpretation of his most personal traumas, Munch hoped not only to understand his existence, but to demonstrate for all to see the importance of living an examined life: of seeking and achieving the freedom to which such journeys of self-awareness, however painful, can lead.

About this desire he wrote: "In my art I have tried to find an explanation for life and to discover its meaning. I also intended to help others understand life." With this goal in mind, Munch set out systematically to question his own beliefs on such personal and universal themes as life, death, love, loss, sexuality, sickness, pain, suffering, loneliness, alienation, and, ultimately, salvation. At the heart of this quest was *The Frieze of Life*, the project consisting of a vast cycle of paintings produced throughout Munch's career in which he sought to deal with the fundamental questions of human existence— what he called "the modern life of the soul."

Such an ambitious mission for art was not unique to Munch at the end of the 19th century. *The Frieze of Life* must be understood against similar grand projects with comparable goals created by Munch's contemporaries, most especially the sculptor Auguste Rodin's (1840–1917) *Gates of Hell*, 1880–1917 (Musée d'Orsay, Paris); and such cycle-of-life paintings as Paul Gauguin's *Where Do We Come From? What Are We? Where Are We Going?*, 1897–98 (Museum of Fine Arts, Boston); and Pablo Picasso's *La Vie*, 1903 (Cleveland Museum of Art, Cleveland).

By definition, such projects are destined never to be finished. How is an artist ever to feel that the final word on

such ther
comprisin
constantly
deleted, r
Among t
are most
1890s in
Anxiety, 1
Museum,
Madonna
Sickroom,
1899–19

Munch
and obse
beyond t
Krohg an
experime
first enc
artists su
find a mo
bold col
all in ser
subject n

Van
expressic
as Munch
separate
Van Gog
biograph
and anxi
wheat fie
Van Gog
events o

Munc
fearlessn
soul, and
as Leona
and diss
in this re
German
Expressi
as Munc
with one

The Sick Girl,
Christian Krohg, 1881, National Gallery, Oslo

Realist painter and writer Krohg chose to portray the underbelly of society, whether the problems of the poor or the fight against disease.

● **James Ensor**
(1860–1949)
Ensor's *The Entry of Christ into Brussels* (1888–89), with its masklike faces and streaming hordes of people descending toward the viewer, finds its reinterpretation by Munch in *Evening on Karl Johan Street* (1892).

◆ **Post-Impressionism**
Munch's arrival in Paris in 1885 brought him into contact with works by the major painters of Post-Impressionism, including Paul Gauguin (1848–1903), Vincent van Gogh (1853–90), and Henri de Toulouse-Lautrec (1864–1901), as well as with earlier works by Édouard Manet (1832–83), Claude Monet (1840–1926), and James Abbott McNeill Whistler (1834–1903).

◆ **Fauvism**
Munch responded to the work of Henri Matisse (1869–1954) and the Fauves almost as soon as their paintings appeared in Paris in 1905. As his health recovered from 1908 to 1909, Munch's subject matter reflected more positive themes.

1889	1890	1892	1893	1906	1908	1916	1937	1944	1963
First solo exhibition in Kristiania, 110 works	Living in St. Cloud, outside Paris; frequents Léon Bonnat's School of Art	Berlin exhibition of his works causes a scandal; meets August Strindberg	Paints *The Scream*	Designs sets for productions of Ibsen's *Ghosts* and *Hedda Gabler* in Berlin	Suffers nervous breakdown; enters the clinic of Dr. Daniel Jacobsen in Copenhagen	Settles in Ekely, Norway	Munch's art labeled "degenerate" by Nazis; 82 works confiscated	Dies January 23 in Ekely, Norway; leaves his estate to the city of Oslo	Munch Museum in Oslo opens

● **Ingmar Bergman**
(1918–2007)
Bergman's films explored the human emotions existing at the deepest levels of the unconscious, continuing the tradition of Ibsen, August Strindberg, Søren Kierkegaard (1813–55), and Munch.

● **Tracy Emin**
(b.1963)
Emin has openly acknowledged the importance of Munch's example for her art, mentioning *The Scream* as her favorite painting from art history. She has been inspired by Munch to explore her own personal biography through art, has executed a number of works inspired by Munch paintings, and wrote a student thesis on him.

◆ **Neo-Expressionism**
Most Neo-Expressionist painters from Anselm Kiefer (b.1945) to Sandro Chia (b.1946) to Julian Schnabel (b.1951) are indebted to Munch's paint handling, scraping technique, and the tortured surfaces of his paintings.

The Sick Child,
Edvard Munch, 1896, National Gallery, Oslo

Krohg taught Munch, whose work was often ill-received for its psychological depiction of personal feelings.

The history of modern Abstract painting begins with Wassily Kandinsky. His gifts as a painter, intelligence as a theoretician, and eloquence as a writer, all contributed to his pioneering achievement of moving visual art beyond the limitations of realism and nature to the expressive realm of Abstraction. In his exploration of pure color, and in his aspiration to elevate painting to the status of music, Kandinsky forever expanded the possibilities of art.

 INFLUENCED BY

KEY
● artist
◆ artistic movement
■ cultural influence
❖ religious influence

◆ **Russian Art**
Kandinsky had a deep knowledge and abiding interest in Russian art of all kinds and periods, as well as in Russian folktales and ethnology.

● **Arnold Schoenberg**
(1874–1951)
Kandinsky discussed many of his ideas regarding Abstraction with the composer. Schoenberg was also a painter whose works were included in the first Blue Rider exhibition in 1911.

◆ **Fauvism**
Kandinsky exhibited regularly in Paris from 1904 to 1910 during the emergence of French Fauvism. The paintings of Henri Matisse (1869–1954) were particularly important for him.

■ **Theosophy**
Kandinsky, like Piet Mondrian, was influenced by the writings of 19th-century theosophists, Madame Blavatsky (1831–91) and Rudolf Steiner (1861–1925), concerning the spiritual nature of abstract forms and colors.

■ **Music**
Kandinsky's serious knowledge and love of music were crucial components in shaping his attitudes about painting and Abstraction.

WASSILY KANDINSKY (1866–1944)
Russian

	Born December 4 in Moscow	Studies law and economics at the University of Moscow	Decides to study art; settles in Munich	Studies with Franz von Stuck at the Munich Academy of Art	Founding member and director of The Phalanx School of Art	Meets Franz Marc (1880–1916); first exhibition of The Blue Rider	(Der Blaue Reiter); publication of Concerning the Spiritual in Art	Begins teaching at the Bauhaus in Weimar
CHRONOLOGY	**1866**	**1886**	**1895–96**	**1900**	**1901**	**1911**		**1922**

 INSPIRED

● **Gabriele Munter**
(1877–1962)
Kandinsky's close personal and working relationship with Munter from 1902 to 1916 was important for both artists.

● **Mark Rothko**
(1903–70)
Rothko's Russian roots and belief in the spiritual nature of Abstract painting link him to Kandinsky.

◆ **Concerning the Spiritual in Art**
(1911)
Kandinsky's treatise is one of the most important documents in 20th-century aesthetics.

◆ **The Blue Rider**
(1911–14)
All members of the group were inspired by the Abstract language and belief in the spiritual values of art promulgated by Kandinsky.

◆ **Abstract Expressionism**
The Abstraction, freedom, and spontaneity of New York School painting relates back to Kandinsky's example and inspiration.

The
Edv

The
its g
spac
univ

Wassily Kandinsky is among the most important painters in the development of 20th-century Abstraction. His body of work and writings have affected subsequent generations of artists committed to exploring the meaning and significance of Abstract forms. In two pivotal series of paintings, *Improvisations* and *Compositions* (1909–14), Kandinsky broke with the long tradition of art based on the accurate transcription of nature to explore the inherent power of pure Abstraction. Kandinsky's achievement extends beyond his fascination with Abstract color and form to include investigations into the synesthetic relationship of art and music, and the potential of Abstract painting to embody the spiritual. In this last regard, Kandinsky is one of a number of influential 20th-century painters, including Kazimir Malevich (1878–1935), Piet Mondrian, (1872–1944), and Mark Rothko, who believed in the power of Abstract art

to speak directly to a viewer and to transform and transcend the mundane world of reality.

Kandinsky's interests were many and varied including art, music, economics, ethnology, and the natural sciences. His intellect would have allowed him to pursue a wide range of careers. Born in Moscow, by 1892 he had completed all the required studies and exams for a career in law. In 1896, however, he decided to study painting. Settling in Munich, Kandinsky became one of the founders of the association for artists known as The Phalanx School of Art. In 1911, after involvements with other associations, Kandinsky, along with the German artist Franz Marc, founded The Blue Rider (*Der Blaue Reiter*) group, and published the first issue of *The Blue Rider Almanac*. The same year also saw the publication of Kandinsky's theoretical treatise *Concerning the Spiritual in Art*.

Grainstack (Sunset),
Claude Monet, 1891, Boston Museum of Fine Arts, Boston

Kandinsky was influenced by Monet's paintings. He sought to purge representational imagery from his work in his search for the "pure art" of color.

■ **Abstraction and Empathy**
(1908)
Book by the German art historian Wilhelm Worringer (1881–1965) that discussed the nature and importance of Abstract art in history.

■ **Bauhaus**
(1919–33)
Kandinsky joined the faculty of this influential German art school in 1922. Bauhaus aimed to apply design principles to mass production.

Bauhaus moves to Dessau	*Nazis close the Bauhaus in Berlin; Kandinsky moves to France*	*57 works confiscated and labeled "degenerate" by the Nazis*	*Dies December 13 in Neuilly-sur-Seine, France*
1925	**1933**	**1937**	**1944**

◆ **Art Informel**
As with American Abstract Expressionism, European "Art Informel" is directly indebted to Kandinsky.

● **David Hockney**
(b.1937)
Like Kandinsky, an artist who appears to be a "synesthete," someone able to "see" sounds and "hear" colors.

Study for Improvisation 31 (Sea Battle),
Wassily Kandinsky, 1913, Musée National d'Art Moderne Centre Pompidou, Paris

Kandinsky's focus on painting pure color and abstract shapes marked a revolution in art, as he strove to create works that transcended the mundane world of reality.

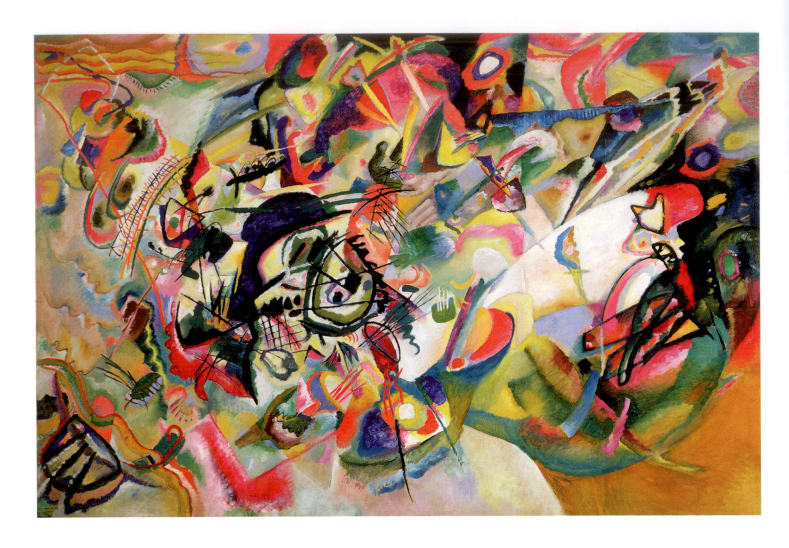

Composition VII,
Wassily Kandinsky, 1913, Tretyakov Gallery, Moscow

Kandinsky's move toward Abstraction led him to see painting as
an art form close to music, and he frequently gave his canvases
titles to reflect this interest.

ABOUT THE WORK

Kandinsky was a pioneer of Abstract
art, making his breakthrough on
the eve of World War I. His early
Compositions evolved out of his
radical, Expressionist experiments.
Often, they were loosely based on
traditional, figurative subjects, such as
The Deluge, *The Resurrection*, and—in
the case of Composition VII—*The Last
Judgment*. Kandinsky reworked these
themes intensively, gradually veiling or
removing all their figurative elements.

COMPOSITION

Kandinsky's painting may look
spontaneous, but he actually produced
several studies for it and sketched
a rough outline onto the canvas at
the outset. He then started work in
the center of the picture (1), moving
outward from there.

FIGURATION

Although he took pains to suppress
figurative elements in his Abstract

works, some hints of physical forms
remain. The motif in the bottom
left-hand corner (2), for example,
derives from the boat with oars, which
appeared in his *Deluge* pictures.

MOVEMENT

Many of Kandinsky's early Abstract
paintings were constructed around a
vortex (3) and convey a dynamic sense
of movement. This stems from the
apocalyptic themes that inspired them.

The Fate of the Animals,
Franz Marc 1913, Kunstmuseum, Basel

Like Kandinsky, Marc was a member of The Blue Rider art movement that focused on Abstraction, the emotional potential of color, and the spirituality of nature.

The paintings produced by Kandinsky between 1909 and the start of World War I are vivid examples of the artist's growing fascination with and belief in the power of Abstraction. Analogies to music are clear in the titles *Improvisations, Compositions,* and *Impressions.* Influenced by the paintings of Claude Monet (1840–1926) and German Jugendstil, the operas of Richard Wagner (1813–83) and music of Arnold Schoenberg (1874–1951), Russian folk art, and French Fauvism, Kandinsky began a systematic purging of representational imagery from his works in search of a "pure art" of color and line inspired by the counterpoint, timbres, pitches, and rhythms of music.

In *Concerning the Spiritual in Art,* Kandinsky defined the *Improvisations* as "a largely unconscious, spontaneous expression of inner character, non-material nature." *Improvisation 31 (Sea Battle),* 1913 (National Gallery of Art, Washington, D.C.) is a classic example of Kandinsky's desire to free himself from the restrictions of representational imagery in an effort to realize meaning through color, line, and compositional effects.

Kandinsky's pioneering exploration of the potentialities of Abstraction, and its relationship to music is among the most important contributions to the history of modern art. Through the influence of The Blue Rider movement, and during his years at the Bauhaus, Kandinsky's art and ideas reached a wide audience and affected the subsequent course of Abstract painting in both Europe and the United States.

The Liver is the Cock's Comb,
Arshile Gorky, 1944, Albright-Knox Art Gallery, Buffalo, New York

Kandinsky's spontaneity, sensuous use of color, artistic sensibilities, and desire to draw an analogy between painting and music resonated with artists such as Gorky and the Abstract Expressionists.

Henri Matisse, along with Pablo Picasso, dominates European painting in the first half of the 20th century. Matisse's art, like Picasso's, explores a wide range of media and techniques. His willingness to advance the autonomy of formal elements such as color and line, and his engagement with Abstraction, mark him as an artistic bridge between 19th-century painters like Vincent van Gogh and Paul Gauguin and the development of Expressionism.

 INFLUENCED BY

KEY
● artist
◆ artistic movement
■ cultural influence
❖ religious influence

● Gustave Moreau
(1826–98)
Symbolist painter who taught Matisse at the École des Beaux-Arts. He instilled a love of art history while encouraging an art of self-expression based on strong formal traits.

● Paul Cézanne
(1839–1906)
Cézanne's example of an artist committed to the purity of painting and to an art that balanced expressive freedom with formal control was a constant inspiration to Matisse.

● Paul Gauguin
(1848–1903)
Gauguin's abandonment of local color in favor of large, flat areas of pure, unmodulated color encouraged Matisse to explore a similar path in his art.

● Paul Signac
(1863–1935)
Neo-Impressionist disciple of Georges Seurat (1859–91) who worked with Matisse in 1904 and whose experiments with color lead to Matisse's breakthrough painting, *Luxe, Calme et Volupté.* (1904–5).

◆ Islamic Art
Matisse's exposure to Islamic art in 1903 affects not only his love of pure color but also his attitudes about surface design and pattern (right: Dome of the Rock Mosque Exterior, Jerusalem, 685–91).

HENRI MATISSE (1869–1954)
French

	Born December 31 at Le Cateau-Cambrésis, France	Studies law in Paris	Studies briefly with Adolphe-William Bouguereau at the Académie Julian in Paris	Studies at the École des Beaux-Arts with Gustave Moreau. Experiments with	Impressionism and Neo-Impressionism	At work in St. Tropez with Paul Signac. Paints Luxe, Calme et Volupté	Exhibits at the Salon d'Automne in Paris with artists soon to be known as the Fauves	Mature paintings of Fauvism. Receives patronage from Gertrude and Leo Stein
CHRONOLOGY	**1869**	**1887–88**	**1892**	**1895–98**		**1904**	**1905**	**1905–08**

 INSPIRED

◆ Notes of a Painter
(1908)
Matisse's article is one of the major documents of 20th-century aesthetics.

● Robert Motherwell
(1915–91)
Motherwell's *Open* series (begun in 1967) was inspired by Matisse's open window paintings.

● Richard Diebenkorn
(1922–93)
Diebenkorn's *Ocean Park* series (c.1967–93) employs colors and structures derived from Matisse's paintings and cutouts.

● Dan Flavin
(1933–96)
Flavin's *Untitled (to Henri Matisse)* (1964) is a direct homage to Matisse in colored light.

Henri Matisse is among the most influential painters of the 20th century. His visual language and thinking have affected countless artists, working in a variety of media and concerned with a wide array of aesthetic issues. While Matisse's art, like Pablo Picasso's, broke no new ground in terms of its subject matter, its formal approach to color, line, space, figuration, and abstraction is so rich, varied and far-ranging that it remains a source of inspiration to contemporary artists whose works may often have very little else in common.

In his influential article, *Notes of a Painter* (1908), Matisse wrote: "What I am after, above all, is expression…I am unable to distinguish between the feeling I have for life and my way of expressing it." Matisse's belief in an art that stressed meaning and feeling through a deep involvement with the pictorial language of pure painting resonates throughout Modernism and contemporary art. His inspiration is apparent in the works of artists as varied as the German Expressionists, American Abstract Expressionists like Mark Rothko (1903–70) and Barnett Newman (1905–70), David Hockney, Richard Diebenkorn, and Dan Flavin.

An example of the importance of Matisse's formal language for later artists is perhaps best demonstrated in his explorations of the theme of the "open window." Starting with the classic Fauve interpretation, *Open Window, Collioure*, 1905 (National Gallery of Art, Washington, D.C.) and extending to later versions, *View of Notre Dame*, 1914 (Museum of Modern Art, New York) and *Window Swung Open at Collioure*, 1914 (Georges Pompidou Center, Paris), Matisse moved steadily and methodically toward an understanding, first of the ability of pure color and varied brushstrokes to create harmony, rhythm and light, to a more cerebral and severe investigation of spatial relationships on the two-dimensional picture plane.

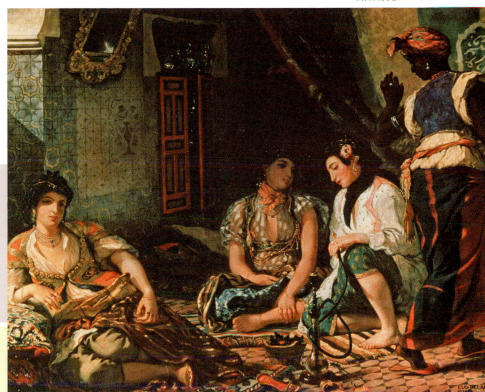

Women of Algiers in their Apartment,
Eugene Delacroix, 1834, Louvre, Paris

The exoticism and sensuality of Moroccan subjects appealed to the Romantic sensibilities of painters like Delacroix (1798–1863).

■ Morocco

Matisse's trip to Morocco in 1911 exposed him to a new world of light, color, exoticism, and innocence that embodied the Arcadian and pastoral themes of the past he so admired.

Meets Pablo Picasso	*Winters in Morocco*	*Winters in Nice*	*At work on the Chapel of the Rosary of the Dominican Nuns of Vence*	*Dies in Nice November 3*
1906	**1911–13**	**1916**	**1948–51**	**1954**

◆ German Expressionism

All of the German Expressionists owed a debt to the new ideas of Expressionist painting developed by Matisse and the Fauves.

● David Hockney

(b.1937)
Hockney's paintings, drawings, and theater designs often parallel Matisse in form and content.

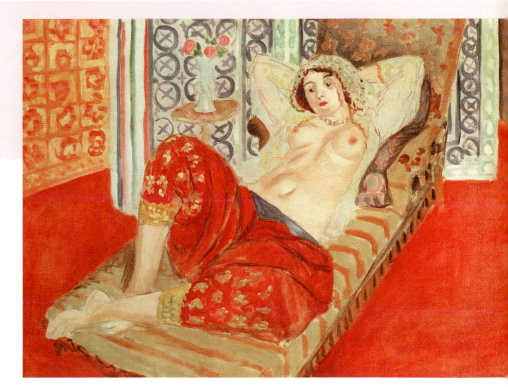

Odalisque in Red Cullottes,
Henri Matisse, 1922, Musée National d'Art Moderne, Paris

Matisse's odalisque speaks a modern formal language through its bold colors and two-dimensional patterns but retains the sensuality of Delacroix.

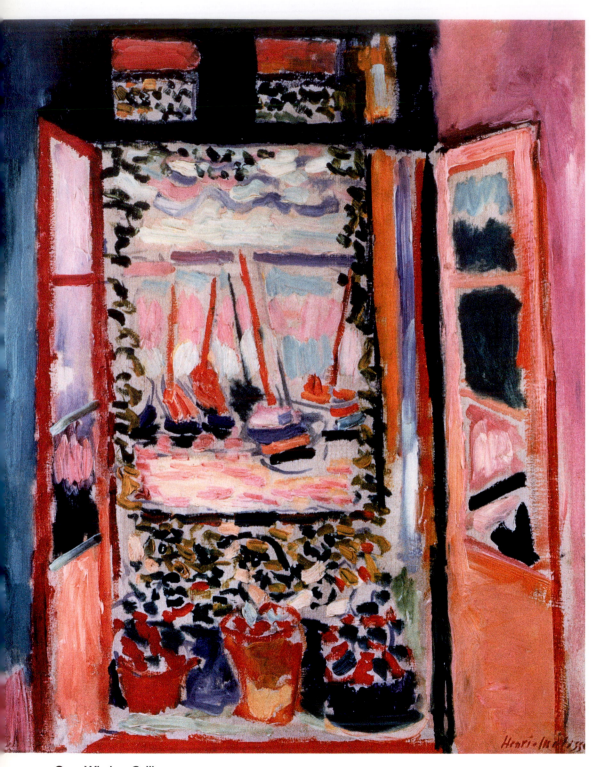

Open Window, Collioure,
Henri Matisse, 1905, National Gallery of Art, Washington, D.C.
This view through an open window to a world of bright
light, explosive color, and energetic brushwork is a modern
icon of Fauvism.

ABOUT THE WORK

Open Window was painted in the
south of France during the summer
of 1905. Matisse and André Derain
(1880–1954) were at work together
in the fishing village of Collioure, near
the Spanish border. This painting, along
with others by Matisse, Derain, Maurice
Vlaminck (1876–1958), and other
artists in their circle, were exhibited at
the 1905 Salon d'Automne in Paris. The
reaction of the critics gave birth to the
term "fauve" (wild beast) to describe
the violent color, expressive brushwork,
distorted drawing, and flattened space
of these paintings—works that went
well beyond the formal experiments of
Impressionism and Post-Impressionism.
With the public exhibition of this
painting, Fauvism, the first modern
art movement of the 20th century,
was born.

COLOR

The saturated colors (1) are not
descriptive of nature, but free and
independent elements used to create
pattern, rhythm, variety, and brilliance.

LIGHT

Traditional modeling in light and
shadow is absent in favor of unblended
complementary colors and active
brushwork that create luminosity and
surface tension.

COMPOSITION

The composition is a series of
"windows within windows" or "frames
within frames" (2) differentiated by
variations in color, brushstrokes, and
surface patterns verging on abstraction.

MOOD

The mood of the painting, created by
the bold colors and active brushstrokes
is one of spontaneity, brightness, and
the celebration of painting.

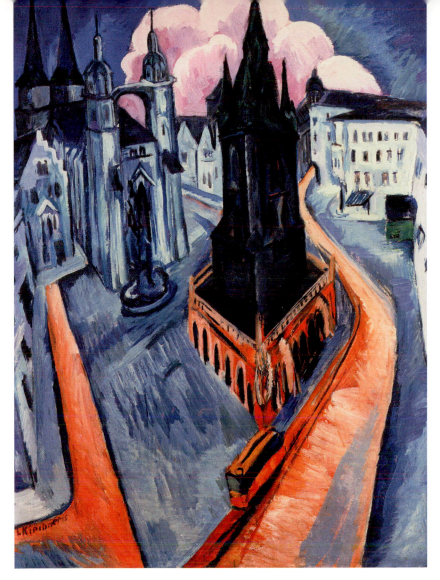

Red Tower in Halle,
Ernst Kirchner, 1915, Museum Folkwang, Essen
German Expressionist artists like Kirchner responded strongly to both the Fauve paintings of Matisse and Cubist paintings of Picasso and Braque.

Matisse needed to test himself against the traditional subjects of art history: the female nude, landscape, still-life, Arcadian, and pastoral themes. In the open-window paintings he is in direct dialogue with one of the most defining concepts underlying Western art history since the Renaissance: the idea of a painting viewed as a window to the world. In the formal language found in this theme, Matisse boldly asserted the autonomy of painting and its freedom from having simply to imitate nature. Matisse's challenge to the traditional three-dimensional illusionism of the painted surface was influenced by late 19th-century painters such as Paul Gauguin and Paul Cézanne. His paintings have gone on to inspire most of the important formalist principles that are now hallmarks of modern art.

Matisse's entire output as an artist displays variety and flexibility of thinking. His paintings are about painting and about an artist's reactions to painting. They exemplify the kind of influence that only the most probing and fecund minds are able to exert.

He successfully completed the work started by Post-Impressionist painters like Paul Gauguin, Vincent van Gogh, Georges Seurat, and Paul Cézanne by liberating color from its subservience to nature and by creating a new syntax and grammar for pictorial space.

Late in Matisse's life, the commission of designs for windows and vestments for the Chapel of the Rosary of the Dominican Nuns of Vence (1948–51) provided the artist with the opportunity to create an environmental synthesis between painting, sculpture, architecture, drawing, design, and decoration; and his continuing belief in the power of light, line, color, and space to touch the emotions and move the spirit. The chapel at Vence is Matisse's final testament both to his belief in the personal language of art and its universal meaning. In 1951 Matisse wrote of the chapel: "This chapel is for me the culmination of a lifetime of labor."

Open No. 122 in Scarlet and Blue,
Robert Motherwell, 1969, Tate Modern, London
The legacy of Matisse's many views through open windows is further abstracted and refined in Motherwell's *Open Series*.

The non-objective paintings of Kazimir Malevich were initially celebrated by the Bolshevik regime in the aftermath of the Russian Revolution. Seen as symptomatic of the dynamic Soviet state, Malevich's "Suprematist" paintings were radical forays into the reality of a non-objective world. By the 1920s, however, Malevich and other avant-garde Russian artists would find their revolutionary experiments in Abstraction suppressed.

 INFLUENCED BY

KEY
● artist
◆ artistic movement
■ cultural influence
❖ religious influence

● **Natalia Goncharova** (1881–1962) and
● **Mikhail Larionov** (1881–1964)
Malevich met both Goncharova and Larionov in 1910. Their paintings introduced him to indigenous Russian art forms including folk art, medieval icons, and a Neo-Primitive style.

● **Vladimir Maiakovsky** (1893–1930)
The writings of this Russian Futurist poet and playwright made a deep impression on Malevich.

◆ **Cubism**
Malevich and his Russian contemporaries were aware of the Cubist works of Pablo Picasso (1881–1973) and Georges Braque (1882–1963) by 1912.

◆ **Futurism**
The theories and works of the Italian Futurists made a significant impact in Russia from 1912 onward.

KAZIMIR MALEVICH (1878–1935)
Russian

	Born February 23 in Kiev	Studies at the Kiev School of Drawing	Studies at the Moscow Institute for Painting, Sculpture, and Architecture	Sees works by Gauguin, Cézanne, and Matisse in Moscow	Meets Russian artists Natalia Goncharova (1881–1962) and Mikhail	Larionov (1881–1964) whose work is inspired by Russian folk art and icons	Exhibits first completely non-representational works he calls "suprematist"	Exhibits series of "white on white" paintings
CHRONOLOGY	**1878**	**1889**	**1904**	**1908**	**1910**		**1915**	**1919**

 INSPIRED

● **El Lissitzky** (1890–1941)
Lissitzky's *Proun* series (c.1922) of paintings owes much to the Suprematist works by Malevich.

● **Alexander Rodchenko** (1891–1956)
Rodchenko's Abstract paintings and geometric constructions show an awareness of the art of both Malevich and Tatlin.

● **Barnett Newman** (1905–70)
Newman's austere, monochromatic paintings and mystical abstraction recall the art and ideas of Suprematism.

◆ **Russian Constructivism**
Malevich's art and theories were inspirational in the creation of this Abstract art movement founded by Vladimir Tatlin (1885–1953) in 1913.

● **Yves Klein** (1928–62)
Klein's advocacy of pure color and of paintings as metaphysical spaces derive from Malevich's ideas.

The rigor and uncompromising nature of Kazimir Malevich's paintings have influenced countless artists subscribing to a wide variety of aesthetic theories and working in a vast array of media. In an art of severe geometric Abstraction referred to as Suprematism, Malevich sought to express pure sensation and experience devoid of illusion, representational tricks, and iconographic complexity.

Between 1913 and 1919, Malevich produced some of the most radical and challenging paintings of the 20th century. Like his Russian contemporary Wassily Kandinsky (1866–1944), Malevich sought to liberate painting from the imitative realm of reality. For the musical analogies of Kandinsky, however, Malevich substituted an austerity and non-objective literalness that sought to fuse object and idea. In paintings like *Black*

Square, 1914–15 (State Tretyakov Gallery, Moscow); *Black Cross*, 1915 (Georges Pompidou Center, Paris); and most famously, *Suprematist Composition: White on White*, 1918 (Museum of Modern Art, New York); Malevich presented a non-objective world of abstract form that expressed "the supremacy of pure feeling or perception in the pictorial arts." Malevich's belief in a philosophical and theoretical basis for art; in an art of self-sufficiency, simplicity, and purity; and in art's ability to free the viewer from the constraints of the material world and to lead to spiritual fulfillment echoed similar utopian views held by Wassily Kandinsky and Piet Mondrian (1872–1944). Later artists and movements—including Barnett Newman, Abstract Expressionism, Yves Klein, and Minimalism—would all draw inspiration from aspects of Malevich's art.

Peasants,
Natalia Goncharova, 1911, State Russian Museum, St. Petersburg

Goncharova introduced Malevich to native Russian art forms such as folk art, iconography, and a Neo-Primitive style of painting that was to influence his later work.

❖ **Russian Icons**
The power and presence of the icon appealed to Malevich. In a 1915 exhibition, he installed *Black Square* high on a wall and across a corner so that it was positoned reverentially like an icon.

Visits the Bauhaus in Dessau; meets Walter Gropius and Lázló Moholy-Nagy	Expelled from the State Institute for Art History in Leningrad	U.S.S.R. officially adopts Socialist Realism as the exclusive style for Soviet art	Dies May 15 in Leningrad
1927	**1930**	**1934**	**1935**

◆ **Minimalism**
The purity, geometric Abstraction, and art-as-object nature of Malevich's work are hallmarks of Minimalism.

Black Square,
Kazimir Malevich, 1914–15, State Tretyakov Gallery, Moscow

Malevich spurned the concept of art as illusion, and his iconic painting was the ultimate denial of representational art, and radical in its use of one geometric shape and only one color.

Abstract Painting,
Ad Reinhardt, 1963, Museum of Modern Art, New York

Successive generations of artists drew inspiration from Malevich's attitude toward art-as-object, including Abstract Expressionists such as Reinhardt with his monochrome works.

Peasant Woman with Buckets and Child,
Kazimir Malevich, 1912, Stedelijk Museum, Amsterdam

Although Malevich's early work was representational, his later concern with planes of flat color and simple shapes was already evident, as was his interest in themes from his native Russia.

Pablo Picasso is the most celebrated artist of the 20th century. His originality, versatility, inventiveness, longevity, and prolific achievement have left a legacy unrivaled by any other modern master. His ability to reinvent himself, curiosity, and constant growth as an artist separate him from his contemporaries. His name is synonymous not only with the formal innovations of Modernist art, but also with its concern for historical context.

 INFLUENCED BY

KEY
- ● artist
- ◆ artistic movement
- ■ cultural influence
- ❖ religious influence

● **El Greco**
(1541–1614)
El Greco's example of elongated figures in expressive poses was particularly influential on Picasso during his "Blue Period."

● **Diego Velázquez**
(1599–1660)
This master of 17th-century Spanish painting held a fascination for Picasso throughout his life.

● **Francisco Goya**
(1746–1828)
Goya's Spanish nationalism, expressive style, and political consciousness had a profound effect on Picasso.

● **Paul Cézanne**
(1839–1906)
Picasso's ideas about pictorial space were directly influenced by Cézanne's art. He referred to Cézanne as "the father to us all."

● **Henri de Toulouse-Lautrec**
(1864–1901)
The influence of Lautrec's paintings and posters of the Parisian demi-monde greatly affected Picasso upon his arrival in Paris.

PABLO PICASSO (1881–1973)
Spanish

	Born October 25 in Málaga, Spain	Begins to paint and draw under his father's tutelage	Moves to Barcelona; studies at the Llotja (School of Fine Arts)	First trip to Paris	Blue Period begins	Settles in Paris	Rose (Circus) Period begins; meets Gertrude and Leo Stein	Paints Les Demoiselles d'Avignon; meets Georges Braque
CHRONOLOGY	**1881**	**1888**	**1895**	**1900**	**1901**	**1904**	**1905**	**1907**

 INSPIRED

◆ **Orphic Cubism (Orphism)**
A short-lived, Cubist-inspired movement that explored color and abstraction. Its members included Robert Delaunay (1885–1941), Marcel Duchamp (1887–1968), and Fernand Léger (1881–1955).

◆ **Futurism**
The formal language of all Futurist painting is directly indebted to Picasso and Cubism.

■ **Cubist Film**
Picasso and Cubism inspired artists and filmmakers to experiment with abstract cinema based on shifting geometric shapes in motion.

● **Piet Mondrian**
(1872–1944)
Mondrian's move toward pure non-objective Abstraction intensified after his exposure to Picasso's analytic Cubist paintings.

● **Gertrude Stein**
(1874–1946)
The American writer and expatriate was Picasso's patron, muse, model, critic, and friend. Her own writing has often been referred to as Cubist.

There have been many important breakthroughs in the history of painting accomplished by a host of influential artists. No artist in modern times, however, can match the record of sustained originality, creativity, and influence over nearly three-quarters of a century that Pablo Picasso can claim. In painting, sculpture, graphic arts, ceramics, and design, Picasso's achievements have few rivals.

Born in Spain, Picasso's art was shaped by his admiration for the works of such masters as El Greco, Diego Velázquez, and Francisco Goya; his exposure to late 19th-century French painters such as Édouard Manet (1832–83), Edgar Degas (1834–1917), Henri de Toulouse-Lautrec, and Paul Cézanne; a growing awareness of African and Oceanic art; and collaborations and rivalries with his contemporaries—all fueled by natural talent, insatiable curiosity, a committed work ethic, and a competitive spirit.

It is impossible to conceive of contemporary art without the contributions and innovations of Picasso. Refusing to embrace the non-objective Abstractions of Kazimir Malevich (1878–1935) or Piet Mondrian, or the conceptual principles of Marcel Duchamp (1887–1968), Picasso remained the painter most engaged in demonstrating the relevance and power of the pure creative act derived from the heart, hand, and mind. In this regard, Picasso's influence on the subsequent history of art is profound. It buttresses and reasserts basic beliefs in the humanity of art and its origins in the passions, cruelties, celebrations, and foibles of life.

From early Expressionistic paintings such as *La Vie*, 1903 (Cleveland Museum of Art); to the revolutionary *Les Demoiselles d'Avignon*, 1907 (Museum of Modern Art, New York); the works of analytic and synthetic Cubism; Neoclassicism; Surrealism, and beyond—Picasso's art was an

The Third of May, 1808,
Francisco Goya, 1814, Prado, Madrid
Goya depicted the struggles of his countrymen against the French, and painted this poignant but bloody masterpiece that influenced depictions of war ever after.

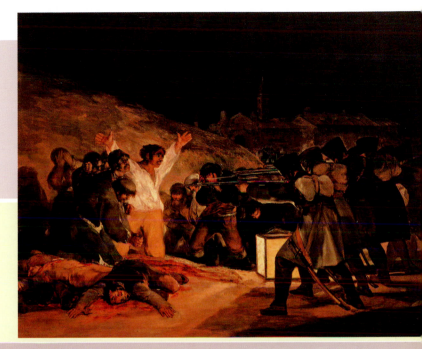

● **Georges Braque**
(1882–1963)
The close collaboration and friendship between Picasso and Braque prior to World War I led to the development of Cubism.

■ **African/Oceanic Art**
Picasso's exposure to African and Oceanic art through private collections and visits to the Trocadéro Museum in Paris brought an expressive and ritualistic power to his painting in 1906 (above: *Wood figure of seated god Oni*).

■ **Spain**
Picasso's love of Spanish art, history, rituals, myths, folktales, literature, and people shaped much of the form, subject matter, and meaning in his art. *Guernica (1937)* was a direct response to the Spanish Civil War.

Analytic and Synthetic Cubism	*Neoclassical Period begins*	*Paints Guernica*	*Dies April 8 in Notre-Dame-de-Vie (Mougins)*
1909–12	**1921**	**1937**	**1973**

● **Georges Braque**
(1882–1963)
Braque and Picasso were both influenced and inspired by each other's work during their close collaboration prior to World War I.

● **Willem de Kooning**
(1904–97)
De Kooning's *Woman* series of the 1950s is especially indebted to Picasso's formal language and visual power.

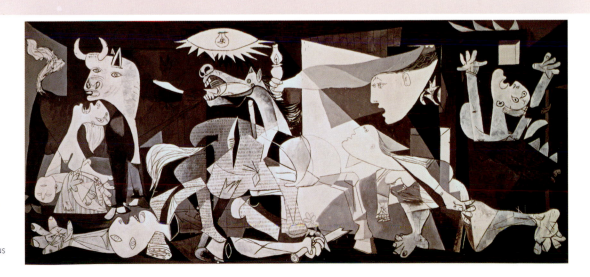

Guernica,
Pablo Picasso, 1937, Reina Sofía Museum, Madrid

Picasso's powerful indictment of the massacre of this small Basque village during the Spanish Civil War has strong echoes of the politically conscious works of Goya.

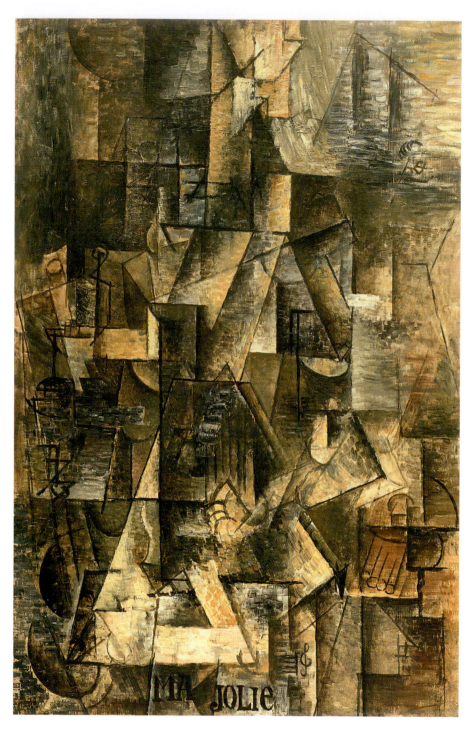

Woman with a Guitar (Ma Jolie),
Pablo Picasso, 1911–12, Museum of Modern Art, New York

Picasso worked with Braque to coinvent what became known as Cubism, and involved breaking down compositional conventions to examine three-dimensional forms on the two-dimensional canvas.

ABOUT THE WORK

This painting was produced during the "Analytic" phase of Cubism, when the style came close to pure abstraction. Picasso and Braque created it together, working in close collaboration and drawing their inspiration chiefly from Cézanne and African sculpture. "Ma Jolie" ("My Pretty One"), which is stenciled at the foot of the painting, was the title of a popular song. Picasso also used it as a pet name for his lover, Marcelle Humbert, who is supposed to be playing a guitar in this scene.

FORM

Picasso's earliest works in this style had been dubbed "Cubist," because natural forms were translated into simple blocks or cubes. By 1911, this description was no longer strictly appropriate, as the cubes had been replaced by geometric planes or facets (1).

COLOR

In this phase of Cubism, Picasso and Braque were experimenting with new ideas about form and space, but had very little interest in color. Their paintings from this period have very muted tones. Some are almost monochrome (2).

FIGURATION

Picasso has left the viewer a few clues about the appearance of his subject, although these are heavily disguised. Fragments of a stringed instrument and some fingers can just be made out, near the base of the picture (3).

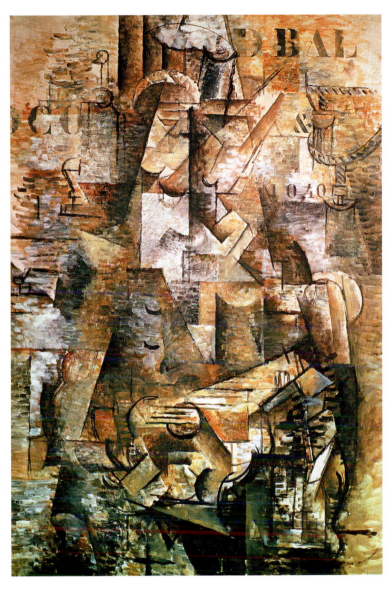

The Portuguese,
Georges Braque, 1911, Offentliche Kunstsammlung, Basel

Braque and Picasso lived near each other, and worked together for more than five years in what was probably the most exciting collaboration in 20th-century art.

endless search for innovative visual strategies and paradigms of meaning.

Picasso's contribution to the development of Cubism reflects similar Modernist aspirations in literature, music, science, and philosophy in the early decades of the 20th century, and links the artist to such illustrious contemporaries as James Joyce (1882–1941), Igor Stravinsky (1882–1971), Albert Einstein (1879–1955), and Sigmund Freud (1856–1939). In all cases, attempts were made to redefine the nature of time, space, and reality in order to create new visual, literary, musical, and scientific realities, and by so doing to deny the absolutism of any single definition of artistic or scientific truth.

Picasso's important legacy is not just embodied in formal innovation and fresh approaches to painting. His concern with the human condition often prompted him to enlist his artistic talents in service to social and political ends. No better example of this exists than his masterpiece, *Guernica*, 1937 (Reina Sofia, Madrid). Responding to the massacre of this small Basque village during the Spanish Civil War (1936–39), Picasso created one of the greatest paintings in Western art history on the specific, universal, and timeless theme of man's inhumanity to his fellow man. *Guernica* echoes not only the powerful works of Picasso's Spanish predecessor, Goya, but also the immediacy of contemporary newsreels and films.

Any attempt to list the artists inspired by Picasso falls prey to the fact that all artists since Picasso have had to respond to his art in one way or another. In Picasso's originality, inventiveness, imagination, creative appetite, technical skills, curiosity, prolific output, and legendary status, exists a lexicon on the nature of art, art history, and the creative life. As such, Picasso is one of a small group of artists whose achievements place him outside the normal bounds of evaluation and understanding.

Woman and Bicycle,
Willem de Kooning, 1952–53, Museum of Modern Art, New York

De Kooning's formidable *Woman* series of paintings of the 1950s owes much to the formal language and visual power of Picasso and Cubism.

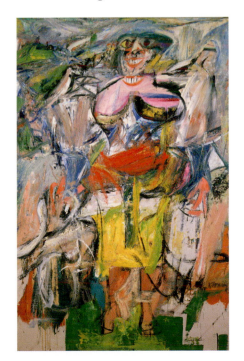

Marcel Duchamp was the most influential artist of the 20th century. Only Pablo Picasso can rival the rich legacy Duchamp's art and attitude have provided to later generations. Duchamp forever changed the way people think about art. His achievements mark a turning point in the redefinition of the purpose, goals, and strategies of art. While not everyone celebrates the implications of Duchamp's thinking, his importance and influence are undeniable.

 INFLUENCED BY

KEY
● artist
◆ artistic movement
■ cultural influence
❖ religious influence

● **Paul Cézanne** (1839–1906)
Cezanne's influence on Duchamp's early paintings is best seen in *Portrait of the Artist's Father* (1910).

● **Francis Picabia** (1879–1953)
Picabia's "machine" style both influenced and echoed similar themes in the work of Duchamp.

◆ **Futurism**
Duchamp first became aware of Futurist painting in 1912 but grew dissatisfied with its visual approach to rendering movement.

◆ **Cubism**
Originally attracted to Cubism's intellectual approach, by 1911 to 1912 Duchamp moved to a more personal Cubist vision.

◆ **Dada**
Dada's anarchic and antiart ideas influenced Duchamp at the same time that he inspired the movement in New York and Paris.

MARCEL DUCHAMP (1887–1968)
French

	Born July 28 in Blainville, Normandy	Begins to paint	Enrolls at the Académie Julian, Paris	Nude Descending a Staircase no. 2 (1912) exhibited at the Armory Show in New	York; develops the idea of the "readymade"	Settles in New York; becomes part of New York Dada; begins work on	the Large Glass (1915–23)	Develops a female alter ego: Rrose Sélavy
CHRONOLOGY	**1887**	**1902**	**1904**	**1913**		**1915**		**1920**

 INSPIRED

● **Richard Hamilton** (b.1922)
Hamilton has not only been inspired by Duchamp as an artist, he is also one of the most articulate writers on Duchamp's art and thought.

◆ **Neo-Dada**
A vague term used to describe American artists Robert Rauschenberg (b.1925) and Jasper Johns, and European artists of Nouveau Réalisme—all of whom were indebted to Duchamp (right: *Persimmon*, Robert Rauschenberg, 1964).

● **Jasper Johns** (b.1930)
The heart of Johns' work explores questions regarding the nature of art inspired by Duchamp's example.

● **Sherrie Levine** (b.1947)
Levine's *Fountain (after Marcel Duchamp: A.P.)* (1991) returned Duchamp's *Fountain* (1917) to the realm of art.

Marcel Duchamp's desire to place art "at the service of the mind" is his most profound contribution to Modernism and contemporary art. Duchamp's fundamental shift from the eye to the intellect, from the perceptual to the conceptual, from the aesthetic contemplation of an object, to the ideas generated by an object, redefined the nature and goals of art. Every artist active today has to confront his legacy.

Duchamp began his career within the conventions of traditional painting—responding to such Modernist influences as Paul Cézanne, Fauvism, Cubism, and Futurism.

His *Nude Descending a Staircase no. 2*, 1912 (Philadelphia Museum of Art) provoked a scandal when exhibited at the 1913 Armory Show in New York. Abstract ideas, however, were always more important than tangible paintings to Duchamp. Then, with *Bicycle Wheel (1913)*, he turned his attention away from painting to explore the realm of the

"readymade," constituting the selection and presentation of mass-produced, mundane objects removed from their context, and presented as art. With this single act, Duchamp challenged traditional concepts of aesthetics, beauty, taste, and what he called the "retinal pleasure" of art.

In 1915 Duchamp began work on his masterpiece, *The Bride Stripped Bare by Her Bachelors, Even* or *The Large Glass*, 1915–23 (Philadelphia Museum of Art), one of the most studied art works of the 20th century. Part painting, part sculpture, part collage, part construction, *The Large Glass* with its enigmatic, mechanistic, humorous, ironic, and cynical exploration of human sexuality, love, and the erotic became a talisman for later art history. The artists who have obsessively investigated and appropriated its images and ideas are many and include such distinguished personalities as Richard Hamilton, Robert Rauschenberg, and Jasper Johns.

Female Nude,
Pablo Picasso, 1909, Pola Museum of Art, Kanagawa

Duchamp began his career responding to the Modernist trends around him, such as the Cubist style adopted by artists like Picasso at the time, before he moved on to a more personal vision.

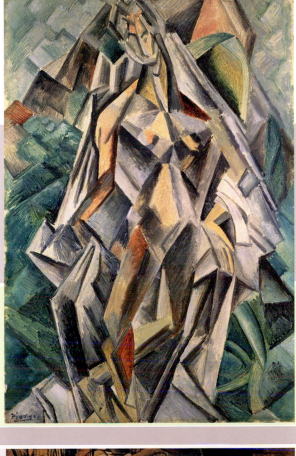

■ Photography

Duchamp's interest in the photography of Eadweard Muybridge (1830–1904) and other time-lapse photographs is evident in *Nude Descending a Staircase no. 2* (1912) (right: *Figure in Different Running Positions*, Eadweard Muybridge, 1884–87).

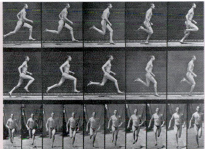

Returns to Paris	*Begins work on Étant donnés, last major project of his life*	*Becomes an American citizen*	*First retrospective exhibition at the Pasadena Art Museum, California*	*Dies October 2 in Neuilly-sur-Seine*
1923	**1942**	**1955**	**1966**	**1968**

◆ Fluxus
A Neo-Dada, German/ American group active in the 1960s dedicated to avant-garde performance art and collaborative events.

◆ Conceptual Art
Term coined in 1967 by Sol LeWitt (1928–2007). Conceptualism's core belief in an art "at the service of the mind" derives from Duchamp.

● Damien Hirst
(b.1965)
Damien Hirst's *Pharmacy* installation (1992) directly references a work by Marcel Duchamp with the same title.

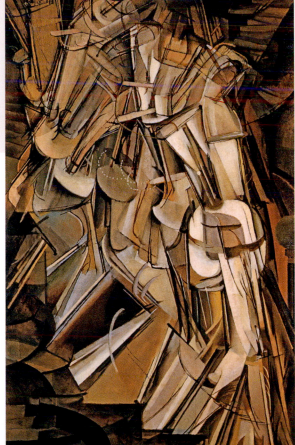

Nude Descending a Staircase no. 2,
Marcel Duchamp, 1912, Philadelphia Museum of Art, Philadelphia

Duchamp's work was influenced by time-lapse photography, and his work depicting the movement of a nude caused controversy when it was shown at the 1913 Armory Show in New York.

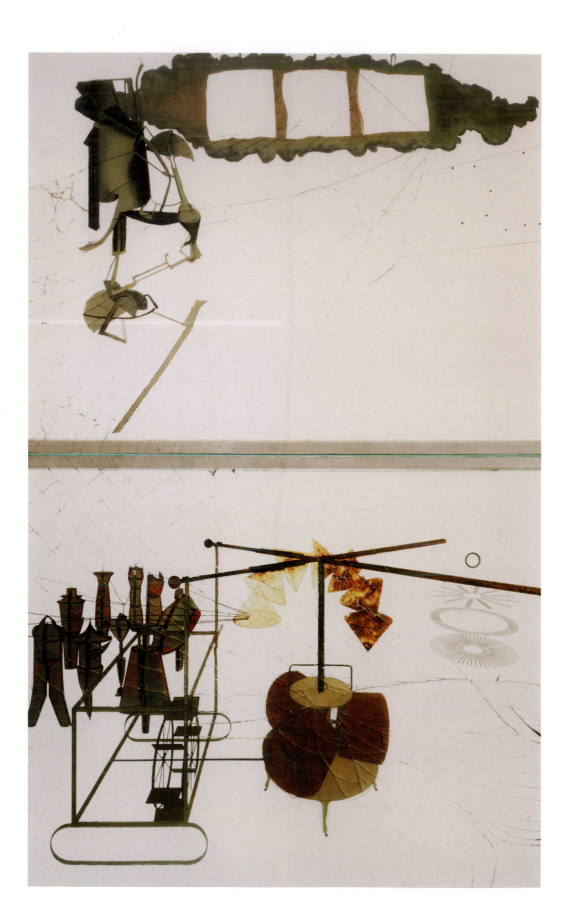

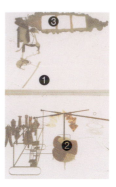

ABOUT THE WORK

A pioneering member of the Dada movement in New York and Paris, Duchamp exerted a huge influence on later trends in art, most notably on the development of Conceptual Art. *The Bride Stripped Bare by Her Bachelors, Even* (known for short as *The Large Glass*) is a nine-feet-high, mixed-media construction described by André Breton as "a mechanical and cynical interpretation of the phenomenon of love."

COMPOSITION

The work is divided into two distinct sections, each of which contains a bizarre, machine-like device. The upper half represents "the bride's domain," (1) while the lower panel displays "the bachelor apparatus."

READY-MADE

Duchamp is renowned for his ready-mades—banal, mass-produced items reinvented as art objects. He executed highly realistic images of some of these articles, one of which appears in the bachelor section. This is the *Chocolate Grinder* (2), which he first noticed in a confectioner's shop in Rouen and subsequently painted on several occasions.

CHANCE

The artist used chance elements to avoid any connotations of style or aesthetic choice in the work. The shape of the three white rectangles (3), for example, was taken from a photograph of a sheet flapping in the wind.

Large Glass,
Marcel Duchamp, 1915–23, Philadelphia Museum of Art, Philadelphia
Duchamp's masterpiece explores eroticism, sexuality, and love, is part painting, part collage, part construction, and part sculpture, and its imagery has been expropriated by artists ever since.

Duchamp's advocacy of the conceptual basis of art, meaning works of art as "brain facts"; his relentless questioning of accepted norms, attitudes, and behaviors; exploration of chance and the accident as part of the artistic process; sense of humor; unwillingness to take either himself or art too seriously; the fertility of his thinking and his acute intellect; all contribute to an artist and thinker of formidable gifts and one who has exerted a powerful influence on his peers.

The art and ideas of Duchamp are so original and varied that they affect the subsequent history of Western art. What presents itself today as original is often a reworking of ideas first articulated by Duchamp decades ago. Duchamp's influence relates to art movements as varied as Dada, Surrealism, Abstract Expressionism, Neo-Dada, Pop Art, Minimalism, Conceptual art, Kinetic art, Happenings, Performance art, Body art, Language art, and new media. His true heirs are those protean artists who share his wide range of interests, sharp mind, probing intellect, and love of art as an expression of ideas: artists such as Joseph Beuys (1921–86), Rauschenberg (b.1925), Johns, Robert Morris (b.1931), Ben Vautier (b.1935), Hans Haacke (b.1936), Bruce Nauman (b.1941), Joseph Kosuth (b.1945), On Kawara (b.1932), Sherrie Levine, and Yasumasa Morimura (b.1951).

In memory of Leonardo da Vinci,
Francis Picabia, 1919, Tate Britain, London

Dadaist Picabia was a friend of Duchamp, and his mechanical style influenced the artist and echoes similar themes.

Gray Alphabet,
Jasper Johns, 1968

Johns was inspired by Duchamp's example to explore questions regarding the nature of art, and the place of art in society as the expression of ideas.

Although perhaps best known for her iconic flower paintings, Georgia O'Keeffe is one of the most significant artists in the development of American Modernism. She made a bold decision to embrace Abstraction in 1915, and in doing so created an original style that advanced the cause of painting in the United States and that continues to resonate among artists of today.

 INFLUENCED BY

KEY
- ● artist
- ◆ artistic movement
- ■ cultural influence
- ❖ religious influence

● **Alfred Stieglitz**
(1864–1946)
Stieglitz and O'Keeffe mutually influenced one another. Through his photographs, writings, and exhibitions, Stieglitz became an influential figure in American art (right: *Alfred Stieglitz and Georgia O'Keeffe*).

● **Arthur Wesley Dow**
(1857–1922)
The teachings of this influential arts educator at Teachers College, Columbia University, defined the goal of art as the expression of personal feeling realized through formal relationships.

● **Wassily Kandinsky**
(1866–1944)
Kandinsky's treatise *Concerning the Spiritual in Art* (translated into English in 1914) was known to O'Keeffe. Paintings by Kandinsky were also exhibited at Gallery 291.

■ **American Southwest**
O'Keeffe's love and experience of the American Southwest, in particular New Mexico, shaped much of her formal and thematic language as an artist.

GEORGIA O'KEEFFE (1887–1986)
American

Born November 15 near Sun Prairie, Wisconsin	Attends School of the Art Institute of Chicago; attends Art Students League in New	York; first visit to The Little Galleries of the Photo-Secession (Gallery 291)	operated by Alfred Stieglitz; moves to Chicago in fall 1908	Enrolls at Teachers College, Columbia University; teaches art at Columbia	College in South Carolina; produces seminal series of Abstract drawings	Stieglitz sees drawings by O'Keeffe; the two begin to correspond	Stieglitz opens first one-person show of O'Keeffe's work at Gallery 291

CHRONOLOGY	**1887**	**1905–08**			**1914–15**	**1916**	**1917**

→ **INSPIRED**

● **Alfred Stieglitz**
(1864–1946)
Stieglitz's photographic portraits of O'Keeffe were taken over decades, and comprise hundreds of images.

● **Paul Strand**
(1890–1976)
Strand, his wife Rebecca, and O'Keeffe lived and worked closely together in New Mexico, often painting and photographing the same places.

● **Mark Rothko**
(1903–70)
Like Helen Frankenthaler, Rothko's color, light, and shapes find precedents in O'Keeffe's painting.

● **Morris Louis**
(1912–62)
In his *Veils* and *Florals* series (1954, 58-9; 1960), Louis explores the qualities of color and Abstraction found in O'Keeffe's flower pictures and watercolors.

● **Agnes Martin**
(1912–2004)
Martin's late Abstract paintings, like O'Keeffe's, were inspired by the white light and the colors of the earth and sky in New Mexico.

The art of Georgia O'Keeffe was instrumental in shaping a modern vision for American painting in the early 20th century. O'Keeffe fused ideas from Wassily Kandinsky's *Concerning the Spiritual in Art* (translated into English in 1914) with the thought of one of the most important arts educators of the United States, Arthur Wesley Dow. Dow's belief that the basis for art resided in personal feeling, and the exploration of the formal elements of line, shape, and color encouraged O'Keeffe to shift her attention to Abstraction. In a series of Abstract charcoal drawings executed late in 1915, O'Keeffe charted a new course for her art. It was these drawings that brought her work to the attention of the photographer Alfred Stieglitz, thus beginning one of the great personal and collaborative relationships in American art history.

In 1916 Stieglitz included some of O'Keeffe's drawings in a group exhibition at his Gallery 291 in New York. Soon after, O'Keeffe joined the artists associated with the Stieglitz Circle. This was a group that included Marsden Hartley, Arthur Dove, and John Marin, all of whom had responded strongly to Modernist European art first seen in the United States at the 1913 Armory Show in New York.

O'Keeffe's career was a long and fruitful one, embracing a range of subjects and responding to a variety of American locales. From her early Precisionist portrayals of New York skyscrapers, to her iconic flower pictures and her personal engagement with the landscape, light, and color of the American Southwest, O'Keeffe's art represents a unique merging of European and American Modernist ideas.

Aleph Series I,
Morris Louis, 1960, Private Collection
Louis's Aleph Series stresses an abstract language of petal-shaped colors running toward a central core.

◆ **Gallery 291**
(1905–17)
Stieglitz's New York gallery was an exhibition space and meeting place that introduced European and American Modernism to the public, including works by Cézanne, Picasso, Brancusi, Matisse, and O'Keeffe.

◆ **The Stieglitz Circle**
A group of Modernist American painters promoted by Stieglitz that included O'Keeffe, Marsden Hartley (1877–1943), John Marin (1870–1953), Arthur Dove (1880–1946), and Charles Demuth (1883–1935); and photographers of the time.

Marries Stieglitz, December 11	Travels and stays in New York, Lake George, Canada, New Mexico, Bermuda, and Hawaii	Stieglitz dies	Settles in New Mexico	Retrospective exhibition at the Whitney Museum of American Art in New York	Dies March 6 in Santa Fe, New Mexico
1924	**1930s**	**1946**	**1949**	**1970**	**1986**

● **Ellsworth Kelly**
(b.1923)
O'Keeffe's Abstract language anticipates many of the concerns of Color Field and Hard-edge painters later in the 20th century.

● **Miriam Shapiro**
(b.1923)
Both Shapiro and Judy Chicago have explored central core imagery inspired by feminist interpretations of O'Keeffe's paintings.

● **Helen Frankenthaler**
(b.1928)
The color, touch, and Abstract qualities in Frankenthaler's paintings are close in spirit to those of O'Keeffe.

● **Judy Chicago**
(b.1939)
In *The Dinner Party* (1979) the O'Keeffe place setting honors her as a painter, and acknowledges her place in the history of women's art.

The Dinner Party,
Judy Chicago, 1979, Brooklyn Museum, New York

O'Keeffe has become an inspiration for female American artists. Chicago's homage to feminist history included a place setting of a symbolic ceramic plate for her as one of 39 guests of honor.

Canna Red and Orange,
Georgia O'Keeffe, 1920, Private Collection

Georgia O'Keeffe's many semi-abstract flower paintings are familiar icons of American art.

Few individuals have affected modern attitudes about artists and art more than Salvador Dalí. He forever altered perceptions about the artist in society, blurring distinctions between the artist as creator and self-promoting impresario. While his art remains a rich source of inspiration for those who choose to explore the personal and the obsessive, his greatest achievement was his infiltration into popular and the collective consciousness.

 INFLUENCED BY

KEY
● artist
◆ artistic movement
■ cultural influence
❖ religious influence

● **Francisco Zubarán**
(1598–1664)
Dalí's early, realistic paintings executed in meticulous detail show the influence of this Spanish master.

■ **Sigmund Freud**
(1856–1939)
Freud's writings on the importance of the dream profoundly affected the style and iconography of Dalí's art.

● **Pablo Picasso**
(1881–1973)
Dalí first met Picasso in Paris in the 1920s. His awareness of Picasso and admiration for his work were well known.

● **Giorgio de Chirico**
(1888–1978)
The empty spatial theaters in Dalí paintings derive from the metaphysical works of this Italian precursor to Surrealism.

● **Federico Garcia Lorca**
(1898–1936)
Dalí's complicated relationship with this poet ended with the premiere of *Un Chien Andalou* (1929).

SALVADOR DALÍ (1904–89)
Spanish

	Born May 11 in Figueras, Spain	Studies at the Real Academia de Bellas Artes de San Fernando,	Madrid; meets Federico Garcia Lorca and Buñuel	First solo exhibition in Barcelona	Expelled from the Academia; travels to Paris; meets Picasso	Joins the Surrealist movement; collaborates with Luis Buñuel on	the Surrealist film Un Chien Andalou	Collaborates with Buñuel on the Surrealist film L'Age d'Or
CHRONOLOGY	**1904**	**1921**		**1925**	**1926**	**1929**		**1930**

 INSPIRED

● **Andy Warhol**
(1928–87),
● **Joseph Beuys**
(1921–86)
Beuys' embellishment of the facts of his life to create an artistic persona and private iconography parallels similar traits in Dalí's life and art.

● **David Cronenberg**
(b.1943)
The images, effects, and themes in Cronenberg's films share much in common with Dalí's art and obsessive concerns about the body.

● **Julian Schnabel**
(b.1951),
● **Jeff Koons**
(b.1955), and
● **Damien Hirst**
(b.1965)
Inspired by Dalí's attitudes regarding the artist as self-promoter, impresario, showman, and public provocateur.

● **Mariko Mori**
(b.1967)
Mori's various artistic personae, interest in popular culture, Hollywood, fashion, dreams, and desires all relate to Dalí.

● **Matthew Barney**
(b.1967)
Barney's videos, films, sculptures, installations, and performances, exploring obsessive, psycho-sexual themes, seem plucked from a Dalí dream.

The art and life of Salvador Dalí are forever intertwined in both positive and negative ways. While his talents as a painter are undeniable and his contributions to Surrealism significant, his greatest legacy for younger artists may reside in the creation of an artistic persona, and this commitment to live his life in a manner true to that persona. In this regard, Dalí set a precedent for successors, ranging from Andy Warhol and Joseph Beuys to Jeff Koons and Damien Hirst.

Born in the Catalonia region of Spain, Dalí matured in the same environment that produced many of the country's other leading artists, including Pablo Picasso and Joan Miró, both of whom influenced Dalí's development and career. An artist of many talents and interests, Dalí, like Picasso, evolved through numerous stylistic periods, exploring a wide range of media and activities including painting, sculpture, object-making,

installations, graphic arts, photography, film, and work for the theater.

Dalí's involvement in Surrealism in 1929 brought a new vitality to the movement. His commitment to exploring the Freudian-inspired aspects of the dream, regardless of how bizarre, revealing, or controversial the imagery—what Dalí called "paranoiac-critical activity"—became a major strategy of Surrealism in all its various manifestations and arenas.

Dalí published his autobiography, *The Secret Life of Salvador Dalí* (1942), a mixture of fact, fiction, and self-adulation that traced the artist's life through the decade of the 1930s. This text remains an inspiration for all artists who seek to create their own personal mythologies in art.

● **Joan Miró**
(1893–1983)
It was Miró who brought
Dalí to the attention of
the Surrealists in Paris
(above: *People at Night,
Guided by Phosphorescent
Tracks of Snails*, 1940).

● **Luis Buñuel**
(1900–83)
Dalí's friendship and
collaboration with
Buñuel shaped many of
his ideas on art and the
importance of film.

**Still Life with Lemons, Oranges and
Rose (detail),**
*Francisco Zubarán, 1633, Norton Simon Museum
of Art, Pasadena*

The starkness, clarity, dramatic light, and meticulous
paint application give this Zubarán still-life an almost
other-world quality much admired by Dalí.

Paints The Persistence of Memory	Expelled from Surrealist movement	Publishes his autobiography	Contributes dream sequence to Alfred Hitchcock's Spellbound	Retrospective at the Georges Pompidou Center, Paris	Dies January 23 in Figueras
1931	**1934**	**1942**	**1945**	**1980**	**1989**

The Persistence of Memory,
*Salvador Dalí, 1931, Museum of Modern
Art, New York*

In this iconic Surrealist image, limp
watches—as if plucked from a dream—
transform from hard to soft in a vast,
empty landscape of the mind.

Soft Toilet–Ghost version,
*Claes Oldenburg, 1966,
Private Collection*

In Claes Oldenburg's soft
sculptures, rigid, everyday
objects are transformed into
exhausted, sagging, and ghostly
skins, as if through over-use.

The Basket of Bread,
Salvador Dalí, 1945, Teatro-Museo Dalí, Figueras

The subject matter, illusionism, strong light, and detailed
realism of this painting are an homage to the 17th-century
Spanish master Zubarán.

The life and art of Frida Kahlo have led to a resurgence of interest in Latin American art and the important role played by women in that story. Kahlo has been linked to movements such as Surrealism, Realism, Primitivism, and Naïve Art. The roots of Kahlo's art, however, reside deep within her Mexican heritage and culture, and even more in the personal events of her life.

 INFLUENCED BY

KEY
- ● artist
- ◆ artistic movement
- ■ cultural influence
- ❖ religious influence

■ **Pre-Colombian and Mexican Art**
The forms, rituals, and beliefs of Pre-Columbian art and culture, were important sources for Kahlo. She also looked to indigenous Mexican art. *Retablos* and *ex votos* figure prominently in the content of her paintings.

● **Henri Rousseau** (1844–1910)
Kahlo greatly admired the simplicity and directness of Rousseau's naïve style (right: *Tropical Storm with Tiger*, 1891).

● **Paul Gauguin** (1848–1903)
The primitive quality of Gauguin's art was very attractive to Kahlo.

FRIDA KAHLO (1907–54)
Mexican

	Born July 6 in Coyoacán, Mexico	Mexican Revolution begins	Seriously injured in bus accident, September 17	Marries Diego Rivera, August 21	Travels to San Francisco and New York with Rivera	In Detroit with Rivera, who is at work on murals for the Detroit Institute of Arts	Leon Trotsky (1879–1940) visits Kahlo and Rivera in Mexico	André Breton (1896–1966) visits Kahlo and Rivera in Mexico; first solo
CHRONOLOGY	**1907**	**1910**	**1925**	**1929**	**1930–31**	**1932**	**1937**	**1938**

➤ **INSPIRED**

● **Maria Izquierdo** (1902–55)
Like Kahlo, her art drew upon her personal history, was tied to indigenous Mexican sources, and displayed a feeling for the primitive and naïve.

● **Remedios Varo** (1908–63)
Varo arrived in Mexico in 1941 and met both Kahlo and Rivera. Varo shared with Kahlo a concern for imagery that explored the realities of the female body, maternity, and self-identity.

● **Alfredo Castañeda** (b.1938)
The forms, subjects, and sentiments in Castaneda's art refer directly back to Kahlo.

● **Nahum B. Zenil** (b.1947)
Zenil greatly admires Kahlo's art. The sources and autobiographical nature of his work owe much to her example.

■ **Photography**
Kahlo had close personal and professional relationships with many of the most important photographers of her time, including Edward Weston, Tina Modotti, Imogen Cunningham, and Manuel and Lola Álvarez Bravo.

The life and art of Frida Kahlo, like that of Edvard Munch (1863–1944), are inextricably bound together. Like Munch, Kahlo's art derives from the often traumatic events of her life. In 1925, at 18 years old, her spine was fractured, pelvis crushed, and foot broken in a bus accident. She was not expected to live but survived only to suffer from severe, chronic, and often debilitating pain that more than 30 subsequent operations could not alleviate.

During her long convalescence, Kahlo began to draw and paint, both to fight the boredom of her confinement and to deal with the physical pain and psychological scars from her accident. Themes that would haunt her work for the rest of her life soon appeared, including the longing to have children (impossible because of her injuries), and an obsessive and intense involvement with her own image and history.

Three years before her accident, Kahlo had met the Mexican Muralist painter Diego Rivera. After recovering from her injuries sufficiently to walk, she took three of her paintings to the artist for his assessment. Thus began a long and stormy relationship that resulted in marriage in 1929, numerous separations, reconciliations, divorce, and remarriage.

Kahlo's style derived from a love of Mexican folk, popular, Colonial, and Pre-Colombian art. Her formal language stressed tight brushwork, simple design, and naïve drawing. Her subjects are personal, poignant, grotesque, fantastic, humorous, surreal, religious, and always deeply felt. André Breton and the Surrealists celebrated Kahlo's originality and vision. Kahlo thought differently, however. "I never painted dreams." she said, "I painted my own reality."

The Elements,
Diego Rivera, c.1926
Mexican muralist Rivera was more than Kahlo's lover and husband, he was her inspiration, and she was his. Like Kahlo, he looked to the rituals and beliefs of Pre-Colombian art.

● **Diego Rivera**
(1886–1957)
Kahlo and Rivera had a kind of reverence for each other's art. Each artist was the greatest influence and inspiration on the other.

■ **Communism**
Kahlo was politically active and was a member of the Communist party, later becoming a Trotskyite.

◆ **Surrealism**
Kahlo was encouraged by André Breton, who claimed her for the movement. Kahlo sarcastically said she never knew she was a Surrealist until Breton told her she was.

exhibition in New York	*Divorces Rivera, November 6*	*Remarries Rivera, December 8*	*First major exhibition at the Gallery of Contemporary Art in Mexico City*	*Dies July 13 in Mexico City*
	1939	**1940**	**1953**	**1954**

■ **Modern Film and Feminist Art History**
Kahlo's life and art have been topics for numerous recent films and documentaries, including the film of her life *Frida* (2002). The pop star Madonna (b.1958) is known to admire Kahlo and collects her work.

Self-Portrait with Small Monkey,
Frida Kahlo, 1945, Museo Dolores Olmedo Patiño, Mexico City

The artist regularly painted her own image, often with Surreal elements.

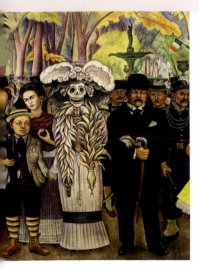

Skeleton Holding the Hand of the Artist as a Young Boy (detail),
Diego Riviera, 1947–48, Hotel del Prado, Mexico City

Like Kahlo, Rivera was sometimes drawn to autobiographical themes, and frequently drew on Mexican imagery and symbolism such as the skeleton, representing death.

Henry Ford Hospital,
Frida Kahlo, 1932, Museo Dolores Olmedo Patiño, Mexico City

Kahlo's concern with her own history was the dominant theme of her work, and her confessional style has been emulated by many contemporary female artists.

CONTEMPORARY ART

The unprecedented options open to today's artists speak of a new era
of discovery and creativity—a contemporary renaissance that will continue
to influence and inspire artists for generations to come.

1947

CHRONOLOGY	Pollock begins using the "drip" technique	Rothko begins signature style depicting hovering blocks of color	John Cage composes 4'33"	Ludwig Wittgenstein's Philosophische Untersuchungen (Philosophical Investigations) published	Rauschenberg creates first "combines"; Johns works on Flag and Target paintings	Allan Kaprow coins the term "Happening"	Riley starts to explore optical phenomena in painting; Warhol's first works based on comics and advertisements	Construction of the Berlin Wall begins
	1947	1950	1952	1953	1954	1957	1960	1961

During the last fifty years, multitudes of working methods and strategies have questioned the basic definitions and goals of art and its meaning. Artists have demonstrated a fascination with new materials and media; an engagement with contemporary politics and society; and a desire to break down the boundaries and constraints of time, place, and language in order to create more relevant forms of artistic communication and meaning in the 21st century.

THE DEATH OF PAINTING?

A primary consideration in any discussion of contemporary painting is the challenge to that medium's importance as a form of visual expression in a world of video, film, the Internet, and other technological media. Many early 20th-century art movements such as Cubism and Dada had already begun to question the validity and basic premises of traditional painting. Marcel Duchamp's assault on the relevancy of optical or retinal art was one of the first attempts to bring about the death of painting and the birth of a new art of the mind.

Since then, artists and critics have continued to announce the end of painting. Experimentation with new media and the application of new technologies to traditional media has increased at a dizzying rate. Painting may no longer be at the top of everyone's hierarchy of media, but the fundamental, almost primordial, impulse toward personal mark-making continues to speak to artist and public alike. Contemporary artists struggle to balance the implications of painting with the profusion of novel forms of artistic expression. Among these artists are a host of talented individuals including Jasper Johns (b.1930), Robert Ryman (b.1930), Bridget Riley (b.1931), Gerhard Richter (b.1932), Brice Marden (b.1938), Elizabeth Murray (b.1940), Sigmar Polke (b.1941), Susan Rothenberg (b.1945), Anselm Kiefer (b.1945), Sean Scully (b.1945), Eric

1963	1965	1975	1975		1981	1989	1999	2007
U.S. President John F. Kennedy assassinated; The Beatles' Please Please Me first heard on American radio	*Warhol exhibits his video art; start of the Vietnam War*	*Fall of Saigon marks the end of the Vietnam War*	*Anshelm Keifer paints My Father Pledged Me a Sword, 1975, based on The Ring (1848–74)*	*operas that the Nazis appropriated for propaganda*	*Fischl paints the voyeuristic Bad Boy; IBM PC. released*	*Fall of the Berlin Wall marks the end of the Cold War*	*The Chapman brothers produce Disasters of War*	*Damien Hirst's momento mori diamond-studded skull, For the Love of God, bought for $100 million (£50 million)*

Fischl (b.1948), Francesco Clemente (b.1952), Neo Rauch (b.1960), John Currin (b.1962), and Jenny Saville (b.1970).

THE HUMANITY OF PAINTING

Whether Realist, Abstract, figural, Expressionist, Minimalist, Modernist, or Post-Modernist—and regardless of their formal vocabularies and diverse themes—the artists share a belief in the continuing relevance and humanity of painting, and its relationship to feeling, thought, emotion, experience, the personal, and the universal.

The story of influence and inspiration in Western painting continues to unfold. Amid the countless connections between great works of art expressed through the achievements of the greatest painters over the centuries, resides both a rich historical legacy and a contemporary source of on-going significance to which everyone can lay claim.

Jackson Pollock redefined the nature of painting through his ability to synthesize European Modernism with an American vision of freedom. His work stands as a testament to the benefits of unfettered personal expression, and the immediacy of improvisational, spontaneously created art.

INFLUENCED BY

KEY
● artist
◆ artistic movement
■ cultural influence
❖ religious influence

◆ Native American Art
The totemic forms and mythic creatures of Native American art, as well as the ritual of Navajo sand painting, were influences on Pollock's forms, subjects, and working methods.

● Hans Hofmann
(1880–1966)
A German émigré artist and teacher in New York who extolled risk-taking, working in an improvisational manner, and the lessons of European Modernism.

● Pablo Picasso
(1881–1973)
All New York School artists had to reckon with Picasso, especially his painting *Guernica* (1937) (Reina Sofia Museum, Madrid) that combined Cubist, Expressionist, and Surrealist traits.

◆ Mexican Muralists
The violent forms, mythic content, strong colors, and expressive strength of the muralists Diego Rivera (1886–1957), José Clemente Orozco (1883–1949), and David Alfaro Siqueiros (1896–1974) were powerful influences on Pollock.

● Thomas Hart Benton
(1889–1975)
American Regionalist painter, and Pollock's teacher at the Art Students League. Benton's swirling forms and rhythms find echoes in Pollock's art.

JACKSON POLLOCK (1912–56)
American

	Born January 28 in Cody, Wyoming	Family lives in various locales in Arizona and California. Attends elementary,	secondary, and manual training schools	Settles in New York City. Studies with Thomas Hart Benton at the Art Students League.	Visits to Los Angeles. Sees works by the Mexican muralists.	Works for the Federal Arts Project of the WPA	Begins Jungian analysis and treatment for alcoholism	Sees Pablo Picasso's Guernica (1937) (Reina Sofia Museum, Madrid)
CHRONOLOGY	**1912**	**1913–29**		**1930–33**		**1935**	**1937**	**1939**

INSPIRED

● Willem de Kooning
(1904–97)
De Kooning called Pollock the "icebreaker," the first artist able to combine European Modernism with a distinctly American way of painting.

● Franz Kline
(1910–62)
Like De Kooning, Kline responded to the immediate, gestural, improvisational, and emotionally-charged aspects of Pollock's art.

● Lee Krasner
(1911–84)
Painter, friend, mentor, supporter, and wife of Pollock. She both influenced him and was inspired by him. She was only fully recognized as an artist after his death.

● Grace Hartigan
(b.1922)
Indebted to Pollock and de Kooning, Hartigan's powerful gestural paintings are important contributions to the later New York School.

● Joan Mitchell
(1926–92)
Mitchell's love of color, nature, and the spontaneous application of paint were inspired by Pollock, and helped shape her style.

Jackson Pollock was deemed the "icebreaker" by his friend and fellow artist Willem de Kooning. He was the American painter who first broke through to a gestural, intuitive, self-expressive, and Abstract language that opened the door for other members of the New York School to follow. In Pollock's most famous works, the *"drip"* paintings executed between 1947 and 1952, he shattered the traditions of easel painting with its limitations of scale, direction, distance, space, working methods, and materials to define an innovative personal realm in pictorial art.

Pollock was born in Cody, Wyoming, and spent his formative years in the American Southwest in California and Arizona before moving to New York at the age of 18. Pollock's time in the Southwest exposed him to the rituals, themes, and mythic content of Native American art that later shaped important aspects of his working methods and subject matter.

In New York, Pollock studied with the American Regionalist painter Thomas Hart Benton, who introduced him to the traditions of art history but against whose Realism Pollock eventually rebelled. His great discovery at this time was the large-scale murals being executed in the United States by the Mexican painters Diego Rivera, José Clemente Orozco, and David Alfaro Siqueiros. Pollock discovered the power of an expressive formal language, and the potency of mythic, often violent, themes in their work. Added to the influence of Native American art and that of the Mexican muralists was Pollock's exposure to the art of Pablo Picasso, notably his antiwar mural *Guernica,* 1937, (Reina Sofia Museum, Madrid) exhibited in New York in 1939. The final revelation came in the form of Pollock's growing awareness of the automatic techniques and subconscious dream imagery explored by the Surrealist émigrés Roberto Sebastian Antonio Matta

Haystack,
Thomas Hart Benton, 1938, Museum of Fine Arts, Houston, Texas
The American Regionalist painter Benton was Pollock's teacher, and the swirling forms and rhythms of his canvases were to influence the work of his pupil.

● **Carl Jung**
(1875–1961)
Pollock's period of Jungian analysis from 1937 to 1942 reinforced ideas of the mythic archetype and the link between creativity and the unconscious.

● **Arshile Gorky**
(1904–48)
He was arguably the first of the Abstract Expressionist circle to explore Surrealist automatism and Abstraction.

● **Roberto Sebastian Antonio Matta Echaurren**
(1911–2002)
Along with other Surrealist émigrés in New York, Matta introduced the automatic techniques of the movement to Pollock.

First solo exhibition at Peggy Guggenheim's (1898–1979) Art	of This Century. Guggenheim commissions a mural for her New York home	Marries painter Lee Krasner	Begins using the "drip" technique	Life magazine publishes article, "Jackson Pollock: Is he the greatest living painter in	the United States?"	Dies August 11 in an automobile accident in East Hampton, New York	Planned mid-career retrospective opens as memorial	exhibition at the Museum of Modern Art, New York
1943		**1945**	**1947**	**1949**		**1956**	**1956–57**	

● **Helen Frankenthaler**
(b.1928)
Frankenthaler's breakthrough paintings combined the scale, overall quality, working methods, and subtle paint application of Pollock and Mark Rothko (1903–70) to point the way to post-painterly Abstraction.

◆ **Happenings**
Pollock's kinetic process, his use of the canvas as an "arena for action," and transformation of painting into an event, affected the development of Happenings and performance-based art in the 1960s.

Going West,
Jackson Pollock, 1934–35, Smithsonian American Art Museum, Washington, D.C.
During the 1930s Pollock's work reflected the subjects of his teacher Benton, and the growing influence of the Mexican muralists.

Number 1, 1950 (Lavender Mist),
Jackson Pollock, 1950, National Gallery of Art, Washington, D.C.
Pollock's pioneering use of the drip-painting technique and move toward the spontaneous and gestural application of paint was influenced by his observation of Native American art.

ABOUT THE WORK

Jackson Pollock was the outstanding figure of the Abstract Expressionist movement, reaching his peak with the celebrated "drip" paintings (1947–51). These were chiefly inspired by the automatic drawings of the Surrealists, though they also owed something to the Native American ceremonies he had witnessed in his youth. The process of painting resembled a ritual itself, as Pollock crouched, prowled, and danced on the canvas, as he poured the paint.

COMPOSITION

In his "drip" paintings, Pollock adopted a distinctive, "all-over" approach. This revolutionary idea overturned the traditional notion of composition, where the eye was usually directed toward specific parts of a picture. By contrast, Pollock's paintings have no main focus, no center, no top, no bottom. Each part of the picture surface is given equal importance.

COLOR

Pollock achieved his rich, coloristic effects with remarkably few pigments. Ironically, lavender was not one of them. The pastel tones are actually salmon pink. (1)

FORM

Pollock countered accusations that his painting was dehumanized by including handprints (2) along the upper edges of the picture. In the most graphic way possible, this emphasized a human presence in the painting.

Echaurren, and Arshile Gorky, who had both settled in New York. Through his absorption and synthesis of this potent mix of images, processes, traditions, and ideas Pollock forged a personal, mythic, and expressive language of painting. *In Guardians of the Secret*, 1943 (San Francisco Museum of Modern Art), *Pasiphae*, 1943 (Metropolitan Museum of Art, New York), and *The She-Wolf*, 1943 (Museum of Modern Art, New York), Pollock became his own myth maker, creating all manner of abstract signs and symbols delineated through an increasingly expressive, automatic, and gestural application of paint.

By the late 1940s Pollock began to purge the mythic signs and symbols from his art, and to accentuate the automatic and spontaneous process of painting. It was no longer his desire to symbolize rituals and myths. The act of painting was now seen as a ritualistic act. His paintings increased in the complexity and spontaneity of their mark making, and in Pollock's desire to wring order from chaos.

In *Sounds in the Grass (Shimmering Substance Series)*, 1946 (Museum of Modern Art, New York), one senses Pollock's desire to burst beyond the confines of the painting's boundaries. It was a short step from this to the first of the so-called *"drip"* paintings of 1947 in which Pollock worked on the floor on large sections of unprimed canvas, pouring, dripping, splashing, and pooling the paint, using an array of implements as he attacked the surface from all directions. It was this kinetic activity that led the critic Harold Rosenberg (1906–78) to coin the term *"action painting"* to describe Pollock's art. Drip paintings such as *Autumn Rhythm (Number 30)*, 1950 (Metropolitan Museum of Art, New York), and *Number 1, 1950 (Lavender Mist)*, 1950 (National Gallery of Art, Washington, D. C.) displayed an all-over surface comprised of lyrical skeins of paint that were both optical and material, visual and tactile, layered and flat, all at the same time. Concepts of artistic process, pictorial space, and the pure expressive power of the creative act were forever changed by Jackson Pollock's achievement with these works.

Untitled ("Rope Piece"),
Eva Hesse, 1970

The Postminimalist sculptor and installation artist Hesse transforms Pollock's two-dimensional skeins of paint into a three-dimensional sculpture made from rubber-dipped string and rope.

Mark Rothko is one of the preeminent American painters of the New York School. Along with Barnett Newman and Clyfford Still, Rothko defined a side of Abstract Expressionism concerned less with the action of paint and more with the investigation of color fields, rigorous in their formal properties and evocative in their potential for meaning.

 INFLUENCED BY

KEY
● artist
◆ artistic movement
■ cultural influence
❖ religious influence

■ **Classical Literature**
In the 1940s Rothko explored themes of myth, prophecy, and archaic ritual derived in part from Classical literature and the works of the Greek playwright Aeschylus.

■ **Friedrich Nietzsche** (1844–1900)
German philosopher Nietzsche's *Birth of Tragedy* (1872) was an important book for Rothko, reinforcing his ideas about the Dionysian and the Apollonian in art, as well as the potential for his paintings to be tragic.

◆ **Non-Representational Art**
Rothko's art is indebted to two earlier 20th-century pioneers in the realm of non-representational abstraction: Piet Mondrian (1872–1944) and Kazimir Malevich (1878–1935).

● **Wassily Kandinsky** (1866–1944)
The Russian artist's ideas concerning the power of abstract painting to embody the spiritual resonated with Rothko.

● **Max Weber** (1881–1961)
Rothko's early teacher and the painter from whom he learned of the leading developments in European Modernism, especially Cubism.

MARK ROTHKO (1903–70)
American

1903	1913	1921–23	1924–30	1933	1942	1946	1950
Born Marcus Rothkovitz on September 25 in Dvinsk, Russia	Moves with family to Portland, Oregon	Attends Yale University; moves to New York	Studies at the Art Students' League with Max Weber; meets Milton Avery and Adolph Gottlieb	First solo exhibitions in Portland, Oregon, and New York	Begins to explore mythological themes and produce Surrealist inspired works	Creates "Multiform" paintings	Signature style depicting hovering blocks of color begins

CHRONOLOGY

INSPIRED

● **Barnett Newman** (1905–70)
Newman's attempt to achieve a mystical abstraction through the unity of materials and surface relates strongly to Rothko.

● **Morris Louis** (1912–62)
Like Helen Frankenthaler, Louis explored thin, diaphanous washes of color that owed much to the visual language and working methods of Rothko.

● **Agnes Martin** (1912–2004)
Martin was directly affected by the art and ideas of Rothko, Barnett Newman, and Ad Reinhardt (1913–67). Her paintings bridge the gap between Abstract Expressionism and Minimalism.

● **Ellsworth Kelly** (b.1923)
The simple forms and subtle relationships of Rothko's work are translated into Kelly's taut, hard-edge colors and shapes.

● **Helen Frankenthaler** (b.1928)
Frankenthaler was attracted to Rothko's thinly applied, subtle washes of color. Her staining technique is a logical extension of Rothko's working methods.

Mark Rothko's art is one of the great achievements in American painting. Rothko combined Modernist European non-representational Abstraction inherited from such luminaries as Kazimir Malevich (1878–1935) and Piet Mondrian (1872–1944) (who settled in New York in 1940), with a concern for the mystical and spiritual properties of art derived from Kandinsky. To these were added the influence of Surrealism and a disregard for old conventions of painting inspired by the breakthroughs of his fellow New York School artists.

Rothko's early paintings charted a course through a range of styles and influences from Realist themes to Modernist formal experiments, and Surrealist-inspired works exploring mythic stories and symbolic language. In the 1940s Rothko began to purge the last vestiges of mythic content from his paintings and allowed the disembodied shapes and colors to speak for themselves. It was then that Rothko and Adolph

Gottlieb (1903–74) published a statement in the *New York Times* (June 13, 1943) proclaiming: "We favor the simple expression of the complex thought. We are for the large shape because it has the impact of the unequivocal. We wish to reassert the picture plane. We are for flat forms because they destroy illusion and reveal truth."

With this declaration he embraced a non-representational art based on blocks of color hovering on a vertical canvas. All references to the natural world and to mythic imagery were deleted in favor of an investigation of the pictorial properties of painting: color, surface, light, proportion, and scale.

Like Malevich, Mondrian, and Kandinsky before him, Rothko asserted the potential for an economical and focused language to express spiritual and philosophical truths. In the same *New York Times* statement he remarked: "There is no such thing as good painting about nothing."

Water of the Flowery Mill,
Arshile Gorky, 1944, Metropolitan Museum of Art, New York

Gorky's work was at the cusp of the shift from Surrealism to Abstract Expressionism, and his artistic use of color and sense of spontaneity influenced the young Rothko.

● **Milton Avery**
(1893–1965)
Rothko met Avery in the late 1920s. Avery's simplified, colorful, and semi-abstract paintings made an impression on the young artist.

● **Arshile Gorky**
(1905–48)
Through Gorky, Rothko discovered the automatic techniques of the Surrealists, fluid-paint application, and biomorphic forms.

● **Jackson Pollock**
(1912–56)
Artist Willem de Kooning (1904–97) called Pollock the "icebreaker." Pollock was crucial to all members of the New York School in their adoption of a more personal, abstract, and intuitive style of painting.

Paintings included in the 29th Venice Biennale; receives commission for	Philip Johnson's Seagram Building; later withdraws from the project	Solo exhibitions at the Phillips Collection, Washington, D.C.,	and the Museum of Modern Art, New York	Works on murals for Harvard University and paintings for Rothko Chapel	Commits suicide on February 25	Rothko Chapel, Houston, Texas, is dedicated on February 28
1958		**1960–61**		**1962–67**	**1970**	**1971**

● **Morton Feldman**
(1926–87)
An important composer in 1940s New York, Feldman was inspired by the paintings of the Abstract Expressionists. He composed *Rothko Chapel* (1971) in honor of the artist and his last great commission.

● **Dan Flavin**
(1933–96)
Flavin's admiration for great colorists such as Rothko and Henri Matisse (1869–1954) was clear. His Minimalist art of light and color brings the illusionism of Rothko's language into real space.

The Bay,
Helen Frankenthaler, 1963, The Detroit Institute of Arts, Detroit

Frankenthaler's soak-stain technique allows her to create oils that appear like watercolors, and are the logical extension of Rothko's use of thin washes of color.

Hierophant (Untitled),
Mark Rothko, 1945, Private Collection

During the 1940s, Rothko's work was increasingly focused on a flat picture plane with large, simple shapes as he gradually sought to let colors and forms speak for themselves.

Untitled,
Mark Rothko, 1953, Private Collection

Rothko's blocks of color hovering on a vertical canvas dispensed with the representational, and allowed him to explore the pictorial properties of light, color, scale, surface, and proportion.

Robert Rauschenberg responded to the legacy of Abstract Expressionism by taking American art in a new direction in the second half of the 20th century. Blending elements from painting and sculpture and blurring the distinction between art and life, Rauschenberg's work combines inspired dialogues regarding the materials, processes, and goals of creativity.

INFLUENCED BY

KEY
● artist
◆ artistic movement
■ cultural influence
❖ religious influence

◆ **Black Mountain College**
From 1933 to 1956 this innovative college in North Carolina was home to some of the key personalities in American art and culture. (Right: *A professor at Black Mountain College looks at a student's project, 1945.*)

● **Marcel Duchamp** (1887–1968)
As with Jasper Johns, Duchamp's influence affected Rauschenberg's ideas on the definitions, possibilities, and boundaries of art.

● **Josef Albers** (1888–1976)
This German artist was one of the first Bauhaus professors to emigrate to the United States where he taught Rauschenberg at Black Mountain College.

● **Jean Dubuffet** (1901–85)
The French artist's concept of "Art Brut" and his advocacy of unconventional materials and methods were well known in New York in the 1950s.

ROBERT RAUSCHENBERG (b.1925)
American

	Born October 22 in Port Arthur, Texas	Studies at the Kansas City Art Institute	Studies in Paris; studies at Black Mountain College in North Carolina	First solo exhibition at Betty Parsons Gallery, New York; meets John Cage	Meets Merce Cunningham and Jasper Johns	First "combines" (uses unusual and found objects to challenge the notion of art)	Monogram	First retrospective at the Jewish Museum, New York
CHRONOLOGY	**1925**	**1947**	**1948**	**1951**	**1953**	**1954**	**1959**	**1963**

INSPIRED

● **John Cage** (1912–92)
Rauschenberg and Cage's relationship was mutually influential and inspirational. Cage's composition, *4'33"*, (1952) was directly inspired by Rauschenberg's *White Paintings* (1951).

● **Jasper Johns** (b.1930)
Johns' seminal decade of work from 1955 to 1965 coincides with his close relationship and collaboration with Rauschenberg.

◆ **Pop Art**
All the artists of the American Pop Art movement are indebted to Rauschenberg, especially Andy Warhol (1928–87) and Claes Oldenburg (b.1929).

● **Sherrie Levine** (b.1947)
Levine's reliance on commercial and mechanical reproduction, and her use of appropriated images are inspired by Rauschenberg.

◆ **Performance Art**
The traditions of Happenings in the late 1950s, and performance art in the 1960s, owe much to Rauschenberg's participation.

Robert Rauschenberg's responses to Abstract Expressionism were theatrical and extroverted compared to Jasper Johns' more cerebral and introspective impulses. Both points of view were important and provocative. Taken together, and seen as complementary sides of a single assault, the achievements of Rauschenberg and Johns represent a fundamental shift in thinking regarding the direction that American art was to take in the aftermath of Abstract Expressionism.

Rauschenberg, like his friends the composer John Cage and the choreographer Merce Cunningham, embraced the idea that art is life and life is art. Among the artist's most famous comments in this regard was: "Painting relates to both art and life. I try to act in that gap between the two." "Combines" such as *Bed*, 1955 (Museum of Modern Art, New York); *Monogram*, 1955–59 (Moderna Museet, Stockholm); and *Canyon*, 1959 (National Gallery of Art, Washington, D.C.) were the means by which Rauschenberg took elements from art and life, painting and sculpture, and combined them to create fresh but somehow familiar expressions of form and content.

Incorporating materials such as paint, fabric, clothing, paper, photographs, illustrations, and the discarded detritus of life, Rauschenberg collaborates with his materials in a physical way while exploring and commenting upon a range of concepts related to life, high art, low art, consumerism, politics, and popular culture. In so doing Rauschenberg asks the viewer to consider both the nature of art and the nature of the society that gives rise to it. Unlike the Surrealist object that often serves as a point of departure for the dream and subjective rumination, Rauschenberg's use of objects and concrete materials is meant to keep the viewer in reality. As he once said: "A picture is more like the real world when it is made out of the real world."

MZ 325 (Blitznadeln),
Kurt Schwitters, 1921, Private Collection

Dadaist Schwitters was a master of collage using unconventional materials ranging from string to socks in his work, and often incorporated typography.

● **Alberto Burri**
(1915–88)
Rauschenberg made two visits to the Italian artist's studio in 1953 as his idea of the "combines" was taking shape.

● **Merce Cunningham**
(b.1919)
Rauschenberg's collaborations as set, costume, and lighting designer for the choreographer and dancer expanded his own vision of art.

Cofounds Experiments in Art and Technology (E.A.T.)	*Moves to Captiva, Florida*	*Robert Rauschenberg: A Retrospective at Guggenheim Museum, New York*
1966	**1970**	**1997**

● **David Salle**
(b.1952)
Like Levine, Salle is among a younger generation of American artists exploring ideas and techniques employed by Rauschenberg.

◆ **New Media**
Rauschenberg began experimenting with light, sound, motion, and new technologies as early as 1954 (left: *White Anger, Red Danger, Yellow Peril, Black Death*, 1985 by Bruce Nauman).

Self Portrait,
Robert Rauschenberg, 1965, Dwan Gallery, Los Angeles

Although Rauschenberg was influenced by the work of the Dadaists and Surrealists, his use of photomontage, found objects, and concrete materials is meant to keep the viewer in reality.

Four Views,
Robert Rauschenberg, c.1950s
Rauschenberg often commented on the nature of
consumerism, high and low art, asking the viewer to
consider the nature of the society that gives rise to art.

ABOUT THE WORK

Together with Jasper Johns,
Rauschenberg led the move away from
Abstract Expressionism in the 1950s.
His extensive use of imagery from
popular culture and commercial art
marked him out as one of the earliest
pioneers of Pop Art. Equally, his anti-art
approach to materials linked him with
the post-war revival of Dadaist ideas.

COMPOSITION

One of Rauschenberg's most distinctive
creations was the "combine"—a
novel form of collage, in which
seemingly unrelated elements were
brought together in a single artwork.
The most famous examples include
three-dimensional objects (*Monogram*
combines a stuffed goat with a rubber
tire), but he sometimes just employed
painted surfaces and photographs.

COLOR

When working with photographic
images, Rauschenberg adopted the Pop
Art process of divorcing them from
their original context. He did this by
using negatives, over-exposures, or
by altering the colors.

MOOD

By manipulating his "found" images,
Rauschenberg removed any meanings
or associations that they might have.
On their own, photos of a row of bins
(1) or a stairway that leads nowhere
(2) might provoke an emotional
response, such as a sense of desolation.
Here, though, they become random,
depersonalized elements in a larger
composition.

Electric Chair,
Andy Warhol, 1966,
Musée National d'Art
Moderne, Paris

All the artists of the American Pop Art movement, including Warhol, are indebted to Rauschenberg in their use of appropriated images and mechanical reproduction.

The Weather Project,
Olafur Eliasson, 2003, Tate
Modern, London

Eliasson is one of many artists who have responded to Rauschenberg's use of light, sound, and motion, and the concept that the artist is not an isolated ego but part of a cultural context that creates meaning.

Rauschenberg's far-ranging interests and love of collaboration have also played major roles in the dissemination of his ideas. His accomplishments extend beyond the realm of painting, sculpture, and printmaking to encompass music, dance, theater, performance art, happenings, technology, and new media. In discussions of influence and inspiration it is easier to mention the names of those who have not been affected by Rauschenberg's art than to try to list all those who have.

Among the most influential aspects of Rauschenberg's art and thought, indebted as they are to Marcel Duchamp, include: his belief in the role of the viewer in creating meaning; his assertion that an artist is not an isolated ego but part of a cultural context and society that also determine meaning; his leveling of traditional hierarchies regarding materials deemed "inappropriate" for making art; his advocacy of a painting not as an inviolate surface, but as a support upon which to hang other objects; and his conviction that a painting is less an emotive field rather than a physical entity—a material object consisting of other objects.

In these ways and for such reasons, Rauschenberg helped to expand the boundaries of art and to set the stage for the seemingly unlimited array of possibilities, options, motivations, working methods, materials, and modes of expression available to artists today.

Jasper Johns is among the most significant artists of the postwar era. His paintings combine working methods and strategies of art-making that delight the senses, with a rich grammar of ideas and intellectual challenges that stimulate the mind. Exploring paradox, ambiguity, Abstraction, and representation, Johns questions basic assumptions about art and what it means to be an artist.

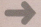 **INFLUENCED BY**

KEY
● artist
◆ artistic movement
■ cultural influence
❖ religious influence

● **Paul Cézanne**
(1839–1906)
Cezanne's questions about the nature of painting and its levels of meaning are echoed in Johns' work.

● **Pablo Picasso**
(1881–1973)
From specific motifs and paintings to general attitudes, all of Picasso's work is important to Johns.

● **Marcel Duchamp**
(1887–1968)
The conceptual basis of Duchamp's art, life, and ideas are fundamental to Johns' artistic language (right: replica of *Fountain*, 1951).

● **Ludwig Wittgenstein**
(1889–1951)
Wittgenstein's ideas about meaning and the philosophy of language have shaped Johns' grammar of representation.

JASPER JOHNS (b.1930)
American

	Born May 15 in Augusta, Georgia	Studies at the University of South Carolina	Moves to New York	Meets Robert Rauschenberg	Meets John Cage and Merce Cunningham	Flag and Target paintings	First solo exhibition at Leo Castelli Gallery, New York	Meets Marcel Duchamp
CHRONOLOGY	**1930**	**1947**	**1948**	**1953**	**1954**	**1954–55**	**1958**	**1959**

 INSPIRED

● **Andy Warhol**
(1928–87)
Johns' use of everyday objects and references to commonplace images directly inspired Warhol's art.

◆ **Pop Art**
All Pop artists were stimulated by the altered contexts, iconic forms, various levels of meaning, and irony associated with Johns' art (right: *Varoom!* by Roy Lichtenstein, 1965).

◆ **Minimalism**
The detached, cerebral, and serial aspects of Minimalism owe much to Johns' ideas of replication, duplication, and mechanical processes.

◆ **Conceptual Art**
Johns' exploration of ambiguity, paradox, and shifting definitions of art look back to Duchamp and forward to later conceptual practices.

Jasper Johns is one of the most influential artists of recent times. Like Paul Cézanne, Johns has consistently engaged most of the fundamental questions related to definitions of art and what it means to be an artist in a changing world. Johns' art is an intensely rigorous and intellectually rich exploration of the nature, themes, working methods, visual and intellectual preconceptions, and historical assumptions of art and creating art. Influenced by a host of different personalities working in a variety of fields, most importantly by fellow artists Marcel Duchamp and Robert Rauschenberg, the composer John Cage, choreographer Merce Cunningham, and philosopher Ludwig Wittgenstein, Johns has been able to create an art of wit, insight, visual delight, and psychological complexity. If the hallmarks of influence and inspiration are the ability of an artist to create a dialogue between the past and present; and the degree to which his body of work can be mined by future

artists pursuing many and varied paths of discovery, then Johns' accomplishments are among the most significant in the late 20th century.

Johns came of age in the aftermath of one of America's most influential and dominating art movements, Abstract Expressionism, led by such larger-than-life personalities as Jackson Pollock (1912–56), Willem de Kooning (1904–97), Mark Rothko (1903–70), and Barnett Newman (1905–70). Johns and his younger contemporaries, Rauschenberg and Cy Twombly (b.1928), all confronted the same problem: how to emerge from under the influence and at times the oppressive shadow of the earlier movement and its dramatic protagonists. In each case, these younger artists, most of whom were in their twenties, sought new methods through which they hoped to discover their unique voices. For Johns, this path led to a questioning of the ideas related to the nature of

Merce Cunningham Dancers Rehearsing,
September 1957, Rehearsal, New York

Both Robert Rauschenberg and Jasper Johns served as artistic advisors for the Merce Cunningham Dance Company: Rauschenberg beginning in 1954, succeeded by Johns in 1966.

● **John Cage**
(1912–92)
Cage's anti-elitism, exploration of chance, beliefs in all sound as music, and in art as "purposeless play," shaped Johns' development.

● **Merce Cunningham**
(b.1919)
Cunningham's advocacy of the significance of all movement as dance is part of Johns' thinking about art's relationship to life.

● **Robert Rauschenberg**
(b.1925)
Rauschenberg's desire to close the gap between art and life as seen in his combines is reflected in Johns' art.

Skin Drawings	Flagstone and Cross-Hatch paintings	Paints The Seasons	Prize for Painting at the Venice Biennale	Jasper Johns: A Retrospective at Museum of Modern Art, New York
1962	**1970s**	**1985–86**	**1988**	**1997**

● **Jeff Koons**
(b.1955)
Koons' ideas about banality, the commonplace, popular culture, creativity, and artistic personality owe a debt to Johns (below: *Puppy* in Bilbao, 2000).

● **Damien Hirst**
(b.1965)
Hirst's attitudes about mortality, viewer engagement, and the visual and conceptual layers of art have much in common with views expressed by Johns.

Flags 1,
Jasper Johns, 1973, National Gallery of Art, Washington, D.C.

Johns used popular iconography such as the American flag to encourage the viewer to see an image without reference to its symbolic connotations, but as a carefully crafted object.

Andy Warhol challenged the basic assumptions of what art is, who makes it, how it is made, and why. He forever blurred the boundaries between high and low art, fine and commercial art, and long-held beliefs concerning originality, talent, masterpieces, celebrity, fame, and the power of personal image and public persona.

 INFLUENCED BY

KEY
● artist
◆ artistic movement
■ cultural influence
❖ religious influence

● **Marcel Duchamp**
(1887–1968)
Duchamp's challenges to the privileged status of art and to the unique talent of the artist are fundamental concerns of Andy Warhol.

● **Salvador Dalí**
(1904–89)
Warhol's skill at self-promotion and his creation of an artistic persona took a page from the behavior and provocations of his Spanish predecessor.

● **Willem de Kooning**
(1904–97)
De Kooning's 1954 depiction of Marilyn Monroe would be reinvented dozens of times by Warhol throughout the 1960s.

● **Robert Rauschenberg**
(b.1925)
Rauschenberg's interest in appropriation, commercial replication, and popular culture directly shaped Warhol's artistic vision.

● **Jasper Johns**
(b.1930)
Johns' use of familiar, iconic images that question and blur traditional distinctions between art and life became a hallmark of Pop Art and of Warhol's art (right: *Painted Bronze II: Ale Cans*, 1964).

ANDY WARHOL (1928–87)
American

	Born Andrew Warhola, August 6 in Pittsburgh, Pennsylvania	Studies painting and design at the Carnegie Institute of Technology in Pittsburgh	Moves to New York; begins work as a commercial artist for Glamour magazine	Andy Warhol Enterprises is legally incorporated	Paints his first works based on comics and advertisements;	sees paintings by Roy Lichtenstein	Death and Disaster series; Campbell's Soup Can paintings; first silkscreens	Makes his first films including Sleep, Kiss, and Haircut
CHRONOLOGY	**1928**	**1945**	**1949**	**1957**	**1960**		**1962**	**1963**

→ **INSPIRED**

■ **The Velvet Underground**
Singer and songwriter Lou Reed (b.1942) was managed by Warhol until 1967. The now classic cover of his band's debut album was designed by Warhol.

● **Robert Wilson**
(b.1941)
This avant-garde stage director, playwright, performer, video artist, painter, and sculptor owes much to Warhol's film and video work.

● **Cindy Sherman**
(b.1954)
Sherman's *Untitled Film Stills* (1977–1980) series explores many of the same themes related to popular culture, fame, and celebrity as in Warhol's art.

● **Robert Gober**
(b.1954)
Gober's use of everyday objects and his mixture of the sacred and profane find inspiration and precedents in Warhol.

◆ **Postmodernism**
Warhol's art was fundamental in the postmodern shift toward an art derived from mass media, the photographic image, and replication.

Andy Warhol redefined the materials, techniques, sources, purposes, and goals of art. In a New York studio called The Factory, Warhol elevated commercial objects to the realm of fine art, equated the mechanical methods of reproduction with artistic expression, challenged traditional definitions of what it meant to be an artist, and forever blurred the distinction between high and low art.

Warhol was able to connect with, provoke, and sometimes outrage his audience through iconic portraits of Marilyn Monroe and other contemporary celebrities, as well as symbols. He had the ability to appeal to the collective consciousness through familiar and easily understood objects and shared current events, and in his establishment of mechanical processes as the foundation for making art. His sense of timing and understanding of the intoxicating and, at times, toxic power of fame, celebrity, and glamour set the stage for many of the obsessions in today's global mass media culture. When Warhol said: "If you want to know all about Andy Warhol, just look at the surface of my paintings and films and me, and there I am. There's nothing behind it," he was pointing out the aspects of his work that are today both celebrated and criticized.

Warhol's vision encompassed high art, low art, anti-art, and nonart. In this regard he builds on the rich legacy of predecessors such as Marcel Duchamp, Robert Rauschenberg, and Jasper Johns. Warhol opened the door to new definitions, possibilities, and worlds of visual communication. His story of influence and inspiration continues unbroken to the present day.

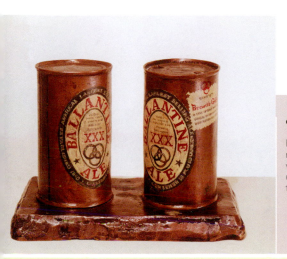

Tilted Head Portrait, Salvador Dalí,
Philippe Halsman, 1942, Halsman Estate
Surrealist Dalí's capacity for self-publicity,
and ability to work in a range of media
from painting to sculptures, films, and
photography resonated with Warhol.

● **Roy Lichtenstein**
(1923–97)
Lichtenstein was the
most successful Pop artist
whose work depended
upon the use of imagery
taken from comic books.

■ **Popular Culture**
*"Where have you gone,
Joe DiMaggio?"* is a
lyric from the Simon
and Garfunkel song
"Mrs Robinson," which
references the baseball
player Joe DiMaggio to
whom Marilyn Monroe
was once married.

Exhibits his video art, the first artist to do so; The Velvet Underground is born	*Shot in his studio, The Factory, on June 3 by Valerie Solanas*	*First monograph on Warhol is published*	*Begins executing portraits on commission*	*Collaborates on paintings with Jean-Michel Basquiat and Francesco Clemente*	*Dies February 22 in New York after gallbladder surgery*
1965	**1968**	**1970**	**1972**	**1983**	**1987**

● **Jeff Koons**
(b.1955)
Koons interest in banality, the relationship
between high art and low art, and popular
icons owes much to Warhol.

● **Jean-Michel Basquiat**
(1960–88)
The young New York
artist met Warhol
in 1982, and began
collaborating with
him shortly thereafter.
He died the year
after Warhol.

● **Mariko Mori**
(b.1967)
The Japanese artist has
described herself as a
child of Warhol and a
grandchild of Duchamp.

**Michael Jackson and
Bubbles,**
*Jeff Koons, 1988, San
Francisco Museum of
Modern Art, San Francisco*

Koons is one of many
artists continuing in
Warhol's footsteps by
exploring the distinction
between high and low
art, and the nature of
celebrity.

Green Marilyn,
*Andy Warhol, 1967,
Kupferstichkabinett,
Staatliche Museen, Berlin*

Warhol was the master
of creating iconic images,
even when the subjects
were celebrities like Marilyn
Monroe whose image was
already widely recognized.

Self-Portrait,
Andy Warhol, 1986, Guggenheim Museum, New York

The almost skull-like appearance of Warhol was
deliberate given his skill in self promotion: he realized
the power of his own image and how to project
himself and his work to the art world and beyond.

Bridget Riley is among the best-known British artists of the 20th century. Her paintings defined Op Art and remain among the most dynamic visual statements of the movement. Her focused investigation into the nature of painting, perception, and human vision; and the high quality of her work distinguish her as an original, significant, and gifted painter.

 INFLUENCED BY

KEY
● artist
◆ artistic movement
■ cultural influence
❖ religious influence

● **Claude Monet**
(1840–1926)
The scale, colors, textures, optical effects, and Abstraction of Monet's *Water Lilies* affected Riley, and all of Op Art.

● **Georges Seurat**
(1859–91)
The color theory behind Seurat's Neo-Impressionist paintings and Pointillist technique was closely studied by Riley from 1958.

● **Giacomo Balla**
(1871–1958)
The dynamics and illusion of movement in Balla's paintings and Italian Futurism are echoed in Riley's paintings.

◆ **Kinetic Art**
The illusion of movement in Riley's paintings is often discussed within the larger context of kinetic works of art that do move.

● **Josef Albers**
(1888–1976)
Albers' studies into the theoretical, optical, and structural properties of color and form are basic to Riley's work (right: *TOG 79*, 1964).

BRIDGET RILEY (b.1931)
English

| Born April 24 in Norwood, London | Studies at Goldsmiths College, University of London | Studies at the Royal College of Art, London | Paints landscapes in the Pointillist manner of Georges Seurat | Begins to explore optical phenomena in painting | First solo exhibition at Gallery One, London | Her paintings are included in The Responsive Eye exhibition at the MoMa, New York | Wins the International Painting Prize at the 34th Venice Biennale, the first |

CHRONOLOGY | **1931** | **1949–52** | **1952–55** | **1958** | **1960** | **1962** | **1965** | **1968**

 INSPIRED

● **Jésus Rafael Soto**
(1923–2005)
The optical and kinetic qualities in Soto's paintings and sculptures echo Riley's subtlety, precision, and playful effects dependent upon visual perception.

● **Piero Dorazio**
(1927–2005)
Dorazio's colorful, open, lattice-work paintings are less rigorous than Riley's but are indebted to her visual dynamics (left: *Oval I*, 1982).

● **Yaacov Agam**
(b.1928)
Agam's paintings share the precision of Riley's but require movement on the part of the viewer to complete their visual realignment.

● **Yayoi Kusama**
(b.1929)
Kusama's obsessive investigation of the dot in small-scale paintings and environmental installations combines aspects of Pop Art, Op Art, and Minimalism.

Bridget Riley's precisely conceived and visually stunning paintings are synonymous with the Op Art (optical art) movement. Her work stands today as one of the pinnacles of achievement within the concepts and goals of that phenomenon. Riley's influences extend as far back as Claude Monet, Paul Cézanne (1839–1906), and Georges Seurat. She is also indebted to the modern pioneers of retinal art and perceptual dynamics, Josef Albers and Victor Varsarely.

In paintings such as *Current*, 1964 (Museum of Modern Art, New York) and *To a Summer's Day*, 1980 (Tate Britain, London), Riley combines beauty with obsessive technical execution, optical complexity, and intellectual rigor. Visual energy is both controlled and unleashed. Her art represents one of the most advanced investigations into pure visual sensation, color, movement, and light in modern art.

Riley's paintings also explore a host of traditional and contemporary ideas in the history of art from the importance of nature, to the presence of the spiritual, and the meaning inherent in formalism. About these ideas Riley states: "I draw from nature. I work with nature, although in completely new terms. For me nature is not a landscape, but the dynamism of visual forces—an event rather than an appearance—these forces can only be tackled by treating color and form as ultimate identities, freeing them from all descriptive or functional roles."

In a more recent statement she says: "Properly treated, formalism is not an empty thing but a potentially very powerful answer to this spiritual challenge." Riley's thoughts echo those of Wassily Kandinsky (1866–1944), Kazimir Malevich (1878–1935), Piet Mondrian (1872–1944), Mark Rothko (1903–70), and others inspired by nature, while at the same time seeking to transcend it through the pure pictorial means of painting.

Bright Morning with Willow Trees,
Claude Monet, c.1914–18, L'Orangerie, Paris

Monet translated the forms he observed in nature into paintings of light, color, and optical sensation.

● **Victor Vasarely**
(1908–1997)
Vasarely's black-and-white paintings from the 1930s helped shape Riley's more dynamic use of black and white in the 1960s.

British contemporary painter and first woman ever to win	Mural for the Royal Liverpool Hospital; set designs for the ballet Color	Moves at the Edinburgh Festival	Solo exhibition at Waddington Galleries, London	Bridget Riley: A Retrospective at Tate Britain, London
	1983		**1996**	**2003**

● **Richard Anuszkiewicz**
(b.1930)
Anuszkiewicz creates the same kind of action and retinal energy in his paintings as his British counterpart.

● **Larry Poons**
(b.1937)
Like Riley, Poons's paintings are concerned with the illusion of movement, optical effects, and surface tensions created by patterns.

◆ **Contemporary Design**
The patterns and optical effects of Riley's work are evident in fashion, graphic, interior, and multimedia design.

Dots Obsession,
Yayoi Kusama, 2006, New National Gallery, Berlin

Kusama's obsession with the dot has led her to create installations that pay homage to the Op Art created by Riley and the sense of powerful movement in her work.

Cataract 3,
Bridget Riley, 1967, The British Council, London

Like Monet, Riley's starting point is nature, and she reduces the patterns and forms she sees in the real world to create energetic and dynamic compositions that explore pure visual sensation.

CREDITS